BLACK
TV

BLACK TV

Five Decades of Groundbreaking Television
from *Soul Train* to *Black-ish* and Beyond

BETHONIE BUTLER

BLACK DOG
& LEVENTHAL
PUBLISHERS
NEW YORK

Black Dog & Leventhal Publishers
Hachette Book Group
1290 Avenue of the Americas
New York, NY 10104
www.hachettebookgroup.com
www.blackdogandleventhal.com

First Edition: December 2023

Black Dog & Leventhal Publishers is an imprint of Perseus Books, LLC, a subsidiary of
Hachette Book Group, Inc. The Black Dog & Leventhal Publishers name and logo are
trademarks of Hachette Book Group, Inc.

The publisher is not responsible for websites (or their content) that are not owned
by the publisher.

The Hachette Speakers Bureau provides a wide range of authors for speaking
events. To find out more, go to hachettespeakersbureau.com or email
HachetteSpeakers@hbgusa.com.

Black Dog & Leventhal books may be purchased in bulk for business, educational,
or promotional use. For more information, please contact your local bookseller or the
Hachette Book Group Special Markets Department at Special.Markets@hbgusa.com.

Additional copyright/credits information is on page 287.

Print book interior design by Joanna Price

LCCN: 2022051812

ISBNs: 978-0-7624-8151-4 (hardcover), 978-0-7624-8152-1 (ebook)

Printed in China

1010

10 9 8 7 6 5 4 3 2 1

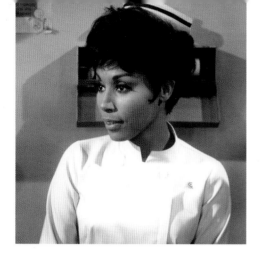

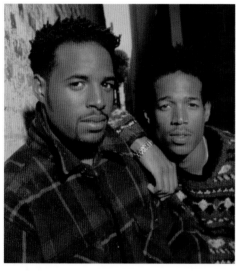

CONTENTS

7 *Introduction*

11 **Chapter 1: Pioneers Under Pressure**

29 **Chapter 2: Black Entertainment**

45 **Chapter 3: A Piece of the Pie**

63 **Chapter 4: Roots**

75 **Chapter 5: '80s Sitcoms**

91 **Chapter 6: Comedy and Variety Shows**

121 **Chapter 7: '90s Sitcoms**

161 **Chapter 8: UPN and the WB**

213 **Chapter 9: A Dramatic Turn**

251 **Chapter 10: The Future of Black TV**

260 *Acknowledgments*

261 *Notes*

280 *Index*

287 *Photo Credits*

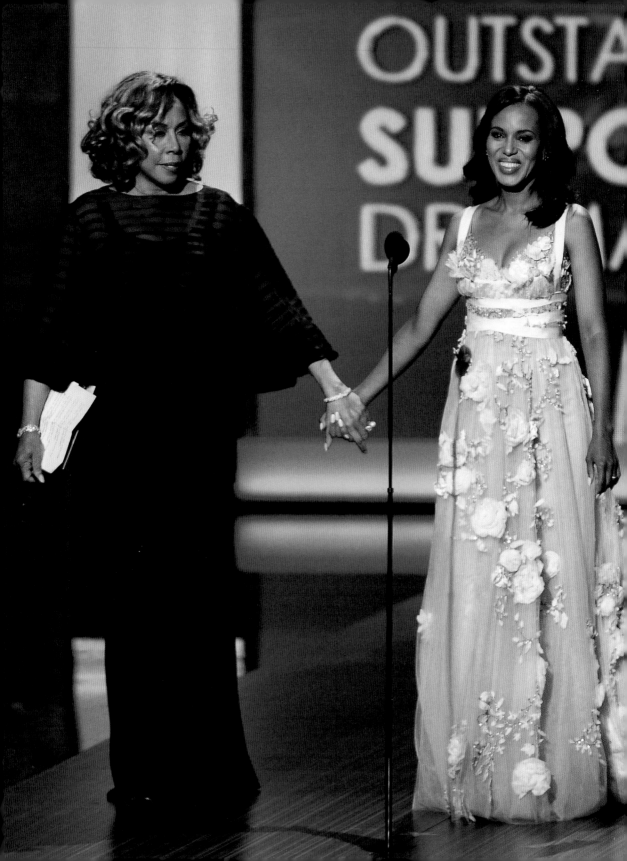

Diahann Carroll with Kerry Washington at the
Emmy Awards in 2013

INTRODUCTION

Olivia Pope, the formidable fixer at the center of Shonda Rhimes's internet-breaking ABC drama *Scandal*, assigned aliases to several of her clients over the course of the show's seven-season run. But it was rare that the character, played by Kerry Washington, would use one herself. So when the show's fourth season premiere revealed that its gutsy protagonist was living under the alias "Julia Baker," Shondaland fans knew there had to be a deeper meaning behind the nom de guerre.

Washington herself had offered a hint of sorts a year earlier at the 65th Primetime Emmy Awards, where she presented the award for Outstanding Supporting Actor in a Drama Series alongside veteran actress Diahann Carroll. The pairing was poignant: Washington was up for best leading actress in a TV drama, a category that had not included a Black woman since 1995 when Cicely Tyson earned a nod for *Sweet Justice*. Carroll had made history decades earlier as the first Black woman to receive a best leading actress Emmy nomination—for her role as Julia Baker in the 1968 sitcom *Julia*.

With *Julia*, Carroll became the first Black woman to lead a prime-time network series as something other than a servant. Julia Baker was a nurse whose husband died in the Vietnam War and the show's drama revolved partly around her raising their young son as a single mother. Four decades later, *Scandal* became only the third

7

prime-time network series to center a Black woman—and the first to air since the short-lived 1970s cop procedural *Get Christie Love!*

When Carroll died in 2019, Rhimes said in a statement that her pioneering role had "escorted the tv drama into the 20th century," calling Julia Baker "queen mother to Olivia Pope's existence." It was a fitting line of succession—both *Julia* and *Scandal* represent the dawns of two distinct eras in the history of Black television.

Black television can be a somewhat ambiguous term. After all, the first TV series to feature an all-Black cast was *The Amos 'n Andy Show*, which was slammed for its copious use of stereotypes—and adapted from a radio show starring two white vaudeville performers in blackface. That's not the Black television we're talking about in this book. This is a celebration of shows that center Black people and their experiences, without tethering those experiences to the white people in their midst. So *Julia* gets a chapter, but *Beulah*—which starred Ethel Waters as the benevolent problem-solving maid to a white family—does not. As we get into the '90s, the definition of Black TV gets more fluid as the expanding TV grid features more Black people on-screen (and behind the scenes) than ever. From there, the emphasis shifts to shows created by Black writers or featuring a predominantly Black cast, or both. David Simon's *The Wire* portrayed Baltimore's Black communities with largely unprecedented nuance—and marked Idris Elba's breakout—but it's not a Black TV show. Our focus is primarily on sitcoms and dramas that aired during prime time, in addition to variety/sketch/late-night series that helped increase the visibility of Black entertainers.

Julia is the beginning of our journey—a left bookend if you will—through five decades and counting of iconic Black TV. We'll talk about the '70s as an era of unprecedented representation, hampered by largely white writers' rooms that sidelined or refused to hire Black talent. We'll also recall it as the decade that gave us *Soul Train* and *Roots*. From there, we'll look at the increasingly nuanced comedies of the 1980s—some of which hold up better than others—paving the way for the Black sitcom boom of the '90s and early aughts. We'll revisit iconic scenes, breakout performances, important guest appearances and theme songs, delivering some overdue flowers along

the way. And we'll discuss efforts in, and out of, Hollywood to ensure the stories told on our screens are more inclusive and more authentic than ever.

Which brings us back to *Scandal*. Rhimes's political thriller followed decades of progress and innovation on the part of Black creators, writers, and actors—a legacy Rhimes had long infused into her work. *Scandal* went a step further, helping define an era that made social media integral to the TV viewing experience—it was on Twitter, of course, that viewers (dubbed gladiators) put forward theories about the significance of Julia Baker.

In the years since, TV shows from Black creators have proliferated. In 2014, Rhimes added another drama led by a Black woman to her roster. Viola Davis became the first Black woman to win the Emmy for lead actress in a TV drama for her role as defense attorney Annalise Keating in *How to Get Away with Murder*. Accepting the award at the 2015 ceremony, Davis declared: "You cannot win an Emmy for roles that are simply not there."

Increasingly, they are. The last few years have seen influential TV debuts from storytellers including Issa Rae (*Insecure*), Donald Glover (*Atlanta*), and Ava DuVernay (*Queen Sugar*). These and other unapologetically Black shows have honored their forebears while reflecting many different Black experiences. This book will take you from *Julia* to what will likely be remembered as a golden age for Black television.

So put on your Hillman sweatshirt, make some popcorn, and get ready for a *dyn-o-mite* retrospective of some of the most groundbreaking, iconic Black TV shows of the last fifty years.

Actress, singer, model, and activist Diahann Carroll is shown here in 1968.

1 PIONEERS UNDER PRESSURE

Issa Rae was making her way down the red carpet at the 69th Primetime Emmy Awards in 2017, when a *Variety* reporter stopped the *Insecure* creator to ask about her beloved HBO dramedy. During the exchange, Rae had recounted frustrating meetings she'd had with TV executives before *Insecure* landed at HBO. Rae was intent on creating a series that shared the same witty and relatable DNA of Rae's viral web series, *The Misadventures of Awkward Black Girl*. One exec wanted to cast celebrities who weren't, in Rae's view, "awkward Black women." Another, hilariously, told Rae she didn't "have an audience." Rae's publicist had already given the signal to wrap up the interview when the reporter asked one last question: "Last but not least, who are you rooting for tonight?"

"I'm rooting for, ummm, everybody Black," Rae said, inspiring a cascade of internet memes, rap songs, T-shirts, and other unauthorized merch bearing the phrase, which conveyed a sentiment deeply familiar to just about *everybody Black*. The "ummm" that punctuated Rae's response—delivered amid a backdrop of mostly white faces—felt less like hesitation and more like taking a deep breath before doing a cannonball at a poolside party. At the ceremony, Lena Waithe became the first Black woman to win an Emmy for best comedy writing (for cowriting an acclaimed episode of Netflix's *Master of None*) and *Atlanta* creator Donald Glover became the first Black director to win an Emmy in the TV comedy category. Amid the celebration, some critics pointed out the perennial elephant in the room: These milestones could—and should—have happened long before 2017.

JULIA

CREATED BY: Hal Kanter

STARRING: Diahann Carroll, Lloyd Nolan, Marc Copage, Betty Beaird, Michael Link

PREMIERED: September 17, 1968

EPISODES: 86

...

BLACK TV HISTORY is full of overdue milestones. *Julia*, the first TV show to feature a Black family—in this case, a single mother and her young son—didn't premiere until 1968. Starring Diahann Carroll as the titular Julia Baker, the series introduced a decidedly middle-class protagonist: a registered nurse raising her five-year-old son, Corey (Marc Copage), following the death of her husband, an army captain who died in combat in the Vietnam War. *Julia*, which premiered just months after the assassination of Martin Luther King Jr. and the anguished riots that followed, was criticized for depicting Julia's Blackness as incidental.

Nothing about the scripted television landscape of the 1960s (or adjacent decades) facilitated an authentic dive into Blackness in America. "It meant something any time a Black person was on television—there were so few of us," says Tim Reid, a veteran actor and director, who helped create a couple of the series you'll read about in this book—and later starred as Ray Campbell in *Sister, Sister*.

"Way before the internet," Reid says, "Black people had a personal net" that would spread word—through families, churches, or social organizations—of Black entertainers appearing on prime time. Rooting for everybody Black, basically.

As historian Donald Bogle noted in his 2001 book, *Primetime Blues*, the few Black actors who had prime-time breakthroughs in the 1960s played characters often or entirely removed from the racial politics of the United States. This included Bill Cosby's secret intelligence agent on *I Spy* and Nichelle Nichols's Uhura on *Star Trek*. *Julia* was the first weekly series to break that tradition.

Even as Carroll accepted some of the criticism around *Julia*, she bristled at the pressure inherent in being the first. "I felt even before the show went on the air that there would be some impact, just from

Diahann Carroll broke racial barriers with the title role of *Julia*. It was the first American television series to feature a Black woman in a nonstereotypical role.

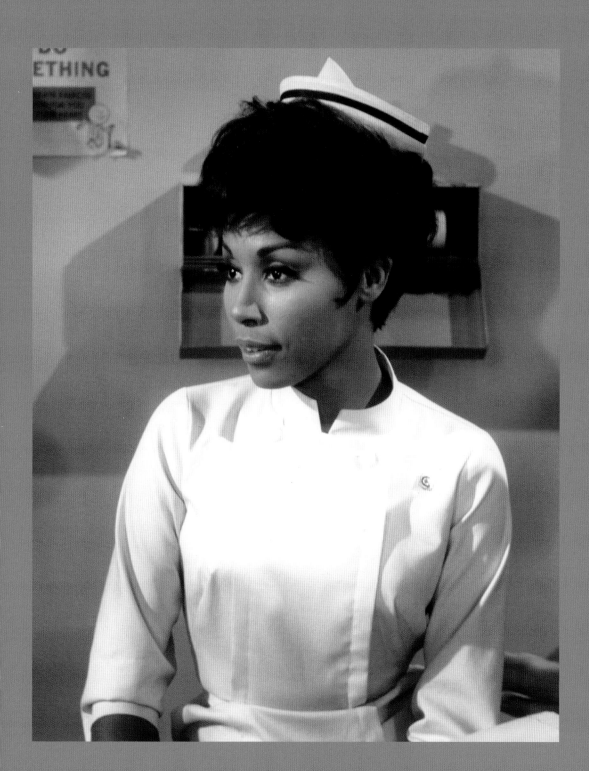

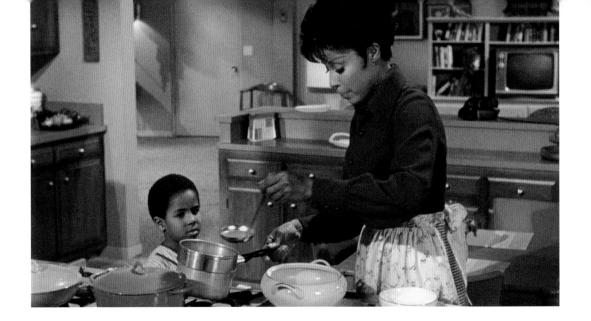

the fact that black people are on TV, in a setting of banality or not," she told *Time* magazine. "Why are we singled out as a TV show? The fact that the show went on the air at all is a plus, and a plus long overdue. Somebody decided, 'Let's have a black lady starring on TV in 1968'—in 1968. Why not attack that? That it took so long? Isn't that an outrage?"

Julia would become, along with *Dynasty*, a career-defining role for Carroll. But series creator Hal Kanter had initially been skeptical about making her the sitcom's lead. Carroll headlined Vegas clubs before appearing in the 1954 film *Carmen Jones.* She shared the screen with Dorothy Dandridge and Sidney Poitier in *Porgy and Bess* and went on to win a best actress Tony in 1962 for playing fashion model Barbara Woodruff in *No Strings.* Kanter, Carroll wrote in her 2008 memoir, "felt my image was too worldly and glamorous" to play a single mother.

Carroll had been somewhat tentative about the role herself. For one, the Bronx native—who grew up in Harlem—wasn't interested in relocating to Hollywood. But as Carroll revealed in a 1998 interview with the Television Academy Foundation, she also didn't expect the show to be on the air long. "I really didn't believe that this was a show that was going to work. I thought it was something that was going to relieve someone's conscience for a very short period of time," she said. "And I really thought, 'Let them go elsewhere.'"

The characters Julia Baker and Corey Baker constituted the first Black family portrayed on television.

Carroll recalled that it was longtime NBC exec David Tebet who convinced her to audition for *Julia*. Kanter's doubts about her—and whether housewives tuning in could relate to her chic presence—added some excitement to the mix. The actress flew to Los Angeles a few days before she was set to meet with Kanter to rehearse the script and figure out the character's aesthetic with the help of a makeshift glam squad that included her assistant and two friends.

Kanter had already expressed, in a 1967 letter to NBC programming head Mort Werner, that he "was disappointed" by Carroll as a prospective Julia. But when Carroll walked in to meet Kanter on the day of her audition, the TV producer pointed out how much "that woman"—in a simple black dress* and trendy updo—matched what he envisioned for Julia Baker.

That woman, he soon learned, was Diahann Carroll.

————

Kanter was a veteran radio-turned-film-and-TV scribe, who pitched the series after hearing Roy Wilkins, then head of the NAACP, lament the lack of positive portrayals of Black people in entertainment. As he acknowledged in a 1997 interview with the Television Academy Foundation, Kanter felt partially responsible for that bleak landscape—having worked on both *Amos 'n Andy* and *Beulah*. Those popular early 1950s sitcoms drew protests for stereotypical and demeaning depictions of Black people even as they marked pioneering roles for Black actors.

Julia pointedly rejected such stereotypes but it also did little to reflect the cultural atmosphere of the late 1960s. "As a slice of Black Americana, *Julia* does not explode on the TV screen with the impact of a ghetto riot. It is not that kind of show," *Ebony* magazine asserted in a 1968 cover story about the series. "Since the networks have had a rash of shows dealing with the nation's racial problems, the light-hearted *Julia* provides welcome relief, if, indeed, relief is even acceptable in these troubled times."

In 1968, "the networks" referred to the three national broadcasters that existed at the time: ABC, CBS, and NBC. And "the

* Let it be known that the dress was Givenchy. Because this is Diahann Carroll we're talking about.

rash of shows dealing with the nation's racial problems" referred not to other sitcoms but to a news cycle that had been jolted by the civil rights movement. It had been just over a decade since NBC had struggled to land a national sponsor for Nat King Cole's eponymous variety show, one of the first TV shows to be hosted by a Black entertainer.

Cole was at the height of his fame when *The Nat King Cole Show* premiered, and the fifteen-minute program boasted a diverse rotation of similarly popular guests, including Harry Belafonte, Peggy Lee, Ella Fitzgerald, Sammy Davis Jr., Tony Bennett, Eartha Kitt, and Mahalia Jackson. But by the summer of 1957, *The Nat King Cole Show* still had not found a sponsor, forcing the network to rely on a mix of regional sponsors to help finance it. (Cole also put his own money into the show, while forgoing much higher-paying gigs.) NBC adjusted the show's time slot several times before announcing it would be dropped from the schedule.

Julia's smoothly integrated, middle-class life may not have fully reflected the struggle that Black Americans faced in the civil rights era (and certainly not the burgeoning Black Power movement), but the groundbreaking series wasn't completely removed from the social justice movement that unfolded—and was regularly televised—in the years following Cole's pioneering but short-lived variety show. "Part of what opened the door for *Julia* was the fact that civil rights activists were so skilled at using television to make their case and to dramatize their struggle," said historian Matthew Delmont, a distinguished professor of history at Dartmouth University.

The advances that preceded *Julia* "really forced networks to understand that there are Black consumers who are interested in seeing TV shows and have money to spend," said Delmont, noting that there were also several prominent Black ad agencies by this time. "There's also an understanding that white consumers and white viewers may be interested in these shows as well."

Julia had three national sponsors when it premiered on September 17, 1968: General Foods, Menley & James Laboratories, and Mattel, which would later release a line of Julia dolls in Carroll's likeness. The design gave nods to Carroll's glamorous profile and her

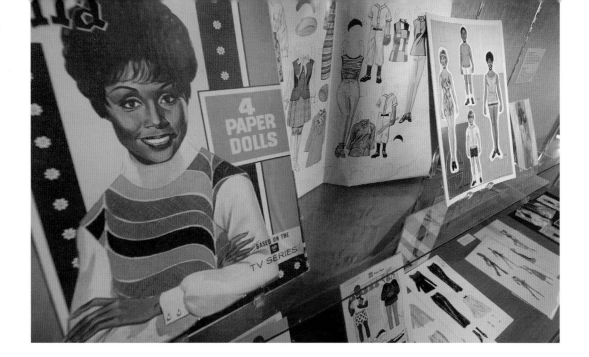

famed character's occupation, with a crisp white nurse's uniform for the daytime Julia and a chic culotte jumpsuit for the evening version.

———

Julia's prospective job—at an aerospace company's on-site clinic—is at the center of the pilot, titled "Mama's Man" (Kanter's original title for the show). The episode also introduces two recurring characters: Corey's friend Earl J. Waggedorn (Michael Link) and his mother Marie (Betty Beaird), who—like most of the people in their building—are white. Julia and Marie become friends (the kind that watch each other's kids in a pinch) after their sons become close, with the younger generation virtually clueless about their differences.

"There are aspects of the TV pilot I could criticize. But I'm not going to criticize them because we have a dialogue now that is positive toward correction," Carroll told the *New York Times* ahead of the series premiere. "We want to make *Julia* more black and not just a character who is colorless. I think I've made that clear and I think everyone agrees that if Julia has no racial consciousness at this time, the fact that I'm starring in my own series is of no consequence."

From the beginning, *Julia* made references to racism, at times more pointedly than others. But in typical sitcom fashion, issues were neatly addressed, if not resolved, within the span of an episode. In

eBay is full of vintage *Julia* memorabilia, including a talking doll, a lunchbox with a companion thermos, and paper doll collections by Saalfield Publishing Company. Some items are on display at the Smithsonian National Museum of African American History and Culture.

the pilot, the personnel manager who arranges for Julia to come in to interview is visibly stunned to discover that Julia Baker is a Black woman and a registered nurse (a highly recommended one at that), and their brief pre-interview finds them dancing around Julia's race. The clinic's Black janitor is more direct: "You're not going to *register* with Mr. Colton," he says upon learning Julia's vocation.

The edgiest dialogue arrives when the gruff Dr. Chegley (Lloyd Nolan) calls Julia directly to come in for an interview and she asks if Colton has informed him that she's "colored."

"What color are you?" Chegley asks.

"I'm a Negro," Julia replies.

"Have you always been a Negro, or are you just trying to be fashionable?" Chegley jokes before telling her to "try and be pretty," which was, abhorrently, a socially acceptable thing to say at the time.

Kanter chose this scene to promote the episode ahead of *Julia*'s debut. The exchange "was startling in 1968," Carroll recalled. She and Kanter disagreed on whether to say "colored" or "Negro," and while the dialogue ultimately contained both, this was one of many disagreements she and Kanter would have over the course of the show's three seasons.

There was one thing on which Carroll and Kanter adamantly agreed: *Julia* should present the Black middle class. "We were allowed to put this point of view on the air. We were allowed to have a comedy about a Black middle-class family," she said. "Television was going to have the kind of scope in time that would allow the ghetto situation, the middle-class situation, the upper middle-class situation."

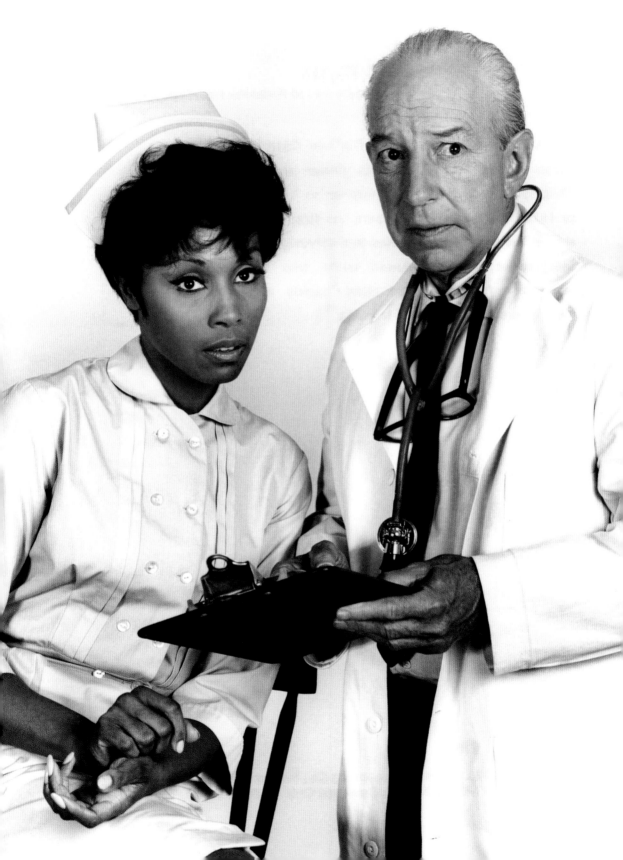

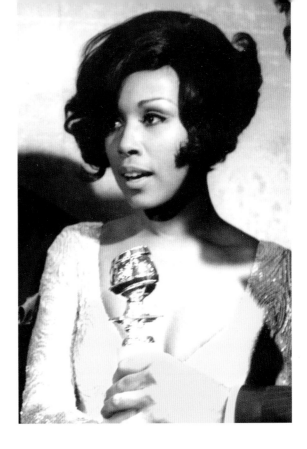

"Hal and I were of a like mind about that," Carroll added. "So while the criticism was heavy and sometimes very, very unkind—sometimes threatening—we stuck with that premise."

Early reviews for the show proclaimed the milestone in Carroll's starring role but took issue with the show's authenticity or lack thereof: "Watts it ain't," *Variety* declared. "Orange County maybe?" "The inconsistencies of *Julia* abound," *New York Times* critic Jack Gould wrote, noting the "luxuriously appointed apartment" in which the Bakers lived. Julia's swanky living space was a recurring thread of criticism—one Carroll seemed to poke fun at when she appeared on Tom Jones's variety show, *This Is Tom Jones*, a month after *Julia* premiered. Carroll appeared as a nurse in a sketch that featured her and Jones as a couple. A costume change—into a white cutout number with glittery accents—prompted Jones to quip: "How can you afford a dress like that on a nurse's salary?"

Julia quickly became a hit, landing among the season's top-rated shows and winning its time slot opposite *The Red Skelton Show* on CBS

Diahann Carroll was the first Black woman to win a Golden Globe in 1969.

and ABC's *It Takes a Thief*. The first season was nominated for four Emmys—including Outstanding Comedy Series and a historic best actress nod for Carroll, the first Black woman to be nominated for leading actress in a TV comedy. She became the first Black woman to win a Golden Globe—for best female TV star in 1969—and was nominated for that award's updated equivalent—best actress in a TV comedy—the following year.

Amid the accolades, *Julia* faced relentless criticism over the decision to make its pioneering lead a single mother. As Bogle noted in *Primetime Blues*, Kanter justified the choice as a TV trend amid a fall season that featured several widowed TV mothers: Lucille Ball in *The Lucy Show*, Hope Lange in *The Ghost & Mrs. Muir*, and Doris Day in *The Doris Day Show*. The difference, of course, is that there had been many examples of white nuclear families on TV by the fall of 1968. The same could not be said for Black families.

The show did hire a handful of Black writers, including Harry Dolan, Gene Boland, Ferdinand Leon, and Robert Goodwin.

"There was no question in my *mind* that *Julia* had a responsibility to set a positive example in the way it presented the Black family. And it didn't take long to realize that it was largely up to me to try to make that happen."

—DIAHANN CARROLL, FROM HER 1986 AUTOBIOGRAPHY *DIAHANN!*

Goodwin was a prolific writer who penned episodes for dozens of shows, such as *Bonanza*, *The Outcasts*, and *Mod Squad* during the mid to late 1960s. But he often felt sidelined in the industry, telling *Ebony* in 1969, "There are a number of places in Hollywood where I'm not even considered."

"In the beginning, I thought if a guy wrote well, that's all it takes. Well, it's not all it takes," he continued. "You go in to see a producer and pitch a story idea and you don't realize it, but for the first time he may be sitting down listening to an original, creative piece of work from a Negro. All his conditioning tells him you can't possibly do this as well as a white man."

Goodwin wrote an early episode in which Julia quits her job in protest after being restricted to the clinic because of an issue with her security clearance. One scene finds Julia confronting a bigoted security supervisor with a withering monologue alluding to slavery. In the same episode, Julia is horrified to discover that Corey and Earl J. Waggedorn (as Corey always calls him) started a shoe-shining business at the suggestion of Earl's mother. "I want you to promise me you will never *ever* shine shoes again," she tells Corey before marching down to talk to Marie. "I don't want my son shining shoes in this building or anywhere else," Julia tells her. "I put myself through nursing school to ensure his future, and his father's insurance money is in a trust fund to educate him for a life of dignity and pride."

"But what's wrong with two little boys shining shoes to earn money for some silly little toy?" a clueless Marie asks.

"Because there was a time when that was the only work our men could get—shining shoes, waiting tables, menial jobs," Julia says.

"Times have changed," Marie pipes, rattling off a list of successful Black men, including Thurgood Marshall, A. Philip Randolph, and Edward Brooke. She concludes that "little boys are little boys and nothing carries a stigma unless we put it there." The term "whitesplaining" hadn't yet entered the public lexicon, but the scene certainly fits that description.

In the end, though, Julia goes back to work at the aerospace clinic after Dr. Chegley pays a visit to her apartment building to tell her she has been cleared and that he appreciates her good work. He also gets a shoeshine from Corey and Earl, which seems to imply that Marie's "times have changed" spiel had shifted Julia's perspective.

Dolan, who for years served as director of the storied Watts Writers Workshop, cowrote a first-season episode that guest starred Susan Olsen (before the world knew her as Cindy on *The Brady Bunch*). Olsen played Pamela, the granddaughter of a couple in Julia and Corey's building. The episode, "Paint Your Waggedorn," is one of the show's more pointedly race-related installments. Corey and Earl are invited to play with Pamela, but it's clear that Mrs. Bennett is uncomfortable with her granddaughter playing with Corey. Julia later overhears Mrs. Bennett insinuate that Corey colored on a wall

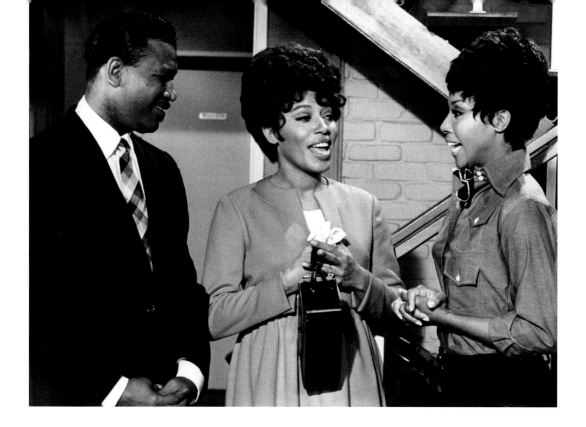

in their apartment building. "This place is turning into a ghetto," she says. "Because of a few pictures on the wall?" her husband protests. Mrs. Bennett, unaware that Julia is behind them, worries aloud that the building is turning into "a tenement," and says "it always happens when those people move in." "What people?" her husband asks.

"I believe, Mr. Bennett, the reference is to me and my son," Julia says, making her presence known. Mrs. Bennett sputters into silence, but it's clear she thinks Corey is responsible for the unauthorized artwork.

Back at home with Corey—who has picked up on the fact that Mrs. Bennett doesn't like him—Julia tenderly explains that their neighbor "is a sad lady" who thinks she and Corey are different from her. Corey doesn't quite understand. "What I mean is we have dark skin," Julia says, "and people like Mrs. Bennett think that Afro-Americans like you and me and Uncle Lou and Aunt Emma—that we're different."

Corey tells Julia he overheard Mrs. Bennett say that Black people "move into nice clean places and make them dirty." But, he says, "our house isn't dirty."

Julia had many guest stars over its three-season run, including Sugar Ray Robinson and Diana Sands in 1970.

"Of course not, but Mrs. Bennett doesn't know that—she's never been to our house," Julia tells Corey. "And it's up to you and me, and all of us, to help teach her and other prejudiced people how wrong they are."

Indeed, that's the problematic message of the episode—it turns out that young Pamela is the graffiti culprit, which Mrs. Bennett discovers when her granddaughter attempts to swallow the crayon she used to decorate the lobby (and several of her grandparents' walls). Pamela begins choking and Mr. Bennett runs upstairs to ask their neighbor, a nurse, for help. Julia immediately runs down to the Bennett's apartment, where she successfully dislodges the crayon.

"Mrs. Baker, I've been a very stupid woman," Pamela's grandmother tells Julia. "You've opened my eyes. I hope you can open your heart enough to forgive me."

Despite its kumbaya ending, "Paint Your Waggedorn" was more effective at addressing racism than another episode in which Julia tells a neighbor about the first time she experienced prejudice—at a high school dance. In *Diahann!*, Carroll recalled that "the whole story was so naive, so completely unreal," she "struggled to take it seriously."

Even before *Julia* aired its first episode, Carroll offered suggestions to make *Julia* more authentic—including having Julia wear her hair natural (which never happened) and introducing family members to give the Bakers a sense of community (which, to an extent, did happen—most notably, with Diana Sands playing Julia's cousin in several episodes). "If a Black child doesn't get a sense of himself and his history from the beginning, his self-image is destroyed," Carroll told the *Times*.

One area in which Carroll advocated successfully for her character was when it came to Julia's dating life. It rightfully made no sense to Carroll that an attractive, young working mother like Julia Baker wouldn't have men pursuing her. And it made little sense to her that the idea of Julia dating "was problematic" for producers initially, Carroll recalled. The show had tepidly approached its lead character's social life in early episodes—the first episode found Corey innocently trying to set his mother up with a repairman who frequented their building; in another episode, Julia won a date with a champion boxer

Fred Williamson played Steve Bruce, one of Julia's love interests. Carroll insisted that her character be shown to have a dating life.

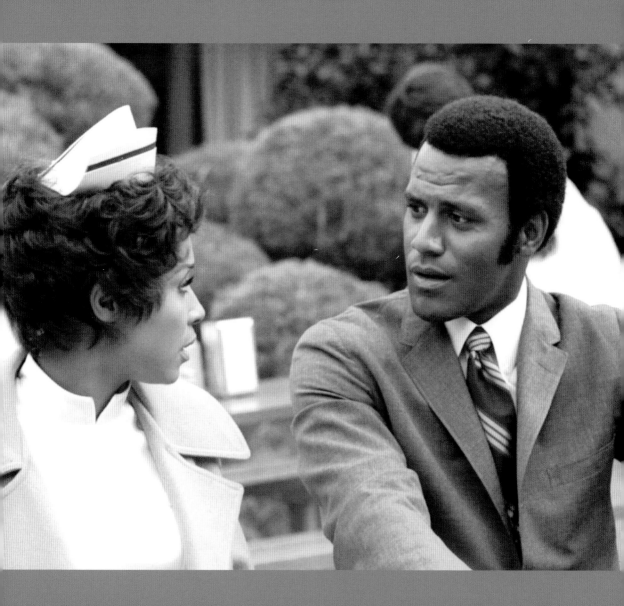

while appearing on a TV game show. "But eventually, we allowed Julia to date. It was a major event."

Paul Winfield, of *Sounder* and *Picket Fences* fame, *Land of the Giants* star Don Marshall, and NFL player–turned–actor Fred Williamson played memorable love interests. Carroll and Williamson's chemistry was captured for the cover of *TV Guide* in 1971.

At times, the debate around how progressive *Julia* was—or wasn't—has overshadowed what a significant moment the series was for television. In a 2014 episode of PBS's *Pioneers of Television*, Carroll recalled that the studio did not even have makeup for her complexion on her first day on set.

Criticism about the show's lack of father figure notwithstanding, *Julia* was the first to regularly let viewers into the home of a Black family. The first episode begins with Julia and Corey having breakfast together. It ends with Julia telling Corey, her "little man," that she loves him before the two collapse into a pile of giggles on the couch in their apartment.

But after three seasons, the criticism—and the pressure to represent an entire race of underrepresented people—took its toll. "I cannot spend every weekend studying each word, writing an analysis of everything I think may possibly be insulting, then presenting it to you in the hope that we might come to an understanding," she recalled telling Kanter. "You can see it—I'm falling apart."

Carroll understood from the beginning that her trailblazing role would have implications for decades to come. "Black children are going to have a marvelous time now," she told *Ebony* in 1968. "Their self-image is going to be so much greater."

In addition to the famed Julia dolls—created on the heels of the first mass-produced Black baby doll—the series inspired coloring books, playing cards, a *Julia*-themed lunchbox and thermos, among other nostalgia-inspiring merchandise.

Arguably, what—and who—followed *Julia* is the best measure of the show's influence. When Halle Berry became the first Black woman to win best actress at the Academy Awards in 2002, she dedicated her trophy to Carroll and other Black women who helped pave the way for that (overdue) moment.

Carroll's death in 2019 prompted an outpouring of tributes to the actress and her groundbreaking work across film, TV, and Broadway stages. "Seeing Diahann Carroll being the star of a show and playing a mother who was a nurse, who was educated, who was beautiful, just rearranged me," Berry said on a 2021 episode of PBS's *American Masters*. "And it made me realize that I had value and that I could turn to every week a woman that looked like who I would aspire to be when I grew up."

"Diahann Carroll you taught us so much," said Debbie Allen, who directed the actress in her recurring role as Whitley Gilbert's mother on *A Different World*. "We are stronger, more beautiful and risk takers because of you," Allen added. "We will forever sing your praises and speak your name."

Shonda Rhimes, who tapped Carroll to play the mother of Isaiah Washington's Preston Burke on the long-running ABC medical drama *Grey's Anatomy*, said Carroll "escorted the tv drama into the 20th century. Her Julia Baker is queen mother to Olivia Pope's existence."

"I love you for eternity. With all my heart," said Kerry Washington. "I am because of you."

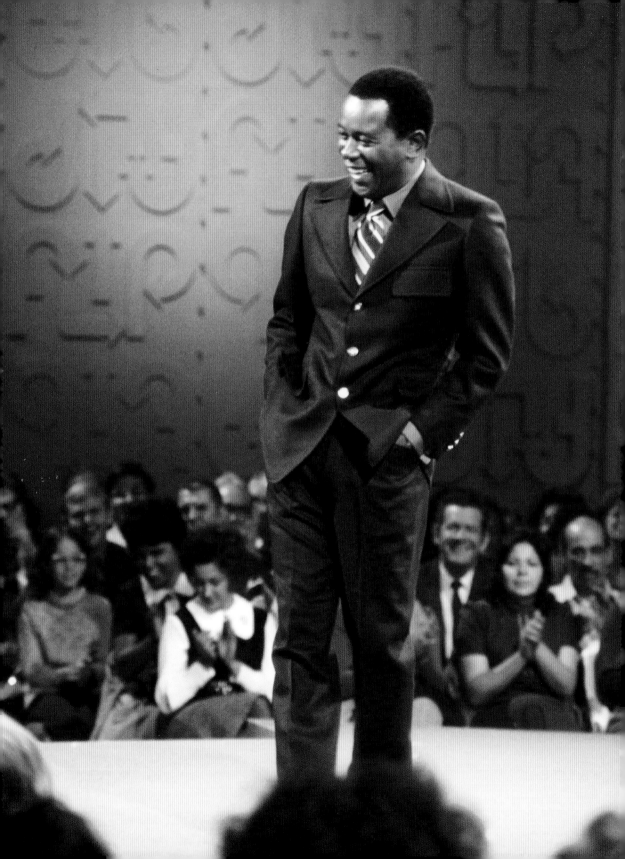

Flip Wilson was the first Black person to host a successful variety show on network television.

2 BLACK ENTERTAINMENT

Julia brought overdue representation to the sitcom space, but the series, which ended after three seasons, was criticized for presenting a whitewashed view of Black life. It would take years for scripted television to present anything resembling an authentic Black experience—and longer still for any nuance in telling those stories. But the 1970s still brought breakthroughs for Black entertainers, including unprecedented—though not uncomplicated—platforms for Black humor. Around the same time, a Chicago producer named Don Cornelius launched a local show that would showcase the beauty and joy of Black culture for generations to come: *Soul Train*.

THE FLIP WILSON SHOW

CREATED BY: Flip Wilson (produced by Bob Henry)
STARRING: Flip Wilson and various celebrity guests
PREMIERED: September 17, 1970
EPISODES: 95

REDD FOXX WAS ON *The Tonight Show Starring Johnny Carson* in the summer of 1965 when the venerated late-night host asked Foxx—appearing on the condition that he tone down the notoriously raunchy stand-up that had made him famous—to name "the funniest comedian out there right now."

"Flip Wilson," Foxx said.

For most of Carson's viewers, the brief exchange was largely unremarkable. But Foxx's shout-out on the popular late-night show was pivotal for Clerow "Flip" Wilson. Wilson was

a struggling comic, though not completely unknown; he had honed his stand-up along the Chitlin' Circuit, a network of segregation-era clubs where Black entertainers performed for Black audiences. He had also released two comedy albums, the latter of which was recorded at New York's famed Village Gate in 1964.

Carson took Foxx's recommendation seriously: Wilson made his *Tonight Show* debut that August, telling a joke he'd spent years finessing—one that would end up on his Grammy-nominated 1967 comedy album *Cowboys and Colored People*—about Christopher Columbus trying to convince Queen Isabella to finance his journey to the Americas. Only in Wilson's anachronistic retelling, it was Queen "Isabelle Johnson" holding the purse strings. And it wasn't the promise of acquiring new lands (or colonizing populations) that motivated the Spanish crown, it was the threat of a future without Benjamin Franklin, "The Star-Spangled Banner," or—to Queen Isabelle Johnson's particular horror—Ray Charles. "Chris gonna find Ray Charles!" Wilson said, delivering the punchline in a snappy falsetto that prompted laughter from the audience and Carson himself.

Wilson's first special, *The Flip Wilson Special*, aired in 1969 and featured guests like the Pointer Sisters.

Wilson's career picked up swiftly after that. The comedian, then thirty-one, was invited back to *The Tonight Show* the following month, and quickly became one of Carson's go-to guests. That affiliation found its way into ads touting the comedian's increasingly high-profile gigs. Ahead of an October 1965 stop at San Francisco's storied hungry i club, an ad in the *San Francisco Examiner* billed Wilson as "Johnny Carson's Comedy Find" (feel free to cast a side-eye on behalf of the late great Redd Foxx). By that December, Wilson was the "hot new comic of the Playboy circuit," per an ad in the *St. Louis Post-Dispatch*, which noted "Johnny's used him 3 times since August."

Over the next few years, Wilson would make dozens of appearances on *The Tonight Show*—even filling in as a guest host when Carson was away—along with semiregular showings on *The Ed Sullivan Show*. He became one of several Black entertainers—including Carroll, Harry Belafonte, Lena Horne, Sammy Davis Jr., and Leslie Uggams—making the variety show rounds (*The Dean Martin Show, The Kraft Summer Music Hall, Rowan & Martin's Laugh-In*, among others) in the mid to late 1960s. He also signed with Monte Kay, a prominent agent (who was previously married to Diahann Carroll), and landed a lucrative development deal with NBC.

From the outside, it may have looked like overnight success for Wilson, a Jersey City native who enlisted in the air force at sixteen (after lying about his age) to escape the poverty and instability of a childhood spent navigating foster homes and reform school. But Wilson had been very intentional about his comedy success. In interviews, he often spoke about the fifteen-year plan he'd established in the late '50s, promising himself he'd make it big by 1973. If he wasn't famous by then, he'd give up the dream. Wilson became known for toting around a notebook filled with comedy rules such as "Make them remember Flip Wilson as a self-confident man of the world, projecting an 'I Don't Care If You Laugh' attitude."

"I'm about a year and a half ahead of schedule," Wilson told the *New York Times* in 1968, referencing his fifteen-year plan. "I've got more offers than I have time to take."

The writer of the article, Tom Burke, noted that "at a time when virtually every Negro speaks bitterly of his past and present, and

uncertainly of his future, Flip Wilson's story is told without a shred of racial rancor." Amid his rise to fame, Wilson told Burke, "I don't have anything to kick about."

"His best comic routines are subtle but pungent expressions of black versus white America, yet when the topic is introduced off-camera he shrugs and stares blankly," Burke wrote.

This approach was, at least partly, strategic on Wilson's part. Another comedy law he followed was to "be topical, but not too topical." In the 2013 biography *Flip: The Inside Story of TV's First Black Superstar* author Kevin Cook notes that Wilson joked about his "riot outfit," while performing for a racially mixed crowd after the race riots of 1967. "Got it in Detroit, right out of the window," Wilson riffed. He didn't do the searing racial humor for which Richard Pryor—whom Wilson met along with a young George Carlin during his *Kraft Summer Music Hall* days—would become known. But Wilson also eschewed the respectable, seemingly curated-for-white-audiences comedy of Bill Cosby. Wilson had decided early on in his career that his act didn't need to be political or blue, the preferred term of the era for notoriously vulgar or profane comics. It just needed to be funny. "I began to think it was better to lose four or five people and get across to fifty," Wilson would later recall.

In 1969, NBC paired Wilson with Bob Henry, a veteran producer whose previous credits included Nat King Cole's short-lived variety show, to plan a special that would capitalize on the comedian's popularity with Black and white viewers. When *The Flip Wilson Special* aired that September, it was clear the network was testing the comedian out for his own show. The Labor Day special, featuring Jonathan Winters and Arte Johnson, introduced two of Wilson's most beloved comic personas: the fast-talking Reverend Leroy and the effervescent Geraldine Jones, for whom Wilson donned a shoulder-length wig, a Pucci dress, and pantyhose.

The Flip Wilson Special drew 42 percent of TV viewers in its time slot, ranking eighth among all shows that aired that week. Wilson leveraged the special's success to broker an unparalleled deal for his own variety show. Most notably, he insisted on owning the

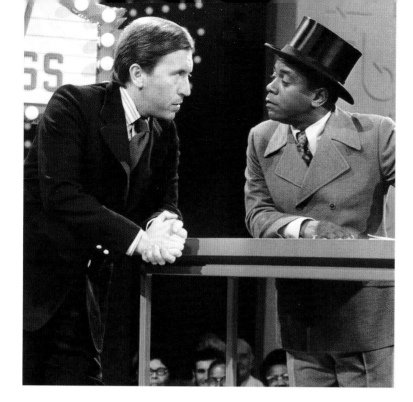

syndication rights himself—a provision most variety show hosts did not achieve—making him both a producer and the star of *The Flip Wilson Show*.

The groundbreaking variety show premiered with James Brown, David Frost, and—perhaps the clearest indication that Wilson had reached mass appeal—Big Bird and Oscar the Grouch (yes, the *Sesame Street* Muppets) among the guests. Wilson performed a duet with Oscar about their shared affinity for trash. Frost interviewed Geraldine, who sashayed to her seat as brassy horns played and audience members whistled. She primped for the camera and said hello to her boyfriend, "Killer."

The reviews were stellar. "The burgeoning talents of Mr. Wilson, whose energies are matched by a felicitous sense of timing in rolling eyes in his own form of a delayed double-take, had been increasingly obvious in his many guest appearances," wrote the *Times*'s TV critic, Jack Gould. "But for the debut of his own show he and his producer, Bob Henry, were truly astute showmen. They worried first about the overall production, and by generously sharing the stage with others Mr. Wilson had it made."

David Frost appeared on *The Flip Wilson Show* several times.

The show was also an instant ratings hit, ranking second only to *Marcus Welby, M.D.* (ABC's first TV hit) for the fall season of 1970. The variety series occupied the same spot the following season, landing behind *All in the Family*, which would top Nielsen's ranking for five consecutive seasons. *The Flip Wilson Show* earned eighteen Emmy nominations across its four-year run, winning two—Outstanding Variety Series and Outstanding Writing Achievement in Variety Series—in 1971.

America's collective favor, though, went to Geraldine, who appeared opposite Wilson on the December 1970 cover of *Ebony*. "The entire transition from Flip Wilson to Geraldine Jones takes only 20 minutes," noted an inside photo spread detailing Wilson's transformation. In the accompanying article, Wilson explained that the voice he lent to Geraldine (and other female characters) was a spin on a trend he noticed among other comics who would reference significant others or a mother-in-law in their acts. But other comics "were knocking women," Wilson told the magazine. "I wanted to make my character the heroine of the story."

> **"I had to use words to sustain interest. All these years I've been preparing myself. I'm a story-teller, rather than a comedian, because story-tellers last longer."**
> **—FLIP WILSON**

In the decade and a half following the ill-fated *Nat King Cole Show*, only two Black entertainers—Sammy Davis Jr. and Leslie Uggams—hosted their own (short-lived) variety shows. Wilson was the first Black person to host a successful variety show on network television. Fifteen years after Cole's show failed to secure a national sponsor, NBC quickly raised the advertising rates for its newest hit—upping the cost per minute of advertising on *The Flip Wilson Show* by nearly $20,000 over the course of the first season.

Eddie Murphy once called Wilson an "unsung hero" for Black comics. "He's in Middle America's living room. He's not assimilating," Murphy recalled during a conversation with Jerry Seinfeld and

Flip Wilson's character Geraldine Jones was a fan favorite. While other comedians disparaged women, Wilson "wanted to make my character the heroine of the story."

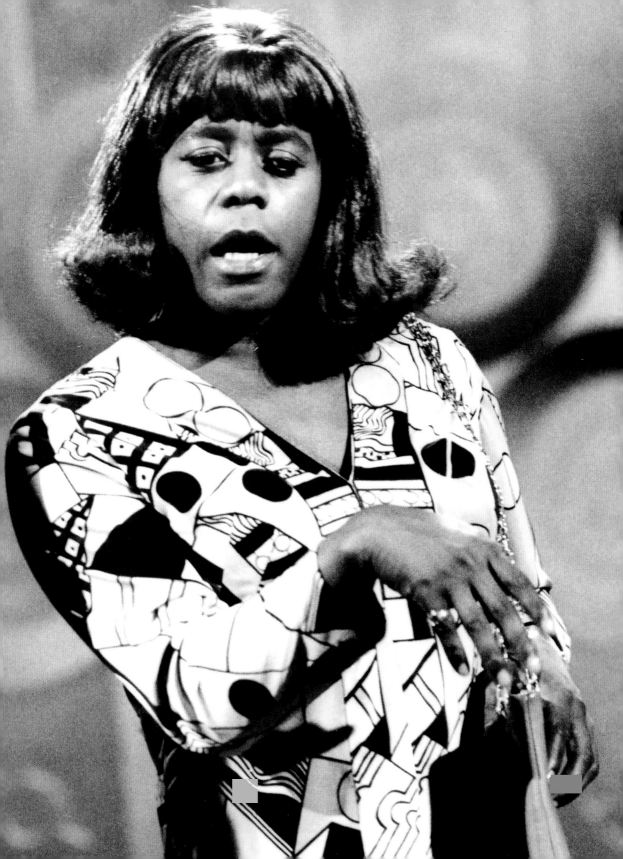

MSNBC's Joy Reid, in promotion for Netflix's *Comedians in Cars Getting Coffee*. "He's being him. He *owns* his fucking show."

"The others had acts or routines. They were out of their bag as hosts," Wilson theorized in a January 1971 story in *Jet*, which gave its cover completely over to Geraldine. "In the beginning, when I decided to be an entertainer, I knew I was funny. I also knew I couldn't sing or dance."

The ratings for *The Flip Wilson Show* slipped in its third season, and the series was no longer in the top ten when it ended in June of 1974. Wilson opted to spend more time with his children, though he made occasional TV appearances and starred (opposite Gladys Knight and a young Jaleel White) in the sitcom *Charlie & Co.*, which lasted for one season.

The Flip Wilson Show continued at least one legacy of the pioneering variety shows that preceded it: Wilson used his show to give platforms to up-and-coming (or underappreciated) talent, such as George Carlin, but especially Black celebrities, including Richard

Wilson made a point to feature up-and-coming comedians like Richard Pryor on his show.

Pryor, comedian Jackie "Moms" Mabley, the Jackson 5, Roberta Flack, and, of course, Redd Foxx. Foxx was a guest on *The Flip Wilson Show* multiple times, but his appearance on January 13, 1972, was especially significant because it marked a full-circle moment for both comedians. Foxx joined Wilson for a sketch that featured the host as a stand-up comic whose act is repeatedly interrupted by a heckler (played by Foxx) who is conspicuously funnier than the in-house entertainment. "Oh, you're back again?" Wilson says. "I just ran in here to get away from a mugger," Foxx says, smoking a cigarette and nursing several drinks. "It's obvious I didn't know when I was well off."

After the sketch wrapped, Foxx joined Wilson on the stage, where the variety host got a chance to pay Foxx's *Tonight Show* endorsement forward. "I'd like to take a moment today to tell you about Redd's new show," Wilson said. "It's called *Sanford and Son* and it begins tomorrow night on NBC."

Of course, we're going to talk about Fred Sanford and his antics—in the next chapter. First, we need to take a ride on a cartoon locomotive in search of *peace, love, and SOUL!*

SOUL TRAIN

Created by: Don Cornelius
Hosted by: Don Cornelius
Premiered: October 2, 1971
Episodes: 902

WHEN GLADYS KNIGHT & the Pips appeared on *Soul Train* in May of 1974, it marked a homecoming of sorts. The group had performed on the very first syndicated episode of *Soul Train* in 1971. Three years later, Gladys Knight & the Pips were fresh off winning their first Grammy. They had finally triumphed in the category for Best R&B Vocal Performance (by a duo, group, or chorus) for "Midnight Train to Georgia" on their fourth consecutive nomination. "We got a speech together the first year in case we won," a breathless Knight said at the ceremony. "It's been four years, I forgot the speech!" When the group won Best Pop Vocal Performance, for the wistful

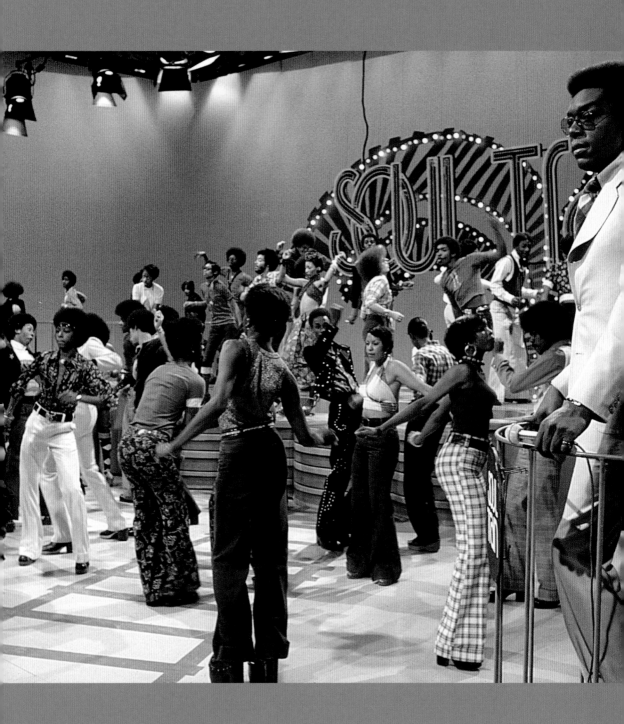

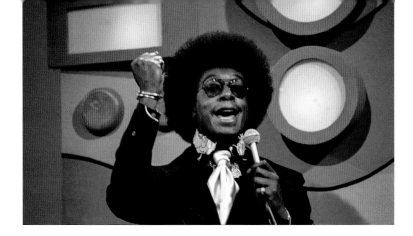

ballad "Neither One of Us (Wants to Be the First to Say Goodbye),"
Knight was so surprised that—as she later told *Soul Train* host Don
Cornelius—she just about "keeled over." "I didn't think to rehearse
two speeches," she quipped at the podium before saying, simply,
"thank you" and "thank God."

The group had arranged for the ceremony to be taped so they
could watch their big moments later—the wins had been a blur—
but as Knight recounted to Cornelius, there had been technical
difficulties. So Knight had never actually seen her exhilarated
acceptance speeches. "Well, let me tell you something," Cornelius
said in his indelible baritone. "You guys have been so good to us since
our very beginning," he said. Instead of buying them something,
Cornelius said, he had arranged for video snippets of the Grammys to
be shown on a big screen TV in the *Soul Train* studio.

In some ways, there was no better setting for Gladys Knight
& the Pips to relive one of the biggest moments of their career.
Cornelius had envisioned *Soul Train* as a place where Black artists
were given an unprecedented platform to show off their talents. And
that exposure had undoubtedly helped Knight & the Pips reach one of
the most prominent stages in the music industry.

The first iteration of *Soul Train* premiered as a local show on
Chicago's WCIU, where Cornelius—a former radio DJ—was a
sports reporter on a show called *A Black's View of the News*. The first
episode of *Soul Train*, which aired August 17, 1970, featured popular
local musicians Jerry Butler, the Chi-Lites, and the Emotions. Local
youth danced around the acts on a minimalistic set that reflected its
local budget.

ABOVE
Don Cornelius hosted
Soul Train for twenty-
two seasons, from
1971 to 1993.

LEFT
Soul Train was a
showcase for Black
music and culture.
It became one of
the longest-running
shows on American
television.

Soul Train was immediately popular. After less than two months on air, the *Chicago Tribune* reported that the live variety show drew "triple the Chicago rating of rival David Frost on WMAQ-TV," citing a television survey. The show caught the attention of Joan and George Johnson, the husband-wife team behind Johnson Products, the maker of Afro Sheen. Their sponsorship—perfect for a groundbreaking show debuting at the height of the Black Power movement—allowed *Soul Train* to go into syndication, bringing the revelry and music to the masses. Initially, the show started in seven large cities—Atlanta, Birmingham, Cleveland, Detroit, Houston, Philadelphia, and Los Angeles. Cornelius moved to LA, establishing his show as part of the entertainment industry, and the show would tape there for its entire thirty-five-year history.

In its first years of syndication, the show spotlighted artists including Bill Withers, Al Green, the Staple Singers, Bobby Womack, Lou Rawls, Little Richard, Curtis Mayfield, Stevie Wonder, and Marvin Gaye. The format drew comparisons to Dick Clark's *American Bandstand*, but it was a lazy comparison. For one, WCIU, where *Soul Train* originated, had aired two local dance-variety shows in the 1960s—*Red Hot and Blues*, which featured teens dancing to R&B, and *Kiddie-a-Go-Go*. And there were other examples outside of Chicago. Matthew F. Delmont, the historian, cites *The Mitch Thomas Show*, which premiered in Wilmington, Delaware, in 1955. "It was like *Soul Train* fifteen years before *Soul Train*," says Delmont, noting that locally, it was known as "the Black Bandstand because it was the Black equivalent of the show that was airing across the river in Philadelphia at a time when *American Bandstand* didn't allow any Black teens in the studio."

Though *American Bandstand* had been integrated for a decade prior to *Soul Train*, the dancing on Clark's show couldn't compare. Each *Soul Train* dancer had a style all their own—in terms of both dancing and fashion—and the iconic Soul Train line gave them opportunities to mingle and play off one another.

"Dance shows aren't new, of course," the writer and cultural critic Clayton Riley wrote in the *New York Times* in 1973. "But if you're into comparisons, *Soul Train* is to the old *American Bandstand* what champagne is to seltzer water."

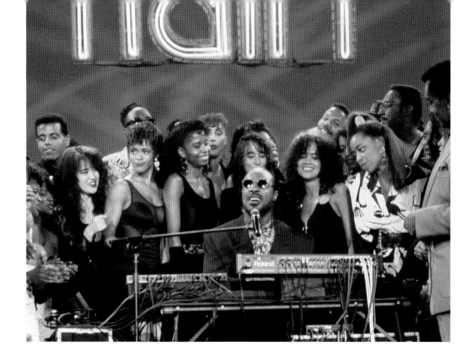

Soul Train brought a number of R&B and soul acts to prominence. It also marked the first brush with the entertainment business for a number of celebrities, including Vivica A. Fox, Rosie Perez, Jody Watley, Carmen Electra, and Nick Cannon. But from the very beginning, Soul Train dancers *were* celebrities, at least in Los Angeles, where talent emerged just as easily from the street as the dance studio.

Several dancers have reflected on their Soul Train tenures on BET's "I Was a Soul Train Dancer." Evette Moss, who Cornelius nicknamed "Legs," said she dreamed of dancing on Soul Train before being handpicked by the show's crew. She became known for her short, glossy mushroom haircut and skin-baring outfits she styled herself. "The best time of my life was waiting to go down that line," she recalled. For other LA natives, Soul Train literally kept them safe. Louie Ski Carr, who danced on the show from 1980 to 1990, called the show "life-changing" and said it "saved" him from the streets. He became an actor after leaving the show.

BET acquired the rights to the Soul Train brand—including other franchise elements including the annual Soul Train Music Awards since 2016. As vice president of talent and original programming at the network, Robi Reed has helped shepherd the show's legacy with

Stevie Wonder was one of the first well-known musicians to appear on Soul Train, shown here in 1971.

SOUL TRAIN CAMEOS

The Fresh Prince of Bel-Air

In the season 5 episode titled "Soul Train," Philip (James Avery) and Vivian Banks (Daphne Maxwell Reid) receive a videotape of one of their biggest relationship milestones, and it's revealed that Philip proposed to his wife on an episode of Cornelius's long-running series. Vivian is clueless as Philip, picked to play the show's famed scramble board, spells out "Vivian, I love you and I always will. Marry Me." Cornelius, making a cheeky cameo, says, "I'm sorry, Philip, that's wrong. The correct answer is James Brown."

After watching the tape, Will (Will Smith) says, "So, Uncle Phil, you proposed *on Soul Train*, huh? Where y'all get married—*The Flip Wilson Show*?"

In Living Color

In a sketch dubbed "Old Train," creator Keenen Ivory Wayans played a senile Don Cornelius, who has to be reminded of his name by a stagehand (Tommy Davidson) and introduces the group Fine Young Cannibals as Find One Carnival.

Elderly dancers (styled like breakout talents) went down the line with the assistance of walkers or canes. Someone in a horse mask is wheeled down the line, and just when you think it can't get any darker, a casket follows.

"I'm Don Corleone," Wayans says as the sketch ends, "and as usual, in parting we wish everyone love, peace, and OLD," he says before falling to the floor.

"I Was a *Soul Train* Dancer" and *American Soul*, the dramatized series based on the show and Cornelius's pioneering role in television.

"*Soul Train* was appointment television," says Reed, who grew up in Los Angeles and remembers watching the series every Saturday morning. She and her brother knew to have their chores done, so they could watch to see "number one, who was lip-syncing—because very little was live—and then, what the dances were, who was coming down the *Soul Train* line."

As a teenager, Reed made an even deeper connection to the franchise as a dancer. A friend convinced her to audition at fourteen, and though dancers on the show were required to be at least sixteen, a choreographer allowed Reed and her friends to dance if they had

an adult present on the set. Every weekend they were on, Reed says her father joined them in the studio. "Every time we had to shoot, he would just be there in the audience, and loved it," Reed recalls.

Reed remembers having a blast on the show, where she regularly danced from 1974 to 1979. "The energy was always exciting," she says. But she was so young, she didn't really understand how influential the show or its creator was. "We didn't know we were making history."

Generations of Black children grew up on *Soul Train*, anticipating the opening sequence—a colorful animated "soul train" barreling down the tracks as legendary announcer Joe Cobb heralded the "Soooooooooul Train." For decades, it was one of few places where Black culture was highlighted with pride and authenticity.

"Black viewers think of *Soul Train* as theirs," Cornelius told United Press International (UPI) in 1984. "It feels like something they could belong to. Maybe that's because it's the only entertainment show on television directed at blacks."

Tyrone "The Bone" Proctor and Patricia Davis were two of the many dancers featured on *Soul Train*.

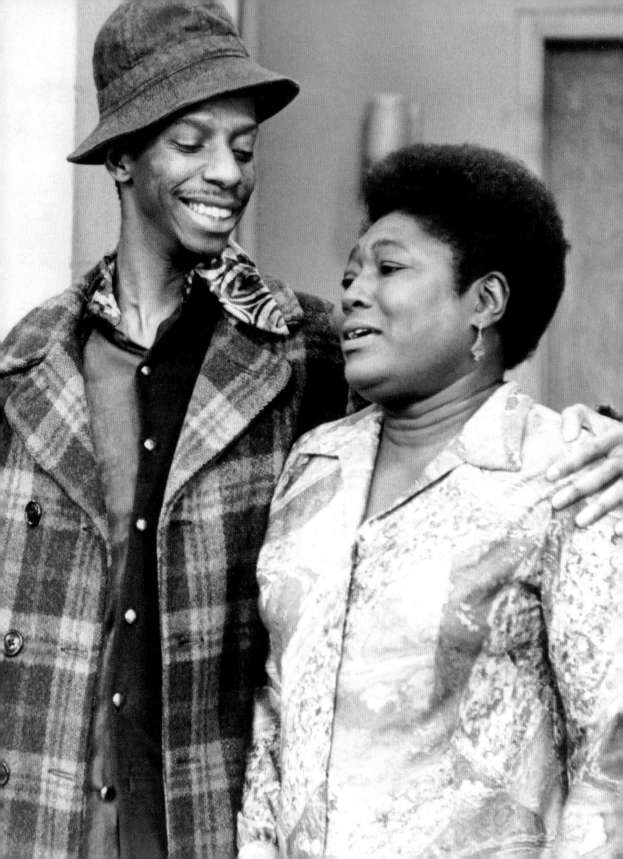

3 A PIECE OF THE PIE

The season 2 finale of *Black-ish* paid tribute to one of the show's biggest inspirations: Norman Lear, the prolific producer behind *Good Times*, *The Jeffersons*, and other legendary 1970s sitcoms. In the 2016 episode aptly titled "Good-ish Times," Dre Johnson (Anthony Anderson) falls asleep while watching a *Good Times* marathon and dreams that he and his family are members of the Evans clan. Dre's parents (played by Laurence Fishburne and Jenifer Lewis) took on the roles of Florida and James Evans. Dre became Keith, boyfriend to the Evanses' teenage daughter Thelma (embodied by Tracee Ellis Ross's Rainbow).

Black-ish's creator, Kenya Barris, has said that his own groundbreaking ABC sitcom would not exist were it not for Lear, whose name has become shorthand for topical sitcoms.

"Good-ish Times" drew on parallels between *Black-ish* and the 1970s sitcom—namely Dre's oft-referenced upbringing, which resembled the Evanses' life in Chicago's Cabrini-Green public housing project far more than it resembled the pampered upbringing Dre and his wife, Rainbow (Tracee Ellis Ross), were able to provide for their own children. Amid jokes about the Evans family's tenuous financial situation, "Good-ish Times" reflected Dre's real fears about falling back into poverty.

The well-reviewed episode, which came about following Lear's visit to the *Black-ish* writers' room, was also symbolic of how far television had come in the decades since Lear's omnipresence on network television. *Black-ish* had a Black creator, Black executive producers, and a diverse writers' room that included a range of perspectives.

45

SANFORD AND SON

CREATED BY: Bud Yorkin and Norman Lear
STARRING: Redd Foxx, Demond Wilson, LaWanda Page
PREMIERED: January 14, 1972
EPISODES: 135

JULIA HAD BEEN off the air for nearly a year when *Sanford and Son,* only the second sitcom to revolve around a Black family, premiered on January 14, 1972. The series, created by *All in the Family* creator Norman Lear and his producing partner, Bud Yorkin, starred Redd Foxx as a curmudgeonly junk dealer living in Watts with his son and business partner, Lamont (Demond Wilson).

Like *All in the Family, Sanford and Son* was based on a British sitcom (*Steptoe and Son*). Producers had seen Foxx perform in Las Vegas and watched him play, of all things, a junk peddler in Ossie Davis's 1970 directorial debut, *Cotton Comes to Harlem.* "He could walk into a room and tell you your mother died and make you laugh," Lear said of Foxx in an interview for the Archive of American Television in 1998. "His earlobes were funny."

Foxx had become popular, if controversial, for his raunchy stand-up sets and comedy albums dubbed "party records" because of his notoriously ribald material. Signing on to *Sanford and Son* meant cleaning up his act for TV's censors, something he had only previously done for one-off performances. *Sanford and Son* brought Foxx's humor to new audiences, including white viewers and younger Black people who weren't necessarily familiar with his nightclub material. "I had to do dirty jokes 'cause I worked in a nightclub," Foxx told the *San Francisco Examiner.* "This is a funny show, human, honest. The kids can enjoy it."

Sanford and Son joined *All in the Family,* which premiered in 1971, in helping define the slate of socially conscious sitcoms—including *Maude, Good Times,* and *The Jeffersons*—that premiered in the decade that followed. Collectively, these series helped bring more representative depictions of American families to the small screen. But the networks and writers' rooms remained overwhelmingly white (a problem not limited, of course, to the '70s). The all-white writing staff behind *Sanford and Son,* the first sitcom since *Amos 'n*

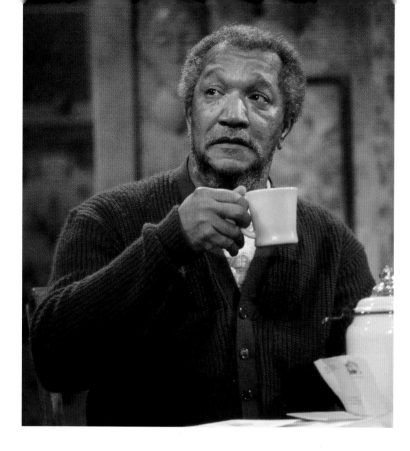

Andy to feature a predominantly Black cast, raised eyebrows even before the series debuted.

"We're doing a black show but the men who are doing it are all white," producer Aaron Ruben told the *Minneapolis Star Tribune* in 1972. "And so you always naturally run into a problem there and the kinds of questions I'm getting, 'How do you come to be writing a black show?'" In interviews leading up to the premiere, Foxx said he hoped to bring on Black writers and that he had penned material for the show himself. The show's title was pulled directly from the comedian's life, with Foxx (real name: John Sanford) naming his character after his late brother, Fred. But the fourteen-episode first season featured no Black writers: Most of the episodes were credited to Ruben, who also expressed a desire to hire Black writers, but described it as a near impossible task.

Sanford and Son premiered in an undesirable time slot for a prime-time sitcom: Friday at 8 p.m. Despite that inherent challenge, the series quickly became the nation's second most popular show, right behind *All in the Family* (which hadn't even cracked the top twenty in its first

Only a talent like Redd Foxx could have immortalized the beloved character of Fred Sanford in the annals of sitcom history.

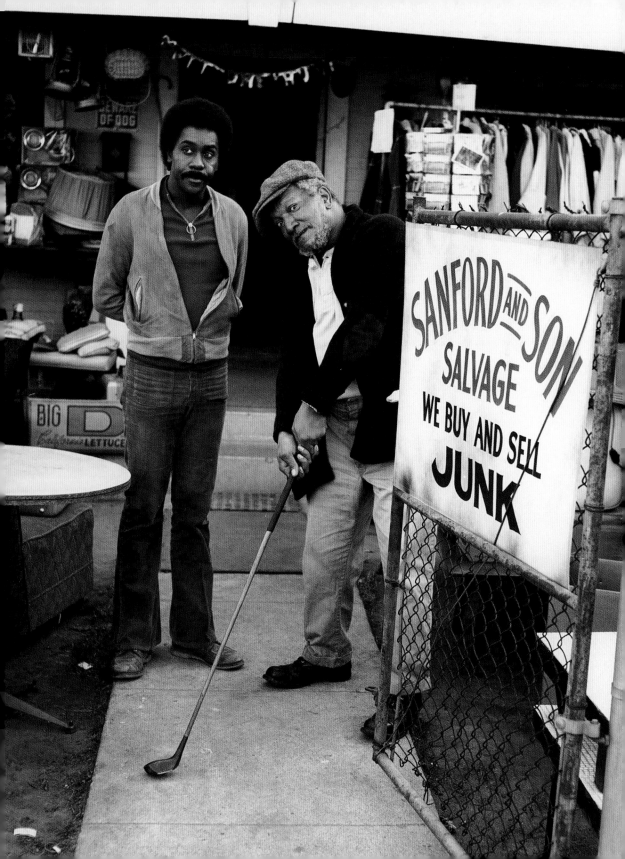

season). Foxx endeared viewers with his crotchety catchphrases: "You big dummy," which he said frequently to Lamont, and some variation of "This is the big one, Elizabeth." The latter became a running gag that found Fred feigning a heart attack and calling out to his late wife. (Foxx would later die of a heart attack while filming his comeback sitcom, *The Royal Family*, opposite Della Reese.)

Two months after *Sanford and Son*'s debut, the *New York Times* grappled with the racial dynamics of the production and its talent, while praising Foxx's performance and the ease with which he and Wilson played off each other. "But for all of its earthy humor and outspoken observations, *Sanford and Son* will not carry the weight of any profound social implications," wrote the paper's TV critic John J. O'Connor. "It does, however, represent several giant steps taken from the days of 'Amos 'n' Andy' and even the more recent *Julia*. The direction is right. Some day an all-black produced situation-comedy will be able to be just as silly and unrealistic as an all-white production."

The second season of *Sanford and Son* included several episodes by Black writers. Ruben had seen a photograph of a young playwright named Ilunga Adell in the *New York Times* and reached out to see if he might be interested in writing a script for the show. Adell, just twenty-three at the time, told the producer something that floored him: He hadn't spoken to a white person until he was eighteen. Adell, credited as Adell Stevenson in early episodes, penned five season 2 installments, including the finale episode in which Fred accompanies Lamont and a friend to a casting call for (unbeknownst to them) an adult movie. Adell—who went on to create the short-lived Nickelodeon teen series *My Brother and Me*—wrote eight episodes of the twenty-four-episode third season.

Adell's employment on the show, as a writer and eventually story editor, made national news, but there was less of a spotlight on two other Black writers who were brought on at Foxx's request: Richard Pryor and his writing partner Paul Mooney. The duo wrote an early season 2 episode titled "The Dowry," which finds Fred attempting to set Lamont up with a distant cousin set to inherit a large sum of money when she marries. The *Los Angeles Times* reported in 1973 that they had written three additional episodes, but only one of those—

Foxx's curmudgeonly Fred Sanford was comically in tune with Demond Wilson, who played Lamont, Fred's patient and peacemaking son.

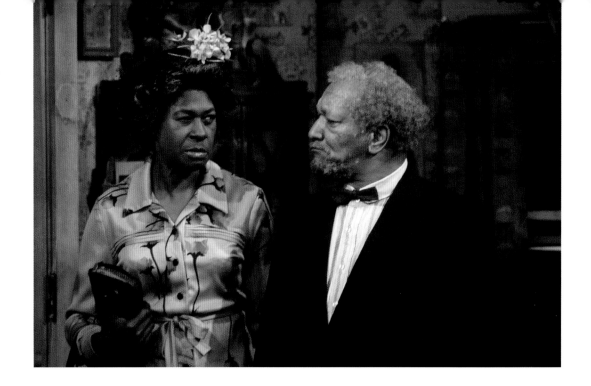

"Sanford and Son and Sister Makes Three"—made it to air following a fallout with Ruben. "They say at *Sanford* they wanted black people writing the scripts," Pryor told the paper, "but they changed them to the way they thought black people was."

In his 2009 memoir, *Black Is the New White*, Mooney described their brief tenure as strained from the start. "Richard and I have to jump through all sorts of Hollywood hoops to get taken on as writers," he wrote. "It ain't Lear or Yorkin, they're all for us. It's the system." Mooney recalled that NBC's executives would mention in meetings that they were "having trouble finding black comedy writers." "Baffled and apparently invisible to them," Mooney wrote, "I reply, 'I guess if I'm running this show, I would have trouble finding white ones.'"

Foxx's *Tonight Show* endorsement of fellow comic Flip Wilson in 1965 hadn't been a fluke: He was known for advocating for Black people from various corners of the industry. In addition to recommending Pryor and Mooney as writers, Foxx insisted on hiring several of his comedy peers, including his childhood friend LaWanda Page, who played Aunt Esther, and Slappy White, who appeared (mostly in the first season) as Fred's buddy Melvin. Foxx was so adamant that Page play Fred's sister-in-law that he threatened to walk

Aunt Esther, played by LaWanda Page, was Fred's nemesis and a fan-favorite character.

after producers suggested Page would need to be replaced because she lacked television experience. Esther became a fan-favorite character: Page starred in dozens of episodes and reprised the Esther role in two short-lived spin-offs.

When Stan Lathan was hired to direct *Sanford and Son* in 1974, word quickly got around at NBC's studio in Burbank, where the series was filmed, that a young Black director would helm multiple episodes of the show. When Lathan entered the cafeteria for the first time, the largely Black staff erupted into applause. "I never paid for anything there," Lathan recalled in a 2015 interview with the Directors Guild of America. Black employees from around the building would come to see the show's rehearsal. One woman brought her kids so they could "see a Black man in charge" of a TV set. "I was just beset with this sense of responsibility and purpose and it was a pretty rewarding experience," recalled Lathan, who had grown up admiring Foxx and remembered seeing him perform at Philadelphia's Uptown Theater, a prominent stop on the Chitlin' Circuit. "He felt responsible for me being hired and he was proud of me."

Foxx also fought to bring Mooney back to the writers' room, resulting in the season 3 episode "Fred Sanford, Legal Eagle," which credits Mooney as a story writer (the teleplay is credited to Gene Farmer). The plot revolves around Lamont fighting a traffic ticket at his father's suggestion. Mooney recalled battling NBC execs who thought a joke Foxx delivered about Lamont getting "a ticket from a white cop in a Black neighborhood" and "seeing red" was "too angry." The episode comes to a peak in court, where Fred designates himself Lamont's "counsel" and calls the ticketing officer's bluff. "Listen, why don't you arrest some white drivers?" Fred prompts. "I do," the officer responds.

Fred: "You do? Well, where are they? Look at all these niggers in here...There's enough niggers in here to make a Tarzan movie."

In his memoir, Mooney lamented that the scene had been censored in syndicated versions, though fans will be delighted to know that the show's official streaming home (Peacock) sticks to the scene as Mooney wrote it.

Local Programs May 13-19

TV GUIDE

®

15¢

Daytime TV:
Where the Money—
and the Fighting–Is
Page 6

Demond Wilson,
Redd Foxx of
'Sanford and Son'

A month after NBC aired the last *Sanford and Son* episode Mooney would write, Foxx grew tired of his own battles with NBC—over everything from his salary to the network's apparent unwillingness to hire more Black writers. Foxx, initially citing what was widely reported as "a nervous condition" and exhaustion, did not appear on the show for eight episodes, resulting in an arc focused on Lamont and Grady (Whitman Mayo). Tandem Productions sued Foxx for $10 million for breach of contract, and a judge ordered the comedian not to take on any entertainment gigs without the production company's permission.

A *Jet* cover story, accompanied by a photo of Foxx with his middle finger raised, outlined the veteran comedian's requests:

"You got a ticket from a white man in a blue uniform, in a Black neighborhood, and you're so mad you see red, and you won't fight it 'cause you're too yellow. Now, what are you, a man or a box of crayons?"

—FRED SANFORD IN "FRED SANFORD, LEGAL EAGLE"

"He wants 25 percent of the *Sanford and Son* show, changes in the wardrobe 'so Black women won't be dressed like prostitutes,' the right to hire his talented friends and other Blacks, and credit for writing some of the script." Other press reports cited Foxx's desire to have a window in the studio. His attorney told the magazine that Foxx had "been made out to be the villain, when all along he has just been asking for things he was promised when he started." Foxx's lawyer also noted that the rehearsal and filming schedule for the show was an adjustment for the comedian, who was used to doing sporadic nightclub sets. Foxx publicly blamed the show for the demise of his nearly twenty-year marriage.

As the dispute played out in headlines, some TV columnists blasted Foxx's weekly salary—reported to be $30,000 when he returned to the set of *Sanford and Son* in April 1974. But Foxx surely was not alone in complaining about his six-figure monthly salary. The following year, the *New York Times* reported that Carroll O'Connor,

Sanford and Son appeared on the cover of the May 13–19, 1972 issue of *TV Guide*, four months after it debuted, becoming the second most popular show on television.

who played Archie Bunker on *All in the Family*, was making $30,000 per half-hour episode of the sitcom, following his own contract dispute with Tandem. "The actors and producers are merely pawns in a larger scheme," Lear told the paper. "The purse strings are held by the networks. It's their ballpark, and you play by their rules."

For Foxx, though, his fight with *Sanford and Son* producers was representative of the barriers that had held him and other Black entertainers back for decades. "For 38 years, I've written jokes because I couldn't tell them on TV because I was Black," Foxx told *Jet*. "My jokes were lifted by white comics. It was depressing to hear my words spoken by others in a medium from which I was barred."

And though you might not have known it reading mainstream press outlets, a number of Black viewers supported the comedian in his battle. "After nearly 40 years in show business a white man would not even have to *ask* to receive credit for his contributions to the show business world," one *Jet* reader urged alongside the May 1974 cover story.

"I'm behind you 100 percent and, please, for all Black people, don't bend."

GOOD TIMES

CREATED BY: Eric Monte and Mike Evans
STARRING: John Amos, Esther Rolle, Jimmie Walker, Ralph Carter, Bern Nadette Stanis, Janet Jackson (seasons 5 and 6)
PREMIERED: February 8, 1974
EPISODES: 133

BY THE TIME Lear and Yorkin dissolved their Tandem partnership in the summer of 1974, the company had four hit sitcoms on air, including *Sanford and Son*, which Yorkin continued to run, *All in the Family,* and its spin-off *Maude*, starring Bea Arthur. *Maude* had also led to *Good Times*, which centered on Florida Evans (Esther Rolle), the no-nonsense maid introduced in *Maude*'s memorable third episode, and her family. The show was the brainchild of Eric Monte, who would go on to pen the cult-favorite 1975 film *Cooley High*, and Mike

Esther Rolle insisted that her character, Florida Evans, be married to avoid falling into the single Black matriarch trope. John Amos played her husband, James Evans Sr.

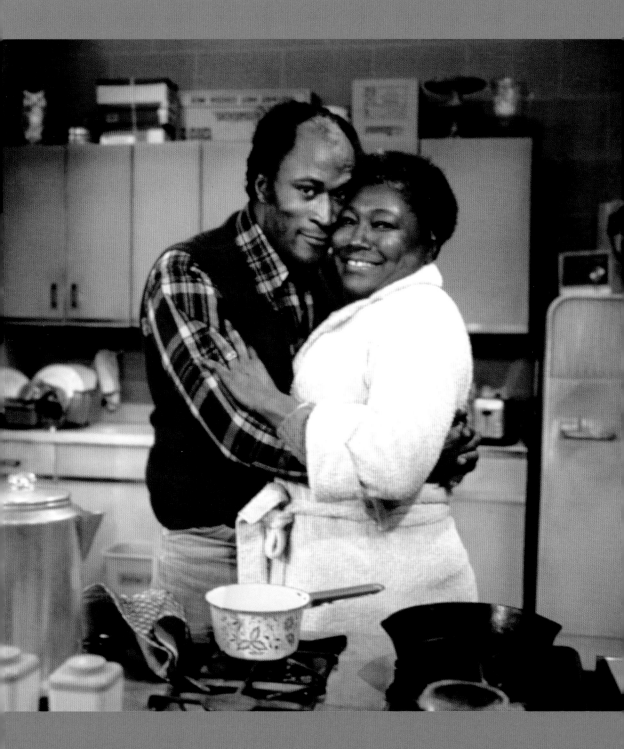

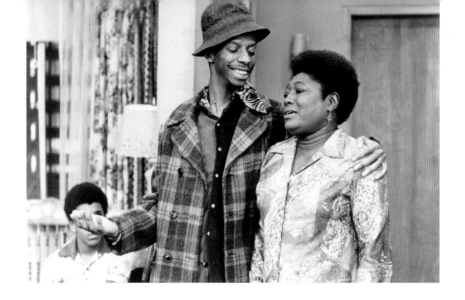

Evans, who played Lionel Jefferson on *All in the Family*, and later *The Jeffersons*. Monte had grown up in Chicago's Cabrini-Green public housing project, which became the setting of the series.

Good Times employed more Black directors and writers than *Sanford and Son* but its executive producers were still white. Most of the scripts were penned by white writers. "Norman has so much insight, I'm not worried," Rolle said ahead of the series premiere. "I'm used to fixing lines in 'Maude.' I tell the writers to write straight. If I'm the actress, let me be it. I'll supply the right slang and inflection."

Good Times garnered mixed reviews. On one hand, the Evans family was led by a Black father (John Amos)—in part because Rolle had insisted her character be married so as not to play into matriarchal stereotypes. But a year and a half into the show's run on CBS, tension had started to build on set. *Ebony* cited issues ranging from "questionable scripting to salary disputes to character concepts" but summarized the central problem as the cast's "continuing battle" to ensure the series didn't devolve into harmful stereotypes. One character in particular drew ire from the cast and some viewers: Jimmie Walker's J.J.

"He's 18 and he doesn't work. He can't read and write. He doesn't think. The show didn't start out to be that," Rolle told the magazine. "I resent the imagery that says to black kids that you can make it by standing on the corner saying 'Dyn-o-mite!'" She was referring, of course, to J.J.'s (initially ad-libbed) catchphrase, which audiences

Some cast members, including Rolle, didn't appreciate the way Jimmie Walker's character, J.J., was portrayed.

responded to with such glee that producers encouraged the actor to use it regularly.

Amos, meanwhile, had started the show's second season in a contract dispute with the show's producers. And like Rolle, he felt the J.J. character was verging on buffoonery. "Esther and I both had assumed the responsibility of being the first black family on TV and I was worried about what people would think," Amos recalled in the 2016 documentary *Norman Lear: Just Another Version of You.* "I didn't want to be seen in a role that was gonna disparage and denigrate a Black family. I wasn't going to do it. I wanted it to be right."

"There were lines that were dropped on you that were meant for you to say," Rolle said in a 1990 interview featured in the documentary. "Because you were Black. And I had to see behind all of that foolishness and say no, no, no, no, no. I can't say that."

"We had to do the show for twenty-six weeks and it had to be good," Lear said. "But we couldn't deal with this reaction of actors being upset with the script all the time. It was extraneous to the needs of a show that had to be done every week." In the documentary, Amos recalls Lear urging him not to take the show "quite so seriously," effectively missing the point.

Lear later got a visit from a trio of Black Panthers, who showed up at CBS headquarters looking for "the garbage man." It was Lear they were looking for, the producer of what they called "a white man's version of a Black family." They took issue with J.J. and the fact that

Bern Nadette Stanis, Jimmie Walker, Ralph Carter, and Ja'net DuBois.

the Evans were impoverished. "We got Black men in America doing better than most whites," Lear recalled them telling him.

Despite the behind-the-scenes turmoil, *Good Times* did resonate with Black viewers, including a young Barris. "*Good Times* for me, it was so unexpected," Barris told Lear in 2019. "It was so daringly truthful…it was me seeing myself reflected in a way that I had never really seen myself reflected."

THE JEFFERSONS

CREATED BY: Don Nicholl, Michael Ross, Bernard West
STARRING: Sherman Hemsley, Isabel Sanford, Marla Gibbs, Roxie Roker
PREMIERED: January 18, 1975
EPISODES: 253

FOR ALL OF ITS PARALLELS with *Good Times*, *Black-ish* also shared common threads with *The Jeffersons*, which could be viewed as Lear's answer to critics of J.J. Evans and his family. The sitcom expanded the story of George (Sherman Hemsley) and Louise Jefferson (Isabel Sanford), the upwardly mobile Black couple who lived next door to Archie and Edith Bunker. Like the Johnsons on *Black-ish*, the Jeffersons were navigating newfound wealth— literally "movin' on up" a la the sitcom's iconic theme song—that set them apart from other Black people in many (but certainly not all) contexts. In the first episode, Weezy (Louise) befriends Diane (Paulene Myers), a woman working as a housekeeper in the Jeffersons' building. Diane assumes Weezy is also a maid there and continues to believe this after being invited into the Jeffersons' apartment. When George comes home, the visitor muses that she "didn't realize the Jeffersons had a couple."

"A couple of what?" George asks.

"A maid and a butler. You two," Diane says. "Yeah, [the Jeffersons] must be real rich."

When George replies that he and his wife *are* the Jeffersons, Diane is so astounded she spits out her coffee before breaking into laughter

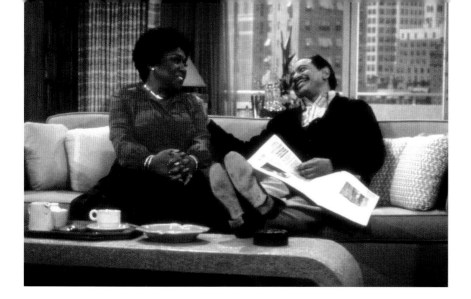

as she assumes George is joking. Sizing George up, Diane concludes he's "not tall enough to be a basketball player" nor young enough to be "a rock-and-roll singer." "You've got to be a number runner," she says. "I'm getting out of here." After George exasperatedly explains that he owns his own business, with one of his dry-cleaning shops in the same building as their apartment, Diane rushes out, uncomfortable with the unbalanced dynamic. The subplot dovetails with the Jeffersons' debate around whether to hire their own maid. Though Weezy initially struggles with the idea, the Jeffersons eventually hire Florence (Marla Gibbs), a firecracker—and foil to George—as their live-in maid. Florence quickly became a fan-favorite character.

George, prone to referring to white people as "honkey" or "whitey," was a counterpart of sorts to the bigoted, working-class Archie Bunker, though the subtexts could never be the same. There was something bold in his refusal to concede to anyone—white or Black—regardless of whose company he was in. *The Jeffersons* introduced the first interracial couple on prime-time television, Helen (Roxie Roker) and Tom Willis (Franklin Cover). Roker was in an interracial relationship with then-husband Sy Kravitz (collectively known as Lenny Kravitz's parents).*The Jeffersons* became the longest-running series of Lear's sitcoms, ending after eleven seasons.

Let's go back to *Good Times* for a moment. That sitcom ended in August 1979, looking a lot different from when it premiered. Amos, amid his discord with producers, hadn't had his option renewed

The Jeffersons, starring Sherman Hemsley and Isabel Sanford as George and Louise Jefferson, is one of the longest-running sitcoms in history.

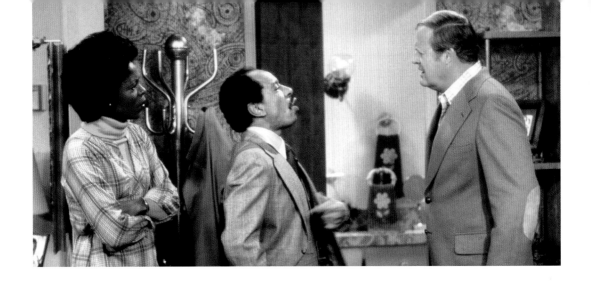

following the show's third season. James Evans was killed off in a car accident, leaving Rolle to play the single Black matriarch she had wanted to avoid. The fourth season of *Good Times* opened with a two-part episode that found Florida avoiding her grief before breaking down in one of the show's most powerful moments. After all the condolences and visits have subsided, Florida attempts to distract herself by tidying up the apartment. A starkly quiet moment is interrupted by Florida's rage at her tremendous loss: She throws a glass punch bowl to the floor before clenching her hands in grief: "Damn, damn, damn," she says. (The iconic line was remixed into the spellbinding refrain of "SpottieOttieDopaliscious" from Outkast's 1998 album *Aquemini*. ["Damn, damn, damn, James."]) Rolle left the show ahead of the fifth season, which introduced one Janet Jackson as Penny, but returned for the sixth and final season.

Lear remains a beloved figure in Hollywood and is credited with inspiring a number of Black TV writers, including Barris and Jerrod Carmichael of *The Carmichael Show*. But his public recollection of the genesis of *Good Times* has long been at odds with Eric Monte's account. In his memoir, Lear wrote that the show's journey "from idea to a script we felt worthy of presenting…just might fall into the 'No good deed goes unpunished department.'" Evans and Monte "blew it creatively with a poor copycat of a script," according to Lear, who said that the show they filmed ended up looking a lot different from what the pair wrote. Despite that, Lear said, Evans and Monte were still given sole credit as co-creators. "I could be confessing to a

Helen (Roxie Roker, left) and Tom Willis (Franklin Cover, right) were the first interracial couple seen on prime-time television.

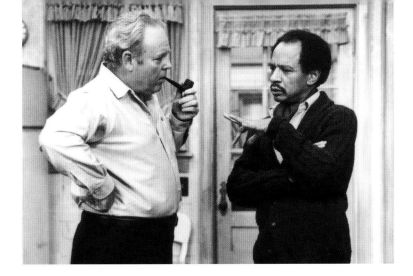

bit of inverse racism here when I admit that it even pleased me to see them credited and paid," he wrote. "That would not have happened, at least not gratuitously, if they were white."

In 1977, Monte sued Lear and Yorkin, along with ABC and CBS, accusing producers and networks of stealing his ideas for *Good Times*, as well as the characters of George and Louise Jefferson, and *What's Happening!!*, the 1976 sitcom based on Monte's *Cooley High*. Monte, who battled addiction and lived in a homeless shelter for a time following his Hollywood career, told the *Los Angeles Times* he received a $1 million settlement and a portion of residuals from *Good Times*.

The shows created under Lear and Yorkin's banner have come to define the '70s sitcom era. In recent years, Lear, always the more public personality, has been associated with the classic Black sitcoms that generations of Americans have watched. But for all of the decade's advances in representation, Black entertainers still faced an uphill battle when it came to ownership and getting credit for their work and passion.

After *Sanford and Son* ended in 1977, Foxx lamented that NBC hadn't submitted the show for industry accolades. "We were the Number One show at NBC for six years, and you'd think they would nominate us," Foxx mused. "What is there that keeps blacks from being nominated—and winning? I mean, give 'em that much encouragement. I don't mean just *Sanford and Son*. What about other black shows, like *The Jeffersons*, *That's My Mama*, and *Good Times*? Never a mention of them at the Emmys."

George and Louise Jefferson were first introduced as characters on *All in the Family*, which starred Carroll O'Connor (left).

LeVar Burton was a sophomore in theater school at the University of Southern California when he won the role of Kunta Kinte. The character was based on one of Haley's ancestors, a Gambian man who was born in 1750.

4 ROOTS

By the mid-1970s, TV featured several sitcoms that revolved around Black people. But there had yet to be a drama that centered the history and relationship dynamics of a Black family. Very few Black actors had even had the opportunity to star in television dramas, let alone lead them: Cicely Tyson played a secretary to a white New York City social worker in the 1963 series *East Side / West Side*, which later featured an Emmy-winning episode about a Black couple (played by James Earl Jones and Diana Sands) grieving their baby who was bitten by a rat in a Harlem tenement. That same year, Diahann Carroll starred in an episode of *Naked City*, which landed her a historic Emmy nomination for best actress

in an anthology. A decade later, Teresa Graves took the titular role in the 1974 crime drama *Get Christie Love!*, which was a blaxploitation-inspired TV movie (hardly a drama) and aired for just one season. That same year, Tyson earned acclaim, including two Emmys, for the CBS drama film *The Autobiography of Miss Jane Pittman*.

In late 1974, ABC announced it would serialize the novels *Rich Man, Poor Man*; *Eleanor and Franklin*; and *Roots*, which chronicled author Alex Haley's family history from the eighteenth century, when his ancestor Kunte Kinte was kidnapped from Gambia in West Africa and sold into slavery, to the family's emancipation and the generations that followed.

ROOTS

BASED ON: *Roots: The Saga of an American Family* by Alex Haley
PRODUCED BY: David L. Wolper, Stan Margulies
STARRING: LeVar Burton, Cicely Tyson, John Amos, Louis Gossett Jr., Leslie Uggams, Ben Vereen, Richard Roundtree, Olivia Cole, Ed Asner, Ralph Waite, Robert Reed
PREMIERED: January 23, 1977
EPISODES: 8

...

ROOTS **DIDN'T AIR** until 1977 but its journey to the small screen was a saga in itself—one that started in the early 1960s. Alex Haley was a budding journalist who had recently retired from the Coast Guard when he was hired to write about the Nation of Islam for *Reader's Digest*. The March 1960 piece, titled "Mr. Muhammad Speaks," explained how Elijah Muhammad became the leader "of a vitriolically anti-white, anti-Christian cult that preaches black superiority."

Over the next few years, Haley made a name for himself as a magazine writer. He interviewed Miles Davis for what became *Playboy* magazine's first interview and helped set the intellectual tone for the magazine's written pieces. It was during that 1962 interview that Davis—speaking freely about race opposite Haley—pointed out how racially homogenous TV was at the time. "Look, the next movie or TV [show] you see, you count how many Negroes or any other race but white that you see," Davis said. "But you walk around in any city, you see the other races—I mean, in life they are part of the scene. But in the films supposed to represent this country, they ain't there. You won't hardly even see any in the street crowd scenes because the studios didn't bother to hire any as extras."

A year later, building on a rapport that began when he was reporting on the Nation of Islam, Haley interviewed Malcolm X for *Playboy*. Interviews with Muhammad Ali (the same year he renounced his birth name, Cassius Clay), Martin Luther King Jr., and Sammy Davis Jr. followed, establishing Haley as a writer who could distill race and other complicated topics for readers of various backgrounds. Haley also wrote Malcolm X's autobiography, based on a series of interviews he conducted prior to the civil rights leader's assassination

Alex Haley on the set of *Roots* in 1977.

in February 1965. *The Autobiography of Malcolm X* was published later that year. By then, Haley had already envisioned the foundation of *Roots*, which he initially called "Before This Anger," and pitched it to literary agent Paul R. Reynolds. Haley signed his first contract with publisher Doubleday in 1964 and spent more than a decade on the manuscript while traveling the country giving captivating lectures on his research. In 1972, Haley penned a *New York Times Magazine* cover story called "My Furthest Back Person—'The African,'" which recalled his trips to Gambia in West Africa in hopes of confirming and expanding the stories he had heard from his grandmother and other elders about an ancestor who had been kidnapped from his African village and sold into slavery in what was then the province of Maryland.

The ancestor, Haley learned on his first trip to the Motherland, was Kunte Kinte. Writing in the *Times Magazine*, Haley recalled people of all ages emerging from a local village and calling him by his ancestral surname. "Let me tell you something: I am a man. But I remember the sob surging up from my feet, flinging up my hands before my face and bawling as I had not done since I was a baby." As historian Matthew Delmont notes in *Making Roots*—a singular retelling of how the iconic miniseries came together—Haley received thousands of letters following his *New York Times Magazine* story. Some were deeply personal, as readers wrote of being moved to tears and motivated to investigate their own family histories. *Reader's Digest*, where Haley had worked for decades, published an excerpt of *Roots* in 1974. (The magazine also funded much of Haley's travel in support of the project.) Haley received another round of enthusiastic and emotional letters after the excerpt ran. Delmont recounts that the preview also prompted a letter between producers David L. Wolper and Stan Margulies, who had previously sold ABC on two never-produced series that would have followed different generations of a family. "Using stories handed down in his family, plus his education and historical museums and associations, he (Haley) manages finally to locate the actual African village where his family began," Wolper explained in a letter to Margulies. "It is an incredible mystery-suspense tale, spanning three continents and seven generations." Margulies later recalled meeting Haley over lunch at the Beverly Hills

Tennis Club, where the author gave a more intimate version of his lecture: "Alex told us the story and our mouths dropped open 10 feet," he told the *Los Angeles Times* in 1997. Wolper Productions purchased the film and TV rights to Haley's not-yet-complete novel and sold the project to ABC. The production had been underway for more than a year by the time Haley finished his magnum opus.

The cast of *Roots* still reads like a Who's Who of Black Hollywood: John Amos as the adult Kunte Kinte; Cicely Tyson as his mother, Binta; Louis Gossett Jr. as Fiddler, an enslaved man who becomes a father figure to Kunte; Leslie Uggams as Kunte's daughter, Kizzy; Ben Vereen as Kizzy's son Chicken George; Richard Roundtree as Kizzy's love interest, Sam Bennett; and then-newcomer LeVar Burton, who was plucked from the drama department at the University of Southern California, as the young Kunte Kinte. But despite the predominantly Black cast and Haley's involvement, the producers and executives of the network were white, as were the series writers (save for Haley, co-credited as a screenwriter) and three out of four directors.

Concerned that white Americans wouldn't want to tune in, the network and producers insisted on hiring big names, including several white actors associated with beloved TV characters to fill roles made much more visible than they had been in Haley's book:

The all-star Black cast included Cicely Tyson and Maya Angelou.

Ed Asner, who played the gruff but endearing Lou Grant on *The Mary Tyler Moore Show*, played the temporarily conflicted slave ship captain. The cast also included three actors known for playing affable TV dads: Ralph Waite (Pa Walton of *The Waltons*), who played the ship's hateful first mate; Lorne Greene (*Bonanza*) as the enslaver who changes Kunte Kinte's name to Toby (and orders him to be viciously whipped when he refuses to answer to it); and Robert Reed (Mike Brady of *The Brady Bunch*), who played a kinder but still complicit slave owner.

As Delmont explained in *Making Roots*, these well-liked actors were cast to offset the guilt and shame that white viewers might feel while watching the series. And the producers also considered the feelings of these viewers when casting the main roles, hiring Black actors who—as Wolper described—were "more accepted to the white audience." This was true when it came to special guest stars that included Maya Angelou, who made a Part I appearance as Kunte's grandmother, and a young O.J. Simpson (seriously), then known to Americans as an NFL running back.

Although no TV show had ever cast as many Black actors, the overwhelmingly white production crew drew backlash. Woodie King Jr., who founded New York City's New Federal Theatre, addressed the "grave injustice" in a letter to Wolper and Margulies, also sending copies to the *Hollywood Reporter*, *Variety*, and the NAACP, along with all three broadcast networks. "Not one Black director or Producer or script writer has been hired to work on *Roots*," King wrote. "This is 1976: One cannot deal with that old argument about there being no qualified Blacks; nor can one remain silent when it happens."

The pressure applied by King was enough that producers looked into hiring Gilbert Moses, the cofounder of a Black theater company, to direct. Moses had directed plays by Melvin Van Peebles and Amiri Baraka, but ABC was hesitant about the choice because he lacked film and TV credits. Ultimately, Moses was hired to direct the fourth installment; Joseph Wilcots, a cinematographer who had worked on films with Gordon Parks (and understood the technique of lighting Black skin on-screen), was hired as director of photography. Years earlier, Wilcots had written to Haley and to Margulies, who saw

Despite concerns from network executives that white Americans wouldn't tune in, *Roots* was a massive hit. According to Nielson, more than half of American TV homes watched the last episode.

a snippet of a student film he'd shot on a bare-bones budget and agreed to hire him—only to have the network balk at hiring a young cameraman to film a $6 million production. But as Wilcots recalled in an interview with the Archive of American Television, he was abruptly brought in to shoot the third installment after the previous cinematographer missed several deadlines. After Wilcots managed to cut down on shooting time while filming a complicated scene, he was told he would be cinematographer for the remaining episodes.

––––––––

Roots premiered on January 23, 1977, and ran for eight nights, concluding on January 30. Reviews were mixed, but no one could deny that the miniseries had resonated with Americans, both Black and white. Newspapers across the country ran breathless recaps of each night, often accompanied by graphics detailing the family tree at the center of the miniseries.

One common criticism was that *Roots* (sold as nonfiction before historians raised questions about Haley's research and before the author settled a plagiarism lawsuit) was better on the page than on-screen. "Haley's depiction of evil was stark," Associated Press TV critic Jay Sharbutt wrote. "Sunday's version pulled punches in changing the captain, only briefly described in the book, to a major figure who at least worried about evil while engaging in it."

Decades before the term "critical race theory" became a political lightning rod, some viewers took issue with how white people were portrayed in the miniseries. "The millions of admirers of the TV presentation of *Roots* didn't include Ronald Reagan, who said, 'Very frankly, I thought the bias of all the good people being one color and all the bad people being another was rather destructive,'" the *Washington Post* reported in its A section on February 14, 1977. "He added that he was impressed by the huge audience the series attained, but 'I didn't know there was anyone who could stay home eight nights in a row.'"

As it turned out, a great many people did just that. *Roots* played to roughly 130 million viewers, the largest collective audience for any TV program, falling short only to the 1976 airing of *Gone with the Wind*. Its success led the *New York Times* to conclude that the network

had underestimated its own miniseries, which it scheduled to air the week before sweeps, the quarterly ratings period that measures viewership on a local level.

The April 1977 issue of *Ebony* declared Haley "a folk hero." "Having just been afforded an unusually close look at their peculiarly intertwined histories," Hans J. Massaquoi wrote, "many Americans—both black and white—were reassessing their racial attitudes, vaguely sensing that, because of *Roots*, race relations in the United States could never be quite the same again."

Roots was a monumental moment in television and pop culture, but it did not change the hiring landscape for Black actors as many expected. A few months after *Roots* aired, Amos was asked if his role had led to more opportunities. "Well," he joked, "at the employment office they call me Kunte!!"

"That was really the sense of all of the actors that were on the show is that two years later, they were no better off than they were before they got the *Roots* gig," Delmont says. "It was kind of a standalone in many ways in that there was a lot of optimism that it was going to swing open doors and it did launch a handful of careers, but it didn't change Hollywood in the way that some people hoped it would."

"Even though we all had very high expectations and thought that the world was going to be everyone's oyster, it didn't happen that way. We expected more."
—LESLIE UGGAMS

More than five decades later, the title *Roots* represents more than just the 1977 miniseries and the historic epic that inspired it. ABC aired *Roots: The Next Generations* to critical acclaim in 1979, and Haley's final book, *Queen: The Story of an American Family*, which was completed by David Stevens following Haley's death in 1992, was adapted into the 1993 CBS miniseries *Queen*, starring Halle Berry, Jasmine Guy, Danny Glover, Paul Winfield, and Martin Sheen.

In 2016, History Channel aired a reimagining of the groundbreaking miniseries that sought to update the story for a new generation and placed much more emphasis on the Black heroes of Haley's saga. But the eight-hour series shared many parallels with the original, including an all-star Black cast—Forest Whitaker, Laurence Fishburne, Anika Noni Rose, and Derek Luke, among them. It also featured two memorable newcomers: Malachi Kirby in the role Burton originated and Regé-Jean Page (four long years before *Bridgerton!*) as Chicken George.

David Wolper's son, Mark, was an executive producer of the update, alongside Burton and Will Packer, who calls the remake "a huge opportunity and a huge undertaking." Unlike the 1977 version of *Roots*, the 2016 project was preceded by several Hollywood productions around slavery. And for that reason, the criticism around the project was a bit different.

"The criticism was not 'this was poorly done,' that it didn't do what it set out to do, which was [to] remake the story of *Roots* to tell the origin story of African Americans in this country," Packer says. "What people said was, I'm tired of Black trauma. I'm tired of slave narratives. I'm tired of stories that have us, Black people, looking less than, being subservient, going through all the horrors of slavery. And there's validity to that because there haven't been enough television projects that have shown African Americans in a diversity of lights and perspectives and with a diversity of characters."

"There haven't been enough so that I could push back against somebody that would say 'I don't want to see us like that.' I get it. I don't want to see us like that. I think it's important, though, because it happened. This isn't fictional. It happened," he adds. "It's important for a whole generation to realize and understand it happened—and there were more of that generation that saw our remake of *Roots* than would ever watch the original. So, from that standpoint, I think it was important and I'm proud of it."

Malachi Kirby took on the role of Kunta Kinte in A&E's 2016 remake of *Roots*.

Jackée Harry and Marla Gibbs in *227*.

5 '80s SITCOMS

The paradox of *Roots* is that it did not lead to more opportunities for Black actors. "It's like after *Roots*, they thought they had employed enough black actors for the next 10 years," actor Tim Reid told the *St. Petersburg Times* in 1981 when he was starring as disc jockey Venus Flytrap on *WKRP in Cincinnati*. "My character is one of very few in television today. It's not just regression, it's a *push* backward."

Incidentally, Reid was one of a few Black entertainers who did not appear in *Roots* or any of its sequels. But he did audition for the 1977 miniseries and recalls sitting next to a young LeVar Burton at an early audition. "Just the energy that he had was like 'Woah, this kid is, I mean, he's on it,'" Reid recalls. "You know, at that time, I'm in my thirties. I started late in show business, so I'm sitting there going, 'Oh man, to start off with that kind of energy now, wouldn't that

have been great?'" Reid was just a couple years removed from his first acting role—as a charismatic young preacher in a 1974 episode of *That's My Mama*.

We know how Burton's audition turned out. When it was Reid's turn, he recalls trying to show the same kind of energy: "The first thing they said to me, basically—and they were very bold back in the day—[was] that I wasn't Black enough. I didn't look like someone who would be out in the field picking cotton—I was too fair." This wasn't the first or last time Reid would hear that feedback. "Every Black person that ever walked, talked, or said a line was in *Roots*. And I wasn't one of them. And that kind of rubbed me the wrong way," he says. "And I realized that if anybody was going to have a career the way I wanted to have a career and make the kind of money that I dreamed of making, that you would have to have some

control. You have to have some control of your instrument as an actor. You have to have some control of the words you say."

Reid made up his mind: If he ever really got into the business, he "was going to try to figure out how to get more creatively involved as a writer, as a producer, as a director." His acting breakthrough arrived when he was cast on *WKRP*, and it set him on a path to producing and starring in *Frank's Place*, a groundbreaking (and Emmy-nominated) 1987 series that lasted for exactly one season. Before we talk about why that was—and what it led Reid to do next—we need to take a look at the TV landscape of the early to mid-1980s.

———

By the early 1980s, sitcoms seemed to be falling out of favor with American television viewers. Instead, their attention was trending toward prime-time soaps, such as *Dynasty* and *Dallas*. While the top ten TV programs for the '80–'81 and '81–'82 seasons included several sitcoms—including *The Jeffersons* and the diner comedy *Alice*—the following season's top ten included just one: *Three's Company*.

Several Black entertainers were leading sitcoms in the early '80s, but nearly all focused on Black people who were adjacent to white families. Nell Carter was housekeeper and surrogate mother to the daughters of a widowed police chief on *Gimme a Break!* Robert Guillaume played an affable butler in *Benson*. Gary Coleman and Todd Bridges played two brothers taken in by their mother's former employer, a wealthy white man, on *Diff'rent Strokes*. And in 1983, Emmanuel Lewis became a star on *Webster*, about an orphan adopted by his godfather (Alex Karras), a retired NFL player, and his socialite wife.

THE COSBY SHOW

CREATED BY: William Cosby Jr., Ed. Weinberger, Michael Leeson
STARRING: Bill Cosby, Phylicia Rashad, Keshia Knight Pulliam,
Tempestt Bledsoe, Malcolm-Jamal Warner, Lisa Bonet,
Sabrina Le Beauf
PREMIERED: September 20, 1984
EPISODES: 197

DESPITE THE GROUNDBREAKING Black TV families of the
1970s, there had been nothing like *The Cosby Show* when it premiered
on NBC in the fall of 1984. The sitcom bucked stereotypes with the
Huxtables, a two-parent family in which the father and mother were
both highly educated—a doctor and a lawyer, respectively—and they
encouraged their children to excel academically. From their cozy
Brooklyn brownstone, Heathcliff (Cosby) and Clair (Phylicia Rashad)
were true partners in raising their five children: Rudy (Keshia Knight
Pulliam), Vanessa (Tempestt Bledsoe), Theo (Malcolm-Jamal Warner),
Denise (Lisa Bonet), and Sondra (Sabrina Le Beauf), their already
grown eldest child who wasn't introduced until the tenth episode.

The show was an instant hit, landing in the season's top-ten
rating's list—flying in the face of industry execs who had been
prepared to declare the sitcom dead—and giving NBC its best ratings

An early cast photo of
The Cosby Show with
(clockwise from left)
Lisa Bonet, Tempestt
Bledsoe, Bill Cosby,
Phylicia Rashad,
Malcolm-Jamal Warner,
and Keshia Knight
Pulliam. The iconic
show's legacy has been
marred by Bill Cosby's
sexual assault scandal.

in decades. Critic David Bianculli, then writing for the *Philadelphia Inquirer*, called *The Cosby Show* "the major story of the 1984–85 season," noting that the first season had wrapped as the third most-watched series on prime time, right behind *Dynasty* and *Dallas*. "For the ailing TV situation comedy, relief is spelled C-O-S-B-Y," *Ebony* declared in an issue that featured the picture-perfect Huxtable family on the cover.

Generations of Americans have grown up on *The Cosby Show*, remembering iconic scenes—a pint-size Rudy lip-syncing to the belt-iest part of "Night Time Is the Right Time" in honor of her grandparents' fiftieth anniversary; Vanessa trying to have Big Fun in Baltimore; the family recording music with Stevie Wonder—in addition to the title sequences that (from the second season forward) featured the family dancing to the show's theme song. Up until about a decade ago, conventional wisdom held the series as one of the most significant achievements in the history of Black people on TV. And in many ways that remains true. But it's also true that *The Cosby Show*'s legacy is inextricable from the dozens of women—more than sixty ahead of the comedian's 2018 trial—who have accused Bill Cosby of sexual abuse. (Cosby has maintained he is innocent of all charges.) Cosby was convicted of sexual assault in 2018 but was released from prison three years later after the Pennsylvania Supreme Court ruled Cosby's Fifth Amendment rights had been violated in pursuit of the case.

Allegations of sexual assault had followed Cosby for years, most publicly after he settled a lawsuit with a woman who had accused him of drugging and sexually assaulting her in 2004. But it wasn't until comedian Hannibal Buress lambasted the comedian during a 2014 stand-up set, captured on cell phone video, that the allegations became national news. "Bill Cosby has the fucking smuggest old Black man persona that I hate," Buress said while performing in the comedian's hometown of Philadelphia. "He gets on TV, 'Pull your pants up, Black people. I was on TV in the '80s! I can talk down to you because I had a successful sitcom!' Yeah, but you rape women, Bill Cosby, so turn the crazy down a couple notches," Buress said in a scathing mock response.

TV Guide ranked *The Cosby Show* twenty-eighth on their list of 50 Greatest Shows in 2002.

TV GUIDE

®

July 11–17　　　◁ 60¢

Two *Cosby* Kids Tell How to...

Shape Up–While Watching Your Favorite Show

Page 30

Tempestt Bledsoe
and Malcolm-
Jamal Warner
of *The Cosby Show*

The viral clip was illuminating not least because it marked the first time many Americans had heard of the serious allegations against Cosby. ("Trust me, if you leave here and google 'Bill Cosby rape,' that shit has more results than 'Hannibal Buress,'" the comic told the crowd.) Buress's routine tapped into an even more long-standing criticism of the comedian. As groundbreaking as it was, *The Cosby Show* flourished in part because of the persona—friendly, nonthreatening to white viewers—that had made Cosby famous. As his industry clout increased, Cosby postured himself as a wise Black community elder, responsible for guiding younger generations toward respectability and morality as he ostensibly defined it. Eddie Murphy's eponymous 1987 stand-up comedy film features a memorable scene in which the comedian recalls getting "chastised" by Cosby for using profanity in his act. "You cannot say 'filth, flarn, filth, flarn, filth' in front of people," Murphy narrates in Cosby's modular sitcom dad voice. "And I said, 'I never said no filth flarn filth! I don't know what you're talking about! I'm offended that you called! Fuck you!' And that's when Bill got raw on me!" Murphy slipped back into Cosby's lecture voice. "That's what I'm talking about! Yooouu cannot say 'fuck'!"

As the allegations against Cosby resurfaced and more women came forward, Cosby—who had been poised to make his TV comeback in a new NBC series—became an industry pariah. In 2015, a deposition he gave in the 2005 case was unsealed, revealing that the comedian had testified under oath that he had obtained quaaludes, a type of sedative, with the intent of giving them to women he wanted to have sex with. In the years following Cosby's public fall from grace, writers and entertainers alike have grappled with Cosby's alleged crimes and their incongruity with the image he curated as a beloved TV dad. Cliff Huxtable's occupation as an obstetrician-gynecologist who treated patients in the basement of his family's home seems downright sinister in retrospect. Seemingly innocuous scenes have been rendered unsettling: One season 7 episode revolves around a chaotic barbecue during which Denise and Sondra are squabbling with their respective husbands. When Clair notices that the couples are lovey-dovey and seem to have worked things out, a delighted Cliff boasts that it's his sauce. "Haven't you ever noticed that after one of

my BBQs and they have the sauce, people want to get right home?" he tells his wife before suggesting they go upstairs and "have some sauce."

In 2022, comedian W. Kamau Bell devoted a four-part documentary, *We Need to Talk About Cosby*, to the debate around whether Cosby's television legacy could survive the fallout. The documentary makes clear there is no easy answer to that question.

227

CREATED BY: C.J. Banks and Bill Boulware
STARRING: Marla Gibbs, Hal Williams, Jackée Harry, Regina King, Curtis Baldwin, Helen Martin, Alaina Reed-Hall, Countess Vaughn
PREMIERED: September 14, 1985
EPISODES: 116

THE THIRD EPISODE of HBO's *A Black Lady Sketch Show* featured a "reboot" of the 1980s sitcom *227*. Holly Walker played Mary Jenkins, the character originated by Marla Gibbs. Quinta Brunson, who went on to create *Abbott Elementary*, played Rose. And Daniele Gaither played their gossipy neighbor, Pearl Shay, who was portrayed to feisty perfection by Helen Martin.

227 centered around the Jenkinses, a middle-class family portrayed by Regina King, Hal Williams, and Marla Gibbs.

The showstopper was series creator Robin Thede bursting out of 227 Lexington Place in a fitted red dress and feathered coif. Even before Thede opened her mouth, she was a dead ringer for Jackée Harry's Sandra, but when she greeted her neighbors—Hi Rose, Hi Meeeeehry—in Harry's nasally purr, it was so spot-on that *Tonight Show* host Jimmy Fallon later joked that Thede does "an almost better Jackée Harry than Jackée Harry."

In the sketch, Mary learns that her husband, Lester, is leaving her for Sandra ("Sorry, Meeeeehry," Thede says). "What is happening?," a gobsmacked Mary asks. "This," Lester replies before dipping Sandra into a passionate kiss. The end of the sketch reveals the kicker: It was all a dream. Williams, the original Lester, is relieved when he wakes up—until he realizes Harry (aka Sandra) is in bed next to him. Next, Harry wakes up relieved before realizing Gibbs is next to her in bed. Screaming, Gibbs soon wakes up by herself, riffing: "Well, I guess I best stop drinking before bed."

The signature note from the show's theme song, "There's no Place Like Home," zings before Gibbs's familiar signoff: "I mean no place, child."

The sketch was a nostalgic and hilarious example of the cultural specificity that makes *A Black Lady Sketch Show* a singular variety series (we'll talk more about that in a few chapters). *227* is a beloved Black sitcom, but it never got the mainstream, full-stop recognition it deserved.

227 was based on a play that Gibbs had starred in at Crossroads Academy, a community theater she cofounded (with her sister, *Punky Brewster* actress Susie Garrett) in Los Angeles. Written by Christine Houston, a Black Chicago native, the show created such buzz that execs from the Big Three networks went to see *The Jeffersons* star in the production. Among them was NBC's Brandon Tartikoff.

The sitcom's setting was updated from a 1950s Chicago tenement to an apartment building in Washington, DC. Hal Williams reprised his role as Mary's husband, Lester, who was upgraded from a philandering husband to a dedicated family man helping Mary raise their daughter, Brenda (Regina King). Curtis Baldwin played Calvin, who was Pearl's grandson and a friend (and eventual love interest) to Brenda.

Ebony dubbed the show "Marla's Masterpiece," noting in a 1986 article that the show had been one of the few new series to get another season. But there was also a sense that *227* was underappreciated even at its own network. Despite playing the fan-favorite Sandra, Harry was initially contracted for only seven episodes, and the actress's response to that was telling: "I wasn't really expecting anything," she told the magazine. "This business is so precarious and I also thought that because of *Cosby* there wouldn't be much of a market for *227*. I was shocked at the ratings."

Harry earned two consecutive Emmy nominations in 1987 and 1988, becoming the first Black woman to win best supporting actress in a comedy in 1987—something that wouldn't happen again until 2022 when Sheryl Lee Ralph won the category for her turn in *Abbott Elementary*.

Marla Gibbs, Jackée Harry, and Helen Martin (bottom) played neighbors in a middle-class apartment building fictionally located at 227 Lexington Place, Washington, DC.

While *227* let its ensemble shine with stories about the various families and characters at 227 Lexington, the series was built around Gibbs, who helped develop the show, sat in on casting and editing sessions, and wrote several episodes but was only credited as a star of the show. "I'm an uncredited producer. Initially, I really wanted to be billed as an executive producer and it really stuck in my craw when they wouldn't let me," Gibbs told *TV Week* in 1989. "They can't stop me from contributing, so I don't need the title!"

The show tackled social issues including poverty and drugs (at a time when crack was ravaging DC and other cities around the country). Gibbs wrote the story for an episode titled "Rich Kid," which finds Calvin and Brenda befriending a classmate whose flossy lifestyle is revealed to be financed by dealing drugs. Mary visits the boy's mother, who is in denial about what her son has been doing. She later shows up to a meeting, in which the community is discussing how to combat the drugs increasing on their streets. There, she reveals that her son was stabbed to death in a drug deal. Gibbs fought for the character to be killed at the end. "That's what happens when you sell drugs," she reasoned to the producers. "People lose their children."

When the show's fourth season came along, *227* still enjoyed a loyal audience. But it had yet to reach its full potential, according to Williams. "There is a lot of talent in the show that has not been addressed," he told *Jet.* "The show does very well with minimal promotion by the network. I know it would be around a long time if we had promotion." Gibbs was asked frequently whether *The Cosby Show* had helped *227* find success. "Sure, it has helped, even though our show was planned before *Cosby* hit," Gibbs told the *Los Angeles Daily News* in 1985. "But *Cosby* is going to help all good shows, not just shows with black characters, to find places on the schedule." In interviews, Gibbs underscored what was unique about *227*—it was about a working-class Black family, for one, and though it was centered around the Jenkinses, the show provided a range of perspectives.

"We represent the masses who are hardworking and struggling to help themselves," she said in 1986. "We are black, but there is nothing particularly unique to these black families. We're just people struggling to improve ourselves."

AMEN

CREATED BY: Ed. Weinberger
STARRING: Sherman Hemsley, Clifton Davis, Anna Maria Horsford
PREMIERED: September 27, 1986
EPISODES: 110

..

WHILE GIBBS WAS leading *227*, her on-screen *Jeffersons* frenemy, Sherman Hemsley, was shaping another iconic character on NBC's *Amen*. Hemsley played Ernest Frye, a widowed lawyer and Philadelphia church deacon who often bumped heads with Reverend Reuben Gregory (Clifton Davis). In addition to leading the church, the reverend was love interest (and eventually husband) to Ernest's daughter, Thelma (Anna Maria Horsford).

The title sequence, anchored by an energetic gospel tune, captured Hemsley's boundless energy as Deacon Frye pulled into his personal parking spot, skipped double Dutch with neighborhood kids, and strutted into the church. Hemsley told *Jet* he had received "all kinds of offers" after *The Jeffersons* was canceled. "I didn't know if I'd get anything this meaty. You have to think about the show and if it's going to have longevity," he told the magazine. "Family comedies are in abundance. The kids have enough shows. This is a funny adult show."

Amen, while not a ratings juggernaut, had a loyal fan base for five years.

Davis, meanwhile, hadn't been in a TV series since *That's My Mama* and he had transformed his life in the interim, earning a theology degree and becoming an associate pastor at a Seventh-Day Adventist church. He was cast in *Amen* after Reuben Cannon—a pioneering Black casting director—told NBC execs he knew an actor who was a real-life preacher.

Amen was a modest ratings hit—while it never cracked the top ten, it did maintain a loyal fan base during its five-season run and a memorable stint in syndication. A May 1991 issue of *Jet* bid goodbye to the beloved show with a poignant cover showing Davis's Pastor Gregory and Horsford's Thelma gazing at their newborn baby. The series finale, aptly titled "Deliverance," featured a guest appearance by THE James Brown—an appearance that came about because Hemsley's managers knew an associate of the Godfather of Soul. Brown had been a fan of the show and watched it "religiously" during his 1988 prison stint for charges related to a high-speed police chase. "I just love it," he said. "I love the good, clean entertainment."

FRANK'S PLACE

CREATED BY: Hugh Wilson
STARRING: Tim Reid, Daphne Maxwell Reid, Tony Burton, Virginia Capers, Robert Harper, Don Yesso
PREMIERED: September 14, 1987
EPISODES: 22

TIM REID SPENT four years on *WKRP in Cincinnati*, where he wrote several episodes. He starred on several TV shows, including the cop procedural *Simon and Simon* during the 1980s before reuniting with *WKRP* creator Hugh Wilson to create a series about a college professor (Reid) who moves from Massachusetts to New Orleans after inheriting a restaurant in the Big Easy.

Reid, from Norfolk, Virginia, and Wilson, who grew up in Florida, both wanted to set the show in the South. An NBC exec suggested New Orleans, which piqued Reid's interest. He had spent

two weeks there in the early 1970s, in town for a comedy stint at the Playboy Club. "I will never forget it. It was an incredible two weeks," Reid recalls. "I can't say it changed my life, but it certainly took the senses of my life to another level that I had never experienced."

With that in mind, Reid and Wilson headed to New Orleans. "We spent a few days there going around, trying to find this place…where would the restaurant be, what kind of people?" Reid recalls. "Every character in that series—every character—was found in New Orleans."

That includes Hanna, the embalmer played by Reid's real-life wife, Daphne Maxwell Reid (who would go on to play the second incarnation of Vivian Banks on *The Fresh Prince of Bel-Air*.) Hanna's mother, Mrs. Bertha Griffin-Lamour (Virginia Capers), was based on a funeral home owner Wilson and Reid met in New Orleans. "She had the power. She was the matriarch of this funeral home," Reid recalls. "The richness of her story was just like 'wow.'"

Reid wanted the story to include people who felt real. "I wanted to introduce people to some of the Black characters and people I grew up with that mentored me," he says. They found another character in a restaurant called Chez Helene, where an elderly woman sat folding napkins at the end of the bar. She would get up only occasionally to

Frank's Place, starring Tim Reid, center, was a critical success. The show tackled race and class issues and was canceled after only one season.

greet certain people who walked in. Wilson asked who the woman was and was told: "That's Miss Marie. She only serves people who have been coming in here for ten years or more."

"I was like, 'We got to have it,'" Reid recalls with a laugh. "She's in the show." Frances Williams, a veteran actress who had starred in two of Oscar Micheaux's films, took the role of the "waitress emeritus."

When he and Wilson returned from their trip, Reid handed some notes over to Wilson and told him he trusted his writing instincts and to "go for it." A few weeks later, a messenger delivered Wilson's script for the *Frank's Place* pilot. When Reid finished reading, "I was emotionally stunned," he says. He had never read anything like it. It was "insightful" and "so rich in the culture," and Reid found himself tearing up at memories of his great-uncle and "the people and places" of his youth. He called Wilson. "I don't know that this could ever be made," he recalls telling his collaborator. "It was so different from anything about Black life in America that had ever [been] shown on television, including *Roots*."

To Reid's delight, CBS saw potential in the series. But there were also battles—the network initially balked at some of the casting decisions, including Williams, who was one of several actors over seventy years old. The show was ostensibly a sitcom but was often branded a dramedy because it was thoughtful in addition to being funny and lacked a laugh track (another fight the producers had with the network). "It was a marvelous, painful" experience, Reid recalls. "Oh, God was it painful. It was just one of the most difficult things I've ever been a part of. And yet the most glorious."

Critics loved the show. "What started out as another sitcom-simple show has turned into one of the most innovative programs on television this fall," Mark Schwed wrote in a UPI wire story. He praised the characters as "so finely tuned, so blessedly refreshing, that any one could be extracted from *Frank's Place* and given a spinoff show of his own."

"We've broken some rules," Reid told the *San Francisco Examiner*. "First of all, we're going to have nine black characters in a series. In a half-hour comedy, for crying out loud? *Cosby* only has seven, *Amen*, maybe eight. And we have nine, including four women. How many

women are there usually in a series who are not mothers or wives or the love interest?"

Over twenty-two episodes, the show dealt with social issues such as colorism within the Black community in an unprecedented episode. Ultimately, though, its willingness to tackle real-world issues may have led to its demise. A day after being picked up for a second season, *Frank's Place* was canceled, a decision Reid attributes to an episode on junk bonds that ruffled someone near the top of the network.

"The part that I keep with me when I think about that show is that we were all at our A game. When you're performing at that level," Reid says, "it's a different zone. And I am blessed to have been in that zone for twenty-two episodes. It's a rarefied air."

In the decades since, *Frank's Place* has been remembered fondly as an important and regretfully short-lived series—even in the Big Easy, a setting that many TV and film creators have flubbed. "New Orleanians recognized it as groundbreaking for its willingness to push past the stereotypes, making an effort to showcase the real New Orleans rather than presenting the easy, cliched postcard version," Mike Scott wrote for the *Times-Picayune* in 2017. "Not only did it feature a main character who was black, but it often dealt with issues of race, in the process painting a compelling portrait of black, working-class New Orleans."

"I still think if we had stayed on for four or five years, the race relations in America would be extremely different," Reid says in 2022. "Not necessarily better, but extremely different. We would have shattered some of the myths that are now still being used to destroy our character."

6 COMEDY AND VARIETY SHOWS

When it comes to comedians on prime-time television, all roads lead back to Redd Foxx, who introduced Middle America to Flip Wilson in the 1960s and recruited lesser-known contemporaries—including LaWanda Page and Slappy White—to appear on *Sanford and Son*. By the late 1970s, a clear heir to Foxx's irreverent but socially aware comedy had emerged in one of the writers Foxx had fought to hire in the early days of his sitcom: Richard Pryor.

Pryor—a movie star by that point—never went the sitcom route, but for four glorious weeks in the fall of 1977, he had his own variety series. And though short-lived, *The Richard Pryor Show* would influence generations of comedians—and the shows they would bring to prime time.

THE RICHARD PRYOR SHOW

CREATED BY: Richard Pryor
PRODUCED BY: Rocco Urbisci
FEATURING: Richard Pryor, John Witherspoon, Marsha Warfield, Tim Reid, Robin Williams, Sandra Bernhard
PREMIERED: September 13, 1977
EPISODES: 4

..

THREE DECADES BEFORE Barack Obama became the first Black president of the United States, *The Richard Pryor Show* imagined the comedian as the fortieth POTUS. Facing a crowd of reporters in the White House briefing room, Pryor's president responds to questions with inane doublespeak. Asked whether the development of neutron bombs might hinder Cold War–era peace talks, he responds: "Quite contrary to that fact, a matter of nuclear existence deals with atoms and

91

atomic weapons, not with neutron weapons. The neutron bomb is a hold-cost weapon, it is not in the cellular realm of reality. We're trying to hold it in place and it's a neo-, uh, neo-pacifist weapon."

An Associated Press reporter asks if the president believes the unemployment rate will drop within the fiscal year. "Well, as you know, the five-percent level pertains to mainly, if I may say, white America. In the Black American and minority situation, it's up to as high as forty-five percent. And we plan to, with all our efforts, try to lower that rate to about twenty percent in the Black areas and, of course, it will be lower in the white areas," he says. "We're trying to do this and merge a *United* States."

The president's tone and specificity shift when the few Black reporters in the room ask pointed questions evoking race. A Chicago-based reporter (played by a young John Witherspoon) asks about a $250 million increase to the space program and whether it means "we can finally recruit Black people." The president replies that it's time for Black people to go to space. "White people have been going to space for years. And spacing out on us, as you might say," he says. "And I feel with the projects that we have in mind, we're going to send explorer ships through other galaxies and no longer will they have the same type of music—Beethoven, Brahms, and Tchaikovsky— now we gon' have a little Miles Davis and Charlie Parker. We're gonna have some different kinds of things in there."

The Richard Pryor Show came out of an eponymous prime-time special Pryor had done earlier that year. As with the special, Pryor put his writing partner Paul Mooney in charge of casting. Mooney was a regular at the storied West Hollywood club known as The Comedy Store, where he handpicked up-and-coming talent to join Pryor's show. Among them were Marsha Warfield, who would go on to play Roz on *Night Court*, Witherspoon (later of *Friday*, *The Boondocks*, and *The Wayans Bros.* fame), Tim Reid, and Robin Williams (pre–*Mork & Mindy*), who has a blink-and-you-missed-it role as a cameraman in the background of the Black president sketch.

It's Warfield who introduces herself as Roberta Davies from *Jet* magazine, prompting Pryor's prez to salute her before she asks whether Huey P. Newton (as in the Black Panther Party founder and

Richard Pryor's controversial sketch comedy show paved the way for *In Living Color* and *Chappelle's Show.*

revolutionary) is among the candidates he's considering for director of the FBI. "Yes, I figure that Huey Newton is best qualified," Pryor says with a straight face. "He knows the ins and outs of the FBI, if anybody knows them, and he would be an excellent director."

Reid plays Brother Bell, an *Ebony* reporter who gets the president's (stunned) attention with a "Yo Blood!" and greets him with the Arabic greeting that's customary between members of the Nation of Islam: "As-salaam alaikum, Brother." (The first Black president responds, naturally, with "Wa-alaikum-salam.") After glaring at a journalist he dubs "Snow White" (played by Sandra Bernhard, another Mooney recruit), Bell asks what the president plans to do "about having more Black brothers as quarterbacks in the National Football Honky League."

"I plan not only to have lots of Black quarterbacks, but we gon' have Black coaches and Black owners of teams. As long as it's gon' be football, it's gon' be some Black in it somewhere!" the president says, voice starting to rise along with the studio audience's applause. "'Cause I'm tired of this mess that's been going down. Ever since the Rams got rid of James Harris, my jaw been uptight. You know what I'm talkin' 'bout? We gon' get down on the case now!"

Here, Pryor was speaking directly to Black Americans, echoing, on national television, discourse that had largely been limited to Black media publications, Black barber shops, and football-loving Black households. Harris (nicknamed "Shack") became the first Black quarterback to lead a season-opening game when the Buffalo Bills faced the New York Jets in September 1969. It should have been the start of a promising career with the Bills. But Harris—who regularly received racist hate mail—only started twice after that and was released by the team three years later. He later led the Los Angeles Rams to two consecutive division championships. Following the 1974 season, he became the first Black quarterback to make the Pro Bowl, where he was named MVP. Despite his successful record (including one of the top passer ratings in the league), the Rams traded Harris ahead of the 1977 season.

By the time Pryor finishes his response, he's so heated he snaps "YEAH, WHAT?" in response to another member of the press

corps. When the reporter identifies himself as Mr. Bigby from the *Mississippi Herald*, Pryor instantly tells him to "sit down."

The sketch spoke to the moment, but it was also prescient. Pryor foresaw a president who would croon "Let's Stay Together" at Harlem's famed Apollo Theater and open a gospel tribute with "Weeell." He foresaw a president who might say something like "Folks wanna pop off and have opinions about what they think they would do?" before challenging his detractors to "present a specific plan."

There still haven't been any Black NFL team owners, by the way.

The Richard Pryor Show premiered to positive reviews but it was otherwise doomed from the start. After repeated battles with the network, Pryor quit the show several times during rehearsals but ultimately agreed to do four episodes (scaled back from ten) and several specials. To the bewilderment of TV critics, Pryor fans, and the comedian himself, NBC scheduled the show for Tuesdays at 8 p.m., a prime slot to be sure—but one usually associated with family-friendly viewing. Ahead of the premiere, NBC announced that its broadcast standards department had already deemed one sketch "inappropriate," leading to what the network characterized as "a brief edit." But the decision effectively stripped Pryor's opening bit from the show. You can find it on YouTube, where you'll almost certainly wonder what all the fuss was about. Pryor appears, his face and bare shoulders in the frame, to introduce himself and the series:

> *I'm telling you it's going to be a lot of fun. You know, there's been a lot of things written about me, people wondering am I going to have a show, am I not going to have a show—well, I'm having a show! People say, "Well, how can you have a show? You'll have to compromise, you'll have to give up everything." Is that a joke or what? Well look at me. I'm standing here naked. I've given up absolutely nothing.*

The camera pans out to reveal a fully naked Pryor minus a few anatomically typical details (think naked Ken doll). Viewers who

tuned in to the debut of *The Richard Pryor Show* wouldn't see the subtle joke about its star being neutered in the name of prime-time comedy. But if they had seen coverage of Pryor quitting the show over creative differences—as announced in a press conference earlier that day—they might have caught it. In the 2013 book *Furious Cool: Richard Pryor and the World That Made Him*, Rocco Urbisci, the show's producer, recalled "that the naked opening was shown that night on every network newscast, including NBC" and "got more exposure than if they'd left it alone."

"They wanted to have a format and the same old stuff. I said, 'No, I don't work that way,'" Pryor later told *Ebony*. "I don't feel like that about comedy. I think it's sporadic and spontaneous and it should be related that way—from my point of view of Black awareness and where I come from and what I see."

For the month that *The Richard Pryor Show* was on the air, Pryor and the players he and Mooney assembled tackled everything from *Star Wars*, in a bar-themed sketch that found Pryor serving up drinks to George Lucas's aliens, to a courtroom riff on *To Kill A Mockingbird*, which featured Williams as a lawyer "from the civilized North" defending a Black man accused of raping a white woman. Another sketch featured Maya Angelou as the wife to Pryor's bumbling drunk, Willie (served by a bartender played by John Belushi). The sketch is pure comedy at first—Willie and his fellow patrons slurring their words and flinging their limbs aimlessly with every inebriated step. But after Willie—booted from the bar for fighting—stumbles up the steps to their apartment and slumps down on the couch, Angelou delivers a show-stopping monologue, written by the poet herself, that exposes the layers of pain—from the racism he's experienced—beneath Willie's alcoholism. Pryor, at the center of it all, showed the full breadth of his range. "The tales of Richard's angst and furious meltdowns belie how brilliant and defiant the show is, especially for its time," David and Joe Henry wrote in *Furious Cool*. "Forget pushing the envelope; they tore the envelope to shreds and tossed it like confetti."

Pryor largely wrote off television after *The Richard Pryor Show** but, like his comedic influence, the spirit of what he brought to prime

* Pryor did host a short-lived children's program, *Pryor's Place*, in 1984.

time endures today. The through lines from *The Richard Pryor Show* to *In Living Color* to *Def Comedy Jam* to *Chappelle's Show* (which featured its own Black president sketch, with Dave Chappelle as "Black Bush" and Jamie Foxx as "Black Tony Blair") are plentiful.

One through line is Mooney, who wrote for *In Living Color*, took the *Def Comedy Jam* stage multiple times, and, in one of his more visible roles, appeared as Negrodamus on *Chappelle's Show*, where he also shared jagged pearls of wisdom in the recurring "Ask a Black Dude" segment. Mooney's star was never as visible as Pryor's, but he's no less important to comedy.

A decade apart, *In Living Color* and *Chappelle's Show* helped revolutionize sketch comedy. But before we get to *In Living Color*, we have to talk about two cultural juggernauts that premiered in the late 1980s and offered platforms to Black comedians and other entertainers who had gone largely overlooked by mainstream late-night and variety shows: *Showtime at the Apollo* and *The Arsenio Hall Show*.

Paul Mooney (left) was Richard Pryor's writing partner and helped cast many comedians on the show including Sandra Bernhard.

A BRIEF HISTORY OF
FIRST BLACK PRESIDENT JOKES

1977

Richard Pryor's fortieth president gets Blacker with every question in the White House briefing room on *The Richard Pryor Show*.

1990

In Living Color imagines Jesse Jackson (Keenen Ivory Wayans) leading his final press conference as POTUS in a sketch optimistically set in December 2000. The bit is as much a parody of Jackson—who had sought the Democratic Party nomination in 1984 and 1988—as it is an extreme comedic template of a Black president. Asked if he was ever concerned about "an attempt on [his] life," Jackson (whose penchant for rhyming was the subject of a 1988 *New York Times* story) replies: "My administration did fear assassination, either by strangulation, decapitation, or driving through the South without identification."

1992

Two years later, Chris Tucker takes the *Def Comedy Jam* stage, where he riffs that white people "won't vote for no Black president" because they "don't trust Black people...Like a Black brother will fuck up the White House. Like the grass won't be cut. Dishes piled up. Cousins running through the White House. Cookouts. Basketball going in the back." The audience cackles as Tucker builds to the kicker: The first Black president would be too proud to use a bodyguard, he says. Rather, he would take matters into his own hands. "He's gonna have a gun," Tucker says. "Like, damn! The president fucked somebody up. Did you see that shit, man?"

2003

In his feature directorial debut, *Head of State*, Chris Rock plays DC alderman Mays Gilliam, who abruptly finds himself the 2004 Democratic presidential nominee following a chaotic sequence of events. Five years ahead of Barack Obama's historic win, Rock introduced a Black president who led the electric slide (to Nelly's "Hot in Here") at his first campaign fundraiser and delivered sermon-like speeches ("Let me hear you say 'That ain't right!'") on economic inequality. *Head of State* opens and closes with Nate Dogg recapping part of the story in his smooth baritone while flanked by two white women. Also, when Mays is introduced to his decoy, he cracks, "You know, Tupac could have used a guy like you." Bernie Mac plays Mays's brother and vice-presidential running mate in the film, which Rock cowrote with frequent collaborator Ali LeRoi.

2004

In the season 2 finale of *Chappelle's Show*, which became the series' de facto finale after Chappelle abruptly left ahead of the planned third season (more on that in a moment), Dave Chappelle plays a Black version of then-president George W. Bush as he tries to make the case for going to war in Iraq. Jamie Foxx makes a cameo as Black Tony Blair; Mos Def (now known as Yasiin Bey) is the CIA director. Introducing

the sketch, Chappelle asserted that "if our president were Black, we would not be at war right now...Not because a Black person wouldn't do something like that," he clarified. "Just because America wouldn't let a Black person do something like that without asking them a million questions."

2012
Keegan-Michael Key and Jordan Peele get an honorable mention for heightening the reality of the actual first Black president with multiple sketches, including the recurring bit that channeled "Obama Meet & Greet," a sketch that found the first Black POTUS (played by Peele) greeting potential supporters. As he moves down the line, it becomes clear that his greetings for Black and white constituents are vastly different. Ian Roberts and Peter Atencio, both middle-aged white men, get firm handshakes and pleasantries. But when he gets to Jerome Smith, a bespectacled Black man in a burgundy sweater, the president offers a hug with a fist bump to the back. "What up, fam?" Peele's Obama says. After another series of brisk handshakes, POTUS meets Tasha Robinson. The pattern continues even as POTUS comes across a pair of babies (he kisses the Black baby and shakes the white baby's tiny hand) and a racially ambiguous man (played by Key), who gets a warm greeting after a secret service agent assures Obama the man is "one-eighth Black."

Key and Peele also famously riffed on the first Black president's anger with a sketch that featured Luther, the anger translator (Key), stepping in to offer more colorful remarks when Obama's stirring rhetoric (as delivered by Peele) just won't do.

Jordan Peele portrays Barack Obama and Keegan-Michael Key is Luther, the anger translator.

IT'S SHOWTIME AT THE APOLLO

PREMIERED: September 12, 1987
PRODUCED BY: Percy Sutton, Bob Banner
EPISODES: 1,094

AS AN INSTITUTION, the Apollo Theater existed long before the revered Harlem landmark's Amateur Night came to syndicated television in the late 1980s. A seventeen-year-old Ella Fitzgerald won Amateur Night in 1934 after switching her talent from dancing to singing just before taking the stage. Over the years, the Apollo would play host to Black entertainers in various stages in their careers: Billie Holiday, Duke Ellington, Lena Horne, Leslie Uggams, Miles Davis, Nina Simone, Jimi Hendrix, James Brown, the Jackson 5, Stevie Wonder, and D'Angelo, to name a few. Former president Obama famously crooned Al Green's "Let's Stay Together" at a campaign stop there in 2012.

Black comedians have been a cornerstone of the Harlem landmark since it opened to integrated audiences after changing ownership in 1933. In those very early days, billed comics—Pigmeat Markham, Tim Moore, and Stepin Fetchit among them—regularly performed in blackface. Later, the Apollo crowd took in sets by Redd Foxx, Slappy White, Moms Mabley, Nipsey Russell, and Flip Wilson, who performed there regularly in the years leading up to his big break but (according to the Apollo's then-manager Bobby Schiffman) never got booed.

It's Showtime at the Apollo premiered amid an evolving comedy scene: Eddie Murphy was a newly minted superstar. An up-and-coming Chris Rock was the comic featured in the very first episode; he would go on to host his 1999 HBO special *Bigger & Blacker* from the hallowed venue, where the *New York Times* reported Rock "intentionally sold tickets only at the box office the week before the show, in order to attract a Black audience." "It was probably the best I've ever been in my life. That night, something just happened," Rock later told *Vanity Fair* of his now-classic HBO special. "It sounds corny, but the Apollo is just kind of a magical place."

And while the show's first few seasons were helmed by a rotating cast of guest hosts, it would become tradition for the show to be

The Apollo Theater in Harlem has been hosting Amateur Night on Wednesdays for more than seventy years.

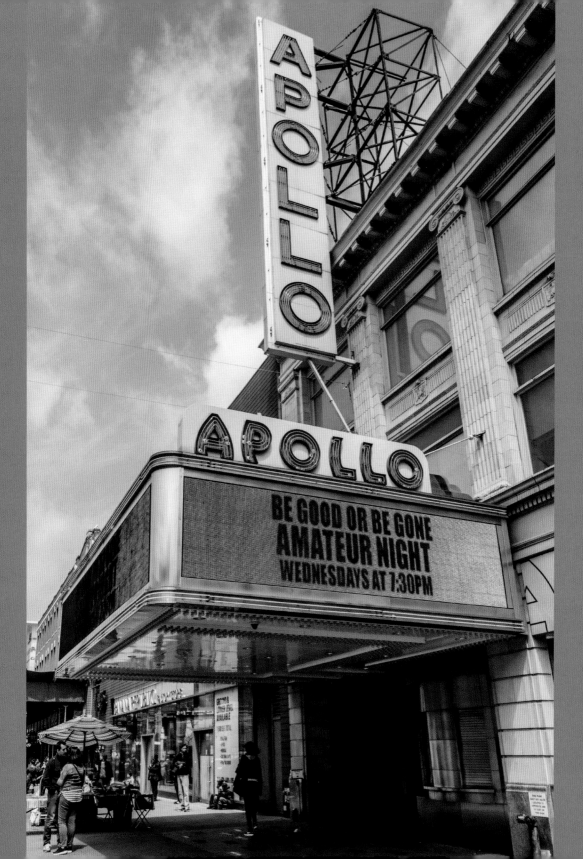

hosted by a comedian. By 1989, Sinbad was named host of the show. Mark Curry did a guest stint before Steve Harvey took over in 1993. Meanwhile, the show established beloved personalities in cohost Kiki Shepard and the Executioner (C.P. Lacey), the unforgiving tap-dancing figure who removes acts the crowd doesn't like. Later iterations of the show, retitled *Showtime at the Apollo*, were hosted by comedians such as Whoopi Goldberg, Anthony Anderson, and Mo'Nique.

It's Showtime at the Apollo spotlighted an institution that has influenced Black entertainers on- and off-screen. Luther Vandross, Jamie Foxx, and Lauryn Hill are among the superstars who faced boos during their first (and second, third, and fourth in Vandross's case) time in front of the notoriously tough Amateur Night crowd. As Dave Chappelle recounted to James Lipton on *Inside the Actor's Studio* in 2006, he moved to New York (from his native DC) with his sights set on taking the Apollo stage and, in the unmistakable vernacular of his hometown, "ripping that mug." Reality unfolded quite differently: "When I say I got booed," the comedian said with a grimace, "I still remember that boo. I'd never been booed offstage before, but I just remember looking out and seeing everybody booing—everybody."

"Meanest crowd in the world!" Chappelle joked before calling the experience "the best thing that had ever happened to" him. "I failed so far beyond my wildest nightmares of failing, that it was like, 'Hey, they're all booing, my friends are here watching, my mom—this is not that bad,'" he told Lipton. "And after that I was fearless."

THE ARSENIO HALL SHOW

CREATED BY: Arsenio Hall
PREMIERED: January 3, 1989
EPISODES: 1,168

IN FEBRUARY 1994, Martin Lawrence stood next to Arsenio Hall beaming at an audience that included his *Martin* costars. Catching sight of *Saturday Night Live* alum Garrett Morris—who had a recurring role on Lawrence's Fox sitcom—the host of *The Arsenio Hall Show*

remarked that "it must be cool to work with" Morris, the first Black cast member of NBC's long-running sketch comedy show.

"That's the man," Lawrence said of Morris. "We had to go back. I got respect for old school," Lawrence replied. "What I mean by that is veterans that paved the way for us, man, because there would be none of us on television if not for them."

"Garrett Morris been berry berry good to me," Hall cracked, channeling Morris's fan-favorite SNL character—the fictional Dominican baseball player Chico Escuela. The joke fell flat but the sentiment behind it was real. Hall, in his early thirties, was the first Black person to host a late-night show. And like Flip Wilson, Hall had insisted on creative control over every aspect of his show.

Hall, not surprisingly, has cited Wilson, along with Richard Pryor and George Carlin, as a major influence. "Flip Wilson doesn't get enough shine in my world, especially as a businessman who did some amazing things," he said in 2017. "When you look at TV as a child, and see Flip Wilson owns the show, is executive producer, I remember as a kid wanting to know what that meant."

Arsenio Hall was American TV's first African American late-night talk show host.

Hall's late-night break arrived after he had been called in as a pinch hitter on Fox's *Late Show*, after the network fired Joan Rivers (a messed-up story for another book and time!). The temporary assignment gave Hall more freedom, which translated to edgier monologues and guests who weren't regulars on the late-night circuit (often they were his friends: his *Coming to America* costar Eddie Murphy; Robert Townsend). One *Late Show* producer told the *New York Times* that Hall had garnered only slightly higher ratings than Rivers, but execs were intrigued by the "phenomenal audience share, 60 or 70 percent, that he was pulling among black viewers in places like Atlanta."

The Arsenio Hall Show widened Hall's pool of potential guests, but he continued to zag where reigning late-night kings Johnny Carson, David Letterman, and even fellow newcomer Pat Sajak zigged, booking guests that viewers weren't likely to see elsewhere. (Sajak's effort lasted for just one season.) When it came to musical guests, Hall looked to the R&B and rap charts as well as the pops. Over the years, *The Arsenio Hall Show* featured performances by A Tribe Called Quest, Boyz II Men, Eazy-E, New Edition, Public Enemy, Poison, and Lenny Kravitz. Miles Davis gave a rare performance (and an interview) in 1989. Mariah Carey, who made her television debut on *The Arsenio Hall Show*, recalled in her 2020 memoir that "Arsenio

Eddie Murphy, a close friend of Hall's, appeared on the late-night show several times.

was more than a host; he had more than a late-night show; it was a cultural event, a true Black experience…I will always be grateful and proud that it was on Arsenio's stage that most of America got to see my face, know my name, and hear my song for the first time."

The Arsenio Hall Show stood out for its energy that Hall shared with his viewers. Announcer Burton Richardson offered a distinctive "Arseniooooooooooooo Hall!" as the host took the stage each night. The Arsenio Hall Show was on for just over a year when Julia Roberts offered up the Arsenio crowd's trademark barks of approval at a stuffy polo match in Pretty Woman. By fall 1989, The Arsenio Hall Show was second only to Carson's Tonight Show in the ratings and was particularly popular in two key demos: women and younger Americans, ages twelve to thirty-four.

Critics weren't particularly impressed by Hall's interviewing skills, though it's hard to imagine Lawrence—who went on to talk about grappling with his responsibility as a Black entertainer—being as candid on, say, Letterman. Hall was always more focused on the platform, pitching his late-night show as the show for people who didn't have a late-night show. "If a guy's watching Johnny Carson," Hall told the Washington Post, "I want his kids in the other room to be watching me." He landed major interviews: Magic Johnson, Hall's close friend, chose to appear on Arsenio a day after sharing that he

Magic Johnson's appearance on The Arsenio Hall Show in 1991 drew nine million viewers.

had contracted the AIDS virus; the episode played to nine million households. As the presumptive Democratic presidential nominee in 1992, Bill Clinton played "Heartbreak Hotel" on the saxophone before doing an interview with Hall.

Hall wasn't immune to criticism; he told the *Los Angeles Times* he had gone as far as hiring a research firm to do focus groups with fans in an effort to understand what they liked about the show. The takeaway, Hall said, was that they appreciated the ways *The Arsenio Hall Show* broke the late-night mold.

When Hall met with executives who suggested he could make a few tweaks in an attempt to court some of Carson's older viewers by making them "more comfortable," the host balked. "I don't want to make anyone here uncomfortable, but I ain't tweaking sh–," Hall told the room, according to *Ebony*. "The only thing I can be every night is Arsenio Hall."

And for four seasons, he was. *The Arsenio Hall Show* faced increased competition in its final season from Jay Leno, at the helm of *The Tonight Show* following Carson's retirement and Letterman's new *Late Show* perch. Ahead of the show's cancellation in the spring of 1994, Hall was slammed for booking and then interviewing Louis Farrakhan, who went virtually unchallenged by Hall as the Nation of Islam leader spouted anti-Jewish rhetoric.

The final episode of *The Arsenio Hall Show* ended, fittingly, with a hip-hop cypher made up of some of the artists Hall had championed during his run, including Yo-Yo, MC Lyte, Naughty by Nature, Wu-Tang Clan, KRS-One, and A Tribe Called Quest. *"Everybody wanna host / But everybody is not a hostess,"* Yo-Yo began. *"The hostess with the mostest / Arsenio the boldest / the biggest the baddest / the meanest, the toughest...we wrote this song just for you."*

IN LIVING COLOR

CREATED BY: Keenen Ivory Wayans
STARRING: Keenen Ivory Wayans, David Alan Grier, Damon
Wayans, Jim Carrey, Tommy Davidson, Shawn Wayans, Kim
Wayans, Kim Coles
PREMIERED: April 15, 1990
EPISODES: 127

IN THE FALL OF 1990, Keenen Ivory Wayans, fresh off the
runaway success of the 1988 blaxploitation parody *I'm Gonna Git
You Sucka*, introduced a new variety show. Billed as an edgier (and
Blacker) *Saturday Night Live*, *In Living Color* broke ground in sketch
comedy with its diverse cast and propelled several of its stars—
including Jim Carrey, Jamie Foxx, David Alan Grier, and Tommy
Davidson—to comedy stardom. The show also introduced a few
dancers—dubbed Fly Girls—you might be familiar with: Jennifer
Lopez (ring a bell?) and Carrie Ann Inaba (of *Dancing With the Stars*
fame). *Soul Train* alum Rosie Perez, who had (literally) danced her
way into Spike Lee's *Do the Right Thing* a year prior to *In Living Color*'s
debut, served as choreographer.

"Men On..." with
Damon Wayans and
David Alan Grier as
Blaine Edwards and
Antoine Merriweather,
was one of the most
popular sketches on
In Living Color.

The show was an instant hit for the fledgling Fox network. Its
predominantly Black cast, peppered with relative unknowns, was

groundbreaking for television. How many Black cast members were on SNL when *In Living Color* premiered? One: Chris Rock, who would eventually leave Studio 8H for the fifth and final season of Wayans's show (Ellen Cleghorne and Tim Meadows joined the *SNL* cast in 1991 and stayed on for four and ten seasons, respectively). "I wanted to be in an environment where I didn't have to really translate the comedy that I wanted to do," Rock said of the move.

In interviews leading up to *In Living Color*'s debut, Wayans embraced the *SNL* comparison. "But instead of a house band, we have deejays and Fly Girls," Wayans told the *Los Angeles Times* in 1990. "I want to do what Arsenio Hall did for talk shows, and make America comfortable with another entertainment format for black Americans."

Homie D. Clown
(Damon Wayans)
was inspired by
Paul Mooney.

Comfortable is, of course, a relative term. *In Living Color* pushed boundaries with sketches that included "Men On…," which featured David Alan Grier and Damon Wayans as flamboyantly gay cultural critics, Jim Carrey's confoundingly reckless Fire Marshall Bill, and Homey D. Clown, who was inspired by one Paul Mooney. "I used to call everybody homey. And Homey D. Clown is actually me," he told the *Miami New Times* in 2010. "That's the only way they could get me on TV. It's me without the edge and it made Homey D. Clown famous. You see that kind of character sticks with people like glue."

The first episode established *In Living Color* as a fresh and pop culture–savvy half hour that had bite. Sketches included a *Love Connection* parody starring Carrey as Chuck "Don't ever call me Charles, I'll go off" Woolery opposite Wayans as Mike Tyson and Kim Coles as Robin Givens. Damon Wayans played Redd Foxx in a *Sanford and Son* spoof that found Fred offering tax tips ("If the IRS comes to your house, lie about everything") and trying to elude romantic overtures from Aunt Esther (Kim Wayans).

Critics called *In Living Color* tasteless and offensive as often as they dubbed it brilliant and hilarious. And most noted the milestone in Wayans's role as creator, writer, actor, and often director. Wayans hadn't been interested in doing a television show but heard Fox executives out when they pledged that he would have complete control over the show. But it was clear leading up to the show that the network was nervous. The inaugural "Men On…" sketch, which found Grier's Antoine Merriweather and Damon Wayans's Blaine Edwards discussing films, divided viewers (and still does).

"We take an exaggerated stereotype and really have fun with it," Wayans told the *New York Times*. "If I take something and ridicule it to such a degree that people could never look at it as anything real, then it really helps to destroy a preconceived notion."

Not everyone agreed. The show earned Spike Lee's ire with a season 1 spoof of *Do the Right Thing*, in which Perez reprised her role as the outspoken girlfriend to Lee's protagonist, Mookie. "He did not like us making fun of him. People would get angry when we poked fun at them," Grier told the *Hollywood Reporter* for a 2019 oral history. "Arsenio Hall too—anybody that we really poked fun at."

Despite his authority over the show, Wayans still faced network executives who were worried that the brash sketches would offend viewers. "I had to constantly remind them that I'm a black man with a very strong social conscience and a pretty decent education," he said. "I'm not a lunatic who's sitting around going, 'How can I totally degrade myself and my community?'"

On top of the representation *In Living Color* brought to the screen, Wayans sought to make the series a launching pad for Black writers and talent. But finding potential stars wasn't easy. "Minority talent is not in the system and you have to go outside," Wayans told *USA Today*. "We went beyond the Comedy Stores and Improvs, which are not showcase places for minorities."

Robi Reed, the casting director behind *In Living Color*'s first season, traveled across the country with Wayans looking for talent. This was pre-digital, so Reed would often lug a video camera with her to comedy houses. "Everything was videotaped—VHS tapes—and then you had to manually dub each tape," Reed recalls. "So I'd be sitting in my office until two and three in the morning making multiple tapes because everything was real time."

"Everyone auditioned—everyone," says Reed. But not everyone had the kind of comedic chops the show required. "For *In Living Color*, we needed people to be able to do characters." Martin Lawrence was among those who didn't make the cut. "All of the characters Martin ended up doing on [*Martin*], he didn't have that in his stand-up," Reed says. "We were friends outside of the business and, just hanging out with him, he would do all of these different characters. But onstage when we needed him to do it, he just froze."

"Eventually," Reed says, Lawrence found his niche, marrying sketch comedy with sitcom humor on his eponymous Fox series. "And it was brilliant and worked for him in his own show."

In Living Color's first season earned three Emmy nominations. Wayans was stunned when his series won best variety show in a category that included Arsenio Hall's show and *SNL*. Overwhelmed, he struggled to get through the speech he had prepared—just in case—as his parents and brother Shawn looked on proudly. Ultimately he dedicated the trophy to his "ma" before walking offstage. It was the

The diverse cast of *In Living Color* also included the Fly Girls, many of which were propelled to stardom. From left: Lisa Marie Todd, Jennifer Lopez, Cari French, Deidre Lang, and Carrie Ann Inaba.

first award Wayans had ever won, and though *In Living Color* would garner a total of eighteen Emmy nominations over five seasons, this was the first and last prize the show would win.

Like *The Arsenio Hall Show*, *In Living Color* gave a platform to the burgeoning hip-hop scene, tapping everyone from Queen Latifah to Heavy D & the Boyz (the outfit behind the show's memorable theme song) to Public Enemy.

Wayans, tired of battling Fox executives, had departed *In Living Color* by the time Rock joined in 1993. "I didn't have antagonistic relationships with the censors. I wasn't irrational. I knew there were restrictions," Wayans said. "It was more about how far can I go? Like, just tell me where the line is. The frustration was that the line was moved week to week. So you could do something one week, but if they got mail, you couldn't do it the next."

DEF COMEDY JAM

CREATED BY: Russell Simmons and Stan Lathan
HOSTED BY: Martin Lawrence
DIRECTED BY: Stan Lathan
PREMIERED: March 7, 1992
EPISODES: 90

A NEW GENERATION of Black comics broke out in the early '90s on *Def Comedy Jam*. Co-created by Def Jam cofounder Russell Simmons and director Stan Lathan, the HBO series was a welcome showcase for emerging and underrated comedians, including Chris Tucker, Dave Chappelle, Bill Bellamy, Eddie Griffin, Bernie Mac, J.B. Smoove, Adele Givens, Steve Harvey, Cedric the Entertainer, Deon Cole, and Tracy Morgan.

Def Comedy Jam capitalized on the increasing demand for comedy, particularly in club settings, that had bubbled up in the era of Eddie Murphy, *In Living Color*, and the flourishing hip-hop scene that had made Def Jam a flagship label. For Simmons, the show's humor was a natural extension of hip-hop as a culture and movement. "These guys are expressing their real values and attitudes," Simmons told the *Los*

Angeles Times. "If they are not as positive as you would like them to be, you have to listen to them and understand them. It's a dose of reality."

Lathan, who had been working in television for nearly two decades, admitted in the same *LA Times* story that even he struggled with "the totally, totally raw stuff." But, he said, "we have an obligation to air it and put it on, totally uncensored." If it's funny to our audience, no matter how dirty it is, we use it."

Critics praised the show even as they warned readers of profanity and vulgar routines simulating sex. But these reviews also highlighted the absence of a platform for Black comics who rejected the virtue signaling of Bill Cosby and weren't concerned about making white audiences comfortable.

Lathan also helped set the show apart by breaking away from the typical comedian-in-front-of-nondescript-wall template and opted for a lower stage that spilled into the audience, extending the energy and excitement to viewers at home. "That was what I think really helped set *Def Comedy Jam* apart from anything that had been actually done in stand-up comedy," Lathan said.

Russell Simmons and Stan Lathan tapped Martin Lawrence to host the groundbreaking *Def Comedy Jam.*

THE CHRIS ROCK SHOW

CREATED BY: Chris Rock

STARRING: Chris Rock, Wanda Sykes, Louis C.K.

DJ: Grandmaster Flash

PREMIERED: February 7, 1997

EPISODES: 55

WHEN CHRIS ROCK entered the late-night television fray on February 7, 1997, he immediately distinguished himself from his network peers, who tended to book guests based on projects—films, albums, books—they were trying to promote. *The Chris Rock Show* welcomed famed defense attorney Johnnie Cochran, a year and a half after the O.J. Simpson trial. "After this trial, people got so mad at you. They didn't give you the respect you were due," Rock said. "I mean, Marcia Clark got a bigger book deal than you."

Like Arsenio Hall before him, Chris Rock offered a platform to guests and performers who went overlooked by network late-night shows. Over the show's five seasons, he talked to guests that included Spike Lee, Allen Iverson, Cedric the Entertainer, Bernie Mac (*before* he had his own sitcom, a glaring TV omission the two men discussed), Jenifer Lewis, Jada Pinkett Smith (who was presented with a bottle of champagne for—oops—not referencing husband Will Smith for the entire interview), and Whoopi Goldberg. With his wry humor and incisive racial commentary, Rock was adept at chatting with non-entertainers, including Cochran (whom he hosted twice), Jesse Jackson, Kweisi Mfume, then head of the NAACP, and Al Sharpton.

The Chris Rock Show, which boasted prominent writer-performers such as Wanda Sykes, Louis C.K., and Rock's frequent collaborator Ali LeRoi, also established itself as a space for biting pretaped segments such as "How to Not Get Your Ass Kicked by the Police" ("If the police have to come get you, they're bringing an ass-kicking with 'em," Rock deadpans) and a segment that found Rock polling South Carolinians on their state's prominent use of the Confederate flag. "What about replacing the stars of the Confederate flag with the stars of the WB?" Rock asks, presenting a mock-up of the flag featuring the faces of Black actors that include Steve Harvey, Brandy, the Wayans brothers,

and Jamie Foxx. ("Oh, now, that's clever," one white woman says.) He later presents the updated flag to then-governor Jim Hodges.

Rock peppered his monologues with references to rappers as hip-hop was exploding into the mainstream and featured them as musical guests long before it became commonplace to see rappers on late night. "On my show, we keep a youthful slant," he told the *Chicago Sun-Times* in 2000. "We're joking about people never joked about before. They're almost happy that their name is in a monologue. It's a new thing 'cause no one ever did Ol' Dirty Bastard jokes before me. And Letterman is doing it now. I brought the world Lil' Kim jokes. I picked on Puffy. No one ever put on a suit and did a monologue and talked about these people."

When *The Chris Rock Show* was abruptly canceled in 2000, the *Boston Globe*'s Renée Graham penned an obituary for "the best late-night talk show." Rock, Graham wrote, "perfectly understood his hip, urban audience and why they tuned in Friday nights. He wanted to give them people, places, and things they knew, whether the topics were mainstream or not."

The Chris Rock Show aired for only three seasons.

CHAPPELLE'S SHOW

Created by: Dave Chappelle and Neal Brennan
Starring: Dave Chappelle, Charlie Murphy, Donnell Rawlings,
Paul Mooney
Premiered: January 22, 2003
Episodes: 28

WHEN *CHAPPELLE'S SHOW* premiered on Comedy Central in 2003, Dave Chappelle introduced a character he had been holding on to for a while. A spoof of the news magazine show *Frontline* introduced Clayton Bigsby as an avowed white supremacist who had written several books with racist titles conveying his absolute disdain for Black people and other minorities.

After the fictional *Frontline* journalist Kent Wallace (William Bogert) navigates "back-country hollows, shifty go-betweens, and palpable danger" to reach the reclusive Bigsby, he is stunned to discover that the white supremacist author he was set to interview is actually a Black man. But Clayton, who is blind, doesn't realize he is Black because he grew up at a home for the blind—where he was the only Black child. "We figured we'd just make it easier on Clayton by just telling him and all the other blind kids that he was white," the headmistress tells *Frontline*.

The nine-minute sketch gets more ridiculous as Wallace agrees to accompany Bigsby on his first public outing in years. When he gets confronted by white supremacists in town, Bigsby assumes they are talking to someone else. "White Power!" he declares as his would-be assailants look around in confusion. The kicker arrives when Bigsby takes off his Klan hood at a meeting, prompting gasps (and at least one graphically exploded head) from the audience. In a post-segment update, Wallace tells viewers that Bigsby has accepted that he's a Black man. He's also filed to divorce his wife of nearly twenty years because she's, you guessed it, "a n[—] lover."

In the *New York Times*, Elvis Mitchell noted that Chappelle's approach to racial humor was "less cerebral" than Rock's and that Chappelle was "intrigued by the tension between blacks and whites, and it fires up his free-floating insolence." The result "bridges the gap

Even though the *Chappelle's Show* aired for only three seasons, it produced many iconic sketches.

between Rock's show and other fast-moving comedy shows like *Mad TV*," Mitchell wrote, adding that Chappelle "comes close to the bruising hostility that Keenen Ivory Wayans brought" to *In Living Color*.

Chappelle created *Chappelle's Show* with his longtime friend and *Half Baked* collaborator Neal Brennan. Over the course of two seasons, Chappelle would become a household name with incisive and innovative sketches that skewered racial stereotypes and subverted expectations. "The Racial Draft" found delegations picking racially ambiguous celebrities to be on their team a la the NBA draft. Mos Def, playing the head of the Black Delegation, announced multiracial golfer Tiger Woods (played by Chappelle) as the first pick. As Black people in the stands celebrated the acquisition, an announcer cracked, "Dave, the Asians have got to be upset." (The Asian delegation would later get their comeuppance by drafting Wu-Tang.)

"There's no question about that, Robert," Chappelle's announcer said. "But you got to think about it. He's been discriminated against in his time, he's had death threats, and he dates a white woman. Sounds like a Black guy to me!"

In one of the show's funniest sketches, Charlie Murphy shared the "True Hollywood Story" of his brother Eddie playing a surprisingly competitive Prince in a game of pickup basketball. In another version of the THS sketch, Chappelle appeared as soul singer Rick James, prone to declaring "I'm Rick James, bitch!" *Chappelle's Show* found another memorable parody in rapper Lil Jon, whose trademark "Yeeeeeeah" became a punch line.

By the end of the second season, *Chappelle's Show* had become so popular, Comedy Central renewed it for a third and fourth season. But Chappelle would not return for the hotly anticipated third round of his television show despite the $50 million contract he had signed. Overwhelmed with his skyrocketing fame and financial success, and unsure of whom to trust, Chappelle flew to Durban, South Africa, to reflect.

"I want to make sure I'm dancing and not shuffling," he told *Time* magazine, the first media outlet to report that Chappelle had gone to South Africa. "Whatever decisions I make right now I'm going to have to live with. Your soul is priceless." The first two seasons

of his show "had a real spirit to them," he says. "I want to make sure whatever I do has spirit."

One season 3 sketch that uneased Chappelle was a twist on the devil-on-your-shoulder scenario. The Black pixie, played by the host himself, wore blackface. Chappelle found the sketch funny, but his outlook shifted at the taping when a white spectator guffawed through the sketch. "When he laughed, it made me uncomfortable," Chappelle told *Time*. "As a matter of fact, that was the last thing I shot before I told myself I gotta take f— time out after this. Because my head almost exploded."

"I was doing sketches that were funny, but socially irresponsible," he later told Oprah. "I felt like I was deliberately being encouraged and I was overwhelmed. It's like you're being flooded with things and you don't pay attention to things like your ethics."

There's a poignant parallel in the ways Chappelle and Pryor walked away from the comedy shows they brought to television. "The minute you hear white people applauding you, you get all pissed at yourself because you think you ain't being black enough," Mooney recalled telling Pryor.

Chappelle would spend years away from the comedy scene, living with his family on his farm in Ohio before quietly returning to stand-up. When he reemerged for a more public comeback, the comedy scene would look much different.

"[Tiger Woods has] been discriminated against in his time, he's had death threats, and he dates a white woman. Sounds like a Black guy to me!"

—DAVE CHAPPELLE

Alfonso Ribeiro and Will Smith in
The Fresh Prince of Bel-Air.

7 '90s SITCOMS

A Different World premiered as a spin-off of *The Cosby Show* in 1987, kicking off a sitcom boom that has come to define Black television of the 1990s . Over the course of six seasons, it became a groundbreaking show in its own right. Originally intended as a vehicle for Lisa Bonet, who garnered a 1986 Emmy nomination for her role as Denise Huxtable on *The Cosby Show*, the series marked breakout roles for Jasmine Guy (Whitley Gilbert), Kadeem Hardison (Dwayne Wayne), Dawnn Lewis (Jaleesa Vinson-Taylor), Darryl M. Bell (Ron Johnson Jr.), and Cree Summer (Freddie Brooks).

Set at the fictional Hillman College, *A Different World* brought the rich culture of historically Black colleges and universities (HBCUs) to prime time. The series made Hillman—and its student hangout, the Pit—feel real. And it made generations of Black children and teens want to go to HBCUs.

A Different World also helped change the industry landscape when it came to shows with predominantly Black casts. More youthful and hip than the Black sitcoms that preceded it, *A Different World* helped set the tone for the slew of iconic sitcoms that premiered in the early to mid-90s.

Nineties Black sitcoms have a few things in common: charismatic lead characters, indispensable supporting casts, fire theme songs, meaningful guest stars, an annoying but hilarious neighbor, and at least one prominent cameo by an older Black sitcom or variety star or a scene-stealing supporting character.

The early '90s was a time of innovation and upheaval for American television, which had expanded just a few years earlier from the Big Three networks—ABC, CBS, and NBC—to include Fox, then a fledgling player in the entertainment industry, and what

the trades called "netlets": specifically, UPN and the WB (which would eventually merge to form the CW).

These less-established networks relied heavily on Black sitcoms—and the audiences they attracted. "[Black '90s sitcoms] either saved networks or they built networks," says Robi Reed, the casting director. "Once that happened, then they were kind of tossed to the side and then the money and the focus was put on the other shows that had predominantly white casts, producers, and writers. But what we always knew was that the talent was there."

A DIFFERENT WORLD

CREATED BY: Bill Cosby
STARRING: Jasmine Guy, Kadeem Hardison, Sinbad, Loretta Devine, Cree Summer, Lisa Bonet, Dawnn Lewis, Marisa Tomei, Jada Pinkett Smith, Mary Alice, Karen Malina White, Darryl M. Bell, Charnele Brown, Glynn Turman, Lou Myers
PREMIERED: September 24, 1987
EPISODES: 144

THE COLLEGE EXPERIENCE is an apt metaphor for *A Different World*, which took a semester or two to come into its own. Initially, the series revolved around Denise Huxtable's first year of college at Hillman, her parents' alma mater. With the Huxtables as lead-ins, *A Different World* was a ratings success, landing just behind its predecessor for the season. But producers and the network were unhappy with the show's first bow, which drew lackluster reviews from critics who openly doubted Bonet's ability to carry the show and found it "listless" (Associated Press) and unfunny.

Debbie Allen, who helped *Fame* find an audience in syndication as choreographer and occasional director, was brought in to overhaul the show in the lead-up to its second season. She quickly learned that Bonet—pregnant with her first child after marrying rocker Lenny Kravitz—would no longer be the show's star. (Cosby had ruled firmly against a pregnancy storyline for *A Different World*, telling Allen that

"Lisa Bonet is pregnant. Not Denise.") Bonet returned to *The Cosby Show* on a recurring basis as a married college dropout. Marisa Tomei, who had signed on to play Bonet's roommate (and one of the few white students at Hillman) was also leaving to pursue film projects.

Allen pored over tapes of the first season's episodes, taking notes on what she liked and what she didn't. It helped that Allen, a graduate of Howard University, had gone to an HBCU herself. "I felt the show needed to be upgraded to a more mature level of talking and thinking. We couldn't have done a show about young people that didn't deal with the things going on in this country," she told AP Television writer Jerry Buck. "Teenage pregnancy, student uprisings, voting and other issues."

Allen added characters, including Freddie (Cree Summer) and Kim (Charnele Brown), and shifted the focus to the show's ensemble cast—particularly Dwayne and Whitley, who had emerged as fan favorites from the uneven first season. ("It was the first time we've had such characters on TV," Allen told the *Washington Post*.) Allen toned down the makeup and hairstyles so that Hillman's coeds

Whitley and Dwayne, portrayed by Jasmine Guy and Kadeem Hardison, became the focus of *A Different World* after the first season.

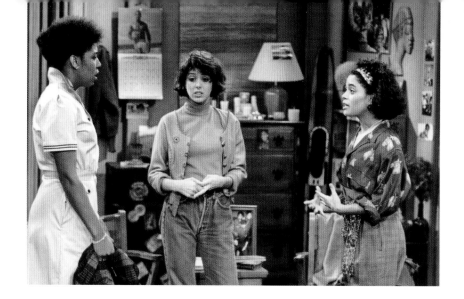

would look "more like real people." She sent writers to Spelman and Morehouse so they could talk with students and observe the culture at two of the country's most prominent HBCUs.

Aretha Franklin's soulful rendition of the show's indelible theme song (which, fun fact, was cowritten by Lewis), heralded the new and improved *A Different World*. (The first season had opened with Phoebe Snow's folksy version of the show's indelible theme song.) Producers had planned to debut new takes on the theme with every new season, but that idea was largely moot after Franklin took on the song. (Boyz II Men sang an updated version for the season 6 opening credits.) With Allen at the helm as both producer and director, *A Different World* took on an authenticity it had previously lacked. The series tackled social issues ranging from the AIDS epidemic to intimate partner violence to apartheid. Characters were given more depth. Guest stars—from Jesse Jackson to Whoopi Goldberg to Lena Horne to Diahann Carroll (in a recurring role as Whitley's mother, Marion)—became more pointed. And by the third season, Whitley and Dwayne had emerged as the show's most ship-worthy potential couple. Several seasons of will-they-won't-they ensued, leading up to one of the show's most memorable moments—when Whitley leaves her fiancé Byron (Joe Morton) at the altar for her true love: *Dwaaaaayne.*

Dwayne and Whitley began the sixth season as newlyweds. But *A Different World* hadn't forgotten its mission amid the romantic

The pilot of *A Different World* featured Dawnn Lewis, Marisa Tomei, and Lisa Bonet. Tomei and Bonet left after the first season.

development. The season 6 opener premiered months after the Los Angeles riots that began in April of 1992 following the acquittal of four Los Angeles Police Department officers who had been charged in the videotaped beating of Rodney King.

The show's writers and producers agreed they had a responsibility to address the uprising even as network executives initially balked at the idea. After some back-and-forth, Allen hinted that Black community leaders might protest if they felt the network had "stifled" the show's voice. "People are waiting to see how we deal with this just like they're waiting to see how *Murphy Brown* is going to deal with Dan Quayle," writer Susan Fales (now credited as Susan Fales-Hill) told the *Los Angeles Times.*

The show's social consciousness came into full view as Whitley and Dwayne recounted watching the riots unfold during their honeymoon in LA (also the title of the two-part episode). The fall 1992 TV schedule was full of riot-related plotlines—even young Doogie Howser, MD (Neil Patrick Harris), grappled with a city in chaos.

"That subject—not just the riots, but why the riots broke out—was very real for us," Guy told the *Washington Post* in 2017. "I was proud that we were able to address issues … that were affecting young people all over the country, and that are now still affecting us."

Sinbad was a series regular in seasons 2 to 4 playing Coach Walter Oakes.

A Different World had tangible effects on both the entertainment industry and its young audience. The series nurtured several writers

who would go on to create and produce their own TV and film projects, while mentoring the next generation of TV scribes: Fales-Hill, Yvette Lee Bowser, Gina Prince-Bythewood, and Reggie Rock Bythewood. Lena Waithe, whose work we'll talk about in upcoming chapters, named her production company Hillman Grad in honor of the fictional HBCU.

To this day, *A Different World* is credited with increasing applications and enrollment at historically Black colleges—and not just anecdotally. The series was cited as helping inspire an HBCU "renaissance" in the early '90s.

Decades after *A Different World* went off the air, Guy told the *Washington Post* she regularly heard from fans who said they went to college because of the NBC series. "That really moves me," she said.

FAMILY MATTERS

CREATED BY: William Bickley and Michael Warren; developed by Thomas L. Miller and Robert L. Boyett
STARRING: Jo Marie Payton, Reginald VelJohnson, Rosetta LeNoire, Darius McCrary, Kellie Shanygne Williams, Telma Hopkins, Jaleel White, Jaimee Foxworth
PREMIERED: September 22, 1989
EPISODES: 215

Family Matters centered around the Winslows, a multigenerational family living in the suburbs of Chicago.

IN THE FALL OF 1989, ABC introduced a new sitcom about a Black family living in a Chicago suburb. The Winslows were a middle-class family: dad Carl (Reginald VelJohnson) was a police officer; his wife, Harriette (Jo Marie Payton), an elevator operator at a local newspaper. The couple shared three children: Eddie (Darius McCrary), Laura (Kellie Shanygne Williams), and Judy (Jaimee Foxworth). Rounding out the Winslow residence was Carl's mother, Estelle (Rosetta LeNoire), and Harriette's widowed sister, Rachel (Telma Hopkins), and her young son, Richie (Bryton McClure, for most of the show's run).

Though *Family Matters* would become synonymous with the Winslows' nerdy neighbor, Steve Urkel (Jaleel White), the sitcom was

built around Payton's Harriette, who first appeared as the sharp-witted elevator operator on *Perfect Strangers*.

As producers prepared to cast the spin-off, they brought in several actors to audition for the part of Harriette's husband, Carl. One of them was VelJohnson. Payton hadn't seen *Die Hard*, which starred the actor as a Los Angeles police sergeant. But from the moment VelJohnson walked in, Payton says, "I just knew he was the one." The feeling was apparently mutual: "We never had an argument or anything on the set," VelJohnson told *Entertainment Tonight* of his rapport with Payton. "Not once, not ever!"

Early *Family Matters* episodes revolved mainly around the Winslows and their multigenerational family. It was typical sitcom fare: a mix of silly, sappy, and, occasionally, poignant plotlines. In one memorable episode, Laura sells a family heirloom, prompting her grandmother to explain that the quilt Laura relinquished maps out the only record of their ancestors. The exchange doesn't directly reference their family history as being lost to generations of slavery but the scene has gravitas. (The B plot revolves around Rachel's less-than-stellar efforts to take up the saxophone.) When Laura discovers that the woman who bought it is an art dealer selling her family's priceless heirloom for ten times its yard sale price, she tearfully explains what the quilt means to her family and convinces the curator to give it back.

It wasn't until the next episode—halfway through the first season—that Steve Urkel, the cheese-loving, suspender-wearing polka enthusiast, was introduced (though the character appears earlier in syndicated episodes and on streaming). White was twelve years old, with a few credits—including the short-lived *Charlie & Co.* and an episode of *The Jeffersons*—to his name when he auditioned for a guest spot on *Family Matters*.

Family Matters introduced Urkel in "Laura's First Date," in which Carl and Harriette disagree on whether to allow thirteen-year-old Laura to start dating ahead of a school dance. Urkel appears in a scene that quickly establishes him as a middle school pariah, literally shoved aside by other students, and rumored to have once eaten a mouse. When Laura quickly rebuffs his request to take her to the dance, he

walks away only to return with a line he hopes might change Laura's mind: "Did I mention my dad knows Wayne Newton?"

Urkel was an instant hit with viewers, earning White more and more airtime until he was the show's main draw. The studio audience routinely cheered, "Urkel!" *AdWeek* attributed an 8.8 percent ratings increase to the addition of "the bizarre, accordion-playing kid next door." By 1991, Urkel-mania had inspired a board game and a Hasbro doll in the character's likeness. A series of crossover appearances tucked into ABC's iconic Friday night TGIF lineup prompted *Dallas Morning News* TV critic Ed Bark to suggest, in a spicy column, various ways the character could be incorporated into any and all ABC programming (On *Coach*, Bark suggested, Urkel's "unique swivel-hipped walk" could be "copied by the team's third-string halfback, who suddenly becomes a more elusive open-field runner than Emmitt Smith.")

"Even though he's clearly a nerd, he's not the everyday, average picture we get of the guy with the pocket protector who walks around talking about math problems all the time," a fourteen-year-old White told the *Chicago Tribune* in 1990. "He's not boring! He has flair! This nerd really has flair! He likes cheese, he likes bugs, he likes computers, he likes Laura. He really likes Laura!"

Steve Urkel's constant pursuit of Laura Winslow feels very uncomfortable today.

Let's talk about that, shall we? Urkel, prone to inadvertent destruction (the *Family Matters* set semiregularly resembled the aftermath of a demolition derby following Steve's entrances or exits), was presented as a nuisance to the Winslows, particularly Laura, whom he attempts to woo in nearly every episode. It was played for laughs, of course, as Steve climbed up the tree conveniently outside Laura's window, crooning *"Feeeeelings"* in his high-pitched voice, for a late-night serenade. But of all the things that hold up about *Family Matters* (the Winslows clearly love each other, for one), Urkel's incessant efforts to court his neighbor isn't one of them. It's honestly a little creepy.

Payton still gets the inevitable question: How does she feel about Urkel becoming the show's breakout character? She often reminds fans that she, too, broke out of another show.

"It happens the same way it happened with Fonzie [on *Happy Days*] and some of the others," Payton says. "But when it's a Black show, an African American show, there seems to be a double standard as to how we look at things and how we compare people to each other, which I think is unfair. But, you know, when we're out there like that, we're fair game."

Jaleel White's breakout performance as Steve Urkel caused some tension on the set.

It's no tightly held secret that Urkel's popularity caused tension on the *Family Matters* set. White has publicly said he felt unwelcome by the cast. Meanwhile, his costars have alluded to White's behavior being affected by having to navigate sudden and unexpected fame as a teenager. Working with White could be "a challenge," VelJohnson told *ET* in 2022. "There were some moments when he was a little difficult, but overall I have nothing but good memories." Even Payton, who recalled White wanting to "physically fight" her in a particularly volatile moment, acknowledges that Urkel's presence helped elevate the show.

"It's like a soup. You could be making a soup and have all the best ingredients in the world in that soup. But if you don't put a little salt in there, it won't bring out the rest of it," Payton says. "I felt like he was the salt that we needed—that other thing."

"But then," she adds, sounding like the thoughtful Harriette, "maybe not because, you know, people like what they like."

On top of the show's noticeable change in direction, the cast of *Family Matters* also battled producers and the network on certain decisions.

Payton was particularly dismayed when the Winslows' youngest child, daughter Judy, quietly disappeared in the show's fourth season. "The way that it was presented to me was, 'She's no longer with the show. We made that decision and don't ask about it,'" Payton says. It sent a disturbing message to Payton, who says it would have been easier to process had the character died.

"That felt like my first Black Lives Matter moment. You tore a family apart and it did not matter to you," she says. "You didn't even ease [the character] out, you just sent her upstairs and she was gone and you wanted people to forget about her." Worse, Payton says, after Judy's abrupt and unceremonious departure, the Winslows effectively adopted Urkel and—in a later season—literally adopted a street-smart youth named Jerry Jamal Jameson (Orlando Brown) aka "3J" Winslow.

There were also script issues that highlighted blind spots among the show's largely white writing staff. "I had an issue with them having Urkel spit in my sink," Payton says, referencing a plot point that anyone with a Black grandmother knows is a no-no. "I said, 'We

The sudden departure of Judy Winslow played by Jaimee Foxworth, right (seen here with Bryton James, Kellie Shanygne Williams, and Rosetta LeNoire), upset the cast and perplexed the audience.

don't spit in our kitchen sink. He's our neighbor. He's somebody else's child.' It was just such a sign of disrespect."

Felicia D. Henderson, who has written for *Sister, Sister*; *Moesha*; and *Empire*—in addition to creating BET's *Soul Food*—was one of few Black writers on staff, which she joined as an apprentice in 1994. Speaking to the *Atlantic* in 2021, Henderson recalled pushing back on an episode that found Carl questioning whether Eddie could have been racially profiled by his fellow officers. The episode is memorable for the rousing speech Carl gives at the end, threatening to have his colleague's badge. But Carl's initial reluctance to believe his son, a Black man, could be racially profiled didn't feel true to life. Henderson told her colleagues that "no Black father would tell his Black son that." Instead of taking the note, "the room got silent" and Henderson sensed that the white showrunner was offended. "It was clear in the room and in the moment that I had offended them," Henderson told the *Atlantic*'s Hannah Giorgis. "Like, 'What, are you saying—we're racist?' No, but I *am* saying that's not realistic."

For Payton, things came to a head when the cast read a script that found Urkel greeting an elderly uncle with "Hi, Uncle Cornelius, how's the baboon heart? Don't let me catch you hanging off any chandeliers!" The character was known for goofball one-liners but

Payton took offense at the implication that a Black man would have the heart of a nonhuman primate. When the line remained after a rewrite, Payton was angry. But she "lost it" after overhearing two producers joke that they should "put a banana in his hand."

"That was it for me," Payton recalls. She told VelJohnson what happened and urged him to "go over there and straighten that out right now, because if you don't I'll take the ceiling off this place."

Payton eventually left the show halfway through its ninth season—which moved the show to CBS amid declining ratings— only staying on as long as she did so that producers could cast a replacement (Judyann Elder eventually claimed the gig).

It's somewhat ironic that Urkel makes his universe-altering appearance in the episode following "The Quilt," which gets to the heartbeat of the Winslow household. After decades of Black family portrayals that reinforced harmful stereotypes, *Family Matters* introduced Black characters that rejected long-standing tropes *and* felt like real people, a combination that seemed more mutually exclusive than it should have in the early '90s. Carl was an engaged father who was openly affectionate with his wife and children. And despite his love-hate relationship with Steve, he became a trusted father figure to his neighbor, whose own parents weren't particularly fond of him. Urkel's nerddom, in and of itself, countered the stereotype of the cool Black dude (even if Stefan Urquelle, Urkel's smooth, scientifically created alter ego, played directly into the trope).

Despite the drama that unfolded on the *Family Matters* set, Payton is proud of her time on the show and of the beloved TV family she helped create. "We were about doing good TV, good family TV with a message to it," she says. "Every show had a message to it. It had something for everybody."

She still hears from fans who tell her how much *Family Matters* meant to them. One piece of feedback sticks out in her mind: A white man recalled coming home to find his children watching *Family Matters*. He began yelling at them to turn it off before realizing he was watching it too—and enjoying it. He softened. "This is the only show you can watch," he told his children.

THE FRESH PRINCE OF BEL-AIR

CREATED BY: Andy and Susan Borowitz

STARRING: Will Smith, James Avery, Janet Hubert (seasons 1–3), Daphne Maxwell Reid (seasons 4–6), Alfonso Ribeiro, Karyn Parsons, Tatyana Ali

PREMIERED: September 10, 1990

EPISODES: 148

NOW THIS IS A STORY all about how a rapper grudgingly auditioned for a sitcom at a swanky party, proved his skeptics wrong, and became a superstar....

The Fresh Prince of Bel-Air is a classic fish-out-of-water story—and so is the audition that made Will Smith the star of the now-iconic sitcom. As Smith recounts in his 2021 memoir, *Will,* he was feeling out of place when he showed up to a lavish birthday party Quincy Jones was throwing at his Bel-Air mansion in March 1990. Among the stars at the bash were the top two executives at NBC Entertainment: president Brandon Tartikoff and his successor Warren Littlefield. As Smith tells it, the legendary producer—who was celebrating both his fifty-sixth birthday and the career achievement award he had received at that evening's Soul Train Music Awards—put him on the spot by suggesting he audition for a sitcom NBC was planning for the fall. Jones had already signed on as executive producer of the show, which was loosely based on the life of another guest at the party: record executive Benny Medina.

Jones urged Tartikoff and Littlefield to "come meet the Fresh Prince" before asking other guests—including Stevie Wonder, Lionel Richie, and Steven Spielberg—as well.

Reading Smith's memoir, in which he recalls brief excitement at the prospect of seeing a live audition (followed by the horror of realizing he's the one who will be under the spotlight), you can almost picture this exact scenario happening to the fictionalized version of Smith on *The Fresh Prince of Bel-Air.* He looks at the camera—eyes wide, famously prominent ears at attention—in one of the show's trademark break-the-fourth-wall moments.

Just a few months before his audition for *Fresh Prince,* in the

Uncle Phil and Will, played by James Avery and Will Smith.

winter of 1989, Smith was known as the rapper who lamented "Parents Just Don't Understand" alongside DJ Jazzy Jeff, in a breakout collab that won the first-ever Grammy for Best Rap Performance. A follow-up proved less popular, and Smith, who had spent his new money with reckless abandon, found himself broke and in major debt with the Internal Revenue Service.

Smith had met Medina during a taping of *The Arsenio Hall Show*, where he appeared at the suggestion of his then-girlfriend who had tired of Smith laying around the house licking his wounds. Medina told him about the show he was producing with Jones, and Smith showed polite interest. He didn't consider himself an actor but obliged when Medina suggested he meet Jones.

That's how Smith wound up at Jones's star-studded party. In *Will*, he recalls how Jones convinced him it was now-or-never time to impress NBC brass while they had their undivided attention. Smith took ten minutes to prepare for the impromptu audition, which earned him cheers and applause. And by the time he left Jones's festivities, he had a sitcom deal in hand.

––––––––––

Within months, Smith was on the set of his new sitcom, where he met the actors who would portray his on-screen family: James Avery played Philip, the Banks family patriarch married to Will's maternal aunt, Vivian (Janet Hubert). The couple lived in a tony Bel-Air mansion with their three children: Hilary (Karyn Parsons), Carlton (Alfonso Ribeiro), and Ashley (Tatyana Ali). The Cosbys were well off, but the Bankses were *wealthy*, with a Black (!!) butler named Geoffrey (Joseph Marcell).

The cast, by all accounts, had instant chemistry. "We connected from the very beginning. We just clicked," says Parsons. "We were a family."

Ahead of its September premiere, the network was so excited about its hip new sitcom that Tartikoff, then chairman of NBC Entertainment Group, joined Smith for a rap at the annual press tour touting the season's newest series. *The Fresh Prince of Bel-Air* was based on a period in Medina's life when he moved to Bel-Air from his native Watts. But the story was remixed to more closely resemble

Smith's upbringing in West Philadelphia, which helped make Smith, the novice actor, more comfortable in front of the camera. Smith had done the obligatory guest role circuit, reading for spots on *The Cosby Show* and *A Different World*, but told the *Baltimore Sun* he "always managed not to be there," during auditions. "Subconsciously, I was scared," he said.

But *Fresh Prince* was different. "With this, I said, 'I'm just going to shoot for it,'" he said ahead of the premiere. "Because the character is me, I get to be myself and that's what's so good for me. The person that my fans will see on stage and hear on the records is the same person that they'll see on television Monday nights."

While *The Fresh Prince of Bel-Air* centered on Smith's character, the show was anchored by its ensemble cast. In some ways, the Bankses were the most dynamic Black family yet to hit prime time in the early '90s. Will had little in common with his cousin Carlton, a card-carrying Young Republican who dressed like a Ralph Lauren mannequin and loved Tom Jones, or the Bankses' elder daughter, Hilary, who was spoiled, ditzy, and unapologetically vain—fashionable proof that Black Valley Girls were a thing. Will more immediately bonded with Ashley, the effortlessly cool preteen who grew up on the series. And although Avery's Uncle Phil was conservative and often at odds with his freewheeling nephew, he and Vivian had a history of civil rights activism, including a radical stint in the '60s when Philip was known as Olufemi and Vivian used the name Adesimbo. (You may remember that they also got down on *Soul Train*.)

The cast's easy chemistry was evident on-screen.

In early episodes of *Fresh Prince*, Smith can often be seen mouthing his costars' lines ("That was my first time, like, really doing dialogue," Smith confessed during the reunion special. "I learned everybody's.") The budding actor took cues from his costars, a mix of raw and under-showcased talents. Avery was a Shakespearean-trained actor who had played recurring roles on *Amen* and *L.A. Law*, in addition to voicing Shredder in the animated *Teenage Mutant Ninja Turtles*. Hubert had performed on Broadway before appearing on a handful of TV shows, including *Tales from the Crypt* and *Coach*.

The series marked a breakthrough role for Ribeiro, who got his start as a child actor on *Silver Spoons*. Ribeiro, who had danced alongside Michael Jackson in a 1984 Pepsi commercial, brought a physical comedy that was unmatched by anyone save for Smith—who became his comedy partner of sorts over the show's run and who was prone to exaggerated strides and turns in his character's goofiest moments. Ribeiro paired one of Carlton's signature moves—a happy-go-lucky dance dubbed "the Carlton"—with the Tom Jones hit "It's Not Unusual."

"For some reason this character just connected for me," Ribeiro told Larry King in 2018. "I knew who this guy was." In an alternate reality, the actor could have ended up on *A Different World*. In fact, Ribeiro has recalled passing on a role in the *Cosby* spin-off in favor of the *Fresh Prince* pilot. "My gut told me Will was going to be special," Ribeiro told Tamron Hall in 2021.

Parsons didn't know what to expect when she auditioned for the role of Hilary Banks, who was described as "a model type" and not much else. "She didn't do much and she just seemed kind of like a snob who came through and then was gone," Parsons says. "It didn't feel like a lot of *there* there." But Parsons had made friends (and at least one Los Angeles waiter) laugh at a random Valley Girl affectation she got a kick out of doing. She borrowed elements of people she knew: her cousin, a friend, and the wealthy Malibu girls she met while attending Santa Monica High School. That combination resulted in the character whose first line on the show was "Dad, I need three hundred dollars," delivered with all the nonchalance of someone who would spend all day looking for "the perfect pair of alligator pumps to wear to the Save the Everglades rally."

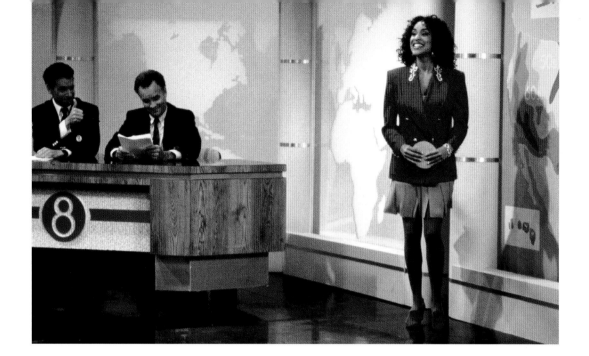

Parsons recalls that Jones was particularly amused by her take on the character. At her audition, he threw his head back and laughed, even slapping the table at one point. "I can't tell you how good that felt," Parsons says. She has a theory about why Hilary resonated with the producer. "Quincy, he's got like a ton of daughters," she says. "And so he just thought it was the funniest thing because I think he, as a wealthy Black man, with all these girls growing up in Bel-Air—I think he felt like 'I know that character' and he thought it was hilarious."

Tatyana Ali was just nine when she auditioned to portray the youngest Banks daughter, Ashley. "It was just an audition," she told VLAD TV in 2014. She had her first kiss with Tevin Campbell (another guest at Jones's fateful birthday party) in a first-season episode.

Hubert, meanwhile, stood out as the fiercely independent Banks matriarch, Vivian, a PhD professor of English literature. Long before Olivia Pope read her foes for filth, it was the elegant Vivian Banks who gave a dressing down like none other. When Will and Carlton get arrested in the episode "Mistaken Identity," Vivian is prepared to go to blows for her family, removing her earrings as she warns the clerk: "Oh, honey, we 'bout to get very busy up in here!"

In one of the show's most iconic moments, Hubert used her background as a dancer in a scene that found Vivian trying to

Karyn Parsons brought charm to the character of Hilary Banks, the spoiled eldest child of the family.

prove she still had "it" ahead of her big 4-0 in an intense class with younger women who doubted her ability to *werk* it. Aunt Viv looks overwhelmed as she watches the instructor demonstrate the routine choreographed to C+C Music Factory's "Gonna Make You Sweat (Everybody Dance Now)." But when the music drops, she masters every step, stunning the twenty-somethings, whom she quiets with a pointed snap of her fingers.

Hubert's departure, following the show's third season, was the elephant in the room during HBO Max's 2020 reunion special. "I couldn't celebrate thirty years of *Fresh Prince* without finding a way to celebrate Janet," Smith said. The former costars cleared the air in a pretaped segment that found Hubert confronting Smith in their first conversation in twenty-seven years. "I just wanted to know one thing: Why? You guys went so far," she said. "I lost so much. How do we heal that?" Hubert was rumored to have been fired from the show, but the actress said that she left after being offered a contract that cut both her episodes and pay. Hubert said the prevailing narrative—that she had been unprofessional on set— was untrue. And it hurt her career. "I lost everything. Reputation,

Rumors that there was tension on the set between Will Smith and Janet Hubert have circulated for years. It was finally addressed by the actors during HBO Max's reunion special.

everything," she told Smith. "I understand, you were able to move forward but you know those words, calling a Black woman difficult in Hollywood is the kiss of death. It's hard enough being a dark-skinned Black woman in this business."

"I was twenty-one years old," Smith said. "Everything was a threat to me...I was so driven by fear and jokes and comedy." The actor later called the exchange one of "the most healing experiences of my life."

When season 4 of *Fresh Prince* premiered in the fall of 1993, Daphne Maxwell Reid was introduced as the new Vivian Banks. The show briefly acknowledged the casting change when Jazzy Jeff deadpanned, "Mrs. Banks, you know ever since you had that baby, there's something different about you." Will, holding his new nephew, looks wryly at the camera.

"I had been asked to audition for the show when it first started and I chose not to because I didn't want to work with a young rap star doing a comedy," Reid says. "It just didn't resonate with me."

But that fall, Reid caught an episode of *Fresh Prince* and found herself thinking, "This is a really cute show. I like what they're doing." When her agent called three years later and said there was an audition available for the Vivian character, Reid "went out to LA and jumped in the pool of two hundred women who were vying for that job."

After landing the role, Reid says, "I walked into a loving environment. I was embraced by the cast." And she watched firsthand as Will Smith the rapper transformed into Will Smith the actor. "I thought he was very astute. He listened well. He always brought the same energy, whether it was rehearsal or performance. And he was able to discuss how he felt about things and grow with the new knowledge that he had."

———

From early episodes, *The Fresh Prince of Bel-Air* explored the tension between the Bankses' wealthy lifestyle and Will's West Philly upbringing. While the culture clash would often play for laughs, the show would occasionally examine class and race more seriously.

In the pilot, Philip chastises his nephew for not being able to "take anything seriously," and Will retorts that Philip has forgotten

where he came from. There's a moment in the episode when Philip overhears Will playing Beethoven's "Für Elise" on the piano and it's clear he realizes he misjudged his nephew.

Philip and Vivian freak out a few episodes later when Hilary falls for Will's hometown homeboy, Ice Tray (Don Cheadle), and Will confronts his family over their unwillingness to accept someone whose childhood so closely resembles his own.

But the show also made it clear that Vivian and Philip had worked their way to wealth and sometimes struggled to square their modest backgrounds with their privileged lives. Ahead of receiving a prestigious award, Philip tries to curate a newspaper profile about his life and accomplishments; he's embarrassed when Will (having discovered the reporter plans to kill the story because it's "boring") passes along the true story of Philip's childhood in rural North Carolina.

When Will gets a job ahead of his school's homecoming dance, it puzzles Philip, who gave him the money to pay for the event. "Nobody does anything without help, Will," Uncle Phil tells him. "People opened doors for me, and I've worked hard to open doors for you. It doesn't make you any less of a man to walk through them."

The *Fresh Prince* writing staff was largely white, but the show did employ prominent Black writers, including Larry Wilmore, John Ridley, and Felicia D. Henderson. The cast found a meaningful tradition in the weekly table reads, where they were encouraged to share feedback in an effort to make the show more authentic to a Black family.

"That was where I learned that what we do is not for us," Ali said during the *Fresh Prince* reunion. "We are here to bring dignity, to represent, to expand, to push forward." It was Avery, she said, who taught her that.

One of the reunion's most poignant moments featured the cast reminiscing about Avery, who died in 2013, and was beloved by his castmates. Avery helped Smith through the challenging scene that unfolds in "Papa's Got a Brand New Excuse," the season 4 episode that finds Will happily reuniting with his deadbeat father, Lou (played by Ben Vereen), only to be disappointed when his dad leaves yet again.

"I'm sorry, Will," Philip says to his nephew, who tries to pretend he's not upset. "Will, it's all right to be angry," Phil says. Will ticks off a list of everything he learned and accomplished without his father in his life. "I spent fourteen great birthdays without him and he never even sent me a damn card," Will says, voice trembling. "To hell with him!"

As Smith recalled on a 2018 episode of the podcast *Rap Radar*, he had struggled with the dramatic scene. "Relax," Avery told him. "It's already in there, you know what it is. Look at me. Use me. Don't act around me, act with me."

Will pledges to likewise get through college and start a career and family without his father, before falling into sobs: "How come he don't want me, man?" Uncle Phil envelops his nephew in a warm embrace as Will cries on his shoulder. The vulnerable moment

Will's father, played by Ben Vereen, returned to Will's life at the end of season 4, setting up an emotional scene between Will and Uncle Phil.

between two Black men, contemplating the tremendous significance of being a father, brought the sitcom to new emotional depths.

"While he's hugging me, he whispers in my ear, 'That's f–ing acting right there,'" Smith recalled on the *Rap Radar* podcast. "I wanted him to want me. I wanted him to approve of me."

Smith had personally requested Vereen do the scene. "You just like him," he told the *Hartford Courant.* "I thought that was very important to see in the character that plays Will's father, and to be able to see where Will got it from."

The scene holds up as one of the best moments on the *Fresh Prince* and in sitcom history. "It still takes my breath away," Reid says, "to see [Smith's] ability to be in that moment and to react honestly to that moment."

Three decades later, Uncle Phil remains one of the most adored TV dads in history. *"First things first, rest in peace, Uncle Phil / For real, / you the only father that I ever knew,"* J. Cole raps on his 2014 song "No Role Modelz."

In the final scene of *The Fresh Prince of Bel-Air*, Uncle Phil puts into words what viewers have come to understand over six seasons: "You are my son, Will," Philip says. "End of story."

ROC

CREATED BY: Stan Daniels
STARRING: Charles S. Dutton, Ella Joyce, Rocky Carroll, Carl Gordon, Garrett Morris
PREMIERED: August 24, 1991
EPISODES: 72

IT WAS A TYPICAL SITCOM SETUP: A pregnant woman goes into early labor and there's not a medical professional in sight, just a few men unqualified to do anything other than call 911 or pass out. That was the gist of the *Roc* episode that aired on February 9, 1992. But there was a twist.

The episode, which found Roc and his family inviting a homeless woman into their Baltimore rowhouse, was aired live. And the cast

of *Roc*, led by Charles S. Dutton as the titular garbage collector, was perhaps better suited than any other sitcom cast to pull off the feat. The cast was full of stage veterans: Dutton and Rocky Carroll, who played Roc's caddish brother, Joey, had earned Tony nominations in 1990 for their roles in August Wilson's *The Piano Lesson*. (Dutton had also been nominated in 1985 for a featured role in *Ma Rainey's Black Bottom*.) Roc Emerson and his wife, Eleanor (Ella Joyce), lived with Roc's father, Andrew (Carl Gordon), and had welcomed Joey in the episode's pilot.

Debbi Morgan played Linda, the homeless woman Joey invites in after he sees her digging through the trash in the back alley. "My husband got laid off a few years ago," she says in between bites of a sandwich. "He's been looking for work ever since."

"That's awful. I can't think of a more terrible situation for you to be in," Roc says just as Joey helps Linda out of her coat, revealing that she's pregnant. Spoiler alert: She goes into labor in the Emersons' kitchen—just as Eleanor, a nurse, is settling into a sleeping pill–induced rest prescribed by her doctor.

The episode, helmed by veteran director Stan Lathan, was *Roc* at its best—a mix of social commentary, sitcom hijinks (Andrew and Joey take a drowsy Eleanor for several laps around the family's living room in an effort to wake her), and the unpredictable thrill of a live performance. Early series, including *The Jackie Gleason Show*, were

Roc, which starred Charles S. Dutton and Ella Joyce as husband and wife Roc and Eleanor, tackled social issues in a typical sitcom format.

broadcast live but only one show—*Gimme a Break!*, featuring the great Nell Carter—had done a live broadcast in the interim decades.

When Linda's husband, Donald (played by *In Living Color*'s Tommy Davidson), arrives at Roc's house looking for her he learns that she's in labor. "That's great, I picked up a book on natural childbirth," Davidson's character says. "Do you have it with you?" Roc asks. "Man, I'm on the street," Donald says. "I got everything with me!"

After Eleanor finally wakes up, she's able to assist the EMTs deliver the baby in an upstairs bedroom. Downstairs, Linda's husband shares the shame he feels in not being able to provide for his family. "I can't go up there and look at another mouth I can't feed," he says. The men around him are incredulous.

"Hey, that's your wife up there, having your child," Roc says.

Donald replies that "this might be a blessed event" for them. "But I'm scared," he adds.

"Okay, you're scared," Roc says. "No offense, but maybe you should have thought of that before you got into this situation!"

"Oh yeah, you can talk. You got a house. You got a job. You got people who care about you. We don't *have that!*" Donald says. "The chips fell your way; they didn't fall my way." Davidson's performance offers a hint of the dramatic turn he would bring to the screen in Spike Lee's excellent (and perpetually underrated) 2000 film, *Bamboozled*.

The typical sitcom formula might have yielded a feel-good episode about the miracle of life and rebirth and second chances. But *Roc* was not a typical sitcom. It was a show that found its blue-collar protagonist grappling with the realities of life while trying to secure a piece of the American dream.

"Why do we allow this?" Roc asks after the episode takes a grim turn. "Why do we allow people to live in doorways and alleys?"

The episode earned high ratings—giving Fox another win just two weeks after *In Living Color* proved it could compete with the Super Bowl halftime show. And it served as a blueprint for the show's second season, in which every episode was broadcast live.

From its inception, *Roc* was praised by critics and often cited as one of the best new shows of the 1991–1992 TV season. Dutton,

Jamie Foxx (left) was a recurring cast member in seasons 2 and 3 as the Emersons' neighbor, Crazy George.

a real-life native of Baltimore, also happened to have a fascinating backstory as a Yale School of Drama graduate who had transformed his life after serving time in a Maryland penitentiary for convicted manslaughter.

Roc became known for tackling social issues that included poverty, drugs, interracial dating, teen pregnancy, and abortion. Twenty-eight years before *Empire* aired a milestone gay wedding, *Roc* featured Richard Roundtree (of *Shaft* and *Roots* fame) as Roc's uncle Russell, who stuns his family by informing them that he's gay and in an interracial relationship. Russell marries his partner (Stephen Poletti) in the episode "Can't Help Lovin' That Man," which GLAAD honored alongside *Roseanne* and an episode of *L.A. Law* in 1992.

Roundtree, who reprised the role in several episodes, later said he received "incredible" fan mail in response to "Can't Help Lovin' That Man." When Roc and Eleanor renewed their vows in a 1993 episode, Russell attended the ceremony with his husband. Roundtree said he took that role to counter Hollywood's tendency to typecast him as his suave, sexy (and very straight) *Shaft* character. Carroll, reflecting on the groundbreaking TV wedding in a 2015 interview with *Entertainment Weekly*, noted that Roundtree's casting was subversive in a way. "He was the epitome of 'a man's man,'" Carroll said. "He played our uncle who happened to be gay."

As a fledgling fourth network, Fox had the space to push the traditional boundaries of prime-time television. *Roc*'s live format had seemed to smooth some of the reservations Dutton had with the sitcom role—issues he discussed candidly in interviews. "I am a serious actor who fancies himself an artist. To some degree, it is hard to do these little one-line jokes at the end of the scene," he told the *Los Angeles Times* ahead of *Roc*'s premiere in 1991. "There are points where I want to disappear."

As *Roc* prepared to present its second season live, Dutton recounted how Spike Lee and Denzel Washington had attended the taping of the *Roc* pilot but left in the middle because "it was just too painful to watch Charles Dutton do a situation comedy."

Lathan, who directed a handful of season 1 episodes before taking on all of season 2 and 3, told *Newsday* that he had been

discouraged by prime-time TV offerings, but *Roc* had given him "newfound energy and purpose."

 Roc went back to conventional taping for its third season, which moved from Sundays to Tuesdays. Dutton was thrilled about the timeslot shift—he felt it incongruous that *Roc* would air between *In Living Color* and *Married with Children*. But he was firmly against the network's decision to introduce a child to the childless Emersons (a sitcom rarity), who had struggled with infertility in early episodes. The move was ostensibly the result of the schedule change as *Roc* now aired opposite ABC's *Full House*.

 "I didn't want a kid on the show. They wanted them on the first year, and I said no. I said you need a kid on the show in the fifth or

Dutton was against adding children to the show, but the network insisted. Alex Fields, right, played preteen Sheila for the third and final season.

sixth season when there's nothing else to do," Dutton told the *Times-Picayune*. "That's what made [*Roc*] special. Every other sitcom has kids. Cosby had 55 of 'em."

Roc ended up with two. The third season opened with a pregnant Eleanor and Roc preparing for the birth of their baby, born in a November 1993 episode, while also taking in the preteen Sheila (Alexis Fields) after her father (guest star Heavy D) went to prison.

"This was an adult show, a smart show," Dutton bemoaned ahead of a season that he said had been ordered, from on high, to be less topical. "I understand the business of television, the corporate world. It's just frustrating when the thinking is so stagnant."

Fox canceled *Roc* after three seasons, citing low Nielsen ratings, prompting fans to circulate petitions urging the network to put the show back on the air. "It's reflective of the forty-year history of television," Dutton told the Associated Press of the cancellation. "Black people are still confined to the buffoon zone, between eight and nine. If they dispute me, just watch television after 9 p.m. and count the number of black people you see."

Twenty-nine members of the Congressional Black Caucus signed a letter urging Fox cofounder Rupert Murdoch to reconsider. "The support for *Roc* has now manifested itself in a much greater struggle," wrote Brooklyn Democrat Edolphus Towns, then a representative for New York's Eleventh Congressional District. "The struggle is essentially about ensuring that networks do not paternalistically define what images will be projected of African Americans."

Towns later met with Murdoch, according to a *Newsday* report on the January 1995 meeting, where Towns noted that few Black households participated in the Nielsen survey that determined ratings at the time. "I don't know anybody black with a Nielsen box in their house," Towns told the Long Island–based paper.

Dutton also called the network's bluff for citing low ratings as the reason Fox canceled the show. "I just find it interesting that a show Fox always said couldn't find an audience was never showcased in order to gain one," Dutton told the *Chicago Tribune*.

MARTIN

CREATED BY: Martin Lawrence, John Bowman, Topper Carew
STARRING: Martin Lawrence, Tisha Campbell, Tichina Arnold,
Thomas Mikal Ford, Carl Anthony Payne II
PREMIERED: August 27, 1992
EPISODES: 132

ABOUT HALFWAY INTO the second season of his eponymous Fox sitcom, Martin Lawrence showcased the full range of his comedy in a scene that should be as iconic as Lucy and Ethel's conveyor belt shenanigans. And in some circles (like this book) it *is*.

The comic had asked for a real dog to feature in "Suspicious Minds," in which Martin Payne (Lawrence), a Detroit radio personality, discovers his new CD player (big '90s energy!) has been stolen. Martin spends a portion of the episode in a beige trench coat, complete with a detective's notebook, as he works his way through interrogating his and his girlfriend Gina's closest friends about his missing device.

The iconic scene arrives with a (literal) flash of lightning as the camera cozies up to Gina (Tisha Campbell) and their friends Cole (Carl Anthony Payne II), Pam (Tichina Arnold), and Tommy (Thomas Mikal Ford), all dressed in black and sitting around the table in

Martin centered around Martin Payne, played by Martin Lawrence, and his girlfriend, Gina, played by Tisha Campbell. It was one of Fox's highest-rated shows when it aired.

Martin's apartment. In the corner of the shot, a large, copiously fake black dog is visible, though no one acknowledges it. Martin, also dressed like a stagehand, emerges from the bedroom to greet his confused friends. "I'm setting my scene," he tells Gina when she asks why he'd asked them to assemble—during a thunderstorm, no less— dressed in all black.

"I have news about my CD player," Martin says, prompting everyone to get up from their seats. He tells them to sit down before unleashing one of the best burns in sitcom history: "Cole, sit your five-dollar ass down before I make change."

"I know who stole my CD player. And the person's in this room right now," Martin says, now stroking the fake, red-eyed dog. "Anybody want to tell me who?"

"Come on now. Don't you all speak at once," he adds before hurling the dog onto the table and improvising a few barks. He fully commits to animating the stuffed canine, dragging him by the collar as he paces around the table. It's at this point that you can see Ford struggling not to break character; it's a wrap after Lawrence instructs the dog to "lay" (because it falls down on "sit") causing Ford to visibly laugh. In *Martin: The Reunion*, a 2022 BET+ special that reunited the sitcom's cast, the scene was cited as a collective favorite, made all the more special following Ford's death in 2016.

Martin spoke to a generation that was unconcerned with respectability or appealing to white audiences. Critics derided the show as raunchy and silly but few reviewers (particularly those at mainstream outlets) seemed to grasp that *Martin* was part sitcom, part sketch comedy—the latter format giving way to his unique brand of physical comedy and memorable, if controversial, characters like Martin's neighbor Sheneneh Jenkins (played by Lawrence in 'round-the-way drag).

Martin also had prominent Black critics in the ever-moralizing Bill Cosby and even *Roc* star Dutton, who alluded to *Martin* while decrying "dumb" and "degrading" shows. But Dutton told the *St. Louis Post-Dispatch* his issue wasn't with "other black shows." "My beef is with the industry," he said. "The only thing I'm asking the industry to do is show balance and diversity of image."

It rankled Lawrence that other Black entertainers would publicly criticize him. Cosby had called *Def Comedy Jam*, which Lawrence hosted from 1992 to 1993, "a minstrel show."

"We can whisper in each other's ears, 'You know, there might be another way for you to do that,'" Lawrence told the *Chicago Sun-Times* in 1994. "But complaining about other black artists to the media—you're starting a whole other thing over here."

Four years before the *Friends* ensemble gathered at a gigantic window to discern whether the neighbor they had dubbed "Ugly Naked Guy" had kicked the bucket, Cole and Martin tried to figure out if Martin's plumber had died in the bathroom. Cole is hesitant to call 911 because of the optics: "A dead white guy in a Black man's apartment? Man they'll be blaming me! Then they'll be hauling me off to jail."

"Dead Men Don't Flush" aired in October 1992 on the heels of several prime-time TV episodes (including a two-part *A Different*

Lawrence played multiple characters on the show, including Sheneneh Jenkins, the outspoken owner of Sheneneh's Sho' Nuff Hair Salon.

World) that incorporated the Los Angeles riots. *Martin* acknowledged the trial—and its jury's noted racial disparity—with a subtle but shrewd riff: "Next thing you know I'll be on trial in Simi Valley, California," a panicked Cole says.

After the pair call for help, they wait for hours, alarming Gina and Pam, who arrive to go to a Pistons game with the group only to discover the apparently dead body in the bathroom. Martin eventually calls 911 pretending to be a white man and offers to prove it with a series of questions (well before this setup was a TikTok meme).

Gina, Pam, and Tommy fall into a *Family Feud*–esque formation on Martin's couch, clapping and saying "good answer" when they decide "America's favorite pie" is apple. "We're going to go with apple pie," Martin says with Caucasian conviction. Cole comes through in the clutch when Martin is asked to name two Barry Manilow songs but fumbles the game when he excitedly grabs the phone to report that "hot sauce" is what he puts on a sandwich.

———————

Martin was consistently one of Fox's highest-rated shows, and it remains a classic—full stop. It spawned catch phrases, including "Damn, Gina!" and "Martin" in the exaggerated way Payne says it in the show's theme song. In addition to his own characters, Lawrence curated a rotating cast of recurring guest stars from Tracy Morgan as Hustle Man to Tommy Davidson as DJ–turned–talk show host Varnel Hill.

Martin played host to a number of hip-hop artists as the genre was spreading in popularity: Notorious B.I.G.; Snoop Dogg; Outkast, who performed their debut single, "Player's Ball," in a 1995 episode (the title "All the Players Came" is a nod to the song's lyrics); and Method Man were among the rappers who appeared on the show. The sitcom also paid homage to veteran Black entertainers, including Marla Gibbs (who played an exacting housekeeper in a nod to her beloved *Jeffersons* character), Rudy Ray Moore (of *Dolemite* fame), and Isaac Hayes.

Despite being one of the most popular shows on Fox, *Martin* received little award show recognition outside of a few organizations known for catering to young, more diverse audiences, like the NAACP Image Awards and the Nickelodeon Kids' Choice Awards. The Emmy count for *Martin* is zero (it was never even nominated).

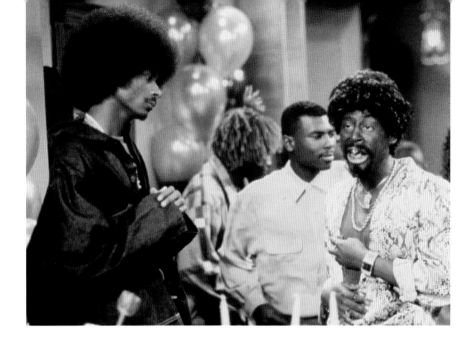

The lack of accolades smarts even more when you consider the enduring comparisons between *Martin* and *Seinfeld*, which has been widely recognized as culturally important since its nine-season run began in 1989.

An interlude at the end of Logic's 2017 song "Black Spiderman" asserts that *Martin* is "the Black Seinfeld." A more astute comparison is made in FX's critically acclaimed miniseries *The People v. O.J. Simpson: American Crime Story*. In an ostensibly fictional scene, the jurors for the closely watched murder trial are divided over whether to watch Lawrence's sitcom or Jerry Seinfeld's, with most of the pool split across racial lines.

Equating *Martin* to *Seinfeld* is a somewhat lazy comparison, though they take place in similarly heightened reality. (Consider that Martin Payne's apartment prominently displays a poster of Spike Lee's 1989 film *Do the Right Thing*, which marked Lawrence's feature film debut.) It's not a stretch to say they both had and continue to have influence on popular culture.

Martin was also a launching pad for prominent Black writers, including *Fresh Prince* alum John Ridley (who penned the episode featuring the fake interrogation dog) and showrunner Bentley Kyle Evans, who went on to create *The Jamie Foxx Show* with the *In Living Color* alum.

Martin hosted many celebrity guest stars, including hip-hop artists like Snoop Dogg (left), who shared scenes with another one of Lawrence's characters, Jerome.

LIVING SINGLE

CREATED BY: Yvette Lee Bowser
STARRING: Queen Latifah, Kim Coles, Erika Alexander, T.C. Carson, John Henton, Kim Fields, Mel Jackson
PREMIERED: August 22, 1993
EPISODES: 118

..

A FEW YEARS INTO *Living Single*, Yvette Lee Bowser's beloved comedy about six twenty-somethings and their lives in (pre-gentrified) Brooklyn, Queen Latifah began seeing a pair of billboards on her way to work at the Warner Bros. studio lot in Burbank, California. As Greg Braxton wrote in the *Los Angeles Times*, "One of the billboards showed a full view of the cast members of *Friends*; the other featured several much smaller pictures of other Warner Bros. shows placed against a backdrop of blue sky—including one, barely visible from the street, of the cast of *Living Single*."

"It just pisses me off every time I see that *Friends* billboard and the little piece of our billboard," Queen Latifah told the newspaper. "I mean, how much more of a push do they need?"

Living Single introduced four upwardly mobile Black women with distinct priorities and passions. Queen Latifah, who had acquired a few acting credits (such as *Juice* and *House Party 2*) by way of her pioneering rap career, played Khadijah James, editor-in-chief and publisher of the grassroots *Flavor Magazine*. Kim Coles, who left *In Living Color* after one season, starred as her delightfully quirky cousin (and assistant) Synclaire James. Khadijah and Synclaire lived in a Brooklyn brownstone with Regine (Kim Fields)—a boutique buyer with bougie taste—and frequently entertained their unofficial roommate, attorney Max Shaw (Erika Alexander).

A theme of Black excellence emerges from the very first episode: Outside of the office, Khadijah cycles through apparel paying homage to HBCUs—a Howard sweatshirt, in a nod to the character's alma mater; in another scene, she wears an African American College Alliance T-shirt.

Alexander, then known for her role as Cousin Pam on *The Cosby Show*, quickly established herself the show's MVP. "Today my look and

my law were fierce!" she says, strutting into the brownstone in a crisp magenta suit. "I got my client the house, the Winnebago, alimony, and 70 percent of all the assets he tried to conceal."

The sitcom was rounded out by John Henton as the sweet handyman Overton (and love interest to Synclaire), and T.C. Carson as Kyle (Max's love-hate interest). Nothing like *Living Single* had graced television screens when the show premiered in August 1993—a full year before *Friends* landed opposite *Living Single*'s 8 p.m. timeslot on Thursday nights. And the show was an instant hit.

There's a very strong argument that *Friends*—the billboard and the show—would never have existed without *Living Single*. Over the years the story has been tossed around like some sort of Hollywood legend, but it's a fact that Warren Littlefield, then head of NBC Entertainment, recognized the genius of *Living Single* well before his network greenlit *Friends*.

Recapping a 1993 seminar held by the Hollywood Radio and Television Society—and attended by execs from all the TV networks, as well as members of the press—the *Hollywood Reporter*'s Lisa de Moraes noted that when "asked to pick a new show from

Erika Alexander, Queen Latifah, Kim Fields, and Kim Coles starred in that *other* show about singles living in New York (and premiered a year before *Friends*).

another network that each would like to have—a question that has become a staple of this annual event—Littlefield picked "[Fox Broadcasting Company's] *Living Single,* which he said he'd schedule Monday after *The Fresh Prince of Bel-Air* in order to move *Blossom* to another night."

Hollywood is cyclical, so it's not shocking that NBC would try to recreate the success (or template, for that matter) of a popular show. But the particular optics were unsettling: *Friends* and *Living Single* were both produced by Warner Bros.—filmed on that very same lot in Burbank—but it was the one with six white New Yorkers that got the big billboard promotion.

"Fox takes our audience for granted. They feel our core audience is already there," Bowser, the first Black woman to develop her own series, told the *Los Angeles Times.* "We've been renewed for two seasons, and we're definitely going into syndication, so it's like they don't have to worry about us. It's unfortunate. My major problem is with promotion at the network level."

Living Single wasn't the first (or last) Black show to feel abandoned by Fox (see: *Roc* and *In Living Color*). And the network, for its part, wasn't always subtle about its strategies. "Sure, we use black shows to hook the hip white audience," Fox Entertainment president Sandy Grushow told *Newsweek* in 1993. "That's one reason we've become the cutting-edge network."

Erika Alexander (center) quickly established herself as a fan favorite playing the sharp-tongued attorney, Max Shaw.

Up against *Friends*, which had become a full-on franchise by the mid-90s, complete with coffee mugs, T-shirts, and other merch, *Living Single* slid in the Thursday night ratings before being canceled by Fox in the middle of its fifth season.

"I don't get canceling the show," Coles told the *New York Times*, which noted that *Living Single* was and remained one of the most popular shows among Black TV viewers. After *Living Single* aired its final two episodes (on New Year's Day, no less) in 1998, Fox appeared to give up completely on competing with *Friends*. That year, with each passing season, the network aired *World's Wildest Police Videos*.

Bowser, fortunately, wasn't finished making TV for the underserved audience that found representation in *Living Single* (we'll be talking more about her work in the coming chapters). And that audience didn't forget *Living Single* or the women it introduced.

When David Schwimmer, who played fan-favorite Ross Geller on *Friends*, suggested in early 2020 that perhaps "there should be a Black *Friends*," the internet was quick to inform him that, ahem, there was, though it predated the franchise that skyrocketed Geller and his costars to fame.

Friends was among the first '90s-era shows to end up on streaming (landing on Netflix in 2015 in a $30 million deal). It would take three additional years (and a fair amount of social media chatter) for *Living Single* to land on Hulu, where it would find new generations of fans.

The show was unceremoniously canceled in the middle of season 5. The cast and showrunners felt the network didn't do enough to support them.

Garcelle Beauvais and Jamie Foxx in *The Jamie Foxx Show*.

8 UPN AND THE WB

Dave Chappelle once famously ended a sketch with the WB's animated mascot, Michigan J. Frog, atop his shoulder crooning "Maaaaaammy" in full-throated mockery. "What? I can't make fun of that fucking frog?" the comedian said to uncomfortable groans (amid laughs and applause) from the audience of his eponymous Comedy Central show. "Fuck that frog. They don't be doing that on the white networks; as soon as [there is] a Black network—*ooon the double uuuuu beeeeeeeeee*," Chappelle imitated in a ragtime-y warble before adding, indelibly, "*I like chickennnnnn.*"

The bit acknowledged an uncomfortable truth about the WB, which entered the prime-time schedule in January 1995 alongside its main competitor, UPN. Within a few TV seasons, both networks had filled their schedules with sitcoms centered around Black characters. Prime-time

television enjoyed an explosion of Black comedies, with fresh premises and largely untapped talents as lead stars.

But at the same time, the Big Four networks (including Fox, now a major player) backed away from Black sitcoms. By the fall of 1996, only one major network (CBS) had a new series with a predominantly Black cast on its roster: the forgettable *Cosby*, featuring Bill Cosby and Phylicia Rashad as a(nother) married couple, this time navigating life in retirement. In many cases, the shows that the Big Four rejected or canceled too soon ended up on one of two networks: UPN or the WB.

The WB and UPN both helped further establish Black writers including Mara Brock Akil (creator of *Girlfriends* and *The Game*); Bentley Kyle Evans (creator of *The Jamie Foxx Show*); and Ralph Farquhar, Vida Spears, and Sara Finney-Johnson (the trio behind *Moesha* and *The Parkers*).

But that progress took on an ouroboros-like dynamic as the term "ghettoization," loaded for both industry execs and Black creators, frequently appeared in the trades and other news stories about the up-and-coming networks.

The optics grew even more fraught as the netlets launched their own original programming. Once series such as *Buffy the Vampire Slayer, Dawson's Creek*, and *Felicity* attracted viewers, these shows became the face of the WB (while the actors in their predominantly white casts enjoyed skyrocketing fame and all the perks that came with it). UPN, meanwhile, attracted loyal, underserved viewers with the likes of *Moesha*, its spin-off, *The Parkers*, and *Girlfriends*, but often failed to promote these groundbreaking series with the same zest reserved for its demographically different flagship series, *Star Trek: Voyager*.

SISTER, SISTER

CREATED BY: Kim Bass, Gary Gilbert, Fred Shafferman
STARRING: Tia Mowry, Tamera Mowry, Jackée Harry, Tim Reid, Marques Houston, RonReaco Lee, Deon Richmond
PREMIERED: April 1, 1994
EPISODES: 119

OUTSIDE OF FAMILY SITCOMS like *Family Matters* and *Fresh Prince*, there were few TV shows where Black children could see themselves as the focus of the storytelling in the early 1990s. After *Hangin' with Mr. Cooper* pivoted from its *Three's Company*–esque first season, the show welcomed Raven-Symoné as Mark Cooper's cousin, setting up a friend dynamic reminiscent of Rudy and Bud on *The Cosby Show*. But the series still revolved primarily around the character played by Mark Curry. The Smolletts (Jurnee, Jussie, et al.) starred in ABC's one-season 1994 sitcom *On Our Own*, in which they played siblings being raised by their eldest brother following the death of their parents. Later that season, Nickelodeon introduced *My Brother and Me*, which was co-created by Calvin Brown Jr. and Ilunga Adell (whom you might recall as a young writer on *Sanford and Son*). The

regrettably short-lived sitcom revolved around the youngest members of a North Carolina family—and starred a young Amanda Seales (of *Insecure* fame).

In 1994, ABC debuted *Sister, Sister*, starring Tia and Tamera Mowry as thirteen-year-old twins who were separated at birth and adopted by single parents. In the pilot, Tia Landry and Tamera Campbell end up at the same clothing store with their parents—Lisa Landry (Jackée Harry) and Ray Campbell (Tim Reid), respectively—and the gag, of course, is that Ray and Lisa keep mistaking the wrong twin for their child. The scene heightens to the inevitable moment when Tia and Tamera finally run into each other and deliver, in unison, one of the show's most quotable lines: "That girl has my face!"

Sister, Sister, starring Tamera and Tia Mowry, was groundbreaking in featuring two Black girls as its stars.

The scenario set up a sweet series about a uniquely blended family. Plotwise, it was your typical teen girl–centric sitcom: One episode revolved around Tia's efforts to get rid of a pimple ahead of a date; another followed the girls' scheme to break up Ray's budding romance out of fear they would be separated; in the season 1 finale, the twins sneak out of the house to see their favorite rapper Cold Dog (Flex Alexander). But the focus on two young Black girls was unprecedented.

Sister, Sister lasted for two seasons on ABC, before the TGIF bubble burst, giving way to a prime-time lineup that was quickly pivoting from the family-friendly TGIF set to more adult fare in the era of *Friends*, *Seinfeld*, and *Frasier*. Fortunately for fans of *Sister, Sister*, the show found a new home on one of the new networks in town: the WB.

Sister, Sister was a bellwether for the Black sitcoms that would come to define the latter half of the decade. For one, it led a spate of shows migrating from the Big Four networks to the WB or its main competitor, UPN. *Sister, Sister* and the slew of Black '90s sitcoms that followed also catered to the youthful demo that put those nascent networks on the map.

Sitcom veterans Jackée Harry and Tim Reid played the girls' adoptive single parents.

The season 2 premiere of *Sister, Sister* featured a plotline familiar to any real or fictional teenage girl: Feeling the pressures of high school

social hierarchy, Tamera wants a makeover and is thrilled when Lisa gets three certificates to a beauty salon. "I want to look just like that skinny white lady," Lisa says, thumbing through a magazine. "Except Black and beautiful," she adds with a smirk.

During their spa day, Tamera gets a sleek new blowout and Tia sticks to her tried and true curls and clear polish. Admiring their looks, Lisa says, "Ooh, we could be the new En Vogue," as the trio slides into formation. "*Never gonna get it, never gonna get it,*" they sing as Jackée belts out the climactic "*Whoo whoo whoo whooo.*"

Tamera's makeover is a hit at school, so much so that she becomes part of the racially diverse popular crowd. Tia, still on the outs and missing her sister, attempts to straighten her own hair—to disastrous results—with a boxed Just For Me relaxer (if you know, you know). The episode, "Hair Today," was culturally specific while driving home an age-old sitcom message: Beauty is only skin deep. "How many times do I have to tell you—looks aren't that important," Ray says as Tia comes running down the stairs with smoke rising from her frizzed-out hair. Lisa, at a loss for words, sprays her hair with the same bottle she uses to water the houseplants. "What am I gonna do, Mom, it looks terrible," Tia says. "No, no," Lisa counters. "It looks real HOT."

By the next episode, both Tia and Tamera were wearing their natural curls again. This was quietly revolutionary in the expanding universe of teen girl sitcoms, which in 1994 included NBC's *Blossom*, Nickelodeon's *Clarissa Explains It All*, and the short-lived *Someone Like Me* starring Gaby Hoffmann.

But even as *Sister, Sister* became an early success for the WB, Tia and Tamera Mowry were reminded that the industry had not been built for leads who looked like them. "When we were younger, it was wonderful being able to wear our natural hair. People were always like, 'Oh, you're so cute. We love your curls,'" Tia Mowry told *Elle* in 2021. But as she and her sister got older, it was a different story. "In this business, if I had my hair curly, I was told, 'Can you pull that back?'" Mowry added. "On auditions, I was told, 'It's distracting.'" By the fourth season premiere, both Tia and Tamera were wearing their hair straight.

Tia Mowry also recalled that when she and her sister asked to be on the cover of a well-known teen magazine (which she did not name), a publicist told them they "wouldn't sell" for mainstream teen publications. This was despite the fact that *Sister, Sister* garnered solid ratings its first season on ABC. By the time the sitcom landed on the WB, it had reached the bottom third of Nielsen's prime-time rankings. But it became the highest-rated offering on Warner Bros.' rookie network, with in-house research showing that *Sister, Sister* regularly drew more than half the teenagers watching television during the sitcom's timeslot.

By the later seasons the twins, who had been wearing their hair naturally, began wearing it straight.

"This magazine was a very popular teen magazine that had fashion, beauty, and was known for spotlighting what they thought was beautiful and what they thought was popular and hot at that time," Mowry said. "It had us navigating who we are as a person and what our value is as a person in this business. It gave us a lot of

insecurity. It made us feel like we weren't valuable in that space. Like we weren't valuable at all."

———————

In July 2020, Netflix announced that it had acquired *Sister, Sister* and six other '90s sitcoms with majority Black casts: *Moesha* and its spin-off, *The Parkers, One on One, Half & Half, The Game,* and *Girlfriends.* The move followed years of discourse about the lack of beloved Black sitcoms on streaming, especially compared to predominantly white sitcoms such as *Friends* and *Gilmore Girls* (both of which Netflix began streaming in 2015). Despite years of syndication, it wasn't until *Sister, Sister* and its WB and UPN counterparts came to a major streaming network that the entertainment industry at large seemed to acknowledge their importance.

These shows helped redefine TV narratives about young Black women, centering their stories instead of making them tangential to those of white characters. *Sister, Sister* followed its teen protagonists to college. For fans who had rallied for shows like *Sister, Sister* and *Moesha* to be on streaming, it was no surprise when the decades-old series crept into the streamer's top-ten rankings following their addition to the platform.

But for the show's stars, who filmed episodes across five years, its multigenerational appeal did come as somewhat of a revelation. "When I was doing *Sister, Sister,* I never thought of it that way," Tamera Mowry told *People* in 2020. "But now, watching it and seeing my kids watch it—and they love it—you're like, 'Wow, we really did hit gold there.'"

Reid, whose role as Ray Campbell etched him into the pantheon of beloved sitcom dads, admits he didn't fully appreciate how groundbreaking the series was in the mid-90s. "That show was a sleeper to me," he says. "I didn't give it much thought at all during the time that I was making it."

If he's being honest, Reid says, he's only seen about five episodes of *Sister, Sister.* "It never grabbed my creative spirit the way it should have—because it was worthy of it," he explains. "Looking back on it now and reading, more so, the response to it by people, I mean, I actually scolded myself."

"What I did take away from that was three people that I worked with that I will love dearly for the rest of my life. And they had a tremendous effect on me," Reid says, noting that he had initially underestimated his costar Jackée. "I thought she was a very arrogant, broad-acting person." But once he started working with her, he realized he had been wrong about the *227* star. "She is a consummate actor. She wouldn't let me get away with anything. She challenged me," Reid says. "She's probably one of the better actors I have ever worked with. I don't think people realize her depth and what she can do as an actress."

Tia and Tamera Mowry, he says, "changed my view of young people," Reid says. "They were not only talented but just *nice people.* There was never a day that they did not show a certain graciousness and a certain love for the blessing that they had been given. There was no arrogance. There was no child actor crap or anything like that—ever."

Love for his costars notwithstanding, Reid didn't realize what *Sister, Sister* meant to fans until a few years after the show ended. He was at an event in Houston when a young woman approached him. She had grown up in foster care, she told him, and had spent her childhood moving from one foster home to another—never staying longer than a year—though some years were better than others. She was in a rough period when she started watching *Sister, Sister,* and one day she decided that whatever Ray told Tamera she would take it as a life lesson for herself. "I've watched every show multiple times," the

Fans advocated for *Sister, Sister,* and other '90s sitcoms with Black casts, to be picked up by streaming services where they have proven to have multigenerational appeal.

woman told Reid. "I just want you to know that you raised a good daughter."

The woman shared that she was a college graduate and an artist. She was engaged to be married. And with that, Reid says, she gave him a hug and left. "I stood there stunned," he recalls. "I've known this, the power of television, but I went '*wow*'—that made me even more respectful for what we do and also why we have to have a bit more concern about the kind of messages we throw out there."

THE WAYANS BROS.

CREATED BY: Marlon Wayans, Shawn Wayans, Leslie Ray, David Steven Simon
STARRING: Marlon Wayans, Shawn Wayans, John Witherspoon, Anna Maria Horsford, Lela Rochon, Ja'net DuBois, Garcelle Beauvais, Mitch Mullany
PREMIERED: January 11, 1995
EPISODES: 101

THE WAYANS BROS. famously opened with a surreal sequence that showed protagonists Marlon and Shawn Wayans dressed like '70s sitcom stars, complete with bell-bottoms and globe-like afros, as they happily made their way down the front steps of a Harlem apartment building: *"We're brothers. We're happy and we're singing and we're colored,"* pipes the theme music, which builds to a jubilant piano riff. *"Give me a high five!"*

"All right, cut and print! Beautiful, guys. Dynomite!" an off-screen voice (ostensibly, a white sitcom director) says. Just as the director adds the trademark exclamation that made *Good Times* actor Jimmie Walker a household name, the scene abruptly changes: An elderly lady gets hit by a bus while crossing the street. The theme shifts to a snippet of A Tribe Called Quest's 1993 hit "Electric Relaxation," letting us know that Granny (who lands unharmed on a nearby bus bench) will be just fine.

The message could not have been clearer: *The Wayans Bros.* was not your grandmother's Black sitcom. And while the show would pay

tribute to *Good Times*—with a brash parody in its fourth season and a recurring role for Ja'net DuBois (known for playing Evans family friend and neighborhood gossip Willona Woods)—*The Wayans Bros.* would be very different from the sitcom that spawned J.J. Evans.

The Wayans Bros. premiered in January 1995 as part of the WB's inaugural lineup. The show revolved around heightened versions of the youngest Wayans siblings: Shawn and Marlon Williams were brothers navigating their early twenties in Harlem. John Witherspoon played their father, John Williams, a diner owner they affectionately called "Pops."

Shawn had appeared on *In Living Color* as the in-house deejay, SW-1; Marlon had appeared on the show's final two seasons. Witherspoon had followed his stint on *The Richard Pryor Show* with memorable roles in films including *Boomerang*, Robert Townsend's *Hollywood Shuffle* (cowritten by Keenen Ivory Wayans), and *Friday*. The comedian was the brothers' first and only choice to play Pops, as Shawn Wayans recalled following Witherspoon's death in 2019. NBC had reportedly passed on *The Wayans Bros.* over the Pops role—according to Shawn, the network had wanted Danny Glover to play his character's father. The WB picked up *The Wayans Bros.* for the network's debut.

The Richard Pryor Show alum John Witherspoon (left) was Shawn and Marlon Williams's first and only choice to play their father, Pops.

Critics were roundly unimpressed by the new network's offerings, but several reviews praised *The Wayans Bros.* as the most promising of its opening-night roster, where the sitcom aired ahead of Townsend's family sitcom, *The Parent 'Hood*, the dysfunctional family sitcom *Unhappily Ever After*, and the short-lived *Muscle*. Other reviewers expressed disdain for *The Wayans Bros.*, which had launched with a characteristically goofy episode that found Shawn and Marlon creating an unfortunate hair pomade that set guest star Gary Coleman's hair on fire.

"It's bad enough that blacks can't get the lead in dramas, that we're in the comedy ghetto of television," one critic wrote in the *Los Angeles Times*. "Must we then dig our hole deeper by acquiescing to do electronic minstrel shows?" Like Martin Lawrence, Marlon and Shawn Wayans faced harsh scrutiny that their white sitcom counterparts—*Seinfeld* doofus Cosmo Kramer (Michael Richards) and resident *Friends* dumdum Joey Tribbiani (Matt LeBlanc), for example—were typically spared.

By all accounts, the first season had some issues. *Season Finale: The Unexpected Rise and Fall of The WB and UPN* describes the cringe-worthy moment when the network's in-house premiere of *The Wayans Bros.* sparked reactions that one former exec described as

> The show's goofy humor was criticized, especially during the early seasons, even when white sitcoms with similar jokes were not.

"like someone had opened up an awful, smelly piece of cheese." It didn't help that the WB's Wednesday night lineup (which had the unfortunate distinction of airing opposite UPN's popular *Star Trek: Voyager*) ended its first season as prime time's lowest-rated shows.

Despite the show finding its footing in later seasons, *The Wayans Bros.* still had its critics. In 1997, several civil rights groups, including the Beverly Hills-Hollywood chapter of the NAACP, called out *The Wayans Bros.*, along with Fox's *Martin* and several other Black sitcoms, for reinforcing negative stereotypes. "I know comedy is comedy, but there's a fine line when people are laughing with you and people are laughing at you," Billie J. Green, then-president of the NAACP chapter, told the Associated Press.

Five years off the air, *The Cosby Show* was still the mainstream standard by which any and all Black sitcoms were measured. It was a double-edged metric: Next to the Huxtables, *The Wayans Bros.* would always be seen as bawdy, mindless slapstick. More family-oriented fare such as *The Parent 'Hood* could be dismissed as an unremarkable knockoff. Not even Cosby himself could escape the comparison when he starred opposite Phylicia Rashad (as Hilton and Ruth Lucas, respectively) in the CBS sitcom *Cosby*, which aired for four seasons following its 1996 debut.

But by the mid to late '90s, the TV landscape looked a lot different than it had when *The Cosby Show* began its run in 1984. The increasingly populated broadcast schedule gave viewers a multitude of options, including more shows with predominantly Black casts than ever before. *The Wayans Bros.* represented a new generation of sitcom creators, writers, actors, and viewers who were more inspired by Richard Pryor and Redd Foxx (and their de facto heir, Eddie Murphy) than by Bill Cosby.

The Wayans Bros. was unceremoniously canceled after five seasons. The WB cited the standard "low ratings" as the reason for the cancellation, but the caveat—as with *Roc* and *Living Single*—was that the show remained popular among Black viewers.

Shawn and Marlon Wayans would eventually laugh their way to the box office with *Scary Movie*, which they cowrote (with four other credited screenwriters), helping launch a multimillion-dollar

The brothers found success after the show was canceled without airing a final episode.

franchise alongside their brother, director Keenen Ivory Wayans. Shawn memorably shouts out the series in the 2000 parody film while his character Ray takes a sinister turn. "Watching television shows doesn't create psycho killers. Canceling TV shows does," Ray says while frantically stabbing another character. *The Wayans Bros.* was a good show, man," he adds in a wink-wink nod to the WB sitcom's cancellation ahead of what would have been its sixth season. "It was a good-ass show, and we didn't even get a final episode!"

THE PARENT 'HOOD

CREATED BY: Robert Townsend, Andrew Nicholls, Darrell Vickers
STARRING: Robert Townsend, Suzzanne Douglas, Kenny Blank, Reagan Gomez-Preston, Curtis Williams, Ashli Amari Adams, Carol Woods, Faizon Love, Kelly Perine
PREMIERED: January 18, 1995
EPISODES: 90

ROBERT TOWNSEND'S 1987 FILM, *Hollywood Shuffle,* was a sharp send-up of the entertainment industry's treatment of Black actors. One scene introduced a "Black Acting School" where Black actors could "learn Jive Talk 101," and how to "walk Black" from white instructors. The parody infomercial featured one alum who proudly reported that since graduating he had "played nine crooks, four gang leaders, two dope dealers," and "a rapist, twice."

Townsend and his cowriter, Keenen Ivory Wayans, drew from experience for *Hollywood Shuffle,* which Townsend (rather tellingly) produced without the backing of a major studio. Townsend thought he had been primed for a breakout after appearing in the 1984 film *A Soldier's Story*, which boasted a predominantly Black cast and was based on a Pulitzer Prize–winning play by the Black playwright Charles Fuller. But the actor was disheartened to find that he was still being offered stereotypical roles. "Robert, every year they do one black movie and you just did it," his agent told him.

He turned to commercials even though many of his fellow actors avoided appearing in advertisements because, as Townsend told the

New York Times following his directorial debut, "they think it's below their dignity."

"But I felt like at least in commercials I had dignity," Townsend added. "I was a bank teller for sixty seconds. It wasn't, 'Here's Clarence, the jive plumber, yo' what's hap'nin'?' It was, 'Mrs. Jones, look how clean your dishes are.' I was playing real people, not caricatures."

Ironically, it was *Hollywood Shuffle* that marked Townsend's breakout—as a versatile filmmaker who went on to direct the box office–breaking *Eddie Murphy: Raw*; *The Meteor Man*; and the 1991 classic *The Five Heartbeats* (another screenplay collaboration with Wayans), in which Townsend had a lead role.

By 1995, Townsend added TV sitcom creator to his résumé with *The Parent 'Hood*. The series centered around Robert Peterson, a New York University professor raising four kids with his wife, Jerri (Suzanne Douglas), who graduates law school during the show's third season. Reagan Gomez-Preston played the Petersons' eldest daughter, Zaria, who often traded barbs with her older brother, Michael (Kenny Blank). Robert and Jerri also had two young children, Nicholas (Curtis Williams) and CeCe (Ashli Amari Adams).

The show hit its stride in the second season, and one standout episode evoked the thoughtful, witty spirit of Townsend's directorial

After years of being offered stereotypical film roles, Robert Townsend produced and starred in *The Parent 'Hood*, a sitcom about a college professor grappling with modern parenting.

debit. The episode revolves around Nicholas's choice to portray Buckwheat (of *Little Rascals* fame) at a Black History Month assembly honoring influential African Americans. Horrified, the Petersons try to convince Nicholas to play someone—anyone—else: Charlie Parker, Duke Ellington, Colin Powell, and Prince are just some of the names that come up.

But Nicholas, committing to the role in a striped red-and-white shirt, suspenders, and an unkempt wig, is steadfast. "I've thought a lot about this and I want to be Buckwheat," he tells his family. Robert vows to support him even though he says he disagrees with the decision because Buckwheat's role reinforced negative stereotypes of Black people. "In Buckwheat's time, the stereotype was that all Black people were lazy and ignorant," Robert tells his son. "That's not true," a stunned Nicholas says.

The show centered around the Peterson family, including eldest son Michael (Kenny Blank), and three other kids living in Manhattan.

"I know it's not, but those were the only roles Black actors were allowed to play," Robert says with a pointed look at the camera. The episode briefly suspends reality with a vignette called "Paintin' Fools," which evoked the vaudeville-era roles given to Black actors. Townsend and Faizon Love (who portrayed Peterson family friend and neighbor Wendell) played Birmingham and Alabama, the

hapless titular fools who were tasked with painting a hotel lobby and not breaking a "priceless Chinese vase." (They succeed at neither.)

Townsend and Love break their dim-witted characters (but not the full vaudeville act) to exchange notes on their performances. "Did that work for you?" Love asks.

"Nah, I could have bugged my eyes more," Townsend says.

"I think my shuffling was a little wrong," Love says, before noting that the studio is casting "another plantation film" called *Cotton Pickin' Jubilee.*

"It's got a good role," Townsend says with mock enthusiasm. "It's a runaway slave and he's trying to get back and they catch him. And then there's a big tap dance scene and they're shooting at his feet."

"Slaves, butlers, and porters," Love says, stripping away the last layer of snark from the scene. "I hate these roles, man."

On the day of the Black History program, Robert, Jerri, and Wendell nervously await Nicholas's turn onstage (saved for last, naturally), following presentations by students dressed as the likes of Thurgood Marshall, Bessie Coleman, and George Washington Carver. They grimace as he bounds out from backstage with a "Hi, everybody! I'm Buckwheat"—an opener that leads the rest of the audience to look disapprovingly at Nicholas's parents. After Nicholas delivers a few Buckwheat-esque lines ("We's going fishing, *otay!*" in an un-enunciated drawl, the father of another Black student leans over Robert's shoulder: "Who's he going to be next year—the guy who posed for the lawn jockey?"

"I appeared in ninety-three movies with the Little Rascals, and it was *otay!*" Nicholas continues as his parents grimace from the audience. But then, as cute sitcom kids are wont to do, he surprises everyone. Nicholas walks to the edge of the stage before taking off the wig to deliver a sobering message: "But in real life, I was an actor named William Thomas Jr. Some people say I set a bad example, but that's all a Black person had to act if you wanted to get a job in the movies. There were great actors like Hattie McDaniel, Lincoln Perry, and Willie Best who always had to play the same roles. Butterfly McQueen got so tired of playing stereotypes, she stopped acting. We

had it rough, but I hope we made it easier for all the Black actors who came after us."

Nicholas gets a standing ovation and an *otay* signal from his dad as his proud parents look on. Despite the Black History Month theme, "I'm Otay, You're Otay" was more than a Very Special Episode: The storyline fit with the Petersons' supportive parenting style and grappled with a weighty topic for a sitcom. "The problem with Hollywood was balance," Townsend told the *Los Angeles Times* ahead of the 1996 episode. Early Black performers including McDaniel, Perry (more widely known as Stepin Fetchit), and Best (often billed as "Sleep n' Eat") "were brilliant," he said. "But because it wasn't balanced out with other images of African Americans, they got a raw deal."

"When you see people in movies or on television, you think they have all the power in the world," Townsend told the *Los Angeles Times*. "I was like, 'Why did he pick that type of role? I would have picked the Jimmy Stewart part.' But once I got into show business, I understood that they didn't have the power."

IN THE HOUSE

CREATED BY: Winifred Hervey
STARRING: LL Cool J, Maia Campbell, Debbie Allen, Jeffery Wood, Lisa Arrindell, Kim Wayans, Alfonso Ribeiro
PREMIERED: April 10, 1995
EPISODES: 76

AFTER *THE FRESH PRINCE OF BEL-AIR,* Quincy Jones brought another charismatic rapper to prime time: LL Cool J. *In the House* premiered as a showcase for the Grammy-winning artist (born James Todd Smith), who had a handful of TV and film credits but hadn't yet entered the *Deep Blue Sea* of acting roles.

On the NBC sitcom, he portrayed Marion Hill, a former football player whose NFL career with the LA Raiders was cut short by an on-the-field injury. With his income diminished following a series of financial missteps, Marion is forced to rent out his house, moving

himself into the apartment over the garage but sharing the kitchen with his tenant.

Debbie Allen—stepping back into acting after helming *A Different World* and directing episodes for various shows, including *The Fresh Prince of Bel-Air* and the short-lived *The Sinbad Show*—portrayed Jackie Warren, a newly divorced mother who lost her wealth and social standing when her husband of twenty years left her for a younger woman. Jackie moves in with her two kids, Tiffany (Maia Campbell) and Austin (Jeffery Wood), but is startled to discover they have a partial roommate because, as she tells Marion, "no one reads the lease."

NBC tapped Winifred Hervey, an Emmy-winning writer-producer who had worked on *Fresh Prince*, *Golden Girls*, and *The Cosby Show*, to write the script for *In the House*. Hervey knew she had a promising sitcom setup when Allen told her she had "no notes" on the script. In a 2013 interview with the Television Academy Foundation, Hervey recalled that she wrote the script without having met LL Cool J.

LL Cool J's character, Marion Hill, was not your stereotypical former football player. He was nurturing at times, especially with Austin (Jeffery Wood).

"I just wrote from the concept; I didn't really write for him and then I met him and it just clicked so great because I kind of wrote against what he was," Hervey said. "You know, he's this big, handsome, very masculine guy but the character is named Marion and he's very nurturing and holistic even though he's a football player."

Marion's holistic tendencies—which ranged from meditation to a trend-predicting sugar-free lifestyle—were played for easy but entertaining laughs. When Jackie expresses hesitation around the shared kitchen arrangement, Marion tries to change her mind with something someone with a crystal collection (no judgment) might say:

> MARION: "Apparently something in my karma has drawn you here to enrich or possibly test my spiritual awareness."

And Marion, eager to make his NFL comeback, finds he has someone to hold him accountable in Jackie, who counters his mysticism with a dose of reality:

> JACKIE: "Plus, you need the money."
> MARION: "First of every month."

From a plot perspective, *In the House* wasn't the most groundbreaking '90s sitcom, but there was something progressive about a male lead, a rapper to boot, who eschewed certain tropes of Black masculinity. One memorable season 2 episode featured RuPaul as Marion's high school friend Kevin, who reveals that he has found a job and passion as a drag queen. On a surface level, the scene stoops to an uncomfortable amount of gay and trans panic, though that's unfortunately true of much of the prime-time schedule in the mid-90s. "You didn't make the *big* change, did you?" a horrified Marion asks. "Everything below the waist is still the same," Kevin replies. Marion also tells Kevin that being a drag queen isn't a job, but rather it's "weird," and clutches his chest in relief when Kevin assures Marion that he's straight.

Alfonso Ribeiro (left), of *Fresh Prince of Bel-Air* fame, Maia Campbell, and Kim Wayans rounded out the cast.

Though Marion tells Kevin he believes "the universe embraces everyone" and promises their friendship won't be affected, he struggles with Kevin's revelation—to the point that he winds up in the garden with power tools (those patron saints of toxic masculinity).

In typical sitcom fashion, it's the cool teen who acts as the voice of reason as Tiffany—echoing advice Marion had previously given her about one of her friends—urges Marion to support his friend. In the end, he goes to see Kevin make his stateside drag debut, performing Aerosmith's "Dude (Looks Like a Lady)," and before the credits roll he's offering advice on which lipstick shade would be most flattering.

Another standout installment ("Sister Act: The Episode") features Phylicia Rashad, Allen's real-life sister, as Rowena aka "Row," Jackie's adventurous, nature-loving sibling, and you can totally see the sisters break into laughter when Jackie tells Rowena—who claimed to have softened an aggressive rhino with a song—to "sing like Joe Jackson's your daddy" when they hear threatening growls in the jungle on an excursion that goes awry.

The show was just as pleasant behind the scenes, according to Hervey, who said she found an easier rapport with Allen and LL Cool J than she had on *Fresh Prince*, where she found herself dealing with an executive producer who had lent aspects of his life story to the project and "the posse" of the rapper who landed the lead role. "It was just great to work with two people who were so gentle and nurturing, and really loved the work."

The network was a different story. "I think there were a couple of times where we bumped heads a little bit, maybe I questioned things a little too much," Hervey said, recalling a *Cosby* spoof that "got huge laughs" but was ultimately cut by NBC, ostensibly worried about offending a powerful star. Hervey cited this as the reason she was not asked back to helm further seasons. "I rubbed somebody the wrong way, obviously. And that was that."

NBC canceled *In the House* in May 1997, leaving UPN to pick it up. On the smaller network, the sitcom shifted to a less family-oriented format—with Jackie and Austin relocating to Nashville and Tiffany staying in LA to finish her senior year of high school. The shift upped Kim Wayans, as Marion's lovestruck physical therapist, to

series regular and brought on Alfonso Ribeiro (who had appeared in the season 2 opener as his *Fresh Prince* character Carlton Banks) as Dr. Maxwell "Max" Stanton, a sports medicine doctor with the power to clear Marion to play pro football again—and the ego trip to match.

THE JAMIE FOXX SHOW

CREATED BY: Bentley Kyle Evans and Jamie Foxx
STARRING: Jamie Foxx, Garcelle Beauvais, Christopher B. Duncan, Ellia English, Garrett Morris
PREMIERED: August 28, 1996
EPISODES: 100

EIGHT YEARS BEFORE Jamie Foxx played singer Ray Charles in a dramatic turn that would make the *In Living Color* alum only the fourth Black man to win the Oscar* for best actor, Foxx (born Eric Marlon Bishop) starred in the eponymous WB sitcom *The Jamie Foxx Show*.

The comedy revolved around Jamie King, who—like the comedian—was from Terrell, Texas, and had Hollywood aspirations. The sitcom places him at the hotel owned and run by his aunt Helen (Ellia English) and uncle Junior (Garrett Morris). There, he meets his love interest Francesca "Fancy" Monroe (Garcelle Beauvais) and finds a verbal sparring partner in Braxton P. Hartnabrig (Christopher B. Duncan), an accountant and grad student working at the hotel. Jamie immediately favors calling the light-skinned Braxton "Chico DeBarge" after the high yellow R&B star.

Foxx had a recurring role on Fox's *Roc* before embarking on his own sitcom. But his biggest credit to date was still *In Living Color*, where he introduced the duck-lipped, cross-eyed character Ugly Wanda. Foxx employed the full range of his comedy, lending both character sketches—including Tyrone Koppel, a Black reporter who parodied Ted Koppel in diction—and musical moments (no one who

* The list has since expanded to include Forest Whitaker (for playing dictator Idi Amin in *The Last King of Scotland*) and Will Smith (for *King Richard*).

heard Jamie King's original ballads was surprised when Jamie Foxx started releasing albums) to the show.

Like *The Wayans Bros.* and *Martin*, Foxx's sitcom was criticized—by the Hollywood branch of the NAACP and by the press—for perpetuating negative stereotypes about Black people. "Every African American family on TV can't be the Cosbys," Bentley Kyle Evans, the former *Martin* scribe who co-created *The Jamie Foxx Show* told the AP. "There are different types of comedy and different types of culture."

Ultimately, the NAACP chapter–led protest caused a major rift with the national organization, which had nominated both *Martin* and its star for several Image Awards and had not been looped in on the public comments by Hollywood–Beverly Hills chapter president Billie J. Green. Foxx would go on to win best actor in a comedy at the Image Awards in 1998 and garnered three subsequent nominations for the role.

Foxx never discredited *The Jamie Foxx Show* and what it had done for his career; he also pointed to the fact that he was co-creator and executive producer. Still, he told the *Los Angeles Times* that the sitcom wasn't on the same playing field as the dramatic role he landed in

Garcelle Beauvais, left, played "Fancy" Monroe, the love interest of Jamie King (Jamie Foxx), an aspiring entertainer who worked at a hotel in Texas. The characters were eventually married on the show.

Oliver Stone's 1999 football flick *Any Given Sunday*. It was that role that got Foxx widely noticed.

"In situations in Hollywood, it's just a matter of getting a chance to swing the bat," Foxx said. "You never know what you can do until you're given a chance."

THE STEVE HARVEY SHOW

CREATED BY: Winifred Hervey
STARRING: Steve Harvey, Cedric the Entertainer, Merlin Santana, Wendy Raquel Robinson, Terri J. Vaughn, Lori Beth Denberg, Tracy Vilar, William Lee Scott
PREMIERED: August 25, 1996
EPISODES: 122

From left, Ellia English, Garrett Morris, and Jamie Foxx. *The Jamie Foxx Show* faced the same criticism shows like *Martin* received about reinforcing harmful stereotypes. Bentley Kyle Evans, who worked on both shows, disagreed.

BEFORE STEVE HARVEY was one of the "Original Kings of Comedy" in the blockbuster stand-up film directed by Spike Lee, before he hosted *Family Feud* to the tune of a million memes, he played a washed-up R&B musician turned teacher in a sitcom that could only be called one thing: *The Steve Harvey Show*.

Created by Winifred Hervey, of *In the House* fame, the role was written specifically for the stand-up comic, who was at the time best known as the charismatic host of *Showtime at the Apollo* and a brief (but critically praised) sitcom called *Me and the Boys*, in which he played the widowed father of three boys. In an interview with the Television Academy Foundation, Hervey said she was reluctant to do a sitcom with Harvey. "I didn't really know what I would do with him because he's a very specific type of a person," Hervey recalled. It was industry veteran Stan Lathan who convinced Hervey to sign on to the project; Lathan later served as an executive producer and director of the series. Hervey hadn't yet met Harvey, but the running suggestion—to have the comedian play an English teacher—didn't make sense to her.

After meeting Harvey—who showed up in a signature ensemble: "a big hat, long black coat"—Hervey struck gold with her script about Steve Hightower, who becomes a high school music teacher after gigs dry up for his once-successful band, the Hightops. Cedric the Entertainer, written into the show at Harvey's request, played Steve's friend Cedric Jackie Robinson, the school's gym teacher.

In the pilot episode, walking down the hall of Booker T. Washington High School in a bright red suit and flat top hair, Steve recalls his glory days as an R&B musician before revealing his very different reality: "I'm so broke they cut my refrigerator off." Steve spends the entire episode wondering why the school's principal, Regina Grier (Wendy Raquel Robinson), appears to hate him. "Did we date?" he asks her at one point. By the end of the episode, he learns that the beautiful and always put together administrator was a high school classmate he nicknamed Piggy because she was overweight.

Booker T. Washington is located on Chicago's West Side, where Mr. Hightower, as he's known to the students, finds himself teaching music, art, and drama because of the school's budget woes. He welcomes an unruly class—in one apt joke, a student reveals that she was an extra in *Dangerous Minds*—but Hightower endears himself to his students with his blunt sense of humor and by using music to find out more about them. Over the show's six seasons, he forges a close relationship with Romeo (Merlin Santana) and Bullethead (William Lee Scott), the class's token white guy.

Steve Hightower, played by Steve Harvey, was an R&B musician turned teacher at Booker T. Washington High School in Chicago's West Side.

The Steve Harvey Show was designed as a vehicle for Harvey, and it helped propel him—along with Cedric the Entertainer—to *The Original Kings of Comedy* and beyond. But the ensemble allowed others, including Santana—who was tragically killed just months after the WB sitcom aired its final episode—and Terri J. Vaughn to shine.

Ahead of its fourth season in 1999, *Jet* magazine's cover proclaimed the show "Black America's Favorite TV Series." The accompanying story explained that "even though the show is tops with Black viewers nationwide, it has made few inroads with whites. It ranks 127th with white audiences." The magazine quickly noted that the rankings didn't bother the show's namesake star.

"Ninety percent of my income is based on Black people. I never short them," Harvey told the magazine. "I'm not concerned with crossover appeal. Crossover is great, but I write my jokes to make Black people proud."

The Steve Harvey Show helped further the careers of Steve Harvey and Cedric the Entertainer.

MOESHA

CREATED BY: Ralph Farquhar, Sara Finney-Johnson, Vida Spears
STARRING: Brandy Norwood, William Allen Young, Sheryl Lee
Ralph, Countess Vaughn, Marcus T. Paulk, Lamont Bentley, Yvette
Wilson, Shar Jackson, Fredro Starr, Ray J
PREMIERED: January 23, 1996
EPISODES: 127

..

"THEY SAY THE FIRST LOVE is the perfect love, something I won't
know for two more months because my Amish father won't let me
date or use electricity until I'm sixteen," Moesha Mitchell declares in
the opening scene of the beloved sitcom *Moesha*.

These hyperbolic words, lifted from the diary of the teenager
played by singer Brandy Norwood, would have fit on nearly any
series with a teen girl as a character, but the image that accompanied
them—a brown-skinned girl with braids, sleeping as the sunlight
poured in through her bedroom window—had never been central to a
prime-time network television show.

Moesha introduced a popular and smart soon-to-be-sixteen-year-
old living with her family in Leimert Park, a predominantly Black
middle-class enclave of Los Angeles. In the pilot, directed by Stan
Lathan, Moesha struggles to adjust to life with her new stepmother,
Dee (Sheryl Lee Ralph), after years of helping her widowed father,
Frank (William Allen Young), take care of their home and her little
brother, Myles (Marcus T. Paulk).

The show established early on that Moesha has a strong
community around her, including her close friends Kim (Countess
Vaughn), Niecy (Shar Jackson), and Hakeem (Lamont Bentley), the
neighbor-friend who frequently drops into the Mitchell residence
unannounced—usually at mealtimes. Whenever Moesha struggled
to get through to her overprotective dad, a Saturn car salesman, or
Dee, a teacher (and later, administrator) at her school, she could go
to Andell (Yvette Wilson), the owner of the Den, a neighborhood
hangout where Moesha and her friends spend time after school.

Moesha was created by Sara V. Finney (now credited as Sara
Finney-Johnson), Vida Spears, and Ralph Farquhar. Finney and

Spears had worked together on *The Facts of Life* and *Family Matters*; Farquhar was the creator of the short-lived but critically acclaimed Fox dramedy *South Central* starring Larenz Tate. Farquhar's younger brother and frequent collaborator Kurt Farquhar composed the mellow score and teamed up with Brandy to write the show's memorable title theme. *Up in the morning / A new day is dawning / It's me, it's me / Now realizing my responsibilities / It's me....*

"I always wanted to do a story about an African American girl," Finney told Rolonda Watts when the cast of *Moesha* appeared on her syndicated daytime talk show in 1996. "Coming-of-age stories, which I think are exciting, you know that time of your life, it's terrifying, it's fun, it's scary and everybody's gone through that time."

Moesha writer and co-producer Felicia D. Henderson suggested that producers look at Brandy—already famous enough to use a mononym at sixteen—for the lead role. The singer had played a main role on comedian Thea Vidale's one-season sitcom *Thea* but didn't consider herself an actress. She connected with the character after reading the script. "At first I said, 'What kind of name is Moesha?'" then seventeen-year-old Brandy told *Newsweek*. "After I read the script I was like, 'This girl is me!'" Her first audition was by all accounts terrible, but Kim Fields, of *Living Single* and *Facts of Life* fame, stepped in to help Brandy master the role.

With Black producers and young Black and Latino writers at the helm, the series was unapologetically Black (and, decades ahead of *Insecure*, very much set in South Los Angeles). "*Moesha* drops black slang and cultural references without footnotes," advised *Newsweek*. "If you don't know that 'booty' means bad, and 'knockin' boots' is a euphemism for sex, or you've never heard of Zora Neale Hurston, then you're 'whack' [*sic*]—and you don't want to know what that means." (Calling all xennials, millennials, and Gen Z-ers to join in on a collective scream.)

"*Moesha* is completely honest to the culture and the environment we're portraying," Farquhar told the *New York Times* ahead of the show's debut. "We make no nods toward making it seem white. You know, it just is what it is."

The show had been a CBS pilot for the 1995–1996 season, but the

Unlike many of its predecessors, *Moesha*, starring Brandy Norwood as the titular character, had predominantly Black and Latino writers and producers.

network passed, leaving UPN to pick up the sitcom. "By the fall [of 1996], on *Moesha*'s lead, UPN had shifted its programming strategy entirely and loaded up two nights of its three-night schedule with six sitcoms featuring predominantly African American casts," former WB exec Susanne Daniels and journalist Cynthia Littleton recalled in the 2007 book *Season Finale: The Unexpected Rise and Fall of The WB and UPN*.

While *Moesha* would become a boon for the network, launching a dedicated fan base and a popular spin-off, the series would remain underappreciated by the industry at large. "We're exactly what the American public says it is looking for: an honest presentation of family life, regardless of color, regardless of ethnicity," Ralph told the *New York Times* in 1999 ahead of the show's fifth season. "And we're doing it with quality scripts, quality producers."

Over the course of six seasons, *Moesha* played host to famous guest stars, including Maya Angelou (as herself), Kobe Bryant, Ginuwine, Lil' Kim, and Gabrielle Union. Usher, then a teen heartthrob and contemporary of Brandy, took on a recurring role as one of Moesha's love interests in the third season. The fourth season of *Moesha* opened

Sheryl Lee Ralph, right, played Moesha's stepmom, Dee.

with a meta Moesha meets Brandy plotline, which culminated in Mo and her friends taking in the real-life singer's performance of "Have You Ever" as her doppelgänger mouths the lyrics.

Though very much a sitcom, *Moesha* took a fair share of dramatic swings. "We wanted to do a show that had a little bit more reality than we were used to doing," Spears explained on *Rolonda*. "All of the humor, all of the warmth comes out of the characters."

Moesha—which followed its title character and several of her friends to college—took on issues including drugs, absentee parents, teen pregnancy, racism, grief, and more during its six-season run. One particularly heavy storyline revealed that Frank was the biological father of Dorian (Brandy's brother Ray J), who had been conceived through an affair Frank had while he was married to Moesha and Myles's mother. At the end of season 3, Moesha briefly moves in with Andell after falling out with her father following a series of arguments over Moesha's desire to date freely and make her own decisions (like the midriff flower tattoo that sends Frank's head spinning).

Numerous famous guest stars appeared on the show, including Usher (left) who played Jeremy Davis, a love interest for Moesha.

Countess Vaughn (center) and Shar Jackson (right) played Moesha's friends Kim Parker and Niecy Jackson. In 1999, the spin-off *The Parkers*, which centered around Kim and her mother, premiered, eventually airing for five seasons.

Brandy's fame skyrocketed over the course of *Moesha*, during which she released *Never Say Never*, her acclaimed second studio album, made history as Cinderella (opposite a Filipino American prince and Whitney Houston as her fairy godmother), and starred in the sequel to the teen thriller *I Know What You Did Last Summer*.

Meanwhile, the writers' room nurtured up-and-coming writers, including Mara Brock Akil, a *South Central* alum who based *Girlfriends* and *The Game* in the same universe as *Moesha*. The UPN sitcom "was a great place to grow," Akil told *Backstage* in 2002. "It was a nurturing environment that helped me find my voice."

The success of *Moesha* led to other shows centered around young Black women, most notably *The Parkers*, which revolved around Moesha's friend Kim's life in college, which she attended alongside her mother, Nikki (Mo'Nique). The spin-off resulted from well-documented tension between Brandy and Vaughn on the *Moesha* set. But Kim was a popular character all her own, and *The Parkers* provided a showcase for both Vaughn (who had starred in *227* as a child) and comedian Mo'Nique.

By the fall of 2000, *Moesha* led UPN's Monday night comedy lineup, which included *The Parkers, The Hughleys,* in its first season since moving from ABC, and *Girlfriends.* But by the new year, *The Parkers* had inched above its predecessor in the Nielsen ratings. Amid continued reports of behind-the-scenes friction, UPN opted not to renew the series for a seventh season. The season 6 finale would serve as the de facto series finale, disappointing fans who were eagerly awaiting the resolutions of two cliffhangers: Would Moesha move in with BFF Niecy or friend-turned-love Hakeem? And who was pregnant?

But as *Moesha*'s long-awaited arrival on streaming proved in 2020, the show's pioneering run looms large across multiple generations. Even for Ralph, who had a Tony nomination and dozens of film and TV credits under her belt when she joined the UPN series, the fact that Brandy's Moesha Mitchell existed was inspiring.

"When I first saw her in all her braided glory, I felt as if everything I had gone through as a Black female entertainer had been worth it," Ralph told *Essence* in 2020.

"So many women tell me, 'I never saw myself on television before *Moesha,*'" said Brandy, reflecting on the show's legacy in the same magazine. "*Moesha* made brown-skinned people feel like they could do anything."

GIRLFRIENDS

CREATED BY: Mara Brock Akil
STARRING: Tracee Ellis Ross, Golden Brooks, Jill Marie Jones, Persia White, Reginald C. Hayes
PREMIERED: September 11, 2000
EPISODES: 172

WHEN *GIRLFRIENDS* PREMIERED in 2000, it drew obvious comparisons to another show about four women navigating love, life, and careers in a major city. But *that* show, like *Friends,* brought little representation to a topic as universal as friendship. When Mara Brock Akil introduced Joan Clayton (Tracee Ellis Ross), Lynn Searcy (Persia White), Maya Wilkes (Golden Brooks), and Toni Childs (Jill

Marie Jones), her mission was unique, particularly during an era when Black shows were dwindling on network television. "I wanted Black women to feel seen," Akil told *Glamour* in 2020. "I was tired of us playing in the background and, in some cases, we couldn't even play in the background. I wanted Black women to see and enjoy their complexity, to see their beauty reflected."

Robi Reed, who cast the third and fourth seasons of *Girlfriends* remembers when Akil, her longtime friend, first told her about her vision for the project. Reed says she knew immediately she wanted to be a part of it. "I didn't cast the first season of *Girlfriends*, but I knew that Tracee Ellis Ross should be considered and saw a sitcom in her long before she got that role."

Reed also knew a story about four dynamic Black women and the complex relationships they had with each other would be in good hands with Akil, who had written for *South Central* and *Moesha*, in addition to serving as an executive producer on *The Jamie Foxx Show*. "I knew with Mara, just as a storyteller and creator, that she would be able to tell stories about us because she lived them and had friends that lived them and that they would be very authentic and unique to anything that we had seen," Reed says.

Girlfriends was an instant hit for UPN, and the show elevated the fame of its largely unknown cast, which also included "honorary girlfriend" William Dent (Reginald C. Hayes). The series could be funny in traditional sitcom ways: Jerry Seinfeld struggled to date a woman with "man hands" on his eponymous sitcom; in one early *Girlfriends* episode, Joan is horrified to discover that an otherwise promising suitor has extraordinarily large hips. But the show also highlighted issues including HIV/AIDS, abortion, pregnancy loss, colorism, and cultural appropriation.

Like *Moesha*, *Girlfriends* helped redefine prime-time beauty standards: Ross often wore her natural curls as Joan, while her costars opted for a range of styles that fit their characters' distinct styles and personalities. For free-spirited Lynn, the show's stylists incorporated locs and braids into her wavy hair; Maya alternated between braids and flowy pressed styles. High-maintenance Toni usually wore her hair sleek and straight. "Normally on TV, the black

Girlfriends, starring (from left) Tracee Ellis Ross, Jill Marie Jones, Golden Brooks, and Persia White, was one of the first shows to center around Black female friendships.

woman is the sidekick, and she's in the background," Jones told the *Dallas Morning News* ahead of the show's sixth season. "But we get to be black and beautiful. By that I mean our beautiful hair, makeup and clothes. We get to shine, and I do think it's groundbreaking."

As for the comparisons to HBO's *Sex and the City*, Akil distinguished *Girlfriends* by consistently focusing on the title of her show. "*Sex and the City* was all about their dating relationships with a girl group to discuss it with. I wanted to shift it to the chosen family of sisterhood and use Joan and Toni as my Carrie and Mr. Big," she told *Harper's Bazaar*. "It was always about that—whether or not that relationship was ever going to make it, and then letting all the other ones wrap around it."

That thread unraveled slightly when Jill Marie Jones abruptly left the series ahead of its seventh season. Jones has repeatedly cited her desire to do movies as the reason she left, but the show lost viewers in the aftermath of her departure, which coincided with UPN's merger with the WB into the CW.

Girlfriends was canceled during the Writer's Guild strike of 2007–2008 without airing a series finale.

Amid the Writer's Guild of America strike of 2007–2008, *Girlfriends* was canceled following its eighth season, adding *Girlfriends* to the

too-long list of Black shows that never got a proper series finale. But the show has lived on through a fandom that has only grown over decades of reruns and, in the last few years, its availability on streaming. The sitcom undeniably influenced *Insecure*, which offered a sweet nod to *Girlfriends* in its second episode when Issa (Issa Rae) and Molly (Yvonne Orji) belt out a modified version of the show's theme song's signature line, as performed by Angie Stone: *"My giiiiiiirlfriends."* The UPN sitcom also led to the popular spin-off, *The Game*, featuring Tia Mowry as Joan's cousin, Melanie Barnett, who was introduced in an episode of *Girlfriends*.

Decades before Tracee Ellis Ross earned a Golden Globe (becoming the first Black woman to win best actress in a TV comedy since Debbie Allen's victory for *Fame* in 1983) and a slew of Emmy nominations for her portrayal of Rainbow Johnson on *Black-ish*, she led a popular prime-time sitcom that ran for eight seasons. But during her time on *Girlfriends*, Ross was never invited to the Globes or Emmys, let alone on the nominee list.

"When I was on *Girlfriends*, I couldn't even get on a late-night show. No joke. I was never on any of those shows," Ross told *Essence* magazine's *Color Files* podcast in 2020. "And I remember the talent agent at one of those late-night talk shows said, 'Call us when Tracee gets something. She's amazing. We love her. Call us when she gets something.' I was on *Girlfriends*. I was the lead. It was a huge hit in our community and we had a lot of eyeballs."

When Ross was finally recognized for her work at the 2017 Golden Globe ceremony, she offered a poignant reminder of her journey. "This is for all the women of color and colorful people whose stories, ideas, and thoughts are not always considered worthy and valid and important," she said. "But I want you to know that I see you. We see you."

BLACK ANIMATED SERIES

The turn of the decade marked major break-throughs in Black animation, which honestly could be a book in and of itself. There are a few animated shows we *have* to talk about, though, because format notwithstanding, they changed the landscape of television in distinct and enduring ways.

"The PJs"
Created by: Larry Wilmore, Eddie Murphy, Steve Tompkins; produced by Ron Howard and Brian Grazer
Featuring the voices of: Eddie Murphy, Loretta Devine, Jenifer Lewis, Phil Morris, Ja'net DuBois, Kevin Michael Richardson, Pepe Serna, Michele Morgan
Premiered: January 10, 1999
Episodes: 28

The PJs sprang from an idea Eddie Murphy had for a sitcom about puppets in the projects. The unique idea resonated with Larry

Wilmore, who—after working in writers' rooms on *In Living Color*; *The Fresh Prince*; *Sister, Sister*; and *The Jamie Foxx Show*—was looking to work on his own creation. And like Murphy, he wanted the sitcom to look different from any other prime-time sitcom.

Wilmore recruited fellow *In Living Color* alum Steve Tompkins to help turn Murphy's kernel of an idea into *The PJs*, a satire about life in the projects. The series was groundbreaking in its use of a stop-motion technique—developed by the inventor of Claymation, Will Vinton—called "foamation," which uses a foam rubber in place of clay. "It's a hypervisualized world," Wilmore said in a 2017 interview with the Television Academy Foundation. "Inventing that was so much fun, and figuring out what it would look like, even what the characters are going to look like and sound like and everything was just amazing."

The jokes can get pretty dark (it is the projects, after all). "Juicy, man, I hope we never get old," Calvin says at one point. "Well, the statistics are in our favor," Juicy assures him.

In another episode, Thurgood—investigating a leak affecting multiple tenants—finds a resident dead in his bathtub and his immediate reaction is to grumble, "How long has this water been running?"

Critics were divided over *The PJs*, which prompted a fair share of controversy over whether it was stereotypical in its depiction of Black people. Spike Lee, a year from releasing *Bamboozled*, his searing 2000 satire about a modern-day minstrel show, made news at the 1999 Television Critics

Association press tour, asserting that *The PJs* "shows no love at all for Black people."

Despite the criticism (or perhaps because of it), *The PJs* premiered to strong ratings and earned Wilmore his second Emmy nomination (for Outstanding Animated Program). DuBois won two Emmys (in 1999 and 2001) for Outstanding Voice-Over Performance. Expensive to produce, it lasted two seasons on Fox before moving over to the WB, where it was canceled following its third season. The series remains a cult classic, and Wilmore has cited the sitcom as "the funniest" series he's created. "We made each other laugh so hard on that show," he told NPR in 2020. "I mean, the jokes we got to tell on that show were so much fun."

"The Proud Family"
Created by: Bruce W. Smith, Doreen Spicer
Featuring the voices of: Kyla Pratt, Tommy Davidson, Paula Jai Parker, Jo Marie Payton, Karen Malina White
Premiered: September 15, 2001
Episodes: 52

The WB wasn't the only network to cater to kids and teens during the '90s and the early aughts. Both Nickelodeon and the Disney Channel introduced content that was, by and large, more inclusive than anything on the major networks. Kenan Thompson and Kel Mitchell broke out of the Nickelodeon variety show *All That* before leading their own sketch comedy-infused sitcom *Kenan*

& Kel in 1996. Two years later, the Disney Channel introduced *The Famous Jett Jackson*, which followed Lee Thompson Young as a teen TV star who relocates to rural North Carolina to get a taste of a normal life.

In 2001, Disney broke new ground with *The Proud Family*, an animated coming-of-age sitcom about a Black family. The series was centered around fourteen-year-old Penny Proud (Kyla Pratt), who lives with her close-knit multigenerational family—including her mom, Trudy (Paula Jai Parker), and dad, Oscar (Tommy Davidson)—in a fictional California city. The Prouds reside in a multicultural neighborhood that includes Penny's BFF Dijonay Jones (Karen Malina White) and her neighbor/nemesis LaCienega Boulevardez (Alisa Reyes).

The show was designed to be iconic with its theme song performed by Solange, *featuring* Destiny's Child (Name another sitcom that made Beyoncé sing backup...) and an ensemble cast full of surprises, from Jo Marie Payton (*Family Matters*) as Penny's feisty grandma, Suga Mama, to an evil version of Al

Roker (voiced by the affable *Today* anchor in a recurring role).

The Proud Family was created by Bruce W. Smith, the pioneering animator who directed the 1992 comedy *Bebe's Kids*. Unlike that PG-13 film, *The Proud Family* was geared toward tweens, teens, and their families. But the series took on the same irreverence—and unapologetic Blackness— as Smith's directorial debut. The show's executive producers included Ralph Farquhar (*Moesha*), who had turned down offers for other animated shows before signing on to *The Proud Family*. The appeal, he told the *Los Angeles Times*, was in the show's ability to do things that would be impossible to do in a live-action sitcom. "From a writing standpoint, it is so much more liberating in terms of the scope we can attempt," Farquhar told the paper, citing a memorable Black History Month episode where Penny travels back in time to 1955 and experiences life as a young Black person in the segregation era.

The Proud Family aired for three seasons but fueled nostalgia long after that with reruns and a 2005 TV movie. Fans rejoiced in 2022, when *The Proud Family* returned with *The Proud Family: Louder and Prouder*. The aptly titled revival brought back much of what made the original series special (including evil Al Roker) while updating the Prouds and their community for the post-TikTok generation.

"The Boondocks"

Created by: Aaron McGruder
Featuring the voices of: Regina King, John Witherspoon, Cedric Yarbrough, Gary Anthony Williams, Gabby Soleil
Premiered: November 6, 2005
Episodes: 56

Decades before R. Kelly was convicted of sex crimes, including child pornography, *The Boondocks* imagined Robert Kelly on trial amid well-documented accusations of the singer's predatory relationships with underage girls. The episode examined the divide between Kelly's fervent fan base and the smaller cohort of people urging a reckoning around the R&B singer.

The Boondocks was one of few shows willing to even broach the topic. At the center of the debate were Huey and Riley Freeman (both voiced by Regina King), the dueling brothers from Aaron McGruder's famed comic strip of the same name.

Practical and quietly revolutionary, Huey hopes for a guilty verdict against R. Kelly. "Every nigga who gets arrested is not Nelson Mandela," he says in a passionate address. "Yes, the government conspires to put a lot of innocent Black men in jail on fallacious charges. But R. Kelly is *not* one of those men!"

Riley, meanwhile, carried a FREE R. KELLY sign and dismissed evidence of Kelly's crimes with idiotic mumblings that captured the edge of McGruder's satire. And like the comic strip that inspired it, the Adult Swim

series was incisive, daring and, yes, offensive (however relative a term). And that was only the second episode. Across its four-season run, the anime-inspired series tackled issues including colorism, racial profiling, denigrating reality television, homophobia (and hypocrisy) in hip-hop, and—in a Peabody Award–winning episode—the unfulfilled legacy of Dr. Martin Luther King Jr.

The Boondocks also courted fans with its thoughtfully cast ensemble. The animated sitcom gave Witherspoon, beloved for playing patriarchal figures in Friday and on The Wayans Bros., another natural role in Robert Freeman, known as Huey and Riley's cantankerous but caring Granddad.

McGruder served as showrunner for the first three seasons of The Boondocks, before stepping down to produce another adult animated comedy Black Jesus. In a statement explaining his decision, McGruder noted "the enormous responsibility that came with" the series and "its relatively young audience."

"It was important to offend, but equally important to offend for the right reasons. For three seasons I personally navigated this show through the minefields of controversy," he added. "It was not perfect. And it definitely was not quick. But it was always done with a keen sense of duty, history, culture, and love."

THE BERNIE MAC SHOW

CREATED BY: Larry Wilmore

STARRING: Bernie Mac, Kellita Smith, Camille Winbush, Jeremy Suarez, Dee Dee Davis

PREMIERED: November 7, 2001

EPISODES: 104

..

BY THE TIME *The Original Kings of Comedy* made a splash at the box office in 2000, three of the four comedians featured in Spike Lee's film had been at the center of a successful sitcom—Steve Harvey and Cedric the Entertainer on *The Steve Harvey Show* and D.L. Hughley on *The Hughleys*. The exception, fittingly, was Bernie Mac.

Mac was beloved among Black audiences for his brash comedy. After being showcased on *Def Comedy Jam*, he earned roles in classic Black comedy films, including *Friday* and *Don't Be a Menace to South Central While Drinking Your Juice in the Hood*.

The Original Kings of Comedy made Mac more visible than ever. And it helped Larry Wilmore come up with an idea for a sitcom that would showcase the best of Mac's talents—the confessional humor he employed onstage. The set that grabbed Wilmore's attention revolved

Inspired by a similar situation in his own life, in *The Bernie Mac Show*, the titular character takes in his sister's children after she enters rehab.

around Mac's decision to take in his sister's children when she went to rehab for drug addiction. Watching the sketch, Wilmore told *Vulture*, "I thought, 'That's a nice emotional thing.' I pitched it to [Mac] and he loved it."

Wilmore had also been watching a fair share of reality television at the time and was particularly inspired by *The 1900 House*, a UK import in which a modern family attempts to live the way people did in the Victorian era. He envisioned a single-camera sitcom (rare in the early aughts) and a confessional element (partly inspired by MTV's *The Real World*) that would have Mac talking directly to viewers. Wilmore was also influenced by the chaotic editing techniques of French New Wave films.

The Bernie Mac Show was loosely based on the comedian's life and stand-up; on the sitcom, Bernie and his wife, Wanda (Kellita Smith), take in his sister's three kids, thirteen-year-old Vanessa (Camille Winbush), eight-year-old Jordan (Jeremy Suarez), and five-year-old Bryana (Dee Dee Davis). Wanda, an exemplary AT&T employee, supports her husband in welcoming the children but leaves him to take on most of the child-rearing, completely overwhelming the cigar-loving celebrity.

"I always said the theme of the show is, 'Kids are terrorists, and I don't negotiate with terrorists,'" Wilmore told *Entertainment Weekly* in an oral history of the pilot. "That's what the show is—that and realizing that oftentimes you end up negotiating with terrorists. That's Bernie's journey through the show."

The six-foot-two comedian towered over his on-screen nieces and nephew, which the show played for laughs. Bernie's no-nonsense approach to discipline led to a controversial but oft-quoted line in which Bernie suggests that he'll "bust" his niece's head open "until the white meat shows." Though alarming to some critics, most viewers seemed to understand that underneath the tough (exasperated) exterior, Uncle Bernie was a teddy bear of a man who loved his family and wanted his nieces and nephew to feel loved.

In his confessionals, Bernie addressed the audience as "America," a play on his tendency to address the crowds at his stand-up shows by their applicable city or state.

On the heels of its first season, *The Bernie Mac Show* was easily network television's most popular show—mainstream popularity, the press regularly noted—and the show racked up accolades. Wilmore became the first Black writer to win an Emmy for Outstanding Writing for a Comedy Series. The show also won a Peabody Award and a Humanitas Prize.

Accolades notwithstanding, Wilmore has said Fox never really got the show. Following the second season of the series, the network declined to renew the Emmy-winning creator's contract. "At the time, I had to fight for all of the creative breakthroughs, and ultimately I was fired for it," Wilmore told the *Hollywood Reporter.*

The Bernie Mac Show aired for three more seasons before being canceled. But it forever changed the American sitcom. "In some ways, Mac's comedy was perfectly poised for prime time," a *New York Times Magazine* profile noted in 2002. "His most famous stand-up routine was all about family—the lifeblood of the sitcom. But its tone was several shades streetier and more explosive than anything Bill Cosby could imagine...His fury was so comically operatic, however, that Mac managed to share a stark, neocon vision of black life without alienating his audience."

The show centered around Bernie's continual adjustment to suddenly becoming a parent.

EVERYBODY HATES CHRIS

CREATED BY: Chris Rock and Ali LeRoi
STARRING: Tyler James Williams, Tichina Arnold, Terry Crews, Tequan Richmond, Imani Hakim, Vincent Martella
NARRATED BY: Chris Rock
PREMIERED: September 22, 2005
EPISODES: 88

AFTER HIS LATE-NIGHT show ended, Chris Rock channeled his unique mix of acerbic wit and tender observation into a sitcom based on his childhood in Brooklyn's Bedford-Stuyvesant neighborhood (during the Bed-Stuy do-or-die era).

The sitcom, set in the early to mid-80s, featured Tyler James Williams as the teenage Chris, a good kid who balances his adventures in gritty New York City with life at home with his close-knit family: his parents, the comically frugal Julius (Terry Crews) and the no-nonsense Rochelle (Tichina Arnold), as well as his younger siblings, Tonya (Imani Hakim) and Drew (Tequan Richmond).

With its nostalgic narration (via Rock) and spotlight on a

Tyler James Williams (left) starred as a teenage Chris Rock who was often bullied by Joey Caruso (Travis Flory) in *Everybody Hates Chris*.

working-class family, *Everybody Hates Chris* drew comparisons to *The Wonder Years*. But as the *New York Times* noted, Rock's sitcom—co-created with longtime collaborator Ali LeRoi—was distinct from other shows about young people in that it "centered on a teenager whose main problem is not adolescent angst, but real life."

In the pilot episode, thirteen-year-old Chris recalls taking two buses to get to school. "My mother thought going to a white school meant that I would get a better education and I would be safer—WRONG," he says before introducing us to Joey Caruso, insufferable ginger bully of Corleone Junior High. The scene establishes the racism Rock encountered as a teen—and how the budding comedian learned to use humor to deal with that pain. When Joey calls him "Bojangles," Chris retorts that "that wasn't what your mom was calling me when I was tap-dancing in her drawers last night."

"I couldn't beat him, but I thought maybe I could out-Black him," Rock quips in voice-over as Chris and Joey exchange words and tough glances. Though the principal steps in to temporarily squash the argument, the bully quickly escalates to calling Chris the N-word. "He got away with calling me a nigger that day," Rock tells us in his characteristically biting commentary. "But later in life he said it at a DMX concert and almost got stomped to death."

Though Julius's penny-pinching is played for laughs, the family's financial struggles are genuine. Julius tells his son to unplug his clock while he's sleeping because "you can't tell time while you sleep—that's two cents an hour." When Chris deigns to ask for an allowance, Julius informs him that he already receives one—every time he breathes, basically.

"I allow you to sleep here at night," Julius tells his son. "I allow you to eat them potatoes. I allow you to use my lights. I allow you to drink my Kool-Aid. I allow you to look at that TV. I allow you to run up my gas bill...."

Everybody Hates Chris aired for one season on UPN before the network merged with the WB into the CW, where the sitcom lasted another three seasons. Its cancellation in 2009 coincided with a dwindling number of shows with predominantly Black casts. But as

The show was based on Chris Rock's teenage years growing up in the 1980s with a wholesome, tight-knit family, while living in Bedford-Stuyvesant, a neighborhood of Brooklyn. (From left, Terry Crews, Tyler James Williams, Tequan Richmond, and Imani Hakim.)

LeRoi told the *Los Angeles Times*, *Everybody Hates Chris* was about a protagonist who just happened to be Black.

"From our perspective, this was never about being a black show," LeRoi told the paper. "The interests of Chris and I are broad and eclectic. The foundation is reflective of our influences, Dick Van Dyke, Andy Griffith. It's broad and global. It's about family, a slice of life."

THE GAME

CREATED BY: Mara Brock Akil
STARRING: Tia Mowry, Brittany Daniel, Hosea Chanchez, Coby Bell, Pooch Hall, Wendy Raquel Robinson, Barry Floyd, Brandy Norwood, Lauren London, Jay Ellis
PREMIERED: October 1, 2006
EPISODES: 148

MARA BROCK AKIL was several seasons into *Girlfriends* when she pitched a show about the women (wives, girlfriends, and mothers) in the lives of professional football players. UPN president Dawn Ostroff greenlit the idea and agreed to introduce the spin-off in an episode of *Girlfriends* (a cost-effective move known as a "backdoor pilot").

The WB's merger with UPN into the CW brought viewers full circle with Tia Mowry, one-half of *Sister, Sister*'s twin duo, playing Joan Clayton's cousin Melanie Barnett, a med school student who moves to San Diego to support her NFL rookie boyfriend Derwin Davis (Pooch Hall). Viewers fell in love with the ensemble cast of twenty-somethings trying to figure out their lives individually and together, while making mistakes along the way.

The CW canceled *The Game* after three seasons. But the show's loyal viewers said—to borrow a phrase from Toni Childs—"Oh Hell No." After decades of viewers writing to networks in support of shows that were canceled or in danger of it ("on the bubble," in industry parlance), *The Game* fans had a new platform that would allow them to get their voices heard. Which brings us to our next chapter.

The Game, starring (from left) Wendy Raquel Robinson, Tia Mowry, and Brittany Daniel, was so beloved by fans that they successfully lobbied for its return after being canceled after three seasons.

Shonda Rhimes's *How to Get Away with Murder* (starring Viola Davis as Annalise Keating) premiered amid an increasing number of shows from Black women creators who were determined to tell stories the industry had long overlooked.

9 A DRAMATIC TURN

After the WB and UPN merged to form the CW, the new network made a predictable move, revamping its slate to focus on one-hour dramas such as *Gossip Girl* and *The Vampire Diaries*. *The Game* lasted two years before the network called an audible, ending the show following its season 3 finale in 2009. Mara Brock Akil had fought for her creation, even pitching *The Game* as a revamped one-hour drama, but the CW made it clear there was no room for the show on its roster.

On January 11, 2011, *The Game* kicked off a second round on BET, where the season 4 premiere notched 7.7 million viewers, becoming the number one sitcom telecast (on an ad-supported channel) in cable TV history. The stellar premiere subverted many of the industry's misconceptions about Black TV shows and the viewers who tune in to watch them. For two years, fans had

circulated online petitions urging the CW (or another network) to put *The Game* back on air. They wrote impassioned pleas on message boards. They tweeted real-time appeals to "bring back *The Game*," which was far more public than the old-fashioned letter to the network.

BET had already been airing reruns of *The Game* (and its predecessor *Girlfriends*), a pattern the network established with other Black shows canceled before their time (Fox's *Roc*) or beloved gems such as *Soul Food*, Felicia D. Henderson's Showtime drama series adaptation of the 1997 film by George Tillman Jr. Though Akil and her producing partner/husband Salim Akil acknowledged the CW's role in getting *The Game* on air in the first place, BET had demonstrated the value it saw in the show. "We always felt the show would do better with advertising and promotion attention,"

Mara told the *Chicago Sun-Times* a few weeks into *The Game* 2.0. "That was certainly proven."

Loretha Jones, then head of programming for BET, "had the idea to bring *The Game* out of the graveyard basically because that's where it was," says Robi Reed, the veteran casting director and BET executive. When Reed got to BET in 2009, "there was no talent department," she says. "I created it from—there was nothing. But Loretha had the vision and she knew she needed [a talent department]." Building it from scratch, though, was not an easy undertaking.

"I had to cast everything out of my phone because the agents were doubting Thomases," Reed recalls. "They just saw BET as the network that did great specials—music specials. And so BET had to prove itself in that realm, even though Loretha Jones was a successful producer in film and TV movies. I had been casting [for] twenty-some odd years, but when I came to BET and had done quite a bit, people still didn't trust it."

The forces that came together to resurrect *The Game* foreshadowed a new era in Black television: one in which viewers would have more say in what they watched and Black writers, producers, and talent would have more creative control over the stories they brought to television. BET, long a source of debate over its content—which had largely been in the music and unscripted realm—became a visible player in scripted television. The Akils signed an unprecedented multiyear agreement with BET that would lead to yet another hit—the drama *Being Mary Jane*, which starred Gabrielle Union as a prominent television news anchor struggling to replicate her career success in the dating world.

The move toward drama—even *The Game* was rendered more true to life on BET—represented another progressive step for Black creators, actors, producers, and writers who had been largely limited to sitcoms even as the industry embraced one-hour prime-time soaps and teen dramas that rarely, if ever, featured Black characters, let alone centered them.

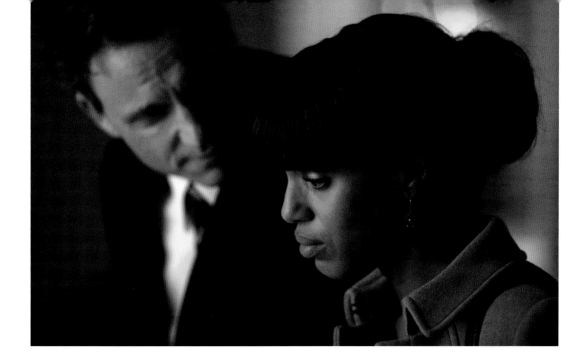

SCANDAL

CREATED BY: Shonda Rhimes

STARRING: Kerry Washington, Joe Morton, Tony Goldwyn, Bellamy Young, Columbus Short, Henry Ian Cusick, Darby Stanchfield, Katie Lowes, Guillermo Díaz, Jeff Perry, Joshua Malina, Scott Foley, Portia de Rossi, Cornelius Smith Jr., George Newbern

PREMIERED: April 5, 2012

EPISODES: 124

WHEN *SCANDAL* PREMIERED in 2012, it quickly became a new kind of appointment television. Shonda Rhimes's drama introduced Kerry Washington as Olivia Pope, a DC-based "fixer" inspired by real-life crisis management expert Judy Smith (whose firm helped rehab the images of clients including Wesley Snipes, Michael Vick, and Monica Lewinsky). On *Scandal*, Olivia managed a team of associates dubbed "gladiators" who carried out various, often unsavory, tasks across DC's political underbelly.

From the very first scene—in which Quinn (Katie Lowes) finds herself interviewing to work for The Olivia Pope—*Scandal*

By playing Olivia Pope, Kerry Washington was the first Black actress to lead a dramatic television series in thirty-eight years.

established itself as a thrilling ride, full of rapid-fire dialogue, ridiculous but absorbing plotlines, and the breathless monologues that became the show's signature. Impossibly stylish and cool under pressure, Olivia Pope was an instant icon, cutting an ever-fashionable figure in tailored ensembles by Proenza Schouler, Tom Ford, and Dior, in addition to chic coats (like the white Tory Burch Liv wore in the first episode) that served as a sort of armor for the well-connected crisis manager.

The series was as engrossing as it was groundbreaking: The drama marked the first time in nearly four decades that a Black woman led a prime-time network television show (since Teresa Graves in *Get Christie Love!*, which lasted one season after premiering in 1974). Shonda Rhimes had already blazed a trail with *Grey's Anatomy*, the hit medical drama that became notable for its true-to-life diversity and its equally diverse spin-off *Private Practice*.

In addition to being immensely watchable, *Scandal* inspired community—both online and in real life—lighting up Black Twitter and sparking weekly watch parties between families, roommates, friend groups, and, in some cases, entire college dormitories. Into the next morning, there were always new things to talk about: Olivia's fashion; the steamy affair she was having with the president of the United States, Fitzgerald "Fitz" Grant (Tony Goldwyn); the searing words (and eventually mutual respect) she shared with his wife, Mellie (Bellamy Young); or whatever fire (or murder) was raising the blood pressure of White House chief of staff (and later vice president) Cyrus Beene (Jeff Perry).

Social media had helped raise the profile of other shows (namely *The Game*) but *Scandal* upped the ante by tapping its stars to live tweet along with fans during each episode. This set the blueprint for television in the Twitter era, as socially savvy shows including *Scandal* and *Empire* prompted Nielsen to incorporate social media conversations into its ratings analysis.

Scandal became especially known for its cliffhanger endings, with each season finale outdoing the previous one. The season 2 closer holds a special place in the hearts of *Scandal* fans as it initiates our formal introduction to Papa Pope aka Eli aka Rowan. Joe Morton

Black Twitter was abuzz during every episode, commenting on the show's twists and turns and Olivia Pope's enviable wardrobe.

(already a Black TV legend as the guy who got left at the altar by Whitley Gilbert in *A Different World*) had appeared as a mysterious but high-ranking figure in the season's seventeenth episode. It wasn't until the season finale that we found out he had an even bigger role as Olivia's father. Papa Pope put Olivia's monologues to shame as he delivered a particularly withering read in the season 3 premiere:

> ROWAN: How many times have I told you?
> You have to be—what?
>
> OLIVIA: Twice as good.
>
> ROWAN: Twice as good as them to get *half* of what
> they have!

The interaction was visceral for those with a certain type of Black parent who doesn't care how grown you are and will bring you down to size at any age. Rowan says cruel things to his daughter ("You could have aimed higher," he tells her after insisting Fitz has no power) but "twice as good as them to get half of what they have" channeled a familiar, often desperate, refrain. "What's wonderful about that speech is you now have a black man in the middle of this episode

who's espousing things that I heard from my parents when I was younger," Morton told BuzzFeed on the heels of winning an Emmy for the role. "So on one level, it's a father talking to his daughter about 'I don't like your choice of a boyfriend.' On the other hand, it's a man talking about...the state of black people in general in America."

Scandal earned a reputation for increasingly bonkers plotlines (Olivia's kidnapping, meant to instigate a war between the United States and a fictional African nation, was a particularly absurd point), but the series also brought gravitas through stories that have rarely been told on television. The series was one of the first TV shows to tackle the burgeoning Black Lives Matter movement that exploded out of Ferguson, Missouri. In a 2015 episode, Olivia had an abortion before viewers were even told she was pregnant (the plotline alone is uncommon; rarer still is the protagonist who goes through with the procedure).

Scandal made incisive use of guest stars, including Courtney B. Vance, Ernie Hudson, Lena Dunham, Yara Shahidi (as young Olivia!), and Marla Gibbs, whose character, Rose, walked into a season 4 episode with an urgent inquiry: "Where's the Black lady? The one in charge."

Scandal would not have been the massive hit it was without Black women—from Rhimes and Washington to the women who watched, recapped, and followed the show from beginning to end. The same could be said of *How to Get Away with Murder*, which starred Viola Davis as Annalise Keating, a brilliant defense attorney and law professor who becomes embroiled in several twisty murder plots involving her students. The groundbreaking dramas crossed over in a two-hour episode that found Olivia and Annalise teaming up in the name of judicial reform.

HOW TO GET AWAY WITH MURDER

CREATED BY: Peter Nowalk

STARRING: Viola Davis, Aja Naomi King, Billy Brown, Jack Falahee, Matt McGorry, Charlie Weber, Liza Weil, Karla Souza, Alfred Enoch, Conrad Ricamora, Amirah Vann, Tom Verica, Rome Flynn, Katie Findlay

PREMIERED: September 25, 2014

EPISODES: 90

Viola Davis, already an Academy Award and Tony Award winner, became the first African American woman to win an Emmy for Outstanding Lead Actress in a Drama Series for portraying Annalise Keating.

HTGAWM (as it was frequently hashtagged) wasn't created by Rhimes but it was very much a Shondaland production; Rhimes was an executive producer alongside her producing partner Betsy Beers and show creator Peter Nowalk. And like *Grey's* and *Scandal*, *HTGAWM* reflected the world in a way that few other prime-time network series did (read: realistically). "It's not trailblazing to write the world as it actually is," Rhimes said while accepting the Norman Lear Achievement Award in Television from the Producers Guild of America Awards in 2016. "Women are smart and strong. They are not sex toys or damsels in distress. People of color are not sassy or dangerous or wise. And, believe me, people of color are never

anybody's sidekick in real life." (Spicy speech, given the setting, but where is the lie?)

One of the most powerful moments on *How to Get Away with Murder* preceded a breathtaking reveal at the end of the show's fourth episode. Annalise confronts her husband with an explosive question: "Why is your penis on a dead girl's phone?" The jaw-dropping inquiry was in service to one of the show's central mysteries, but the scene was most memorable because it unfolded as Annalise removed her makeup and wig to reveal her bare face and natural hair. In that moment, with a secret lingering in the air, the seemingly unflappable attorney was at her most vulnerable.

Davis made history in 2015 when she became the first African American woman to win the Emmy for Outstanding Lead Actress in a Drama Series for *How to Get Away with Murder*. "'In my mind, I see a line,'" Davis said while accepting her trophy. "'And over that line, I see green fields and lovely flowers and beautiful white women with their arms stretched out to me over that line. But I can't seem to get there no how. I can't seem to get over that line.'"

"That was Harriet Tubman in the 1800s," Davis said. "And let me tell you something: The only thing that separates women of color from anyone else is opportunity." She continued:

> *You cannot win an Emmy for roles that are simply not there. So here's to all the writers, the awesome people that are Ben Sherwood, Paul Lee, Peter Nowalk, Shonda Rhimes, people who have redefined what it means to be beautiful, to be sexy, to be a leading woman, to be Black. And to the Taraji P. Hensons, the Kerry Washingtons, the Halle Berrys, the Nicole Beharies, the Meagan Goods, to Gabrielle Union: Thank you for taking us over that line.*

How to Get Away with Murder ended after six seasons, wrapping up its story about one of the most complex women on TV. "Annalise Keating is completely different from anything anyone's ever given me," Davis said of the role in 2015. "When someone is described as

sexual and mysterious and complicated and messy, you don't think of me. I thought it was a really great opportunity to do something different, to transform into a character that people weren't used to seeing me in."

BEING MARY JANE

CREATED BY: Mara Brock Akil
STARRING: Gabrielle Union, Omari Hardwick, Richard Roundtree, Raven Goodwin, Lisa Vidal, Richard Brooks, B.J. Britt, Michael Ealy, Stephen Bishop, Morris Chestnut
PREMIERED: July 2, 2013
EPISODES: 52

The show centers around Professor Annalise Keating, who teaches a class called How to Get Away with Murder.

BEFORE SHE TOOK ON the role of television news anchor Mary Jane Paul, Gabrielle Union was up for the role of Olivia Pope on *Scandal*. Despite not landing the lead on ABC's political thriller, the audition was still a pivotal point in Union's career.

"I said to myself, 'Oh my God, these roles are out there.' It showed me that you don't have to settle," Union told the Associated Press in 2013. "Just from the audition process, I knew that I couldn't go backward."

Being Mary Jane premiered as a one-hour movie that BET planned to turn into a series. Mary Jane was instantly relatable to Black women as the most successful member of her family, who remained the dutiful daughter taking care of everyone in her family—including an underachieving older brother and a teenage niece on her second unplanned pregnancy—often at the expense of her own well-being.

The pilot, written by Mara Brock Akil and directed by Salim Akil, relays a grim statistic, followed by a disclaimer: "Forty-two percent of black women have never been married. This is one black woman's story…not meant to represent all black women."

Within the first ten minutes of the first episode, MJ has gone from bliss to rage, after discovering her lover (Omari Hardwick) is married. Incensed, she tosses him out half dressed, spraying him with her water hose as he protests. Then she takes out the trash (aka her now-disgraced bedsheets), changes into workout clothes, and goes for a run. When she shows up late to work at the broadcast network, her producer and close friend Kara (Lisa Vidal) covers for her before delivering some real talk: Her ratings need work and she needs a great story to do it.

Mary Jane lands on a story about the societal implications of women who steal sperm to get pregnant and—in one of the show's most controversial moments, she resorts to the process herself—

Gabrielle Union starred as Mary Jane Paul, a cable news reporter who is looking for love while dealing with family drama.

collecting and freezing sperm from one of her exes after they sleep together. Through its ensemble cast of people in and around Mary Jane's orbit, the show was one of the first to explore being Black in predominantly white work spaces, while also incorporating social issues such as mental illness and suicide. At heart, *Being Mary Jane* was about a single Black woman, presented in her fully flawed glory, looking for happiness.

"TV writes a lot about single people, but you rarely see them alone. And so I thought I wanted to explore that," Mara Brock Akil told ABC News Radio in 2014. "And I also thought it was fun to get into the minutia of what that is and see what that humanity looks like versus what we're projecting out to our friends and family and coworkers."

Stephen Bishop (left) played David Paulk, one of Mary Jane's love interests, and Margaret Avery and Richard Roundtree played her parents.

BLACK-ISH

CREATED BY: Kenya Barris

STARRING: Anthony Anderson, Tracee Ellis Ross, Yara Shahidi,
Marcus Scribner, Miles Brown, Marsai Martin, Jenifer Lewis,
Laurence Fishburne, Wanda Sykes, Deon Cole, Peter Mackenzie

PREMIERED: September 24, 2014

EPISODES: 176

..

BLACK-ISH WAS ALWAYS about a multigenerational family, and,
fittingly, the sitcom looked to past and future generations to tell a
story about what it means to be Black in a post-Obama America. Cre-
ator Kenya Barris was inspired by Norman Lear, the prolific producer
behind *All in the Family, The Jeffersons,* and *Good Times.*

Barris was also inspired by his children. The idea for *Black-ish*
formed from a conversation Barris had with actor Anthony Anderson
in a Los Angeles diner. Barris—a former writer for *Girlfriends, Soul
Food,* and *The Game*—and Anthony had similar backgrounds, having
grown up in Inglewood and Compton, respectively. Both had reached

The sitcom *Black-ish*
was a fun yet bold
look at one man's
determination to
establish a sense of
cultural identity for
his family.

a level of success that ensured their children's upbringings would be much more privileged than their own.

Black-ish introduced the Johnsons: Dre (Anthony Anderson), an ad agency exec and Rainbow (Tracee Ellis Ross), an anesthesiologist, raising their four children—Zoe (Yara Shahidi), Junior (Marcus Scribner), Diane (Marsai Martin), and her twin, Jack (Miles Brown), in predominantly white Sherman Oaks, California.

In the first episode of *Black-ish*, Dre is shocked to discover that his youngest son, Jack, doesn't know that Barack Obama is the first Black president of the United States—because Jack has only known one US president. The scene was based on a real-life exchange Barris had with his then six-year-old son. Another scene in which Anderson breaks down the multitude of combinations that can come out of a spare fridge (variations of ketchup bologna and baking soda sandwiches) was similarly based on Anderson's come-up.

Black-ish hit its stride in its second season, opening with an episode that tackled the N-word. In "The Word," Jack sings Kanye West's "Gold Digger" and when he gets to the word that rhymes with digger, he lets it rip to his parents' horror. True to Lear's 1970s blueprint, *Black-ish* tackled issues including colorism, police violence, and postpartum depression. Between Dre's parents, Ruby (Jenifer Lewis) and Earl (Laurence Fishburne), who lived with the Johnson family for much of the series, and Dre's clueless white coworkers, the sitcom presented a range of perspectives, mining humor from the various culture clashes.

Four years before Juneteenth was made a federal holiday, *Black-ish* launched its fourth season with an innovative musical episode that explained the history of June 19, which commemorates the day in 1865 that slaves in Galveston, Texas (which hadn't yet received news of the Emancipation Proclamation), were freed. The episode featured music by the Roots and a Fonzworth Bentley–produced number performed by the cast. Costumes worn by cast members during the episode were later put on display in the Smithsonian National Museum of African American History and Culture.

Black-ish aired for eight seasons, spawning two spin-offs— Freeform's *Grown-ish* and the shorter-lived prequel *Mixed-ish*.

Girlfriends alum Tracee Ellis Ross played Rainbow Johnson, center, an anesthesiologist raising her four kids with her husband, Dre.

THE CARMICHAEL SHOW

CREATED BY: Jerrod Carmichael, Ari Katcher, Willie Hunter, Nicholas Stoller
STARRING: Jerrod Carmichael, Loretta Devine, David Alan Grier, Amber Stevens West, Lil Rel Howery, Tiffany Haddish
PREMIERED: August 26, 2015
EPISODES: 32

WHEN *BLACK-ISH* DEBATED the use of the N-word, the ABC sitcom bleeped out each utterance. "Hearing it is a little bit hard," Barris told *Vulture.* "The *bleep,* in a weird way, makes you hear it even louder. But it still allows you to get into the drama and the comedy of the scene without making you feel ostracized."

The Carmichael Show starred co-creator Jerrod Carmichael (right) along with TV alums Loretta Devine and David Alan Grier.

The Carmichael Show took a different approach, dropping the word six times—unedited—on prime-time network television. "Having the word itself said on the show came out of a deeper conversation about do you feel beholden to these unspoken rules for being a Black person, or being a woman or being gay or being whatever you are?" the show's titular star and co-creator Jerrod

Carmichael explained in a column for the *Hollywood Reporter*. "It just naturally went to the N-word and the rules around it and that's where it came from."

"We do not have a set of rules we need to abide by," Jerrod tells his family in the episode, in which the Carmichaels fete Jerrod's mom, Cynthia (Loretta Devine), on her birthday.

"Sure we do," Joe (David Alan Grier) retorts. "We don't ski. We don't let dogs lick all up on our faces. And under no circumstances do we ever, ever drive a Subaru."

Carmichael has also cited Norman Lear's influence in shaping his semi-autobiographical NBC sitcom, which followed the more traditional multicamera format and was set in Charlotte, North Carolina (about eighty miles from Carmichael's native Winston-Salem). *The Carmichael Show* was more willing to consider contrarian perspectives; in one spring 2016 episode, Jerrod's father declared his support for Donald Trump's campaign for president to the horror of Jerrod's fiancée, Maxine (Amber Stevens West).

The show's cast included two breakout comedians: Lil Rel Howery, who would go on to play the real MVP of Jordan Peele's *Get Out*, as Jerrod's brother, Bobby, and Tiffany Haddish (pre-*Girls Trip*) as Bobby's estranged wife, Nekeisha.

POWER

CREATED BY: Courtney A. Kemp
STARRING: Omari Hardwick, Naturi Naughton, Lela Loren, Joseph Sikora, La La Anthony, Jerry Ferrara
PREMIERED: June 7, 2014
EPISODES: 63

DESPITE BEING ONE of the most popular shows on premium cable (second only to *Game of Thrones* at its peak) and growing into a veritable TV franchise, *Power* never quite got its due from the industry at large. And executive producer Curtis "50 Cent" Jackson never let Starz (or anyone else) forget it. Courtney A. Kemp's story about James "Ghost" St. Patrick, a drug kingpin torn between the streets and his

legitimate business as a New York City club owner, took Shakespearean turns that hooked viewers from the very first episode.

The concept for the show came out of a meeting Kemp had with Jackson and executive producer Mark Canton. The series took inspiration from both Kemp's and Jackson's lives, with 50 Cent sharing experiences from his drug dealing days and Kemp taking inspiration from her late father.

Power was part crime drama, part soap. In addition to his entrepreneurial pursuits, Ghost was perpetually torn between his wife, Tasha (Naturi Naughton), who was skeptical about his plan to trade in his drug empire, and his high school sweetheart Angela (Lela Loren), who happened to be an assistant US attorney working with the Federal Bureau of Investigation.

Rounding out Ghost's inner circle was his best friend Tommy Egan (Joseph Sikora), a fan-favorite character (and one of the few white people in the *Power* universe). In addition to signing on as an executive producer, 50 Cent played Kanan Stark, Ghost's mentor turned rival. The result was a powder keg of money, power, and (the battle for) respect that exploded across six seasons.

"The show is always about powerlessness," Kemp told the *New York Times* in 2017. "Ghost always thinks he's in control of a situation, and then he's not."

Omari Hardwick portrayed the main character of *Power*, James St. Patrick, a smart, ruthless drug dealer who has the alias of "Ghost."

EMPIRE

CREATED BY: Lee Daniels, Danny Strong

STARRING: Taraji P. Henson, Terrence Howard, Jussie Smollett, Trai Byers, Bryshere Y. Gray, Grace Byers, Kaitlin Doubleday, Serayah McNeill, Gabourey Sidibe, Xzibit, Leslie Uggams, Bre-Z, Vivica A. Fox, Tasha Smith, Nicole Ari Parker, Malik Yoba

PREMIERED: January 7, 2015

EPISODES: 103

EMPIRE **MADE A SPLASH** on Fox after premiering in the fall of 2015. Like *Power*, Lee Daniels's drama about hip-hop mogul Lucious Lyon (Terrence Howard) and his family gave nods to the Bard. *King Lear* was the specific Shakespearean inspiration for the Fox series, which spun its first season around a dying Lucious, his estranged wife, Cookie Lyon (Taraji P. Henson), and the future of the empire they built together (on the illicit foundation that landed Cookie in prison for nearly two decades while Lucious became a famous rapper).

Empire introduced an ensemble cast that offered a little something for everyone: Cookie, with her vibrant animal prints and luxurious furs, was fiercely protective of her family, including her and Lucious's three sons—ambitious but troubled Andre (Trai

Cookie Lyon (right, played by Taraji P. Henson), Lucious Lyon's (Terrence Howard) ex-wife, quickly became a fan favorite.

Byers), sweet but dumb Hakeem (Bryshere Y. Gray), and the musically talented Jamal (Jussie Smollett), whose identity as a gay man strained his relationship with the homophobic Lucious.

As other musical series ended (*Glee*) or fizzled out (*Nashville*), *Empire* became the rare network TV hit that rose in the ratings week after week—with original music that slapped and matched the show's chaotic plotlines. But after a strong season 2 opener, the show went the way of *Scandal* with runaway storylines that—while still entertaining—became increasingly impossible to take seriously. There were still moments—and guest stars including Chris Rock, Patti LaBelle, Mariah Carey, Naomi Campbell, Courtney Love, Kelly Rowland, and Ludacris—to hold viewers' attention, as the Lyons beckoned us to root for them despite their many flaws.

Jamal was a groundbreaking character for television, particularly in a series with an all-Black cast, and his story ended in the fifth season with Jamal marrying his longtime boyfriend after being walked down the aisle by both Cookie and Lucious. Jamal's early exit was at least partly a logistical choice: Just months before *Empire* resumed its fifth season, Smollett became embroiled in a bizarre legal saga that unfolded after the gay actor said he had been the victim of a brutal homophobic attack in Chicago, where the Fox drama was filmed.

Chicago police later arrested Smollett on charges of felony disorderly conduct for filing a false police report regarding the incident, which authorities claimed had been staged at Smollett's request. (The actor, who was found guilty of lying to authorities in December 2021, has always said he did not stage or lie about the attack.) Following the actor's arrest, Fox announced that Jamal would be written out of the final two episodes of the season. He did not appear on the show again, though the character was referenced as being unable to be with his family for one reason or another (stuck on his honeymoon in the Seychelles was one memorable excuse).

Jamal had been a fan-favorite character and his absence was conspicuous. But any chance the show had of recovering from the scandal was dashed by declining ratings. Fox announced the series would end with its sixth season, which incidentally was cut short by

Empire was initially a ratings juggernaut, but it later suffered from increasingly outlandish storylines and a scandal involving one of its stars, Jussie Smollett.

production delays due to the COVID-19 pandemic. The episode that marked the series finale was originally slated to be followed by two additional episodes. Though *Empire* tried to give viewers closure—most notably between Cookie and Lucious, who were always the endgame— it was not the finale the show or its most loyal fans deserved.

INSECURE

CREATED BY: Issa Rae, Larry Wilmore
STARRING: Issa Rae, Yvonne Orji, Jay Ellis, Natasha Rothwell, Amanda Seales, Lisa Joyce, Y'lan Noel, Alexander Hodge, Kendrick Sampson, Leonard Robinson, Courtney Taylor, Jean Elie
PREMIERED: October 9, 2016
EPISODES: 44

AHEAD OF *INSECURE*'S PREMIERE on HBO, Rae made the media rounds as headlines and interviews touted the history she was making as the first Black woman to create and star in a premium cable series. "Isn't it sad that it's revolutionary?" Rae told NPR. "We don't get to just have a show about regular Black people being basic."

Rae picked up the torch from the likes of *Girlfriends* and *Living Single*, influences she weaved into her HBO dramedy's DNA. *Insecure* captured the full breadth of life in young adulthood—falling in and out of love or friendship, navigating career and (under)employment, getting married (or divorced), and dealing with the death of a parent. Like *Girlfriends*, the show's central theme was female friendship; *Insecure* relied on Molly Carter (Yvonne Orji) and Issa Dee's (Issa Rae) chemistry almost (and at times more) than their chemistry with any love interest. Still, fans of *Insecure* had no problem debating the merits of prospective partners for Issa and whether they were Team Lawrence (Jay Ellis) or Team Daniel (Y'lan Noel).

Insecure was partially based on *The Misadventures of Awkward Black Girl*, Rae's popular web series. Like the protagonist of that digital series, Issa would often reflect (literally) on her anxieties, major milestones, and big decisions by rapping in front of a mirror. (*"Guess you're still single,"* she says, addressing an ex from haphazard

lyrics written in a notebook. *"Couldn't find another bitch to make your toes tingle!")* Insecure took that navel-gazing to a deeper level, as viewers saw Issa's and Molly's growth (and felt their growing pains) over the years. The series balanced that seriousness with sharp humor. Laugh-out-loud moments were usually prompted by surreal interludes in which Issa plays out her darkest fantasies like, say, throwing her ex's whole baby away or any scene featuring Kelli (Natasha Rothwell).

Insecure brought a fresh ensemble in Rae and her costars, whose collective glow-up ahead of the show's second season made viewers all the more invested in their romantic lives. The music, by Raphael Saadiq (of Tony! Toni! Toné! fame), was deeply infused into the show and—as the Tony! Toni! Toné! alum described in one of the show's legendary Wine Down after shows—"All West Coast."

Despite the buzz around *Awkward Black Girl, Insecure* took years to come to fruition, which struck a parallel with Issa's career trajectory—from listless employment in an office environment rife with microaggressions. Rae was paired with veteran writer Larry Wilmore, who spent hours talking to Rae about her life and

Like *Girlfriends* and *Living Single, Insecure* centered around female friendships, mainly between Issa Dee (Issa Rae) and Molly Carter (Yvonne Orji) but also supporting characters like Kelli Prenny (Natasha Rothwell).

priorities, in order to tease out *Insecure*'s script. Another collaborator was Prentice Penny, a former writer for *Girlfriends*, who still kept in touch with his first boss, Mara Brock Akil, and relayed the message she had given him ahead of his first meeting with Rae—as documented in the *New York Times*: 'Get this black girl's vision right.'"

Prentice, who became showrunner for *Insecure*, understood the assignment.

Insecure was Rae's vision from start to finish, an ongoing letter to her beloved South Los Angeles and—from an industry standpoint—an incubator for Black talent. "We always talked about this journey that we wanted to follow from being insecure to being comfortable in your insecurities to being securely insecure," Rae told the *Hollywood Reporter* in 2021. The series, she said, "was for us, by us and opened the doors for a lot of your faves."

One of the main storylines from the series was Issa's love triangle with Lawrence Walker (left, played by Jay Ellis) and Daniel King (played by Y'lan Noel, not pictured).

ATLANTA

CREATED BY: Donald Glover

STARRING: Donald Glover, Brian Tyree Henry, LaKeith Stanfield, Zazie Beetz

PREMIERED: September 6, 2016

EPISODES: 41 (as of this writing)

IN THE FALL OF 2016, Donald Glover brought *Atlanta* to FX. In his dreamlike dramedy, the Georgia city became a universe where Justin Bieber was Black, an invisible car could mow you down as you were leaving the club, and good old-fashioned racism might save you from a brutal beating—simply because the attacker can't tell you apart from another Black person.

Though the show was punctuated by surreal moments, *Atlanta* was anchored in stark reality: At the start of the series, aimless Earn (Glover) hustles to convince his cousin Alfred (Brian Tyree Henry), a rising rapper who goes by Paper Boi, to let him manage his career. There's a coming-of-age theme to *Atlanta* as Earn, who dropped out of Princeton, tries to get his life together and prove himself to his family and Vanessa (Zazie Beetz), his ex-girlfriend and the mother of his child. For Alfred, still a broke weed dealer at the start of the series, the tension lies on the cusp of fame.

Atlanta regularly pushed the boundaries of traditional television with surreal interludes that included bottle episodes that removed some or all of the main cast. Glover won an Emmy for directing a season 1 episode, titled "B.A.N.," that followed Paper Boi as he appeared on a news panel show clearly meant to evoke BET. In between segments, *Atlanta* aired parody commercials for "pre-dumped" Swisher Sweets, Arizona sweet tea (which poked fun at the tax charged on the ninety-nine-cent beverage—"The price is on the can, though!"), and, in a searing animated spoof, Trix cereal. The latter *faux*mmercial featured a police officer violently arresting a wolf for trying to taste the sugary product.

The show's second season placed resident oddball Darius (LaKeith Stanfield) at the mansion of an enigmatic musician with daddy issues and a mysterious skin condition. It's at turns hilarious

and haunting but still grounded in the show's overall theme. (One of the episode's funniest scenes unfolds at a drive-through where an excited employee tells Paper Boi, who ordered only burgers, that he threw some fries in the bag for him. "Take 'em out," the rapper orders.) Season 2 was dubbed "Robbin Season," channeling the pre-holiday desperation that drives an uptick in crime. Even as the men travel to Europe for Paper Boi's tour in season 3, they are ATLiens (in Outkast parlance) to their core.

Atlanta wasn't just experimental in plot; Glover hired a room full of young, Black writers (including his brother, Stephen Glover, an executive producer on the series) and tapped his frequent collaborator Hiro Murai to direct even though he'd only previously helmed music videos. Though installments have been directed by Glover himself, in addition to *Zola* director Janicza Bravo and Amy Seimetz (Starz's *The Girlfriend Experience*), Murai directed the bulk of *Atlanta*'s four seasons.

Atlanta received critical acclaim over the four seasons it aired, but the stronger metric for its success is the show's balance between the show's illusory moments while still reflecting the humanity of its core characters and the people with whom they interact. "Chris Rock told me, 'Man, they wouldn't have let me make your show back in the day,'" Glover recalled in a 2018 *New Yorker* profile. "I'm a little better than Chris, because I had Chris to study."

Atlanta pushed the boundaries of TV comedy into its final seasons. The (critically misunderstood) third installment featured several stand-alone episodes that riffed on cultural appropriation—sending up everything from Nando's to corporate diversity and inclusion efforts—and white privilege. The fourth season, naturally, imagined a serial killer inspired by rapper Soulja Boy. Crank dat.

Creator and star Donald Glover (center, seen here with costars LaKeith Stanfield, left, and Brian Tyree Henry, right) was the first African American to win the Emmy for Outstanding Directing for a Comedy Series in 2017.

LUKE CAGE

CREATED BY: Cheo Hodari Coker

STARRING: Mike Colter, Alfre Woodard, Simone Missick, Rosario Dawson, Theo Rossi, Gabrielle Dennis, Mustafa Shakir

PREMIERED: September 30, 2016

EPISODES: 26

...

AS NETWORK AND CABLE TV brought more stories from Black creators, the streaming era opened up more opportunities to deliver unprecedented narratives. So when Netflix crashed shortly after *Luke Cage* premiered on Netflix in the fall of 2016, viewers and creator Cheo Hodari Coker jokingly asked if *Luke Cage* fans had crashed the platform.

Netflix stayed mum on whether the technical problems were due to the number of people taking in Marvel's Blackest series up to that point, but the speculation pointed to the need for more stories centered around Black people—or in the case of Luke Cage, Black superhumans.

Mike Colter played titular character *Luke Cage* in Marvel's first Black superhero television show.

Mike Colter (*The Good Wife*) played Luke, who used the N-word throughout the blaxploitation-inspired series and protected Harlem to the bump of a hip-hop infused score by Adrian Younge and Ali Shaheed Muhammad. The pioneering series offered a showcase for veteran entertainers, including Alfre Woodard, who played Black Mariah, the powerful cousin of Luke's nemesis, Cottonmouth (Mahershala Ali).

Netflix canceled the series after just two seasons, on the heels of axing another Marvel property (*Iron Fist*).

GREENLEAF

CREATED BY: Craig Wright
STARRING: Lynn Whitfield, Keith David, Merle Dandridge, Kim Hawthorne, Desiree Ross, Lamman Rucker, Deborah Joy Winans, Tye White, Lovie Simone, Gregory Alan Williams, Rick Fox
PREMIERED: June 21, 2016
EPISODES: 60

OWN FIRST GOT INTO the scripted original drama game with Tyler Perry's *The Haves and the Have Nots*, a popular family soap, but *Greenleaf* marked the network's strongest debut when it premiered in the summer of 2016.

Lynn Whitfield, Keith David, and Merle Dandridge starred in the drama *Greenleaf*, which centered around the Greenleaf family, their family compound, and their Memphis megachurch.

In the first hour of *Greenleaf*, prodigal daughter Grace (Merle Dandridge) returns to her family's vast Memphis compound and gets a whirlpool of painful family secrets churning to the dismay of her parents, Bishop James Greenleaf (Keith David) and Lady Mae Greenleaf (Lynn Whitfield), who lead a Southern Black megachurch.

Through its multigenerational ensemble, *Greenleaf* explored issues that included sexual abuse, domestic violence, homophobia, police violence, and drug abuse over the five seasons that it aired. *Greenleaf* got an extra blessing from OWN CEO Oprah Winfrey, who joined the cast as Mavis McCready, estranged, no-nonsense sister to Lady Mae. Let the church say amen.

QUEEN SUGAR

CREATED BY: Ava DuVernay and Oprah Winfrey
STARRING: Rutina Wesley, Dawn-Lyen Gardner, Kofi Siriboe, Bianca Lawson, Dondré Whitfield, Omar J. Dorsey, Nicholas L. Ashe
PREMIERED: September 6, 2016
EPISODES: 88

AS OWN EXPANDED its slate of original programming, Ava DuVernay and Oprah Winfrey teamed up to tell a story about three siblings—Nova Bordelon (Rutina Wesley), Charley Bordelon (Dawn-Lyen Gardner), and Ralph Angel Bordelon (Kofi Siriboe)—trying to hold on to their eight-hundred-acre sugarcane farm following the death of their father.

Based on Natalie Baszile's novel of the same name, *Queen Sugar* tells a sweeping story that touches on inequities within the criminal justice system and the legacy of slavery, both topics that DuVernay has explored in other works, including her 2016 Netflix documentary *13th*. In *Queen Sugar*, these themes are explored more intimately, showing how systemic racism has affected the Bordelon family across generations.

Though grief and loss have exacerbated the complex relationships the siblings hold with one another and their extended families, the

series also highlights the beauty of Black families and communities. *Queen Sugar* celebrates Black love through Ralph Angel's relationship with Darla (Bianca Lawson), with whom he shares a young son, and through the Bordelon siblings' Aunt Violet (Tina Lifford), who finds love in her fifties with Hollywood (Omar J. Dorsey).

One of the show's biggest contributions to television unfolded behind the scenes, where DuVernay hired female directors, including Kat Candler, Tina Mabry, Sallie Richardson-Whitfield, and industry veteran Neema Barnette to helm every episode of the show. For many of these women, *Queen Sugar* marked their first opportunity to direct episode television. DuVernay knew firsthand how challenging it could be to get hired to direct TV with little small-screen experience, particularly as a Black woman. Though she already had a well-reviewed feature film under her belt (and was in the process of helming the Oscar-nominated *Selma*), it wasn't until after directing a season 3 episode of *Scandal* that the TV offers "came pouring in," the director recalled in 2016.

In *Queen Sugar*, siblings Charley, Ralph Angel, and Nova Bordelon (Dawn-Lyen Gardner, Kofi Siriboe, and Rutina Wesley) have to deal with their father's sudden death and the fate of his eight-hundred-acre sugarcane farm in rural Louisiana.

SNOWFALL

CREATED BY: John Singleton, Eric Amadio, Dave Andron
STARRING: Damson Idris, Amin Joseph, Sergio Peris-Mencheta, Carter Hudson, Alon Aboutboul, Michael Hyatt, Isaiah John
PREMIERED: July 5, 2017
EPISODES: 50 (as of this writing)

IN 2017, JOHN SINGLETON—the Oscar-nominated director behind the 1991 film *Boyz n the Hood*—turned his lens on the early years of the 1980s crack epidemic with *Snowfall*, a hazy and cinematic FX drama.

Snowfall, led by Damson Idris as drug kingpin Franklin Saint, is the rare drama to revolve around young men. (Lena Waithe's *The Chi*, which premiered in 2018 is another example and similarly merges the crime and coming-of-age dramas.) Though early seasons incorporated storylines about a Mexican drug cartel and a disgraced CIA agent, the heart of the story is Franklin, a high school student at the start of the series, and his inner circle: his best friend, Leon (Isaiah John); his uncle, Jerome (Amin Joseph); Jerome's girlfriend, Louie (Angela Lewis); and his mother, Cissy (Michael Hyatt).

Singleton, who died in 2019, recruited writers of color, including novelist Walter Mosley to write for the show. "I wouldn't even be doing television right now if John hadn't called me up and said, 'I think I need you in this room. When do you want to come in?'" Mosley told *Deadline* in 2021. "I told John I had never written TV, and he told me that that was OK. I could just come in and be an adviser, and then that helped me become one of the show's writers."

"I know people who are writers, who are actors and people who work as DPs, you know, just working crew," Mosley added. "And John hired them all and gave them a chance. He would say, 'Try it, and if you can't do it, that's fine. But if you can do it, this is your job, and this is your life.' There are so many people that John did that for. Some were fresh out of prison and couldn't get work anywhere else. He was making films and television shows, but he was also changing the system."

That behind-the-scenes representation lent an authenticity that permeates *Snowfall* and makes it much more significant than your

Franklin Saint (Damson Idris) is the main protagonist in *Snowfall*, which is set in the early days of the 1980s Los Angeles crack cocaine epidemic.

average crime drama. "We often talk about the bad that came out of this time, but there's so much good that came out of it too," Idris said in 2020. "It had a huge impact on pop culture, fashion, music, and that's what the show shines a lens on."

POSE

CREATED BY: Ryan Murphy, Brad Falchuk, Steven Canals
STARRING: Michaela Jaé (MJ) Rodriguez, Indya Moore, Billy Porter, Dominique Jackson, Angelica Ross, Angel Bismark Curiel, Hailie Sahar, Evan Peters
PREMIERED: June 3, 2018
EPISODES: 26

FOR ALL OF THE TRAILBLAZING representation of the early to mid-aughts, the lives of queer Black men and women were rarely explored on-screen. That changed when *Pose* brought the electricity of the late 1980s and early 1990s ball scene to FX in 2018.

The series celebrates the Black and Latino pioneers of New York City's underground ballroom culture and the "Houses" that became chosen families for young people who were estranged from biological families who refused to accept them. *Pose* captured the joy, love, and freedom that the ballroom offered, but it didn't shy away from the harsh realities of the era. The show takes place in the shadow of the HIV/AIDS epidemic, which directly affects several characters including Blanca (Michaela Jaé Rodriguez) and Pray Tell (Billy Porter).

Writer and activist Janet Mock made history as the first trans woman of color to write and direct a TV episode, making her directorial debut with "Love Is the Message," which looked at the AIDS crisis through Pray Tell's final few weeks with his dying partner. *Pose* likewise refused to ignore the constant threat of violence against Black trans women, particularly those engaged in sex work.

The series, which ran for three seasons, led to historic accolades including a best actor Emmy for Billy Porter. Michaela Jaé Rodriguez became the first transgender woman to be nominated

MJ Rodriguez, Billy Porter, and Angel Bismark Curiel were part of the large ensemble cast of *Pose*, which was set in New York City's ballroom culture, an LGBTQ subculture in the Black and Latino communities, throughout the 1980s and 1990s.

for a best lead actress Emmy. "We were always deemed these human beings that weren't able to be loved," Rodriguez told the *New York Times* in 2021. "To finally have that on the television screen, it instills a lot of hope."

WHEN THEY SEE US

CREATED BY: Ava DuVernay
STARRING: Asante Blackk, Caleel Harris, Ethan Herisse, Jharrel Jerome, Marquis Rodriguez, Niecy Nash, John Leguizamo, Michael K. Williams
PREMIERED: May 31, 2019
EPISODES: 4

AVA DUVERNAY'S POWERFUL miniseries about the five Black and Latino teenagers falsely accused and convicted of a brutal 1989 rape in New York City's Central Park prompted a reexamining of the case that dominated headlines and public discourse for years. Pointedly, the Netflix series premiered during the presidency of Donald Trump, a vocal critic of the so-called Central Park Five—Korey Wise (Jharrel Jerome), Kevin Richardson (Asante Blackk), Antron McCray (Caleel Harris), Yusef Salaam (Ethan Herisse), and Raymond Santana (Marquis Rodriguez)—urging the death penalty before the teens had even been charged with a crime (and insisting upon their guilt decades after they were exonerated by DNA evidence in 2002).

When They See Us traces the group's legal saga across decades, with young actors portraying the teenagers, who were between the ages of fourteen and sixteen when they were arrested. The four-episode miniseries led to renewed scrutiny of prosecutor Linda Fairstein (portrayed by Felicity Huffman), who at the time was the head of the sex crimes unit for the Manhattan District Attorney's Office. (Fairstein slammed the series as "full of distortions and lies" in a *Wall Street Journal* op-ed.)

Though the cast features a number of A-listers, including Michael K. Williams, John Leguizamo, Niecy Nash, Vera Farmiga,

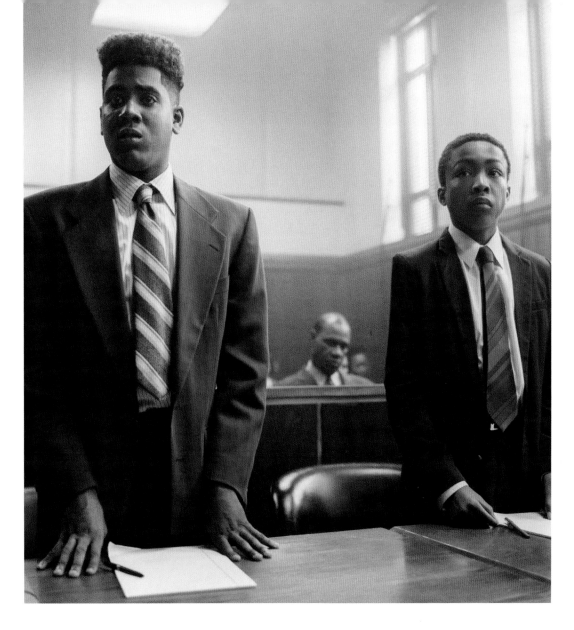

and Joshua Jackson, the core ensemble was made up of up-and-coming talents. Jerome, a Dominican American actor, became the first Afro-Latino to win an acting Emmy—for lead actor in a limited series. The men formerly known as the Central Park Five cheered through tears as Jerome accepted his trophy. "Most importantly, this is for the men we know as the Exonerated Five," Jerome said after thanking his family, friends, and the team behind the series. "Raymond, Antron, Yusef, Kevin, and King Korey Wise."

Jharrel Jerome and Asante Blackk played two of the so-called Central Park Five, Korey Wise and Kevin Richardson.

Quinta Brunson (center) created and stars in *Abbott Elementary*, a workplace comedy about a group of dedicated, passionate teachers and a slightly tone-deaf principal that are brought together in a Philadelphia public school. Brunson is seen here with the ensemble cast of (from left) Tyler James Williams, Chris Perfetti, Sheryl Lee Ralph, and Lisa Ann Walter.

10 THE FUTURE OF BLACK TV

WHEN SHERYL LEE RALPH won an Emmy for best supporting actress at the seventy-fourth annual Emmy Awards in 2022, the recognition had been a long time coming.

"I am an endangered species," the *Abbott Elementary* star belted out, her glistening eyes twinkling in unison with the sparkly gems that adorned her long, braided ponytail. *"But I sing no victim's song / I am a woman, I am an artist / And I know where my voice belongs."*

Decades earlier, Ralph had lobbied the Academy of Television Arts & Sciences—the voting body behind the Emmys—to pay tribute to another sitcom: *Moesha*, the popular UPN series that featured Ralph as the stepmother of a popular teenager played by singer Brandy. Ralph told the *Los Angeles Times* she had reached out to the academy after hearing a woman celebrate the progression from *Beulah* to *Moesha* in an interview that aired during the 1998 Emmys broadcast. But *Moesha* went largely unrecognized

outside of the NAACP Image Awards and Nickelodeon's Kids Choice Awards.

At sixty-five, the Tony-nominated Ralph (*Dreamgirls*), won her first Emmy for playing Barbara Howard, a veteran teacher and mentor to Janine Teagues (played by series creator Quinta Brunson) on *Abbott Elementary*. "Don't you ever, ever give up on you," Ralph urged in her acceptance speech, "because if you get a Quinta Brunson in your corner, if you get a husband like mine in your corner, if you get children like mine in your corner, and if you've got friends like everybody who voted for me, cheered for me, loved me…"

Ralph's reference to Brunson was a beautiful reminder of what makes the universe of Black TV so special. Yes, a universe—not a genre—because despite all the barriers that Black people have faced in the entertainment industry, Black creators have contributed to every genre, often on a defining level.

Along the way, they have made space for other Black writers, producers, directors, and actors, recognizing talent the industry has consistently overlooked.

At the same Emmys ceremony, Brunson won the award for best comedy writing, becoming only the second Black woman (after Lena Waithe) to win in that category. Waithe won alongside Aziz Ansari in 2017 for the "Thanksgiving" episode of *Master of None* that was partly autobiographical for Waithe. In the episode, her character, Denise, a lesbian, comes out to her mother (Angela Bassett), who is initially unwilling to accept that her daughter is gay. The episode weaves in scenes from past years, holidays spent with Denise's Aunt Joyce (Kym Whitley) and longtime friend Dev (Aziz Ansari), and we follow Denise from childhood to adulthood as she becomes more confident in her identity—and her mother comes to love her daughter for who she truly is.

Sheryl Lee Ralph gave a powerful speech when accepting her historic Emmy win for *Abbott Elementary* in 2022.

Both Whitley and Bassett were handpicked by Waithe for the episode. "For every black woman, Angela Bassett, she's iconic," Waithe told BuzzFeed. "I think for the world, she should be iconic, but I think for black women in particular she's such a role model." Waithe considered Whitley, a longtime friend, to be perfect for the auntie role as "every person's aunt and mom's best friend."

Melina Matsoukas, well known for directing Beyoncé's *Lemonade* and as an executive producer and occasional director of *Insecure*, was tapped to helm the episode. With the support of Ansari and *Master of None* co-creator Alan Yang, Waithe was following the blueprint of the Black women she called her mentors. "I had really great bosses," Waithe told *Time* of her early career. "Ava DuVernay and Mara Brock Akil and Gina Prince-Bythewood sort of became my mentors whether they liked it or not, just because I was watching them work, and I would see how they moved through the world and the industry."

The only Black person to win best comedy writing prior to Waithe was Larry Wilmore, whom Brunson thanked "for teaching me to write television as well as he did." ("I was crying because @quintabrunson won but was not ready for the shoutout and now I'm blubbering," Wilmore tweeted.) The *In Living Color* alum had a

Lena Waithe (right) was the first Black woman to win an Emmy for comedy writing for an episode featuring Angela Bassett in *Master of None*.

hand in several of the shows that were up for awards at the ceremony, including *Insecure*, which he co-created with best lead actress nominee Issa Rae, and *Black-ish*—an Outstanding Comedy Series, nominee that counted him among its executive producers and for which he briefly served as showrunner.

Wilmore left *Black-ish* halfway into the first season to take on his eponymous late-night show, which debuted on Comedy Central in 2015. Robin Thede, creator of *A Black Lady Sketch Show*, a nominee in the best variety sketch category, had been head writer (and a recurring on-screen presence) on *The Nightly Show with Larry Wilmore*. *A Black Lady Sketch Show* had featured Brunson in its main cast the first season (she guested in the third) and boasts Rae as an executive producer.

Though *A Black Lady Sketch Show* lost to *Saturday Night Live* in the best variety sketch category in 2022, the show did triumph for the consecutive second year in the editing category. Bridget Stokes won best director for helming the season 3 opener, which kicked off with a sketch that encapsulated the show's raison d'être: In "Product Purge," Black women are given a finite amount of time each year to return hair products that didn't work. "For 364 days, we have suffered with half-used hair products that have gathered dust, sitting around in our beauty cabinets, taunting us," Thede says in the sketch, which features cameos from *Pose* actress Michaela Jaé Rodriguez and Holly Robinson Peete. "Today we take control—edge control!"

With *The Nightly Show*, Thede became the first Black woman to be head writer of a late-night show; she later hosted her own late-night series for BET, *The Rundown with Robin Thede*, which counted erstwhile late-night host Chris Rock among its executive producers. Both shows were groundbreaking for late night, and both were lamentably short-lived (*The Nightly Show* ran for two seasons; *The Rundown* lasted for just one).

Thede had been down about the cancellation, but the next opportunity quickly presented itself when Issa Rae called her and asked her what they might collaborate on. Thede told the *Today* show that she mentioned a sketch variety show she had successfully pitched to a network. The problem, she told Rae, was that "the money wasn't

Robin Thede, Ashley Nicole Black, and Quinta Brunson in a sketch from the first season of *The Black Lady Sketch Show.*

right." Rae suggested they pitch it to HBO. "We went and met with them, and they bought it on the spot," Thede recalled on *Today*.

On *A Black Lady Sketch Show*, Thede has sought to extend similar opportunities to Black women. "I'm creating this new class of women who have been out here and been doing this, but who haven't had the chance to be seen in that way. They've always been in majority white spaces, or if they have been involved in black spaces, it's been as a sidekick-girlfriend to somebody," Thede told *Entertainment Weekly*. "I'm just excited for these current black women to be seen in the light that they deserve. And for people to see all this amazing stuff that they can do."

—————

The Emmys aren't the only game in town when it comes to television accolades but they are the most prominent awards show focused exclusively on the TV industry. The Golden Globe Awards, which honor film and TV categories, have been in flux since 2021 when the *Los Angeles Times* published an explosive report about the Hollywood Foreign Press—the voting body behind the Globes—and its long-standing lack of diversity.

For its part, the Television Academy has made efforts to diversify its ranks but progress has been tentative at best. At the 2021 Emmy Awards ceremony, not one Black actor won an acting category, inspiring headlines and hashtags featuring the phrase "Emmys So White." The backlash evoked the Oscars So White campaign that lawyer April Reign launched in 2015 when all twenty nominations in the acting categories went to white actors. ("#OscarsSoWhite they asked to touch my hair," Reign tweeted.) On the heels of Black Lives Matter, what began as a Black Twitter conversation—a shared joke in the vein of *we laugh to keep from crying*—became a movement.

The campaign "was a catalyst for a conversation about what had really been a decades-long absence of diversity and inclusion," Ava DuVernay later told the *New York Times*. With more eyes on the voting mechanics of awards shows than ever before, each subsequent ceremony has become an opportunity to hold Hollywood accountable. "I've been doing TV since 1995. This will be my 1st time going to the Emmys & I'm presenting an award!" Gabrielle Union tweeted in 2017.

That was the year Waithe garnered her historic win in the comedy writing category at the same ceremony that saw Donald Glover become the first Black person to win the Emmy for Outstanding Directing for a Comedy Series for *Atlanta*. It was also the year Rae announced she was "rooting for everybody Black."

———

Speaking to the *New York Times* after her big win, Ralph explained her impromptu decision to sing "Endangered Species" by Dianne Reeves. "I wanted people to know: I'm a woman. I'm an artist. I'm here. I've been here," Ralph said. "This woman that you are awarding tonight is the woman that I've been growing into my entire career."

Brunson, she told the paper, was among the young women she considered her "children" in the industry, along with Rae, Waithe, and Union. "It's been my job to hang in there," she said. "For them."

Ahead of the ceremony, Laverne Cox had stopped Rae on the red carpet to remind her it had been five years since her red-carpet response was heard 'round the world. "Issa Rae, who are you rooting for?" Cox asked.

"Everybody Black, nothing has changed," Rae replied before breaking into a megawatt grin. "It will never change."

But at least one thing has changed: There are a lot more Black people to root for. Despite the acting shutout in 2021, there were still milestones for Black entertainers at the seventy-third ceremony, where Michaela Coel became the first Black woman to win best writing for a limited or anthology series for her transcendent, twelve-episode dramedy *I May Destroy You*, which was partly based on her sexual assault. Meanwhile, two nominations for Misha Green's *Lovecraft Country*, including a best drama nod and a best leading actress nomination for Jurnee Smollett, highlighted the pitfalls of the industry—HBO had canceled the series before the nominations were even announced. In the years since, there have been exciting premieres that have yet to get awards show buzz. Leigh Davenport's *Run the World* is a rich and dynamic look at a female friendship, as seen through the eyes of a close-knit group of Black women living in Harlem. Davenport, a former journalist, spent years crafting the show, which she based on her own group of friends she met in her

college days at Spelman. In the early days of pitching *Run the World*, execs would regularly ask, "How is this different than *Insecure?*" she recalls, "Because that was the show at the time." Others tried to steer the show away from New York because it had been done "so much." (Davenport's response: "New York has been done by who? What Black women have you seen running around New York?") At least once, there was a suggestion to throw in a mystery, Davenport says, because the twisty *Scandal* and *How to Get Away with Murder* were big at the time.

"So, what if she's a secret CIA agent with a hidden past!" Davenport paraphrases, before volunteering a version of her response: "What if they're not? What if they're just regular women living?"

Ultimately, that's exactly what *Run the World* is—a show about regular women living, and one that Black women have craved for years. The Starz series premiered in 2021 within months of Tracy Y. Oliver's *Harlem*, which also follows Black women in the Upper Manhattan neighborhood, led by Meagan Good. A few years ago that might have been a bad omen, but both shows were renewed for second seasons.

Michaela Coel created, wrote, codirected, and executive produced the award-winning *I May Destroy You.*

"I think it's kind of amazing that two shows, situated in this world that has been underserved, exist," says Davenport. "Tracy's done so much beautiful work for Black women and so, like, great for us—and great for the fans to have more than enough to choose from."

Davenport has found herself part of "a cohort of women," she says she's "lucky to call peers. I adore Quinta Brunson. We connected on Instagram...She's like, 'I love *Run the World*.' I'm like, 'I love you.' I've known Robin Thede for ages. She actually was in the second kind of test version of *Run the World* I did in 2012. I'm so proud of her."

Rae "is phenomenal," adds Davenport. "Just the space that she was able to create and the culture and the fandom around doing it your own way—it's just been incredible. What [Waithe] is doing as a producer is phenomenal...just really opening doors for people. There's just a really solid wave of us right now who are kind of getting into the business and are, yes, doing the things that we want to do, but very mindful of, like, how are we helping other people get here with us?"

Starz's *Run the World* tells the story of four best friends, played by Amber Stevens West, Bresha Webb, Corbin Reid, and Andrea Bordeaux, living and working in New York.

ACKNOWLEDGMENTS

THIS BOOK is dedicated to the memory of my dad, Kevin Butler—who inspired and nurtured my love of pop culture—and to the memory of my grandparents, Grandma Harriet, Grandpa Joe, and Abuelo Dan. Thank you for everything.

To my family, thank you for believing in me and supporting me as I wrote this book. M and W, I couldn't have done any of this without you. Chelle, thank you for being the best mom/ Mimi to our babies and for helping all of us navigate "the big hill." Sloane, thank you for being our anchor and for keeping me on task. To Loli, I love you and am so proud to be your mommy. Bubbeleh, Sugarplum, and Papito: I love you and am so grateful to be your BB.

Sending love to all of my siblings, near and far: Erin, Taylor, Nic, Denise, Ben, and my day one, Genna: thank you for (literally) helping a sister out, I love you. Thank you also to the extended Butler, Goins, and Ramirez families, especially Andrew and Brittany Butler, Neice Butler, D.J. Butler, Victor Ramirez, and Darcy Ramisch. Thank you also to Joyce Ramirez and Chuck Clark.

I am also grateful to Mrs. Carol Sloane and Dr. Walter Sloane Sr. (aka mom and dad), Dana and Charles Quartey, Carla and Mike Conners, Edward and Perrine Mann, Janet Alexander, Heywood Sloane, and the entire Quartey, Mann, and Conners families.

A special thank you to my friends and colleagues at the *Washington Post*, especially Liz Seymour, Mitch Rubin, and David Malitz, who hired me to write about television for my hometown paper (a dream come true), as well as Hank Stuever and Zachary Pincus-Roth. Thank you to my friends in pop culture past and present— Emily Yahr, Elahe Izadi, Helena Andrews-Dyer, Travis M. Andrews, Sonia Rao, Steph Merry, and David Betancourt—and to the entire Features section. (Thank you doubly to Hank, Travis, and Helena for answering a gazillion questions about the book publishing industry.)

I owe a huge debt to several editors who have championed my work over the years, particularly Caitlin Moore, Krissah Thompson, Vanessa Williams, Marcia Davis, Chris Jenkins, Robert Pierre, Natalie Hopkinson, Kierna Mayo, and Marc Vera.

I am blessed with too many friends to list, but I have to shout out Charlise Ferguson (along with Bernadette Lebron, Daisy Larmond and the entire Larmond family), David Carson Lipscomb, S. Anne Marie, Jenae Harvey, Desiree Shelley Flores, Abha Bhattarai and Pedro da Costa, Delece Smith-Barrow and Sean Bland, as well as Victoria St. Martin and Rich Jones. Thank you for your friendship and support. Also sending a huge thank you to Soraya Nadia McDonald, who in addition to being an incredible talent is steadfast in supporting other writers. (To anyone I forgot, please forgive me and know that you are in my heart.)

Lastly, I am grateful to everyone at Black Dog & Leventhal who helped this book come together. Thank you especially to my extremely patient editors, Lisa Tenaglia and Becky Koh, for this tremendous opportunity and for cheering me on at every turn.

NOTES

INTRODUCTION

page 8 *When Carroll died...*: Shonda Rhimes (@
 shondarhimes), "She escorted the tv
 drama into the 20th century," Twitter, 4
 October 2019, twitter.com/shondarhimes/
 status/1180261134370131968.

page 9 *Accepting the award...*: Television Academy,
 "Viola Davis Gives Powerful Speech about
 Diversity and Opportunity," YouTube video,
 02:42, 21 September 2015, youtube.com/
 watch?v=OSpQfvd_zkE.

1: PIONEERS UNDER PRESSURE

page 11 *Rae's publicist...*: "Issa Rae—'I'm Rooting for
 Everybody Black'—Full Emmys Red Carpet
 interview," *Variety*, 19 September 2017,
 youtube.com/watch?v=WafoKj6MzcU.

page 11 *"I'm rooting for..."*: Ibid.

page 12 *"It meant something..."*: Tim Reid, interview
 with the author, 25 January 2022.

page 12 *"Way before the internet..."*: Ibid.

page 12 *As historian Donald Bogle...*: Donald Bogle,
 *Primetime Blues: African Americans on Network
 Television* (New York: Farrar, Straus & Giroux,
 2001).

page 12 *Julia was the first...*: Ibid.

page 14 *Somebody decided...*: "Programs: Wonderful
 World of Color," *Time*, 13 December 1968.

page 14 *But series creator...*: Diahann Carroll, *The Legs
 Are the Last to Go: Aging, Acting, Marrying, and
 Other Things I Learned the Hard Way* (New
 York: Amistad, 2008).

page 14 *Kanter, Carroll wrote...*: Ibid.

page 14 *"I really didn't..."*: Diahann Carroll, interviewed
 by Henry Colman for The Interviews: An Oral
 History of Television, Television Academy
 Foundation, 3 March 1998, interviews.
 televisionacademy.com/interviews/diahann-
 carroll.

page 15 *Carroll recalled that...*: Ibid.

page 15 *The actress flew...*: Carroll, *The Legs Are the Last
 to Go*.

page 15 *Kanter had already expressed...*: Lauren Wilks,
 "Exploring the WCFTR: Searching for
 Marginalized Identities in the Archive,"
 WCFTR Blog, The Wisconsin Center for
 Film and Theater Research, 14 July 2021,
 wcftr.commarts.wisc.edu/blog/2021/07/14/
 exploring-the-wcftr-searching-for-
 marginalized-identities-in-the-archive.

page 15 *But when Carroll...*: Carroll, *The Legs Are the Last
 to Go*.

page 15 *As he acknowledged...*: Hal Kanter, interviewed
 by Sam Denoff for The Interviews: An Oral
 History of Television, Television Academy
 Foundation, 22 May 1997, interviews.
 televisionacademy.com/interviews/hal-kanter.

page 15 *"Since the networks..."*: "Julia: Television
 Network Introduces First Black Family Series,"
 Ebony, November 1968, 56.

page 16 *But by the summer...*: "Nat Cole's Show Gets
 a Reprieve; Singer to Stay on N.B.C.-TV
 Until November," *New York Times*, 15 August
 1957, 45.

page 16 *Cole also put...*: Nat King Cole (as told to
 Lerone Bennett Jr.), "Why I Quit My TV
 Show," *Ebony*, February 1958, 29.

page 16 *NBC adjusted...*: "Nat Cole's Show Gets a
 Reprieve."

page 16 *"Part of what..."*: Matthew F. Delmont,
 interview with the author, 25 January 2022.

page 16 *"There's also an understanding..."*: Ibid.

page 16 *Julia had three national...*: "Julia: Television
 Network Introduces First Black Family Series."

page 16 *Julia dolls...*: "Diahann Carroll Presents the Julia
 Dolls," *Ebony*, October 1969, 48.

page 16 *The design gave nods...*: Ibid.

page 17 *eBay is full of...*: "Lunchbox and thermos
 featuring Diahann Carroll from the sitcom
 Julia," Collection of the Smithsonian

National Museum of African American History and Culture, nmaahc.si.edu/object/nmaahc_2013.108.13ab.

page 17 *Some items...*: "Book of paper dolls from the television show Julia," Collection of the Smithsonian National Museum of African American History and Culture, nmaahc.si.edu/elegance-julia.

page 17 *Kanter's original...*: Hal Kanter, interviewed by Sam Denoff for The Interviews: An Oral History of Television.

page 17 *"We want to make..."*: Judy Stone, "Black Is the Color of Diahann's 'Julia,'" *New York Times*, 18 August 1968.

page 18 *The exchange...*: Diahann Carroll, interviewed by Henry Colman for The Interviews: An Oral History of Television.

page 18 *She and Kanter...*: Diahann Carroll with Ross Firestone, *Diahann!* (New York: Little, Brown, 1986).

page 18 *"Television was going..."*: Diahann Carroll, interviewed by Henry Colman for The Interviews: An Oral History of Television.

page 18 *"So while the..."*: Ibid.

page 18 *"Orange County..."*: Bogle, *Primetime Blues*.

page 18 *"The inconsistencies..."*: Jack Gould, "TV Review; Diahann Carroll Seen in N.B.C.'s 'Julia,'" *New York Times*, 18 September 1968, 95.

page 21 *She became the first...*: "Julia (TV)," The HFPA Golden Globe Awards, goldenglobes.com/tv-show/julia-tv.

page 21 *The difference...*: Bogle, *Primetime Blues*.

page 21 *"There was no question..."*: Carroll, *Diahann!*

page 21 *The show did...*: Bogle, *Primetime Blues*.

page 21 *All his conditioning...*: Louie Robinson, "TV Discovers the Black Man," *Ebony*, February 1969, 27.

page 22 *Dolan, who...*: Ray Loynd, "Looking Back at the Birth of Watts Writers Workshop," *Los Angeles Times*, 27 April 1987.

page 24 *Even before* Julia...: Judy Stone, "Black Is the Color of Diahann's 'Julia.'"

page 24 *"If a Black..."*: Ibid.

page 26 *"But eventually..."*: Diahann Carroll, interviewed by Camille Cosby, National Visionary Leadership Project, youtube.com/watch?v=Kn5kDvpiibA.

page 26 *In a 2014...*: Diahann Carroll, interview, "Breaking Barriers," *Pioneers of Television*, PBS, aired 29 April 2014.

page 26 *Criticism about...*: Bogle, *Primetime Blues*.

page 26 *"I cannot spend..."*: Carroll, *Diahann!*

page 26 *"Their self-image..."*: "Julia: Television Network Introduces First Black Family Series."

page 26 *In addition...*: Rob Goldberg, "Op-Ed: Baby Nancy, the First 'Black' Doll, Woke the Toy Industry," *Los Angeles Times*, 12 March 2019, latimes.com/opinion/op-ed/la-oe-goldberg-baby-nancy-black-doll-shindana-20190312-story.html.

page 27 *"And it made..."*: "How It Feels to be Free," *American Masters*, PBS, directed by Yoruba Richen (1515 Productions Limited, 2021).

page 27 *"We will forever..."*: Debbie Allen (@msdebbieallen), "Diahann Carroll you taught us so much," Twitter, 4 October 2019, twitter.com/msdebbieallen/status/1180164093761617920.

page 27 *Her Julia Baker...*: Shonda Rhimes (@shondarhimes), "She escorted the tv drama into the 20th century," Twitter, 4 October 2019, twitter.com/shondarhimes/status/1180261134370131968.

page 27 *"I love you..."*: Kerry Washington (@kerrywashington), "I love you for eternity," Twitter, 4 October 2019, twitter.com/kerrywashington/status/1180214540375474176.

2: BLACK ENTERTAINMENT

page 29 *Redd Foxx...*: Kevin Cook, *Flip: The Inside Story of TV's First Black Superstar* (New York: Viking, 2013).

page 30 *He had also...*: Tony Cox, "Comic Flip Wilson's Life," *Tavis Smiley*, NPR, 2 January, 2004.

page 30 *Wilson said...*: Cook, *Flip*.

page 31 *Ahead of an...*: John Gary, "Flip Wilson and Olga Sbragia at the hungry i," *San Francisco Examiner*, 9 October 1965, 9.

page 31 *By that December...*: "Hot New Comic of the Playboy Circuit," *St. Louis Post-Dispatch*, 17 December 1965, 53.

page 31 *Over the next...*: Cook, *Flip*.

page 31 *From the outside...*: Ibid.

page 31 *Wilson became known...*: "I Don't Care If You Laugh," *Time*, 19 October 1970, content.time.com/time/subscriber/article/0,33009,944164,00.html.

page 31 *"I'm about a year..."*: Tom Burke, "It Pays to Be Flip," *New York Times*, 13 October 1968, D 27.

page 32 *"His best comic..."*: Ibid.

page 32 *"I began to..."*: Cook, *Flip*.

page 32 *In 1969...*: Ibid.

page 32 *When The Flip Wilson Special...*: Cook, *Flip*.

page 32 *Most notably...*: Ibid.

page 33 *They worried...*: Jack Gould, "Flip Wilson, Supported by David Frost, Scores in His Premiere on N.B.C.," *New York Times*, 18 September 1970.

page 34 *The show was...*: Cook, *Flip*.

page 34 The Flip Wilson Show...: "The Flip Wilson Show, Awards & Nominations," Emmys.com, emmys.com/shows/flip-wilson-show.

page 34 *America's collective favor...*: Louie Robinson, "The Evolution of Geraldine," *Ebony*, December 1970.

page 34 *But other comics...*: Ponchitta Pierce, "All Flip Over Flip," *Ebony*, April 1968, 64–72.

page 34 *Fifteen years after...*: "Flip Wilson: Host of TV's Hottest New Show," *Jet*, 14 January 1971, 61.

page 34 *Murphy recalled...*: "Jerry Seinfeld & Eddie Murphy Debate the Funniest Comedian of All Time," Netflix Is a Joke, youtube.com/watch?v=DqbvsDt_D3o.

page 34 *"I had to use..."*: "Flip Wilson: Host of TV's Hottest New Show."

page 36 *"In the beginning ..."*: Ibid.

page 36 *The ratings for...*: Gary Deeb, "NBC's Summer Cancellations Appear Headed for Death Row," *Chicago Tribune*, 14 March 1974, 54.

page 37 *When Gladys Knight...*: *Chicago Tribune*, 30 October 1971, 86.

page 37 *"We got a speech together...thank God"*: BET, "Gladys Knight and The Pips Won Several Grammys Together!" Facebook, 14 September 2020, facebook.com/watch/?v=1006946706385631.

page 39 *"Well, let me tell you...beginning"*: Ibid.

page 39 *The first episode...*: Amir "Questlove" Thompson, *Soul Train: The Music, Dance, and Style of a Generation* (New York: HarperCollins, 2013).

page 40 *After less...*: Clarence Petersen, "TV Today: Critic Tells Why Season Is a Bust," *Chicago Tribune*, 7 October 1970, 3A-13.

page 40 *Their sponsorship...*: Melissa Magsaysay, "Joan Johnson Gave Black Women a Face in the National Beauty Market," *Chicago Tribune*, 23 September 2019, chicagotribune.com/lifestyles/fashion/ct-life-joan-johnson-beauty-tribute-0919-20190923-yuijwdotqfbsblwztqxhr2r5sq-story.html.

page 40 *Initially, the show...*: Thompson, *Soul Train: The Music, Dance, and Style of a Generation*.

page 40 *Cornelius moved...*: Ibid.

page 40 *For one, WCIU...*: Nina Metz, "Documentary Takes a Trip on 'Soul Train,'" *Chicago Tribune*, 2 September 2011, 4-3.

page 40 *"It was like Soul Train..."*: Delmont, interview with author.

page 40 *"But if you're into..."*: Clayton Riley, "A 'Train' on the Soul Track," *New York Times*, 4 February 1973, 121.

page 41 *The best time...*: "Original Soul Train Dancer
 Evette Moss aka 'Legs' Recalls Time on Soul
 Train and Why She Left," BET, youtube.com/
 watch?v=Ct5byTXLosQ.

page 42 *She and her brother...*: Robi Reed, interview
 with the author, 27 April 2022.

page 43 *"Every time we...":* Ibid.

page 43 *"We didn't know...":* Clarence Petersen, "TV
 Today: Critic Tells Why Season Is a Bust."

3: A PIECE OF THE PIE

page 45 *He told honest...*: "Without Norman Lear,
 There Would Be No Black-ish," An
 Evening with Norman Lear, Television
 Academy Foundation, youtube.com/
 watch?v=OROvEnHahB4.

page 45 *The well-reviewed episode...*: Maureen Ryan,
 "'Black-ish' Gets a Visit (and More) from
 Norman Lear," *Variety*, 27 April 2016, variety.
 com/2016/tv/features/black-ish-norman-
 lear-1201762355.

page 46 *"He could walk...":* Norman Lear, interviewed by
 Morrie Gelman for The Interviews: An Oral
 History of Television, Television Academy
 Foundation, 26 February 1998, interviews.
 televisionacademy.com/interviews/norman-lear.

page 46 *"I had to do...":* Judith L. Kessler, "Fred Sanford,
 as Honest a Black as Archie Is a Bigot," *San
 Francisco Examiner*, 23 January 1972, 168.

page 47 *"We're doing a...":* Irv Letofsky, "TV's 'Sanford
 and Son': Can White Writer, Black Stars
 Succeed with a Black Show?" *Minneapolis Star
 Tribune*, 30 January 1972, 56.

page 47 *The show's title...*: Phil Strassberg, "Foxx Gets
 Big Break," *Arizona Republic*, 1 January 1972.

page 48 Sanford and Son *premiered...*: John J.
 O'Connor, "TV: A Black Situation Comedy
 Settles into Top 10," *New York Times*, 17
 March 1972, 83.

page 49 *The latter became...*: Victor Merina and Lily
 Dizon, "Redd Foxx, TV's 'Sanford,' Dies of
 Heart Attack at 68: Entertainment: Comedian
 Is Stricken While Rehearsing New Show, 'The
 Royal Family,'" *Los Angeles Times*, 12 October
 1991, latimes.com/archives/la-xpm-1991-10-
 12-me-105-story.html.

page 49 *"Some day an...":* John J. Connor, "TV: A Black
 Situation Comedy Settles into Top 10."

page 49 *Ruben had seen...*: "Writer Tells It from Black
 Point of View," *Miami Herald* via Associated
 Press, 10 December 1972, 267.

page 50 *"They say at* Sanford*...":* Gregg Kilday, "Richard
 Pryor—Rapman Without an Exit Line," *Los
 Angeles Times*, 15 March 1973.

page 50 *Mooney wrote...*: Paul Mooney, *Black Is the New
 White* (New York: Gallery Books, 2010).

page 50 *In addition to...*: Marilyn Beck, "Aunt Esther
 Won't Become Big-Headed," *Times Herald*, 17
 October 1974.

page 50 *Foxx was so adamant...*: Charles Parker, "Redd
 Doesn't Forget His Old-Time Friends," *Valley
 News* (Van Nuys), 9 Feb 1977.

page 51 *One woman brought...*: Stan Lathan, interviewed
 by Oz Scott for the Directors Guild of America
 Visual History Program, 29 September 2015,
 dga.org/Craft/VisualHistory/Interviews/Stan-
 Lathan.aspx.

page 51 *"He felt responsible...":* Ibid.

page 51 *Mooney recalled...*: Mooney, *Black Is the New
 White*.

page 51 *In his memoir...*: Ibid.

page 53 *Tandem Productions...*: "Returns to Work,"
 Associated Press, July 1974.

page 53 *"He wants 25 percent...":* Robert E. Johnson,
 "What's Ahead for TV Star Redd Foxx," *Jet*, 30
 May 1974, 60–63.

page 53 *Foxx's lawyer...*: Ibid.

page 53 *As the dispute...*: "Returns to Work," Associated
 Press.

page 54 *"The purse strings...":* Karl Fleming, "Pity the
 Poor Producers of TV Series," *New York Times*,
 31 August 1975, 89.

page 54 *"My jokes were...":* Johnson, "What's Ahead for
 TV Star Redd Foxx."

page 54 *"I'm behind you..."*: Robert E. Johnson, "Readers Support Redd Foxx in His TV Fight," *Jet*, 30 May 1974, 65.

page 56 *Monte had grown up...*: Ronald E. Kisner, "New Comedy Brings Good Times to TV," *Jet*, 23 May 1974, 58–60.

page 56 *"Norman has so much..."*: Charles Witbeck, "Maude's Maid Finds a Home of Her Own," *Miami News*, 23 February 1974, 61.

page 56 *One character in...*: Louie Robinson, "Bad Times on the 'Good Times' Set," *Ebony*, September 1975.

page 56 *"He's 18..."*: Ibid.

page 56 *"I resent the imagery..."*: Ibid.

page 57 *Amos, meanwhile...*: Ibid.

page 57 *Amos recalled...*: "Norman Lear: Just Another Version of You," *American Masters*, PBS, directed by Heidi Ewing and Rachel Grady (1515 Productions Limited, 2016).

page 57 *"There were lines..."*: Ibid.

page 57 *"We had to do..."*: Ibid.

page 58 *"We got Black men..."*: Ibid.

page 58 *"Good Times for me..."*: "Norman Lear: A Conversation with Kenya Barris," PeopleTV, 29 September 2019, peopletv.com/video/ew-special-norman-lear-a-conversation-with-kenya-barris.

page 59 *Roker was in...*: Norman Lear, *Even This I Get to Experience* (New York: Penguin Books, 2015).

page 60 *In his memoir...*: Ibid.

page 61 *In 1977...*: Gary Deeb, "'Good Times' Creator Ready for a Few Good Times, Too," *Chicago Tribune*, 29 June 1977.

page 61 *Monte, who battled...*: John L. Mitchell, "Plotting His Next Big Break," *Los Angeles Times*, 14 April 2006, latimes.com/archives/la-xpm-2006-apr-14-me-monte14-story.html.

page 61 *"We were the Number..."*: Robert Lindsey, "Redd Foxx, Is That You Starring in a Big-Time Movie?" *New York Times*, 20 June 1976, 73.

4: ROOTS

page 63 *Very few Black...*: Bogle, *Primetime Blues*.

page 63 *That same year...*: "Diahann Carroll, Awards & Nominations," Emmys.com, emmys.com/bios/diahann-carroll.

page 63 *A decade later...*: Steven R. Weisman, "'Jane Pittman' Wins Emmy for the Best Program," *New York Times*, 29 May 1974, 82.

page 63 *In late 1974...*: Harry F. Waters, with Janet Huck, "Dear Me, Mr. Lassiter!" *Newsweek*, 25 August 1975.

page 64 Roots *didn't air...*: Dave Kindy, "How a Rookie Writer's Reader's Digest Story Spawned Two Monumental Works of Black History," *Washington Post*, washingtonpost.com/history/2022/02/05/alex-haley-readers-digest-roots-malcolm.

page 64 *It was during...*: Alex Haley, "Miles Davis," *Playboy*, September 1962.

page 66 *Haley signed...*: Matthew F. Delmont, *Making Roots: A Nation Captivated* (Oakland: University of California Press, 2016).

page 66 *In 1972...*: Alex Haley, "My Furthest-Back Person—'The African,'" *New York Times Magazine*, July 16, 1972.

page 66 *Some were deeply...*: Delmont, *Making Roots: A Nation Captivated*.

page 66 *"Using stories handed down..."*: Ibid.

page 66 *Margulies later recalled...*: Susan King, "Roots Plus 20: Present at the Creation," *Los Angeles Times*, 26 January 1997, latimes.com/archives/la-xpm-1997-01-26-ca-22132-story.html.

page 67 *The production had...*: Ibid.

page 67 *But despite the...*: Ibid.

page 67 *Concerned that white...*: Ibid.

page 68 *And the producers...*: Ibid.

page 68 *Woodie King Jr., who...*: Delmont, *Making Roots: A Nation Captivated*.

page 68 *Years earlier...*: Ibid.

page 70 *After Wilcots...*: Joseph M. Wilcots, interviewed by Gary Rutkowski for The Interviews: An Oral History of Television,

Television Academy Foundation, 5 December 2007, interviews.televisionacademy.com/interviews/joseph-m-wilcots.

page 70 *"Haley's depiction..."*: Jay Sharbutt, "TV Doesn't Do Justice to Haley's Book, 'Roots.'" *Oakland Tribune* via Associated Press, 25 January 1977, 14.

page 70 *"The millions..."*: Bethonie Butler, "Everyone Was Talking About 'Roots' in 1977—Including Ronald Reagan," *Washington Post*, 30 May 2016, washingtonpost.com/news/arts-and-entertainment/wp/2016/05/30/everyone-was-talking-about-roots-in-1977-including-ronald-reagan.

page 70 *Its success led...*: Les Brown, "ABC Took a Gamble with 'Roots' and Is Hitting Paydirt," *New York Times*, 28 January 1977, 43.

page 71 *The April 1977...*: Hans J. Massaquoi, "Alex Haley: The Man Behind Roots," *Ebony*, April 1977, 33–41.

page 71 *A few months after...*: Linda Navarro, "Did 'Roots' Bring Fame and Glory? John Amos, aka Kunte Kinte, Plans Original One-Man Show," *Colorado Springs Gazette-Telegraph*.

page 71 *"That was really..."*: Matthew F. Delmont, interview with the author, 25 January 2022.

page 71 *"Even though we..."*: King, "Roots Plus 20: Present at the Creation."

page 73 *In 2016, History Channel*: Bethonie Butler, "Can the New 'Roots' Help Us Understand America's Current Racial Divide?" *Washington Post*, 27 May 2016, washingtonpost.com/lifestyle/style/a-new-vision-of-roots-for-the-age-of-obama/2016/05/26/a8351eea-16d4-11e6-924d-838753295f9a_story.html.

5: '80S SITCOMS

page 75 *"It's like after..."*: Kelly Scott, "Tim Reid Sends Out a Strong Signal for 'WKRP' Show," *St. Petersburg Times*, 11 July 1981, 19.

page 75 *But he did...*: Tim Reid, interview with the author, 7 May 2022.

page 75 *"You know, at the time..."*: Ibid.

page 75 *The first thing...*: Ibid.

page 76 *Reid made up his mind...*: Ibid.

page 76 *His acting breakthrough...*: Mike Scott, "Long before 'Treme,' There Was 'Frank's Place,'" *Times-Picayune*, 5 August 2017, nola.com/300/article_e7abfac0-6ce4-553f-a27d-c547aabb2f23.html.

page 76 *While the top...*: Ibid.

page 78 *Critic David Bianculli...*: David Bianculli, "At Season's End, 'The Cosby Show' Is Rookie of the Year," *Philadelphia Inquirer*, 28 April 1985, 4-I.

page 78 *"For the ailing..."*: Lynn Norment, "The Real-Life Drama Behind Hit TV Show About a Black Family," *Ebony*, April 1985, 27–34.

page 78 *But it's also true...*: Chiqui Esteban and Manuel Roig-Franzia, "Bill Cosby's Accusers Now Number 60. Here's Who They Are," *Washington Post*, 3 August 2016, washingtonpost.com/graphics/lifestyle/cosby-women-accusers.

page 78 *Cosby was convicted...*: Sonia Rao, Paul Farhi, and Manuel Roig-Franzia, "Bill Cosby Released from Prison after Sexual Assault Conviction Is Vacated by Pennsylvania Supreme Court," *Washington Post*, 30 June 2021, washingtonpost.com/arts-entertainment/2021/06/30/bill-cosby-sexual-assault-conviction-overturned.

page 78 *Allegations of...*: Maryclaire Dale, "Bill Cosby, Woman Settle Lawsuit over Alleged Assault," Associated Press, 8 November 2006.

page 78 *"Bill Cosby has..."*: Kevin Fallon, "When Hannibal Buress Called Bill Cosby a Rapist and Helped Topple an Icon," *Daily Beast*, 21 February 2022, thedailybeast.com/obsessed/we-need-to-talk-about-cosby-finale-hannibal-buress-called-bill-cosby-a-rapist-and-helped-topple-an-icon.

page 80 *As the allegations...*: Bill Carter, Graham Bowley, and Lorne Manly, "Comeback by Cosby Unravels as Accounts of Rape Converge," *New York Times*, 20 November 2014, A1.

page 80 *In 2015...*: "Excerpts of Bill Cosby's Statements in a 2005 Deposition," Associated Press, 6 July 2015, apnews.com/article/4c11f7c879ad4b0b8242efbaa251c9dd.

page 82 *Big Three networks went...*: Jerry Krupnick, "A Moonlighting Job Helps Marla Gibbs Find New Role," Newhouse News Service, July 1985.

page 83 *Despite playing...*: Aldore Collier, "Marla's Masterpiece," *Ebony*, December 1986.

page 83 *Harry earned two...*: Neal Justin, "Newcomers to the Party: Asian and Black Artists Made Progress at the Emmys as Old Favorites Took the Top Awards," *Star Tribune*, 13 September 2022.

page 84 *"I'm an uncredited..."*: Evan Levine, "Marla Gibbs Finds the View Fine from '227,'" *St. Petersburg Times* (Florida), 27 August 1989.

page 84 *"That's what happens..."*: Bethonie Butler, "Why Marla Gibbs of 'Scandal' and 'The Jeffersons' Won't Tell You Her Age," *Washington Post*, 12 March 2015, washingtonpost.com/news/arts-and-entertainment/wp/2015/03/12/why-marla-gibbs-of-scandal-and-the-jeffersons-wont-tell-you-her-age.

page 84 *"There is a lot..."*: "In Its 4th Season '227' Still a Big Hit," *Jet*, 31 October 1988, 60.

page 84 *Gibbs was asked...*: Ray Richmond, "Winners, Losers: A Tale of Two Pilots," *Los Angeles Daily News*, 16 May 1985.

page 84 *"We represent the..."*: Barbara Holsopple, "Real Marla Gibbs Not on Stage," *Knoxville News-Sentinel* via Scripps Howard News Service, 3 January 1986, B6.

page 85 *I didn't know...*: "Sherman Hemsley and Clifton Davis Return to TV as Stars of Own Show," *Jet*, 27 October 1986, 58.

page 86 *He was cast...*: Frank White III, "A Star Is Reborn," *Ebony*, February 1988, 104–106.

page 86 *A May 1991...*: "New Baby and Guest Star James Brown Climax Fifth Season of TV's 'Amen,'" *Jet*, 13 May 1991, 58.

page 86 *Brown had been...*: James Brown, interview with *Entertainment Tonight*, 11 April 1991, https://archive.org/details/EntertainmentTonightApril111991.

page 87 *"I will never forget..."*: Tim Reid, interview with the author, 7 May 2022.

page 87 *"We spent a few..."*: Ibid.

page 87 *"She had the power..."*: Ibid.

page 88 *"That's Miss Marie..."*: Ibid.

page 88 *"I was like..."*: Ibid.

page 88 *When Reid finished...*: Ibid.

page 88 *"It was a marvelous..."*: Ibid.

page 88 *"What started out..."*: Mark Schwed, "'Frank's Place' Is More than Just Another Sitcom," United Press International (UPI), 25 July 1987.

page 88 *"We've broken some..."*: Cynthia Robins, "Tim Reid Finds Spot of His Own," *San Francisco Examiner*, 9 November 1987, E-3.

page 89 *A day after...*: Tim Reid, interview with the author, 7 May 2022.

page 89 *"The part that..."*: Ibid.

page 89 *"New Orleanians..."*: Mike Scott, "Long before 'Treme,' There Was 'Frank's Place,'" *Times-Picayune*, 5 August 2017, nola.com/300/article_e7abfac0-6ce4-553f-a27d-c547aabb2f23.html.

page 89 *"I still think..."*: Tim Reid, interview with the author, 7 May 2022.

6: COMEDY AND VARIETY SHOWS

page 92 *"Well, as you..."*: Official Richard Pryor, "The Richard Pryor Show: The First Black President," YouTube video, 06:51, 5 May 2022, youtube.com/watch?v=gFWhoDdnb2k.

page 92 *Among them...*: Mooney, *Black Is the New White*.

page 94 *Here, Pryor was...*: Jason Reid, "James 'Shack' Harris Is Prominent on List of Groundbreaking Quarterbacks," Andscape, 12 October 2017, andscape.com/features/james-shack-harris-is-prominent-on-list-of-groundbreaking-quarterbacks.

page 94 *It should have...*: Steve Wulf, "'All Hell Broke

Loose,'" ESPN, 20 January 2014, espn.com/ nfl/story/_/id/10294156/in-1974-james-harris-became-first-black-qb-start-playoff-game-espn-magazine.

page 94 *was released by...*: Ibid.

page 94 *Despite his successful...*: Justin Tinsley, "Richard Pryor Told America About the Struggle of Black Quarterbacks," 16 January 2020, andscape.com/features/richard-pryor-told-america-about-the-struggle-of-black-quarterbacks.

page 95 *After repeated battles...*: Mooney, *Black Is the New White.*

page 95 *To the bewilderment...*: John O'Connor, "A Season of Sure-Fire Trash," *New York Times*, 2 October 1977.

page 95 *Ahead of the premiere...*: "NBC Chief Mollifies Richard Pryor," Associated Press, 1977.

page 96 *In the 2013 book...*: David Henry and Joe Henry, *Furious Cool: Richard Pryor and the World that Made Him* (Chapel Hill, NC: Algonquin Books, 2013).

page 96 *"They wanted to..."*: Louie Robinson, "Richard Pryor Talks," *Ebony*, January 1978, 116.

page 96 *"The tales of..."*: Henry and Henry, *Furious Cool.*

page 98 *Asked if he...*: Richard L. Berke, "Jackson's Rhymes: Lilting to a Different Cadence," *New York Times*, 16 April 1988, 8.

page 100 *A seventeen-year-old...*: Gail Mitchell, "'Wired to Sing Only from Her Heart': Ella Fitzgerald Feted on 'Ella 100: Live at the Apollo!'" *Billboard*, 23 April 2020, billboard.com/pro/ella-fitzgerald-celebration-ella-100-live-at-the-apollo/.

page 100 *Over the years...*: CBS News, "Obama Sings 'Let's Stay Together' at the Apollo," 20 January 2012, youtube.com/watch?v=0oQI3_K7w_g.

page 100 *Later, the Apollo...*: Kevin Cook, *Flip: The Inside Story of TV's First Black Superstar* (Viking, 2013).

page 100 *An up-and-coming...*: Lynn Hirschberg, "How Black Comedy Got the Last Laugh," *New York Times*, 3 September 2000, 35.

page 100 *"It was probably..."*: Lisa Robinson, "Showtime at the Apollo: An Oral History of the Theater That Became Home to American Legends," *Vanity Fair*, 26 April 2019, vanityfair.com/style/2019/04/showtime-at-the-apollo-oral-history-of-the-theater.

page 100 *And while...*: Steve Holsey, "It's Always Showtime at the Apollo Theater," *Michigan Chronicle*, 8 April 2009, D1.

page 102 *Meanwhile, the...*: Vincent M. Mallozzi, "Meet the Executioner. Your Amateur Night at the Apollo Is Over," *New York Times*, 28 March 2017, C1.

page 102 *Mark Curry...*: Don Kaplan, "'Showtime at the Apollo' Sings, Stomps and Dances Back onto TV," New York *Daily News*, 26 November 2016, nydailynews.com/entertainment/tv/showtiime-apollo-sings-stomps-dances-back-tv-article-1.2885537.

page 102 *Luther Vandross...*: Paula Span, "The Rebirth of the Boos," *Washington Post*, 16 June 1985, washingtonpost.com/archive/lifestyle/style/1985/06/16/the-rebirth-of-the-boos/132dff0f-d675-4345-b668-bb299327d129/.

page 103 *"Flip Wilson doesn't..."*: Jim Radenhausen, "Arsenio Hall on Surprises, Comedy and Customizing His Act for the Poconos," *Pocono Record*, 2 February 2017, poconorecord.com/story/entertainment/local/2017/02/02/arsenio-hall-on-surprises-comedy/22553701007.

page 104 *One Late Show...*: Andy Meisler, "Two TV Veterans March into the Late-Night Fray," *New York Times*, 1 January 1989, nytimes.com/1989/01/01/arts/television-two-tv-veterans-march-into-the-late-night-fray.html.

page 104 *Mariah Carey...*: Mariah Carey and Michaela Angela, *The Meaning of Mariah Carey* (New York: Macmillan, 2020).

page 105 *By the fall...*: Jefferson Graham, "Arsenio Hall Is Living Large," *USA Today*, 20 October 1989, 1D.

page 105 *"If a guy's..."*: Michael E. Hill, "Arsenio Hall," *Washington Post*, 12 March 1989, washingtonpost.com/archive/lifestyle/tv/1989/03/12/arsenio-hall/3f8822c2-0de2-428d-9a05-0942f1fdfb6e/.

page 105 *He landed major...*: Bill Carter, "Familiar Night Bird Reclaims a Perch," *New York Times*, 8 September 2013, nytimes.com/2013/09/09/arts/television/arsenio-hall-show-returns-after-a-nearly-20-year-hiatus.html.

page 106 *As the presumptive...*: David Maraniss, "Tooting His Own Horn," *Washington Post*, 5 June 1992, washingtonpost.com/archive/lifestyle/1992/06/05/tooting-his-own-horn/37cff9b0-07b5-45b6-9c5b-0d9bef7fb4c9/.

page 106 *The takeaway...*: Daniel Cerone, "No Carson Copycat, Hall Woofs Up His Audience by Making His Own Rules," *Los Angeles Times*, 5 January 1992, latimes.com/archives/la-xpm-1992-01-05-tv-2136-story.html.

page 106 *Ahead of the show's...*: Howard Rosenberg, "Arsenio Hall vs. Louis Farrakhan: It's a Rout," *Los Angeles Times*, 28 February 1994, latimes.com/archives/la-xpm-1994-02-28-ca-28353-story.html.

page 108 *"I wanted to..."*: Bethonie Butler, "Blackface Has Long Been an Issue in Comedy. Look No Further than 'Saturday Night Live' for Proof," *Washington Post*, 25 June 2020, washingtonpost.com/arts-entertainment/2020/06/25/saturday-night-live-blackface.

page 108 *"But instead of..."*: Daniel Cerone, "A New Fox Comedy Brought to You 'In Living Color,'" *Los Angeles Times*, 15 April 1990, latimes.com/archives/la-xpm-1990-04-15-tv-2092-story.html.

page 109 *"I used to call..."*: S. Pajot, "Paul Mooney Talks Arizona's Immigration Law, Richard Pryor, and the Birth of Homey D. Clown," *Miami New Times*, 13 August 2010, miaminewtimes.com/arts/paul-mooney-talks-arizonas-immigration-law-richard-pryor-and-the-birth-of-homey-d-clown-6493163.

page 109 *"We take an exaggerated..."*: Marc Gunther, "Black Producers Add a Fresh Nuance," *New York Times*, 26 August 1990.

page 109 *"He did not like..."*: Maria Reinsten, "'We Were Warped Out of Our Minds': 'In Living Color' Stars Recall Fox Censors, Spike Lee's Disdain in Dishy Oral History," *Hollywood Reporter*, 21 June 2019, hollywoodreporter.com/movies/movie-features/living-color-oral-history-fox-censors-spike-lees-disdain-1219192.

page 110 *"I had to constantly..."*: Gunther, "Black Producers Add a Fresh Nuance."

page 110 *"Minority talent..."*: Tom Green, "Wayans' Comedy Comes Alive in 'Living Color,'" *USA Today*, 13 April 1990.

page 110 *"Everything was videotaped..."*: Robi Reed, interview with the author, 27 April 2022.

page 110 *"Everyone auditioned..."*: Ibid.

page 110 *"Eventually," Reed says...*: Ibid.

page 110 *It was the first...*: "In Living Color: Awards & Nominations," Emmys.com, emmys.com/shows/living-color.

page 112 *"I didn't have..."*: Reinsten, "'We Were Warped Out of Our Minds.'"

page 112 *"These guys are..."*: Greg Braxton, "A Showcase for Unknown Black Comics, 'Russell Simmons' Def Comedy Jam' Begins Its Second Season Friday on HBO," *Los Angeles Times*, 6 August 1992, latimes.com/archives/la-xpm-1992-08-06-ca-5268-story.html.

page 113 *Lathan, who had been...*: Ibid.

page 113 *"That was what I think"*: Stan Lathan, interviewed by Oz Scott for the Director's Guild of America Visual History Program, 29 September 2015.

page 115 *"On my show..."*: Cindy Pearlman, "He Will Rock You; Comic Treats Everyone as a Target for Zingers," *Chicago Sun-Times*, 3 September 2000, 4.

page 115 *When* The Chris Rock Show...: "Life in the Pop Lane; Mourning Late-Night's Best Show," *Boston Globe*, 28 November 2000.

page 116 *In the* New York Times...: Elvis Mitchell, "Chappelle's 'Show': A Successor to 'In Living Color'?" *New York Times*, 23 March 2003.

page 118 *Overwhelmed with his...*: Christopher John Farley, "Dave Speaks," *Time,* 14 May 2005, content.time.com/time/magazine/article/0,9171,1061512,00.html.

page 118 *"I want to make sure..."*: Ibid.

page 119 *"When he laughed..."*: Ibid.

page 119 *"I was doing sketches..."*: "Why Comedian Dave Chappelle Walked Away from $50 Million," *The Oprah Winfrey Show*, 15 October 2019, youtube.com/watch?v=tlScX2stRuo.

page 119 *"The minute you hear..."*: Mooney, *Black Is the New White.*

7: '90S SITCOMS

page 121 *Originally intended...*: "Lisa Bonet: Emmy Awards & Nominations," Emmys.com, emmys.com/bios/lisa-bonet.

page 122 *Once that happened...*: Robi Reed, interview with the author, 27 April 2022.

page 122 *With the Huxtables...*: Jerry Buck, "'Cosby Show' Leads Laugh Parade to Nielsen Victory," Associated Press, January 1988.

page 122 *But producers...*: "New Face on 'Different World,'" Associated Press, January 1988.

page 122 *Debbie Allen...*: Jennifer Dunning, "Debbie Allen Chips Away at the Glass Ceiling," *New York Times*, 29 March 1992.

page 122 *was brought in to...*: "'World' Wins Ratings Derby, but Still Seeks Critics' Respect," Gannett News Service, May 1990.

page 122 *Cosby had ruled...*: Debbie Allen, interviewed by Stephen J. Abramson for The Interviews: An Oral History of Television, Television Academy Foundation, 15 April 2011, interviews.televisionacademy.com/interviews/debbie-allen.

page 123 *Bonet returned...*: David Bianculli, "Why 'World' Turned on Tomei," *New York Daily News*, 14 July 2006.

page 123 *"I felt the show..."*: Jerry Buck, "NBC's 'A Different World' Is Most Improved Show of Year," Associated Press, 24 February 1989.

page 123 *"It was the first time..."*: Michael E. Hill, "Debbie Allen: She Made 'Different' a Better 'World,'" *Washington Post*, 13 August 1989, washingtonpost.com/archive/lifestyle/tv/1989/08/13/debbie-allen-she-made-different-a-better-world/3a276c0d-dd5d-4a1f-81bc-6f8ac6eb349d.

page 123 *Allen toned down...*: Buck, "NBC's 'A Different World' Is Most Improved Show of Year."

page 124 *She sent writers...*: Diane Haithman, "Different Touch to 'Different World,'" *Los Angeles Times*, 6 October 1988.

page 124 *Aretha Franklin's...*: Eirik Knutzen, "Dawnn's Bright Light," *Toronto Star*, 9 January 1988.

page 124 *Producers had planned...*: Victoria Johnson, "How Aretha Franklin Ended Up Singing the 'A Different World' Theme Song," *Vulture*, 21 August 2018, vulture.com/2018/08/the-story-of-aretha-franklins-a-different-world-theme-song.html.

page 124 *Boyz II Men...*: Donna Gable, "On 'World,' Newlyweds and New Collegians," *USA Today*, 13 August 1992, 3D.

page 125 *The show's writers...*: Bethonie Butler, "How 'A Different World' Dealt with the L.A. Riots and Set the Stage for a More Political TV," *Washington Post*, 27 April 2017, washingtonpost.com/entertainment/tv/how-a-different-world-confronted-the-la-riots-25-years-ago/2017/04/26/ffe9bea0-28fa-11e7-b605-33413c691853_story.html.

page 125 *After some back-and-forth...*: Ibid.

page 125 *"People are waiting..."*: Greg Braxton, "A 'Different' Take on the L.A. Riots: Television: Industry and Civic Leaders Are Both Impressed and Nervous As 'A Different World' Opens a New Season by

Dealing with the Unrest," *Los Angeles Times*, 13 August 1992, latimes.com/archives/la-xpm-1992-08-13-ca-5854-story.html.

page 125 *"That subject...":* Butler, "How 'A Different World' Dealt with the L.A. Riots and Set the Stage for a More Political TV."

page 125 *The series nurtured...:* Samantha Bergeson, "Lena Waithe Shares a Moving Tribute to the Cast of 'A Different World,'" *E! News*, 24 June 2021, eonline.com/news/1282873/lena-waithe-shares-a-moving-tribute-to-the-cast-of-its-a-different-world.

page 126 *The series was cited...:* Jocelyn Y. Stewart, "Black Colleges Experience a 'Renaissance,'" *Los Angeles Times*, 28 October 1990, B3.

page 126 *Decades after...:* Butler, "How 'A Different World' Dealt with the L.A. Riots and Set the Stage for a More Political TV."

page 126 *Though* Family Matters...: Michael Dougan, "TV Goes Ethnic," *San Francisco Examiner*, 20 July 1989, B1.

page 128 *But from the moment...:* Jo Marie Payton, interview with the author, 31 March 2022.

page 128 *The feeling was...:* "'Family Matters' Reginald VelJohnson Says Jaleel White Was 'a Little Difficult' to Work With," *Entertainment Tonight*, 14 June 2022, facebook.com/watch/?v=592836912123733&ref=sharing.

page 128 *White was twelve...:* "Urkel Wins Big Laughs, Success on Sitcom 'Family Matters,'" *Jet*, 3 June 1991.

page 129 *Urkel was an...:* Nick Romano, "Jaleel White Says He 'Was Not Very Well Welcomed' by the *Family Matters* Cast," *Entertainment Weekly*, 11 May 2021, ew.com/tv/jaleel-white-family-matters-cast-drama-uncensored-video.

page 129 Adweek *attributed...:* Stephen Battaglio, "'Dad,' 'Doogie' Defy Sophomore Jinx," *AdWeek*, 12 November 1990.

page 129 *By 1991...:* Michelle Healy, "Look for TV Stars on Dolls, Duds and Doodads," *USA Today*, 20 June 1991, 1D.

page 129 *On* Coach...: Ed Bark, "Jaleel White's Steve Urkel Character Could Turn Up on *All* of the ABC Shows," *News Tribune*, 7 October 1991, 13.

page 129 *"Even though he's...":* Bridget Byrne, "For Jaleel, Playing a Nerd with Flair Is What 'Matters,'" *Chicago Tribune*, 30 December 1990, 160.

page 130 *"It happens the same...":* Jo Marie Payton, interview with the author, 31 March 2022.

page 131 *It's no tightly...:* Romano, "Jaleel White Says He 'Was Not Very Well Welcomed' by the 'Family Matters' Cast."

page 131 *Meanwhile, his costars...:* "'Family Matters' Reginald VelJohnson Says Jaleel White Was 'a Little Difficult' to Work With."

page 131 *Even Payton...:* Dory Jackson, "'Family Matters' Alum Jo Marie Payton Claims Jaleel White Tried to 'Physically Fight' Her on Set," *People*, 4 May 2022, people.com/tv/family-matters-alum-jo-marie-payton-claims-jaleel-white-attempted-to-fight-her-on-set.

page 131 *"It's like a soup...":* Jo Marie Payton, interview with the author, 31 March 2022.

page 131 *"But then...":* Ibid.

page 131 *"The way that...":* Ibid.

page 131 *"That felt like...":* Ibid.

page 131 *"I had an issue...":* Ibid.

page 132 *Felicia D. Henderson...:* Cheryl Robinson, "How Hollywood Trailblazer Felicia D. Henderson Successfully Inked a Multiyear Studio Deal," *Forbes*, 22 May 2019, forbes.com/sites/cherylrobinson/2019/03/22/how-hollywood-trailblazer-felicia-d-henderson-successfully-inked-a-multi-year-studio-deal/?sh=3ba2c1215555.

page 132 *Speaking to the* Atlantic...: Hannah Giorgis, "The Unwritten Rules of Black TV," *Atlantic*, 13 September 2021, theatlantic.com/magazine/archive/2021/10/the-unwritten-rules-of-black-tv/619816.

page 133 *When the line...:* Jo Marie Payton, interview with the author, 31 March 2022.

page 133 *"That was it for me...":* Ibid.

page 133 *Payton eventually left...*: Ibid.

page 133 *"We were about..."*: Ibid.

page 133 *"This is the only..."*: Ibid.

page 135 *Among the stars...*: Will Smith, "Will Smith on the Impromptu Audition That Changed His Life," *Vanity Fair*, vanityfair.com/hollywood/2021/11/will-smith-book-excerpt-fresh-prince-quincy-jones.

page 135 *Jones urged...*: Ibid.

page 135 *Just a few months...*: A.D. Carson, "Grammys Have Little Credibility in the Hip-Hop Community. Here's Why," *Washington Post*, 10 April 2022, washingtonpost.com/outlook/2022/04/10/grammys-have-little-credibility-hip-hop-community-heres-why.

page 136 *A follow-up...*: Ryan Parker, "Will Smith Did 'Fresh Prince' Because He Was in Trouble with the IRS," *Hollywood Reporter*, 23 May 2018, hollywoodreporter.com/tv/tv-news/will-smith-did-fresh-prince-because-he-was-trouble-irs-1111359.

page 136 *Medina told him...*: Will Smith, "How I Became the Fresh Prince of Bel-Air," YouTube video, 10 May 2018, youtube.com/watch?v=y_WoOYybCro.

page 136 *And by the time...*: Ibid.

page 136 *"We connected from..."*: Karyn Parsons, interview with the author, 4 March 2022.

page 136 *Ahead of its...*: "Corridor Talk: Brandon Takes the Rap on This One," *Adweek*, 6 August 1990.

page 137 *but told the* Baltimore Sun...: Michael Hill, "Fresh Prince Brings Young, Urban Attitude to NBC Sitcom," *Evening Sun*, 9 August 1990, C1.

page 137 *"With this, I said..."*: Ibid.

page 138 *"For some reason..."*: Larry King, "Alfonso Ribeiro on 'AFV,' 'Fresh Prince,' & Will Smith," YouTube video, 29 November 2019, youtube.com/watch?v=CiUi9S6v15I.

page 138 *"In an alternate..."*: Tamron Hall Show, "Alfonso Ribeiro Turned Down a Role On 'A Different World' for 'The Fresh Prince of Bel-Air,'"

YouTube video, 17 November 2020, youtube.com/watch?v=g3mY_U1fCrg.

page 138 *"She didn't do..."*: Karyn Parsons, interview with the author, 4 March 2022.

page 139 *"I can't tell you..."*: Ibid.

page 139 *"It was just an audition..."*: "Tatyana Ali on Being Cast for 'The Fresh Prince' (Flashback)," VLAD TV, youtube.com/watch?v=l_1TNwf63fQ.

page 141 *"I had been asked..."*: Daphne Maxwell Reid, interview with the author, 4 March 2022.

page 141 *But that fall...*: Ibid.

page 141 *After landing the...*: Ibid.

page 143 *As Smith recalled...*: "Will Smith," *Rap Radar*, Tidal, 16 July 2018, youtube.com/watch?v=gaBGMlDde1E.

page 144 *"While he's hugging..."*: Ibid.

page 144 *Smith had personally...*: James Endrst, "From Bel-Air Back to Philadelphia, a Homecoming for the Fresh Prince," *Hartford Courant*, 8 April 1994, C1.

page 144 *"It still takes..."*: Daphne Maxwell Reid, interview with the author, 4 March 2022.

page 146 *Early series...*: "Live, on Saturday Night—'Gimme a Break,'" Gannett News Service, February 1985.

page 146 *The episode earned...*: "Fox's 'Roc' Plans More Live Episodes," *Olympian*, 13 February 1992, 25.

page 148 *Dutton, a real-life...*: Kenneth R. Clark, "After a Rocky Start, Dutton's Life Now 'Roc'-Solid," *Chicago Tribune*, 25 August 1991, C5.

page 148 *Russell marries...*: David J. Fox, "Media Group Cites 'Roseanne,' Others for Positive Gay Images," *Los Angeles Times*, 27 January 1992, latimes.com/archives/la-xpm-1992-01-27-ca-772-story.html.

page 148 *Roundtree, who...*: Ian Spelling, "Second-Shift Shaft; Richard Roundtree Returns to His Most Famous Role," *Kitchener-Waterloo Record*, 15 June 2000, D9.

page 148 *Roundtree said...*: Ibid.

page 148 *"He was the epitome..."*: Marc Snetiker, "Rocky Carroll on Roc's 1991 Same-Sex Wedding: Television Is Always Ahead of the Curve," *Entertainment Weekly*, 29 June 2015, ew.com/article/2015/06/29/rocky-carroll-remembers-tvs-first-same-sex-wedding-we-werent-trying-set-policy.

page 148 *"I am a serious..."*: Susan King, "From Hard Time to Prime Time," *Los Angeles Times*, 15 August 1991, F3.

page 148 *As Roc prepared...*: Patrick Pacheco, "Black and Blue-Collar," *Newsday*, 18 August 1991, 18.

page 149 *Lathan, who directed...*: Ibid.

page 150 *"I didn't want..."*: Mark Lorando, "A Softer 'Roc' Starts Third Season Tonight," *The Times-Picayune*, 31 August 1993, C1.

page 150 *"This was an adult..."*: Ibid.

page 150 *Fox canceled Roc...*: Ken Parish Perkins, "Dutton Frustrated with Demise of 'Roc,'" *Chicago Tribune*, 8 June 1994, C2.

page 150 *"It's reflective..."*: "'Roc' Rolls from Favor; Black Rancor Grows As Star Mounts Fox Hunt," Associated Press, May 1994.

page 150 *The support for Roc...*: William Douglas, "Taking on TV," *Newsday*, 30 January 1995, A8.

page 150 *"I don't know anybody..."*: Ibid.

page 150 *"I just find it..."*: Ken Parish Perkins, "Dutton, Fox at Odds over Demise of 'Roc,'" *Chicago Tribune*, 8 June 1994, C2.

page 152 *But Dutton told...*: Lynn Elber, "Black Shows Draw Criticism," Associated Press, May 1994.

page 153 *"a minstrel show"*: Bob Strauss, "Controversial Comic Answers Critics," *Chicago Sun-Times*, 20 February 1994, 3.

page 153 *"We can whisper..."*: Ibid.

page 156 *"One of the billboards..."*: Greg Braxton, "'Single' Looks for a Little Help Against 'Friends,'" *Los Angeles Times*, 1 February 1996, F1.

page 156 *"It just pisses me..."*: Ibid.

page 157 *Recapping a 1993...*: Lisa de Moraes, "TV Execs Clash over Politics of On-Air Violence," *Hollywood Reporter*, 15 September 1993.

page 158 *But the particular optics...*: Braxton, "'Single' Looks for a Little Help Against 'Friends.'"

page 158 *"Fox takes our audience..."*: Ibid.

page 158 *"Sure, we use..."*: Harry F. Waters, "Black Is Bountiful," *Newsweek*, 6 December 1993, 59.

page 159 *Up against Friends...*: Eric Deggans, "Grim Days for Black TV Comedies," *St. Petersburg Times*, 21 September 1998, 1D.

page 159 *"I don't get..."*: Pamela Noel, "Sitcom's Canceled? Cheer Up at Bendel's," *New York Times*, 21 December 1997.

page 159 *That year...*: "1998–99 United States Network Television Schedule," Wikipedia, last updated 14 October 2022, en.wikipedia.org/wiki/1998%E2%80%9399_United_States_network_television_schedule.

page 159 *When David Schwimmer...*: Kimberly Roots, "*Friends'* David Schwimmer Apologizes for Diversity Comments: 'I Didn't Mean to Imply *Living Single* Hadn't Existed,'" *TV Line*, 3 February 2020, tvline.com/2020/02/03/friends-david-schwimmer-living-single-apology-diversity-controversy.

page 159 Friends *was among...*: Emily Yahr, "'Gilmore Girls' Is Coming to Netflix: Here's Why That's a Big Beal," *Washington Post*, 11 September 2014, washingtonpost.com/news/arts-and-entertainment/wp/2014/09/11/gilmore-girls-is-coming-to-netflix-heres-why-thats-a-big-deal.

page 159 *It would take...*: Jordan Crucchiola, "*Living Single* Is Coming to Hulu, Because You Need a More '90s Kind of World," *Vulture*, 9 January 2018, vulture.com/2018/01/living-single-to-start-streaming-on-hulu.html.

8: UPN AND THE WB

page 161 *But at the same...*: Muriel L. Whetstone, "Cosby Is Back but Black-Oriented Shows Decline," *Ebony*, October 1996.

page 162 *"Once that happened..."*: Robi Reed, interview with the author, 27 April 2022.

page 165 *This was quietly...*: Tom Feran, "TV Teen Girls Blossom-ing; Time for Starring Roles Instead of Playing Second Fiddle," *Cleveland Plain Dealer*, 13 March 1994, 1I.

page 165 *"When we were younger..."*: Nerisha Penrose, "Tia Mowry on Wearing Curls on 'Sister, Sister' and Her Personal Journey to Unapologetic Beauty," *Elle*, 11 February 2021, elle.com/beauty/a35461514/tia-mowry-sister-sister-anser-wellness-black-beauty.

page 166 *Tia Mowry also...*: Ibid.

page 166 *But it became...*: Susanne Daniels and Cynthia Littleton, *Season Finale: The Unexpected Rise and Fall of the WB and UPN* (New York: Harper, 2009).

page 166 *with in-house research...*: Ibid.

page 166 *"This magazine was..."*: Penrose, "Tia Mowry on Wearing Curls on 'Sister, Sister' and Her Personal Journey to Unapologetic Beauty."

page 167 *In July 2020...*: Janice Williams, "'Moesha,' 'Girlfriends' and 5 More Classic Black Sitcoms Are Coming to Netflix and Fans Can Hardly Wait," *Newsweek*, 29 July 2020, newsweek.com/moesha-girlfriends-5-more-classic-black-sitcoms-are-coming-netflix-fans-can-hardly-wait-1521439.

page 167 *both of which...*: Soraya Nadia McDonald, "'You Cannot Win an Emmy for Roles That Are Simply Not There': Viola Davis on Her Historic Emmys Win," *Washington Post*, 21 September 2015, washingtonpost.com/news/arts-and-entertainment/wp/2015/09/21/you-cannot-win-an-emmy-for-roles-that-are-simply-not-there-viola-davis-on-her-historic-emmys-win/.

page 167 *For fans who had rallied...*: Michael Schneider, "'Sister, Sister' Lands on Nielsen's List of Most-Streamed Shows After Hitting Netflix," *Variety*, 8 October 2022, variety.com/2020/tv/news/sister-sister-netflix-nielsen-weekly-streaming-rankings-1234797613.

page 167 *"When I was doing..."*: Nicholas Rice, "Tamera Mowry-Housley on Sister, Sister's Legacy: 'We Definitely Hit Gold with That,'" *People*, 9 October 2020, people.com/tv/tamera-mowry-housley-on-sister-sisters-legacy-exclusive.

page 167 *"That show was..."*: Tim Reid, interview with author, 7 May 2022.

page 167 *"It never grabbed..."*: Ibid.

page 168 *"What I did take..."*: Ibid.

page 168 *"changed my view..."*: Ibid.

page 168 *"I've watched every..."*: Ibid.

page 169 *And with that...*: Ibid.

page 169 *The Wayans Bros. famously...*: Littleton and Daniels, *Season Finale*.

page 170 *NBC had reportedly...*: Monique Jones, "Shawn and Marlon Wayans Had to Fight to Have John Witherspoon Cast as Pops in 'The Wayans Bros,'" Shadow and Act, 15 July 2021, shadowandact.com/shawn-and-marlon-wayans-had-to-fight-to-to-have-john-witherspoon-cast-as-pops-in-the-wayans-bros.

page 171 *"It's bad enough..."*: Gary Phillips, "The Wayans Ought to Give It a Rest," *Los Angeles Times*, 23 January 1995, latimes.com/archives/la-xpm-1995-01-23-ca-23286-story.html.

page 171 *By all accounts...*: Littleton and Daniels, *Season Finale*.

page 173 *"I know comedy..."*: "Groups Call for Changes in Way Blacks Are Portrayed," Associated Press, 8 February 1997.

page 174 *"Robert, every year..."*: Esther B. Fein, "Robert Townsend Has Fun at Hollywood's Expense," *New York Times*, 19 April 1987.

page 174 *as Townsend told...*: Ibid.

page 175 *"But I felt..."*: Ibid.

page 178 *"The problem with Hollywood..."*: Jon Matsumoto, "Parent 'Hood' Salutes Black Actors," *Los Angeles Times*, 20 February 1996.

page 178 *"When you see..."*: Ibid.

page 179 *Hervey knew she...*: Winifred Hervey, interviewed by Amy Harrington for The Interviews: An Oral History of Television, Television Academy Foundation, 8 August 2013, interviews.televisionacademy.com/interviews/winifred-hervey

page 180 *"I just wrote..."*: Ibid.

page 182 *"It was just great..."*: Ibid.

page 182 *"I think there were a couple..."*: Ibid.

page 184 *"Every African American family..."*: "Groups Call for Changes in Way Blacks Are Portrayed on TV."

page 184 *Ultimately, the NAACP...*: David Robb, "NAACP Has Image Problem," *Hollywood Reporter*, 18 January 1995.

page 184 *Foxx would go...*: Brett Johnson, "Making an Impression," *Los Angeles Times*, 26 March 1996.

page 184 *Still, he told...*: Soren Baker, "Ready to Show He's Got Game," *Los Angeles Times*, 25 December 1999, F1.

page 186 *"I didn't really..."*: Winifred Hervey, interviewed by Amy Harrington for The Interviews: An Oral History of Television.

page 186 *After meeting Harvey...*: Ibid.

page 188 *"Ninety percent..."*: "The 'Steve Harvey Show' Black America's Favorite TV Series," *Jet*, 16 August 1999, 60.

page 191 Moesha *writer...*: Joi-Marie McKenzie, "Brandy Created a Name We Can't Forget," *Essence*, 6 December 2020, essence.com/feature/brandy-moesha-series-legacy.

page 191 *"At first I said..."*: Rick Marin and Allison Samuels, "Brandy: Keeping It Real," *Newsweek*, 25 March 1996.

page 191 *Her first audition...*: McKenzie, "Brandy Created a Name We Can't Forget."

page 191 *"Moesha drops..."*: Marin and Samuels, "Brandy: Keeping It Real."

page 191 *"Moesha is completely..."*: Andy Meisler, "On TV, Showing Life as Lived," *New York Times*, 30 January 1996.

page 192 *"By the fall..."*: Littleton and Daniels, *Season Finale*.

page 192 *"We're exactly what..."*: Lawrie Mifflin, "UPN's 'Moesha,' The Nonwhite Hit Nobody Knows," *New York Times*, 26 September 1999, 29.

page 194 *The UPN sitcom...*: Lori Talley, "UPN's *Girlfriends* Is the Best TV Show You're Not Watching. For Real," *Backstage*, 12 September 2002.

page 195 *Amid continued reports...*: Gary Levin, "UPN Slays 'Moesha,' Buffs Lineup," *USA Today*, 17 May 2001.

page 195 *"When I first..."*: McKenzie, "Brandy Created a Name We Can't Forget."

page 195 *"So many women..."*: Ibid.

page 197 *"I wanted Black women..."*: Brionna Jimerson, "20 Years of Girlfriends: The Show's Creator on the Enduring Legacy of the Beloved Sitcom," *Glamour*, 8 October 2020, glamour.com/story/girlfriends-tv-show.

page 197 *"I didn't cast..."*: Robi Reed, interview with the author, 27 April 2022.

page 197 *"I knew with Mara..."*: Ibid.

page 197 *"Normally on TV..."*: Ed Bark, "Acting for Two on UPN," *Dallas Morning News*, 16 May 2005, 8E.

page 198 *"Sex and the City was..."*: Bianca Betancourt, "Mara Brock Akil on the Everlasting Influence of *Girlfriends*," *Harper's Bazaar*, 11 September 2020, harpersbazaar.com/culture/film-tv/a33970111/mara-brock-akil-influence-of-girlfriends-interview.

page 199 *Decades before...*: Alana Bennett, "Tracee Ellis Ross Is the First Black Woman to Win in Her Golden Globe Category in 35 Years," BuzzFeed, 8 January 2017, buzzfeed.com/alannabennett/tracee-ellis-ross-golden-globe-win.

page 199 *"When I was on..."*: Paula Rogo, "Tracee Ellis Ross Was Never Booked on a Late-Night Show While Starring in 'Girlfriends,'" *Essence*, 6 December 2020, essence.com/entertainment/tracee-ellis-ross-color-files-podcast.

page 200 *"It's a hypervisualized..."*: Larry Wilmore, interviewed by Jenni Matz for The Interviews: An Oral History of Television, Television Academy Foundation, and the Writer's Guild of America, 9 May 2017, interviews.televisionacademy.com/interviews/larry-wilmore.

page 200 *Spike Lee, a year...*: David Zurawik, "'Black

Community' Not of One Voice; TV: Controversy over New Fox Series Heats Up as Director Spike Lee Says It Demeans Blacks. But the PJs' Players Rush to Its Defense," *Baltimore Sun*, 18 January 1999, baltimoresun.com/news/bs-xpm-1999-01-18-9901180192-story.html.

page 201 *DuBois won...*: "Ja'Net DuBois: Awards & Nominations," Emmys.com, emmys.com/bios/janet-dubois.

page 201 *Expensive to produce...*: David Bauder, "ABC Making Controversial Moves, the WB Tries New Comedies," Associated Press, 15 May 2001.

page 201 *"We made each other..."*: Sam Sanders, "Larry Wilmore's Return to Late Night," *It's Been a Minute*, NPR, 15 September 2020.

page 202 *"From a writing standpoint..."*: Michael Mallory, "A New Neighborhood for Animated Series," *Los Angeles Times*, 15 September 2001, D2.

page 203 *Across its four-season...*: "The Boondocks: The Return of the King," Peabody Awards, peabodyawards.com/award-profile/the-boondocks-the-return-of-the-king.

page 203 *In a statement...*: Greg Braxton, "Aaron McGruder Bids Emotional Farewell to 'The Boondocks,'" *Los Angeles Times*, 28 March 2014, latimes.com/entertainment/tv/showtracker/la-et-st-aaron-mcgruder-bids-farewell-to-the-boondocks-series-20140328-story.html.

page 203 *"It was important..."*: Ibid.

page 205 *Watching the sketch...*: Zak Cheney-Rice, "Larry Wilmore Knows No Bounds," *Vulture*, 6 July 2022, vulture.com/article/larry-wilmore-in-conversation.html.

page 205 *Wilmore was also influenced...*: Ibid.

page 205 *"I always said..."*: Kristen Baldwin, "'I'm Gonna Kill One of Them Kids': An Oral History of *The Bernie Mac Show* Pilot," *Entertainment Weekly*, ew.com/tv/the-bernie-mac-show-pilot-oral-history.

page 206 *"At the time..."*: Gary Baum, "Hollywood Flashback: Larry Wilmore and Bernie Mac Made History in 2002," *Hollywood Reporter*, 24 June 2021, hollywoodreporter.com/tv/tv-news/hollywood-flashback-larry-wilmore-bernie-mac-1234969468.

page 206 *"In some ways..."*: Chris Norris, "Bernie Mac Smacks a Nerve," *New York Times*, 12 May 2002, nytimes.com/2002/05/12/magazine/bernie-mac-smacks-a-nerve.html.

page 208 *But as the* New York Times...: Alessandra Stanley, "A Boy Grows in Brooklyn, with a Voice-Over," *New York Times*, 22 September 2005, nytimes.com/2005/09/22/arts/television/a-boy-grows-in-brooklyn-with-a-voiceover.html.

page 208 *Its cancellation...*: Rob Owen, "The CW Forgoes Laughs for Drama," *Pittsburgh Post-Gazette*, 22 May 2009, D-1.

page 211 *"From our perspective..."*: Greg Braxton, "Black-Themed Series Come to a Crossroads," *Los Angeles Times,* 18 May 2008, latimes.com/archives/la-xpm-2008-may-18-ca-blackcom18-story.html.

page 211 *UPN president...*: Mekeisha Madden, "CW Touts Combined Net's Old, New Shows," *Detroit News*, 18 July 2006, 1E.

page 211 *The WB's merger...*: Emily Yahr, "'The Game' Is Over and Everybody Won: How BET's Comedy Helped Make TV History," *Washington Post*, 28 June 2015, washingtonpost.com/lifestyle/style/changing-the-game-how-the-bet-comedy-helped-make-tv-history/2015/07/28/6245ed08-3546-11e5-94ce-834ad8f5c50e_story.html.

9: A DRAMATIC TURN

page 213 *Mara Brock Akil...*: Mesfin Fekadu, "'The Game' Breaks BET Ratings, Gets 2nd Chance," Associated Press, January 2011.

page 213 *On January 11, 2011...*: "The Cable Debut of The Game on BET Ranks as the #1 Ad-Supported Scripted Series Premiere in Cable History," PR Newswire, 13 January 2011.

page 213 *They tweeted real-time...*: Paige Wiser, "A 'Game' Changer," *Chicago Sun-Times*, 30 January 2011.

page 213 *"We always felt..."*: Ibid.

page 214 *Loretha Jones, then...*: Robi Reed, interview with the author, 27 April 2022.

page 214 *"I had to cast..."*: Ibid.

page 214 *The Akils signed...*: Allison Samuels, "Whitney's Final Bow," *Newsweek*, 16 July 2012, 50.

page 217 *The drama marked...*: Ira Madison, "How Shonda Rhimes and Olivia Pope Changed TV with 'Scandal,'" *Daily Beast*, 22 April 2018, thedailybeast.com/how-shonda-rhimes-and-olivia-pope-changed-tv-with-scandal.

page 217 *This set the blueprint...*: M. Gorman, "Nielsen Teams Up with Twitter to Create Social TV Ratings," Engadget, 17 December 2012, engadget.com/2012-12-17-nielsen-twitter-tv-rating.html.

page 218 *"What's wonderful about..."*: Emily Orley, "Inside Papa Pope's Most Memorable 'Scandal' Monologues with Joe Morton," BuzzFeed, 18 August 2014, buzzfeed.com/emilyorley/papa-pope-scandal-most-memorable-speeches-joe-morton.

page 220 *"Women are smart..."*: Alex Abad-Santos, "Shonda Rhimes: 'It's Not Trailblazing to Write the World As It Actually Is,'" *Vox*, 25 January 2016, vox.com/2016/1/25/10827842/shonda-rhimes-pga-acceptance-speech.

page 221 *"Annalise Keating..."*: Diane Gordon, "Viola Davis Wouldn't Have Played Annalise Keating if Her Wig Didn't Come Off," *Vulture*, 30 May 2015, vulture.com/2015/05/viola-davis-came-up-with-htgawms-wig-scene.html.

page 222 *"I said to myself..."*: Jonathan Landrum Jr., "Gabrielle Union Stars in BET's 'Being Mary Jane,'" Associated Press, 1 July 2013.

page 224 *"TV writes a lot..."*: Joi-Marie McKenzie, "'Being Mary Jane' Creator Explains Stealing Sperm Plot Line," ABC News Radio, 14 January 2014, abcnewsradioonline.com/entertainment-news/being-mary-jane-creator-explains-stealing-sperm-plot-line.html.

page 228 *"Hearing it is..."*: Maria Elena Fernandez, "The Story Behind *Black-ish*'s Provocative N-Word Episode," *Vulture*, 23 September 2015, vulture.com/2015/09/blackish-n-word-episode.html.

page 228 *"Having the word..."*: Jerrod Carmichael as told to Kate Stanhope, "Jerrod Carmichael: Why I Wanted to Say the N-Word on Broadcast TV (Guest Column)," *Hollywood Reporter*, 20 June 2017, hollywoodreporter.com/tv/tv-news/jerrod-carmichael-talks-n-word-episode-1014450.

page 229 *Despite being one...*: Denise Petski, "'Power' EP Gary Lennon Inks Overall Deal with Starz," *Deadline*, 12 May 2017, deadline.com/2017/05/power-ep-gary-lennon-overall-deal-starz-1202091875.

page 230 *The series took...*: Robert Ito, "A Boss Who's Open to Suggestions," *New York Times*, 27 July 2014, nytimes.com/2014/07/27/arts/television/courtney-kemp-agboh-runs-power-with-50-cents-input.html.

page 234 *"Isn't it sad..."*: Eric Deggans, "Issa Rae Turns Basic into Revolutionary with 'Insecure,'" NPR, 7 October 2016, npr.org/2016/10/07/496984892/issa-rae-is-first-black-woman-to-create-star-in-premium-cable-show.

page 236 *Another collaborator...*: Jenna Wortham, "The Misadventures of Issa Rae," *New York Times Magazine*, 4 August 2015, nytimes.com/2015/08/09/magazine/the-misadventures-of-issa-rae.html.

page 236 *"We always talked..."*: Kirsten Chuba, "Issa Rae on How 'Insecure' Will Be Remembered After Its Final Season: 'It Was for Us, by Us,'" *Hollywood Reporter*, 22 October 2021, hollywoodreporter.com/tv/tv-news/issa-rae-insecure-final-season-red-carpet-premiere-1235035243.

page 239 *"Chris Rock told me..."*: Tad Friend, "Donald Glover Can't Save You," *New Yorker*, 26 February 2018, newyorker.com/

magazine/2018/03/05/donald-glover-cant-save-you.

page 240 *So when Netflix...*: Cheo Hodari Coker (@cheo_coker), "Did ya'll break NETFLIX?" Twitter, 1 October 2016, twitter.com/cheo_coker/status/782314716798550017.

page 241 *Netflix canceled...*: Daniel Holloway, "'Luke Cage' Canceled by Netflix," *Variety*, 19 October 2018, https://variety.com/2018/tv/news/luke-cage-canceled-1202987278/.

page 243 *Though she already...*: Bethonie Butler, "Why Ava DuVernay Hired Only Female Directors for Her New TV Show 'Queen Sugar,'" *Washington Post*, 15 September 2016, washingtonpost.com/news/arts-and-entertainment/wp/2016/09/15/why-ava-duvernay-hired-only-female-directors-for-her-new-tv-show-queen-sugar.

page 244 *"I wouldn't even..."*: Mekeisha Madden Toby, "*Snowfall* EP and Writer Walter Mosley: 'John Singleton Is Happy with How Things Turned Out for the Show,'" *TV Line*, 25 February 2021, tvline.com/2021/02/25/snowfall-walter-mosley-season-4-episode-1-premiere-john-singleton.

page 244 *"I know people who..."*: Ibid.

page 247 *"We often talk..."*: Rosy Cordero, "'Snowfall': Damson Idris on What He Learned from John Singleton; Wants Denzel Washington for Season 6," *Deadline*, deadline.com/2022/02/snowfall-damson-idris-talks-john-singleton-denzel-washington-1234955976.

page 248 *"We were always..."*: Alexis Soloski, "True Romance: Janet Mock on the Final Season of 'Pose,'" *New York Times*, 30 April 2021, nytimes.com/2021/04/30/arts/television/pose-janet-mock.html.

page 248 *Pointedly, the Netflix...*: Aaron Rupar, "Trump Still Refuses to Admit He Was Wrong About the Central Park 5," *Vox,* 18 June 2019, vox.com/policy-and-politics/2019/6/18/18684217/trump-central-park-5-netflix.

page 248 *The four-episode...*: Linda Fairstein, "Netflix's False Story of the Central Park Five," *Wall Street Journal*, 10 June 2019, wsj.com/articles/netflixs-false-story-of-the-central-park-five-11560207823.

page 248 *Though the cast...*: Yara Simón, "Dominican American Jharrel Jerome Is First Afro-Latino to Win an Emmy Award for Acting," *Remezcla*, 22 September 2019, remezcla.com/film/dominican-jharrel-jerome-afro-latino-emmy-award.

10: THE FUTURE OF BLACK TV

page 251 *"I am an endangered species…"*: Alexandra Del Rosario, "Forget the Emmys Speech. Sheryl Lee Ralph Explains Why She Sang That Powerful Song," *Los Angeles Times*, 12 September 2022, latimes.com/entertainment-arts/tv/story/2022-09-12/emmys-2022-sheryl-lee-ralph-song-supporting-actress-song.

page 251 *Ralph told the...*: Greg Braxton, "'Moesha' Tribute a Rare Museum Piece," *Los Angeles Times*, 10 March 1999, latimes.com/archives/la-xpm-1999-mar-10-ca-15713-story.html.

page 252 *At the same Emmys...*: Allison Havermale, "Quinta Brunson Is the Second Black Woman to Win the Emmy for Writing a Comedy Series," *Collider*, 13 September 2022, collider.com/quinta-brunson-second-black-woman-writing-comedy-series-emmy-win.

page 252 *Waithe won...*: Marcus Jones, "A Deeper Look at the Thanksgiving Episode of 'Master of None,'" *BuzzFeed*, 25 May 2017, buzzfeed.com/marcusjones/everything-you-need-to-know-about-the-thanksgiving-episode.

page 253 *Both Whitley and Bassett...*: Ibid.

page 253 *With the support of...*: Ibid.

page 253 *"I had really great..."*: "Lena Waithe: First Black Woman to Win an Emmy for Outstanding Writing in a Comedy Series," *Time*, time.com/collection/firsts/5233533/lena-waithe-firsts.

page 253 *"I was crying..."*: Larry Wilmore (@

larrywilmore), "I was crying cause @ quintabrunson won but was not ready for the shoutout and now I'm blubbering," Twitter, 12 September 2022, twitter.com/larrywilmore/status/1569511141646434304.

page 254 *Bridget Stokes...*: Peter White, "'A Black Lady Sketch Show' Breaks 'SNL's Directing Emmy Streak," *Deadline*, 3 September 2022, deadline.com/2022/09/a-black-lady-sketch-show-breaks-snl-directing-emmy-streak-1235107393.

page 256 *"I'm creating this new class..."*: Clarkisha Kent, "*A Black Lady Sketch Show* Has Arrived to Smash Glass Ceilings and Do 'Weird S—,'" *Entertainment Weekly*, 2 August 2019, ew.com/tv/2019/08/02/a-black-lady-sketch-show-delightfully-weird.

page 256 *The Golden Globe Awards...*: Josh Rottenberg and Stacy Perman, "Who Really Gives Out the Golden Globes? A Tiny Group Full of Quirky Characters—and No Black Members," *Los Angeles Times*, 21 February 2021, latimes.com/entertainment-arts/business/story/2021-02-21/hfpa-golden-globes-2021-who-are-the-members.

page 256 *"#OscarsSoWhite..."*: April Reign (@ReignOfApril), "#OscarsSoWhite they asked to touch my hair," Twitter, 15 January 2015, twitter.com/ReignOfApril/status/555725291512168448.

page 256 *The campaign...*: Reggie Ugwu, "The Hashtag That Changed the Oscars: An Oral History," *New York Times*, 6 February 2020, nytimes.com/2020/02/06/movies/oscarssowhite-history.html.

page 256 *"I've been doing..."*: Gabrielle Union (@itsgabrielleu), "I've been doing TV since 1995. This will be my 1st time going to the Emmys & I'm presenting an award!" Twitter, twitter.com/itsgabrielleu/status/909489976324141056.

page 257 *Speaking to the...*: Jamal Jordan, "Sheryl Lee Ralph Is Glowing," *New York Times*, 21 September 2022, nytimes.com/2022/09/21/style/sheryl-lee-ralph-abbott-elementary.html.

page 257 *Brunson, she told...*: Ibid.

page 257 *There are a lot more...*: Trey Mangum, "Michaela Coel Becomes First Black Woman to Win Emmy for Limited Series Writing for 'I May Destroy You,'" Shadow and Act, 20 September 2021, shadowandact.com/michaela-coel-becomes-first-black-woman-to-win-emmy-for-limited-series-writing-for-i-may-destroy-you.

page 257 *Meanwhile two nominations...*: Kirsten Chuba, "Courtney B. Vance Questions 'Lovecraft Country' Cancellation After Emmy Win: 'It Doesn't Make Sense,'" *Hollywood Reporter*, 12 September 2021, hollywoodreporter.com/tv/tv-news/lovecraft-country-canceled-emmy-awards-win-courtney-b-vance-1235011528.

page 258 *In the early days...*: Leigh Davenport, interview with the author, 26 May 2022.

page 258 *"So what if she's..."*: Ibid.

page 259 *"I think it's kind..."*: Ibid.

page 259 *Davenport has found...*: Ibid.

page 259 *Rae "is phenomenal..."*: Ibid.

INDEX

Abbott Elementary, 81, 83, 251

Adams, Ashli Amari, 174, 175

Adell, Ilunga, 49, 163

Adult Swim, 202–203

Akil, Mara Brock, 161, 194, 195,
 197, 198, 211, 213–214, 222, 223,
 224, 236, 253

Akil, Salim, 213, 223

Alexander, Erika, 156–157

Alexander, Flex, 164

Ali, Mahershala, 241

Ali, Muhammad, 64

Ali, Tatyana, 135, 136, 139, 142

Alice, 76

All in the Family, 34, 46, 47, 49, 54,
 56, 225

All That, 201

Allen, Debbie, 27, 122–124, 125,
 178, 179, 182, 199

Amen, 85–86, 88, 138

American Bandstand, 40

American Soul, 42

Amos, John, 54, 56, 57, 59–60, 64,
 67, 71

Amos 'n Andy Show, The, 8, 15,
 46–47, 49

Anderson, Anthony, 45, 102,
 225–226

Angelou, Maya, 68, 96, 192

Ansari, Aziz, 252, 253

Any Given Sunday, 185

Arnold, Tichina, 151, 207

Arsenio Hall Show, The, 97, 102–106,
 136

Arthur, Bea, 54

Asner, Ed, 64, 68

Atencio, Peter, 99

Atlanta, 9, 11, 237–239, 257

*Autobiography of Miss Jane Pittman,
 The*, 63

Avery, James, 42, 135, 136, 137–138,
 142–144

Baldwin, Curtis, 81, 82

Ball, Lucille, 21

Bamboozled, 146, 200

Bark, Ed, 129

Barnett, Melanie, 199

Barnette, Neema, 243

Barris, Kenya, 45, 57–58, 60, 225–
 226, 228

Bassett, Angela, 252–253

Baszile, Natalie, 242

Beauvais, Garcelle, 169, 183

Bebe's Kids, 202

Beers, Betsy, 220

Beetz, Zazie, 237

Beharie, Nichole, 221

Being Mary Jane, 214, 222–224

Bell, Darryl M., 121, 122

Bell, W. Kamau, 81

Belushi, John, 96

Benson, 76

Bentley, Lamont, 189

Bernhard, Sandra, 91, 94

Bernie Mac Show, The, 204–206

Berry, Halle, 26–27, 71, 221

Beulah, 8, 15, 251

Beyoncé, 201, 253

Bianculli, David, 78

Bigger & Blacker, 100

Black Is the New White (Mooney), 50

Black Jesus, 203

Black Lady Sketch Show, A, 81–82,
 254, 256

Black-ish, 45, 58, 199, 225–226, 228,
 254

Blackk, Asante, 248

Black's View of the News, A, 39

Blank, Kenny, 174, 175

Bledsoe, Tempestt, 77

Blossom, 158, 165

Bogert, William, 116

Bogle, Donald, 12, 21

Bonet, Lisa, 77, 121, 122–123

Boomerang, 170

Boondocks, The, 202–203

Bowser, Yvette Lee, 126, 156, 158

Boyz II Men, 104, 124

Boyz n the Hood, 244

Bravo, Janizca, 239

Braxton, Greg, 156

Brennan, Neal, 116, 118

Bridges, Todd, 76

Brooks, Golden, 195

Brown, Calvin, Jr., 163

Brown, Charnele, 122, 123

Brown, James, 33, 86, 100

Brown, Miles, 225, 226

Brown, Orlando, 131

Brunson, Quinta, 81, 251–252, 254,
 257, 259

Bryant, Kobe, 192

Buck, Jerry, 123

Buffy the Vampire Slayer, 162

Buress, Hannibal, 78, 80

Burke, Tom, 31–32

Burton, LeVar, 64, 67, 73, 75

Byers, Trai, 231, 233

Campbell, Maia, 178, 179

Campbell, Naomi, 233

Campbell, Tevin, 139

Candler, Kat, 243

Cannon, Reuben, 86

Canton, Mark, 230

Capers, Virginia, 86, 87

Carey, Mariah, 104–105, 233

Carlin, George, 32, 36, 103

Carmen Jones, 14

Carmichael, Jerrod, 60, 228–229

Carmichael Show, The, 60, 228–229

Carr, Louie Ski, 41

Carrey, Jim, 107, 109

Carroll, Diahann, 7–8, 12, 14–15, 16–18, 20, 21, 26–27, 31, 63, 124

Carroll, Rocky, 144, 145, 148

Carson, Johnny, 29–31, 104, 105, 106

Carson, T.C., 156, 157

Carter, Nell, 76, 146

Cedric the Entertainer, 112, 114, 185, 186, 188, 204

Chappelle, Dave, 97, 98–99, 102, 112, 116, 118–119, 161

Chappelle's Show, 97, 98–99, 116–119

Charlie & Co., 36, 128

Cheadle, Don, 142

Chi, The, 244

Chris Rock Show, The, 114–115

Clinton, Bill, 106

Coach, 129, 138

Cobb, Joe, 43

Cochran, Johnnie, 114

Coel, Michaela, 257

Coker, Cheo Hodari, 240

Cole, Nat "King," 16, 32

Coleman, Gary, 76, 171

Coles, Kim, 109, 156, 159

Colter, Mike, 240, 241

Cook, Kevin, 32

Cooley High, 54, 61

Cornelius, Don, 29, 37, 39, 41, 43

Cosby, 173

Cosby, Bill, 12, 32, 77–78, 80, 113, 122–123, 152–153, 161, 173

Cosby Show, The, 77–81, 84, 88, 121, 137, 156, 161, 163, 173, 179, 182

Cotton Comes to Harlem, 46

Cover, Franklin, 59

Cox, Laverne, 257

Crews, Terry, 207

Curry, Mark, 102, 163

Dallas, 76, 78

Dandridge, Dorothy, 14

Dandridge, Merle, 241, 242

Dangerous Minds, 186

Daniels, Lee, 231

Davenport, Leigh, 257–259

David, Keith, 241, 242

Davidson, Tommy, 42, 107, 146, 154, 201

Davis, Clifton, 85, 86

Davis, Dee Dee, 204, 205

Davis, Miles, 64, 100, 104

Davis, Ossie, 46

Davis, Sammy, Jr., 31, 34, 64

Davis, Viola, 9, 219, 220, 221–222

Dawson's Creek, 162

Day, Doris, 21

de Moraes, Lisa, 157–158

Def Comedy Jam, 97, 98, 112–113, 153, 204

Delmont, Matthew, 16, 40, 66, 68, 71

Destiny's Child, 201

Devine, Loretta, 122, 200, 228, 229

Diahann! (Carroll), 24

Die Hard, 128

Different World, A, 27, 121, 122–126, 137, 138, 153–154, 179, 218

Diff'rent Strokes, 76

DJ Jazzy Jeff, 136, 141

Do the Right Thing, 107, 109, 155

Dogg, Nate, 98

Dolan, Harry, 21, 22

Don't Be a Menace to South Central While Drinking Your Juice in the Hood, 204

Doris Day Show, The, 21

Dorsey, Omar J., 243

Douglas, Suzzanne, 174, 175

Dreamgirls, 251

DuBois, Ja'net, 169, 170, 200, 201

Duncan, Christopher B., 183

Dunham, Lena, 219

Dutton, Charles S., 144, 145, 146, 148–150, 152

DuVernay, Ava, 9, 242, 243, 248, 253, 256

Dynasty, 14, 76, 78

East Side/West Side, 63

Ed Sullivan Show, The, 31

Eddie Murphy: Raw, 175

Elba, Idris, 8

Elder, Judyann, 133

Eleanor and Franklin, 63

Ellis, Jay, 211, 234

Empire, 132, 148, 217, 231–234

English, Ellia, 183

Evans, Bentley Kyle, 155, 161, 183, 184

Evans, Mike, 54, 56, 60

Everybody Hates Chris, 207–211

Facts of Life, The, 191

Fairstein, Linda, 248

Fales-Hill, Susan, 125, 126

Fallon, Jimmy, 82

Fame, 122–123, 162, 199

Family Feud, 185

Family Matters, 126–133, 191

Famous Jett Jackson, The, 201

Farmiga, Vera, 248

Farquhar, Kurt, 191

Farquhar, Ralph, 161, 189, 191, 202

Farrakhan, Louis, 106

Felicity, 162

Fields, Kim, 156, 191

Fields, Sheila, 150

Finney-Johnson, Sarah, 161, 189, 191

Fishburne, Laurence, 45, 73, 225, 226

Fitzgerald, Ella, 100

Five Heartbeats, The, 175

Flip: The Inside Story of TV's First Black Superstar (Cook), 32

Flip Wilson Show, The, 29–37

Foxx, Jamie, 97, 98, 102, 107, 183–185

Foxx, Redd, 29–30, 31, 46–47, 49, 50–51, 53–54, 61, 91, 100, 109, 173

Franklin, Aretha, 124

Frank's Place, 76, 86–89

Frasier, 164

Fresh Prince of Bel-Air, The, 42, 87, 135–144, 155, 158, 162, 178, 179, 182, 200

Friday, 170, 203, 204

Friends, 153, 156, 157–159, 164, 167, 171, 195

Frost, David, 33

Full House, 149

Fuller, Charles, 174

Furious Cool (Henry and Henry), 96

Gaither, Daniele, 81

Game, The, 161, 167, 194, 199, 211, 213–214, 217, 225

Gardner, Dawn-Lyen, 242

Garrett, Susie, 82

Get Christie Love! 8, 63, 217

Get Out, 229

Ghost & Mrs. Muir, The, 21

Gibbs, Marla, 58, 59, 81, 82, 84, 85, 154, 219

Gilmore Girls, 167

Gimme a Break! 76, 146

Ginuwine, 192

Giorgis, Hannah, 132

Girlfriends, 161, 162, 167, 194, 195–199, 211, 213, 225, 234, 236

Girls Trip, 229

Gladys Knight & the Pips, 37, 39

Glover, Danny, 71, 170

Glover, Donald, 9, 11, 237, 239, 257

Glover, Stephen, 239

Goldberg, Whoopi, 102, 114, 124

Golden Girls, 179

Goldwyn, Tony, 215, 217

Gomez-Preston, Reagan, 174, 175

Good, Meagan, 221, 258

Good Times, 45, 46, 54–58, 59–61, 169–170, 225

Goodwin, Robert, 21–22

Gordon, Carl, 144, 145

Gossett, Louis, Jr., 64, 67

Gossip Girl, 213

Gould, Jack, 20, 33

Graham, Renée, 115

Graves, Teresa, 63, 217

Gray, Bryshere Y., 231, 233

Green, Al, 40, 100

Green, Billie J., 173, 184

Green, Misha, 257

Greene, Lorne, 68

Greenleaf, 241–242

Grey's Anatomy, 27, 217, 220

Grier, David Alan, 107, 109, 228, 229

Griffith, Andy, 211

Grown-ish, 226

Grushow, Sandy, 158

Guillaume, Robert, 76

Guy, Jasmine, 71, 121, 122, 125, 126

Haddish, Tiffany, 228, 229

Hakim, Imani, 207

Haley, Alex, 63, 64, 66–67, 70–71

Half & Half, 167

Hall, Arsenio, 102–106, 109, 110

Hall, Pooch, 211

Hall, Tamron, 138

Hangin' with Mr. Cooper, 162

Hardison, Kadeem, 121, 122

Hardwick, Omari, 222, 223, 229

Harlem, 258

Harris, Caleel, 248

Harris, James, 94

Harris, Neil Patrick, 125

Harry, Jackée, 81, 82, 83, 162, 163, 165, 168

Harvey, Steve, 102, 112, 185–186, 188, 204

Haves and the Have Nots, The, 241

Hayes, Isaac, 154

Hayes, Reginald C., 195, 197

Head of State, 98

Heavy D, 150

Hemsley, Sherman, 58, 85, 86

Henderson, Felicia D., 132, 142, 191, 213

Henry, Bob, 32, 33

Henry, Brian Tyree, 237

Henry, David and Joe, 96

Henson, Taraji P., 221, 231

Henton, John, 156, 157

Herisse, Ethan, 248

Hervey, Winifred, 178, 179–180, 182, 185, 186

Hill, Lauryn, 102

Hollywood Shuffle, 170, 174–175

Horne, Lena, 31, 100, 124

Horsford, Anna Maria, 85, 86

Houston, Christine, 82

Houston, Whitney, 194

How to Get Away with Murder, 9, 219, 220–222, 258

Howard, Terrence, 231

Howery, Lil Rel, 228, 229

Hubert, Janet, 135, 136, 139–141

Hudson, Ernie, 219

Huffman, Felicity, 248

Hughley, D.L., 204

Hughleys, The, 195, 204

Hyatt, Michael, 244

I Know What You Did Last Summer, 194

I May Destroy You, 257
I Spy, 12
Idris, Damson, 244, 247
I'm Gonna Git You Sucka, 107
In Living Color, 42, 97, 98, 107–112, 118, 146, 149, 155, 156, 158, 170, 183, 200, 253
In the House, 178–183, 186
Inaba, Carrie Ann, 107
Insecure, 9, 11, 163, 191, 199, 234–236, 254, 258
Iron Fist, 241
It Takes a Thief, 21
It's Showtime at the Apollo, 100–102

Jackie Gleason Show, The, 145
Jackson, Curtis "50 Cent," 229, 230
Jackson, Janet, 54, 60
Jackson, Jesse, 98, 114, 124
Jackson, Joshua, 249
Jackson, Shar, 189
James, Rick, 118
Jamie Foxx Show, The, 155, 161, 183–185, 197, 200
Jefferson, The, 45, 46, 56, 58–61, 76, 82, 85, 128, 154, 225
Jerome, Jharrel, 248, 249
John, Isaiah, 244
Johnson, Arte, 32
Johnson, Joan and George, 40
Johnson, Magic, 105–106
Jones, Geraldine, 34
Jones, James Earl, 63
Jones, Jill Marie, 195, 197, 198
Jones, Loretha, 214
Jones, Quincy, 135, 136, 139, 178
Jones, Tom, 20, 138
Joseph, Amin, 244
Joyce, Ella, 144, 145
Juice, 156
Julia, 7–8, 9, 12–27, 29, 49

Kanter, Hal, 12, 14, 15, 18, 20, 26
Karras, Alex, 76
Kay, Monte, 31
Kelly, R., 202
Kemp, Courtney A., 229–230
Kenan & Kel, 201
Key, Keegan-Michael, 99
Key and Peele, 99
Kiddie-a-Go-Go, 40
King, Larry, 138
King, Martin Luther, Jr., 64, 203
King, Regina, 81, 82, 202
King, Rodney, 125
King, Woodie, Jr., 68
Kirby, Malachi, 73
Knight, Gladys, 36, 37, 39
Kravitz, Lenny, 104, 122
Kravitz, Sy, 59

L.A. Law, 138, 148
LaBelle, Patti, 233
Lacey, C.P., 102
Lange, Hope, 21
Late Show, 104
Lathan, Stan, 51, 112–113, 145, 148–149, 186, 189
Lawrence, Martin, 102–103, 105, 110, 112, 151–154, 171
Lawson, Bianca, 242, 243
Le Beauf, Sabrina, 77
Lear, Norman, 45, 46, 54, 56, 57–58, 59, 60–61, 225, 229
LeBlanc, Matt, 171
Lee, Paul, 221
Lee, Spike, 107, 109, 114, 146, 148, 155, 185, 200–201, 204
Leguizamo, John, 248
Leno, Jay, 106
LeRoi, Ali, 98, 114, 207, 208, 211
Letterman, David, 104, 106
Lewis, Angela, 244
Lewis, Dawnn, 121, 122, 124

Lewis, Emmanuel, 76
Lewis, Jenifer, 45, 114, 200, 225, 226
Lifford, Tina, 243
Lil Jon, 118
Lil' Kim, 192
Lipton, James, 102
Little Rascals, 176
Littlefield, Warren, 135, 157–158
Littleton, Cynthia, 192
Living Single, 156–159, 173, 191, 234
LL Cool J, 178, 179–180, 182
Lopez, Jennifer, 107
Loren, Lela, 229, 230
Louis C.K., 114
Love, Courtney, 233
Love, Faizon, 174, 176–177
Lovecraft Country, 257
Lowes, Katie, 215
Lucy Show, The, 21
Ludacris, 233
Luke, Derek, 73
Luke Cage, 240–241

Mabry, Tina, 243
Mac, Bernie, 98, 112, 114, 204–205
Marcell, Joseph, 136
Margulies, Stan, 64, 66–67, 68
Married with Children, 149
Marshall, Don, 26
Martin, 102, 110, 151–155, 173, 184
Martin, Marsai, 225, 226
Martin: The Reunion, 152
Massaquoi, Hans J., 71
Master of None, 11, 252, 253
Matsoukas, Melina, 253
Maude, 46, 54
Mayo, Whitman, 53
McGruder, Aaron, 202, 203
Me and the Boys, 186
Medina, Benny, 135, 136
Meteor Man, The, 175
Method Man, 154

Misadventures of Awkward Black Girl, The, 11, 234–235
Mitch Thomas Show, The, 40
Mitchell, Elvis, 116, 118
Mitchell, Kel, 201
Mock, Janet, 247
Moesha, 132, 161, 162, 167, 188–195, 197, 202, 251
Mo'Nique, 102, 194
Monte, Eric, 54, 56, 60–61
Mooney, Paul, 49–50, 51, 53, 92, 94, 96, 97, 109, 116, 119
Moore, Rudy Rae, 154
Morgan, Debbi, 145
Morgan, Tracy, 112, 154
Morris, Garrett, 102–103, 144, 183
Morton, Joe, 124, 215, 217–219
Mos Def, 98, 118
Mosely, Walter, 244
Moses, Gilbert, 68
Moss, Evette, 41
Mowry, Tamera, 162, 163–166, 167, 168
Mowry, Tia, 162, 163–166, 168, 199, 211
Muhammad, Ali Shaheed, 241
Muhammed, Elijah, 64
Murai, Hiro, 239
Murdoch, Rupert, 150
Murphy, Charlie, 116, 118
Murphy, Eddie, 34, 36, 80, 100, 104, 112, 173, 200
Muscle, 171
My Brother and Me, 49, 163

Naked City, 63
Nash, Niecy, 248
Nat King Cole Show, The, 16, 32, 34
Naughton, Naturi, 229, 230
Nichols, Nichelle, 12
Nightly Show with Larry Wilmore, The, 254

1900 House, The, 205
No Strings, 14
Noel, Y'lan, 234
Norman Lear: Just Another Version of You, 57
Norwood, Brandy, 189, 191, 193, 194, 195, 211, 251
Notorious B.I.G., 154
Nowalk, Peter, 220, 221

Obama, Barack, 91, 98, 99, 100, 226
O'Connor, Carroll, 53–54
O'Connor, John J., 49
Oliver, Tracy Y., 258–259
Olsen, Susan, 22
On Our Own, 163
One on One, 167
Original Kings of Comedy, The, 188, 204
Orji, Yvonne, 199, 234
Oscars So White campaign, 256
Ostroff, Dawn, 211

Packer, Will, 73
Page, LaWanda, 46, 50–51, 91
Page, Regé-Jean, 73
Parent 'Hood, The, 171, 173, 174–178
Parker, Paula Jai, 201
Parkers, The, 161, 162, 167, 194–195
Parks, Gordon, 68
Parsons, Karyn, 135, 136, 138–139
Paulk, Marcus T., 189
Payton, Jo Marie, 126, 128, 130, 131–133, 201
Peele, Jordan, 99, 229
Peete, Holly Robinson, 254
Penny, Prentice, 236
People v. O.J. Simpson: American Crime Story, The, 155
Perez, Rosie, 41, 107, 109
Perfect Strangers, 128
Perry, Jeff, 215, 217
Perry, Tyler, 241

Pioneers of Television, 26
PJs, The, 200–201
Poitier, Sidney, 14
Poletti, Stephen, 148
Porgy and Bess, 14
Porter, Billy, 247
Pose, 247–248, 254
Power, 229–230, 231
Pratt, Kyla, 201
Pretty Woman, 105
Primetime Blues (Bogle), 12, 21
Prince-Bythewood, Gina, 126, 253
Private Practice, 217
Proud Family: Louder and Prouder, The, 202
Proud Family, The, 201–202
Pryor, Richard, 32, 36–37, 49–50, 91–92, 94–97, 98, 103, 119, 173
Pryor's Place, 96

Queen, 71
Queen Latifah, 112, 156
Queen Sugar, 9, 242–243
Queen: The Story of an American Family (Haley), 71

Rae, Issa, 9, 11, 199, 234–236, 254, 256, 257, 259
Ralph, Sheryl Lee, 83, 189, 192, 195, 251, 257
Rashad, Phylicia, 77, 161, 173, 182
Ray J, 189, 193
Reagan, Ronald, 70
Real World, The, 205
Red Hot and Blues, 40
Red Skelton Show, The, 20
Reed, Robert, 64, 68
Reed, Robi, 41–43, 110, 122, 162, 197, 214
Reese, Della, 49
Reid, Daphne Maxwell, 42, 86, 87, 135, 141, 144

Reid, Joy, 36

Reid, Tim, 12, 75–76, 86–89, 91, 92, 94, 162, 163, 167–169

Reign, April, 256

Reyes, Alisa, 201

Rhimes, Shonda, 7, 8, 9, 27, 215, 217, 220, 221

Ribeiro, Alfonso, 135, 136, 138, 178, 183

Rich Man, Poor Man, 63

Richard Pryor Show, The, 91–97, 98, 170

Richards, Michael, 171

Richardson, Burton, 105

Richardson-Whitfield, Sallie, 243

Richmond, Tequan, 207

Ridley, John, 142, 155

Riley, Clayton, 40

Rivers, Joan, 104

Roberts, Ian, 99

Roberts, Julia, 105

Robinson, Tasha, 99

Robinson, Wendy Raquel, 185, 186, 211

Roc, 144–150, 158, 173, 183, 213

Rock, Chris, 98, 100, 108, 112, 114–115, 207–208, 211, 233, 239, 254

Rodriguez, Marquis, 248

Rodriguez, Michaela Jaé (MJ), 247–248, 254

Roker, Al, 201–202

Roker, Roxie, 58, 59

Rolle, Esther, 54, 56, 57, 60

Rolonda, 193

Roots, 8, 63, 64–73, 75, 88

Roots: The Next Generations, 71

Rose, Anika Noni, 73

Ross, Tracee Ellis, 45, 195, 197, 199, 225, 226

Rothwell, Natasha, 234, 235

Roundtree, Richard, 64, 67, 148, 222

Rowland, Kelly, 233

Roxx, 37

Royal Family, The, 49

Ruben, Aaron, 47, 49–50

Run the World, 257–259

Rundown with Robin Thede, The, 254

RuPaul, 180

Saadiq, Raphael, 235

Sajak, Pat, 104

Sands, Diana, 24, 63

Sanford, Isabel, 58

Sanford and Son, 37, 46–54, 61, 91, 109, 163

Santana, Merlin, 185, 186, 188

Scandal, 7–8, 9, 215–219, 220, 222, 233, 243, 258

Scary Movie, 173–174

Schwed, Mark, 88

Schwimmer, David, 159

Scott, Mike, 89

Scott, William Lee, 185, 186

Scribner, Marcus, 225, 226

Seales, Amanda, 163

Seimetz, Amy, 239

Seinfeld, 155, 164, 171

Seinfeld, Jerry, 34, 197

Selma, 243

Sesame Street, 33

Sex and the City, 198

Shaft, 148

Shahidi, Yara, 219, 225, 226

Sharbutt, Jay, 70

Sheen, Martin, 71

Shepard, Kiki, 102

Sherwood, Ben, 221

Showtime at the Apollo, 97, 100–102, 186

Sikora, Joseph, 229, 230

Silver Spoons, 138

Simmons, Russell, 112–113

Simon, David, 8

Simon and Simon, 86

Simpson, O.J., 68, 114

Sinbad, 102, 122

Sinbad Show, The, 179

Singleton, John, 244

Siriboe, Kofi, 242

Sister, Sister, 12, 132, 162–169, 200, 211

Smith, Bruce W., 201, 202

Smith, Jerome, 99

Smith, Kellita, 204, 205

Smith, Will, 42, 114, 135–138, 140–141, 142–144

Smollett, Jurnee, 163, 257

Smollett, Jussie, 163, 231, 233

Snoop Dogg, 154

Snow, Phoebe, 124

Snowfall, 244–247

Solange, 201

Soldier's Story, A, 174

Soul Food, 132, 213, 225

Soul Train, 8, 29, 37–43, 137

South Central, 191, 194, 197

Spears, Vida, 161, 189, 191, 193

Stanfield, LaKeith, 237

Star Trek, 12

Star Trek: Voyager, 162, 173

Steptoe and Son, 46

Steve Harvey Show, The, 185–188, 204

Stevens, David, 71

Stokes, Bridget, 254

Stone, Angie, 199

Stone, Oliver, 185

Suarez, Jeremy, 204, 205

Summer, Cree, 121, 122, 123

Sweet Justice, 7

Sykes, Wanda, 114, 225

Tales from the Crypt, 138

Tartikoff, Brandon, 82, 135, 136

Tate, Larenz, 191

Tebet, David, 15

Teenage Mutant Ninja Turtles, 138

That's My Mama, 61, 75, 86

Thea, 191

Thede, Robin, 82, 254, 256, 259

13th, 242

This Is Tom Jones, 20

Thomas, William, Jr., 177

Thompson, Kenan, 201

Three's Company, 76

Tillman, George, Jr., 213

Tomei, Marisa, 122, 123

Tompkins, Steve, 200

Tonight Show Starring Johnny Carson, The, 29–31, 50, 105

Towns, Edolphus, 150

Townsend, Robert, 104, 170, 171, 174–177, 178

Tribe Called Quest, A, 104, 106, 169

Trump, Donald, 248

Tubman, Harriet, 221

Tucker, Chris, 98, 112

227, 81–84, 168

Tyson, Cicely, 7, 63, 64, 67

Uggams, Leslie, 31, 34, 64, 67, 100, 231

Unhappily Ever After, 171

Union, Gabrielle, 192, 214, 221, 222, 256

Urbisci, Rocco, 91, 96

Usher, 192

Vampire Diaries, The, 213

Van Dyke, Dick, 211

Vance, Courtney B., 219

Vandross, Luther, 102

Vaughn, Countess, 81, 189, 194

Vaughn, Terri J., 185, 188

VelJohnson, Reginald, 126, 128, 131, 133

Vereen, Ben, 64, 67, 142, 144

Vidal, Lisa, 222, 223

Vidale, Thea, 191

Vinton, Will, 200

Waite, Ralph, 64, 68

Waithe, Lena, 11, 126, 244, 252–253, 257, 259

Walker, Holly, 81

Walker, Jimmie, 54, 56–57, 169

Warfield, Marsha, 91, 92

Warner, Malcolm-Jamal, 77

Washington, Denzel, 148

Washington, Isaiah, 27

Washington, Kerry, 7, 27, 215, 221

Waters, Ethel, 8

Watts, Rolonda, 191

Wayans, Damon, 107, 109

Wayans, Keenen Ivory, 42, 98, 107, 110, 112, 118, 170, 174, 175

Wayans, Kim, 107, 109, 178, 182–183

Wayans, Marlon, 169, 170–171, 173–174

Wayans, Shawn, 107, 110, 169, 170–171, 173–174

Wayans Bros., The, 169–174, 184, 203

We Need to Talk About Cosby, 81

Webster, 76

Werner, Mort, 15

Wesley, Rutina, 242

West, Amber Stevens, 228, 229

What's Happening!!, 61

When They See Us, 248–249

Whitaker, Forest, 73

White, Jaleel, 36, 126, 128–131

White, Karen Malina, 122, 201

White, Persia, 195

White, Slappy, 50, 91, 100

Whitfield, Lynn, 241, 242

Whitley, Kim, 252–253

Wilcots, Joseph, 68, 70

Wilkins, Roy, 15

Williams, Curtis, 174, 175

Williams, Francis, 88

Williams, Hal, 81, 82, 84

Williams, Michael K., 248

Williams, Robin, 91, 92, 96

Williams, Tyler James, 207

Williamson, Fred, 26

Wilmore, Larry, 142, 200–201, 204–206, 234, 235–236, 253–254

Wilson, Demond, 46, 49

Wilson, Flip, 29–34, 36–37, 50, 91, 100, 103

Wilson, Hugh, 86–88

Wilson, Yvette, 189

Winbush, Camille, 204, 205

Winfield, Paul, 26, 71

Winfrey, Oprah, 119, 242

Winters, Jonathan, 32

Wire, The, 8

Witherspoon, John, 91, 92, 169, 170, 202, 203

WKRP in Cincinnati, 75, 76, 86

Wolper, David L., 64, 66, 68

Wolper, Mark, 73

Wonder, Stevie, 40, 100, 135

Wonder Years, The, 208

Wood, Jeffery, 178, 179

Woodard, Alfre, 240, 241

X, Malcolm, 64, 66

Yang, Alan, 253

Yorkin, Bud, 46, 54, 61

Young, Bellamy, 215, 217

Young, Lee Thompson, 201

Young, William Allen, 189

Younge, Adrian, 241

PHOTO CREDITS